N
O
R
T
H

NORTH

FINDING PLACE IN ALASKA

EDITED BY JULIE DECKER

ANCHORAGE MUSEUM

ANCHORAGE, ALASKA

UNIVERSITY OF WASHINGTON PRESS

SEATTLE AND LONDON

CONTENTS

INTRODUCTION

JULIE DECKER

Alaska is part of a global North that is pivotal to today's world. An interest in the North has long preoccupied artists, scientists, and explorers. The present moment is a critical time for Alaska and its indigenous people. For the United States, Alaska is the only state with Arctic territory. Many around the world—from businesses, industry, and indigenous communities—are now looking to the Arctic and the North for insight into global change. Aside from climate, the economic and social conditions experienced by northern peoples are among the world's most pressing social issues. This publication seeks to place Alaska's history, cultures, landscapes, and people into an American art perspective and an international northern perspective. The chapters illustrate the North from both historical and contemporary points of view, to contribute to new perceptions of landscape and wilderness and the cultural contexts that inhabit them.

Artworks and artifacts are included throughout to provide a visual narrative, with subject matter, materials, and origin reflecting place and perspective. An outsider view dominated the art of the North for two centuries. For the first century of contact in Alaska by Europeans, artists accompanying discovery expeditions focused primarily on the "exotic" Native cultures they encountered. Landscapes were grand and romantic. Human, animal, and geological subjects were seen through the cultural and historical world views the Europeans brought with them. By the third quarter of the nineteenth century, artists were coming to Alaska's coasts on steamers in search of not just new scenery, but also fortune, wonder, wilderness, and escape. The landscape had become and still remains the primary attraction for artists in the North.

The indigenous perspective is critical to representing the North. Millennia of indigenous arts and crafts extend far beyond the colonial. Native-made objects reflect the natural materials of regions and resources. There is not one Alaska Native culture, but many, and identity and material culture are distinct. In the last decades, many contemporary indigenous artists have boldly innovated, sometimes with traditional imagery and methods as inspiration, other times with new media and new subject matter. Traditional knowledge informs history, science, and culture, and living cultures are at the core of discussions about the North's many possible futures.

In the contemporary North, as it becomes more difficult to distinguish between "there" and "here," and as individuals become removed from place, the remotest places on Earth become less distant. Through technology, urban and rural are connected. Today's world is a global world, not a world of frontiers. The North is less romantic than it was to former generations; today's North is connected, pivotal, and conflicted. It is both rarefied and ubiquitous.

Landscape was a term first associated with artists. Science followed. While romantic artworks embraced calm detachment, contemporary work sees the artist as activist more than observer. The art is not passive or detached. In the contemporary North, the landscape has become the "environment." Instead of creating awe-inspiring views, contemporary work questions the very concept of the landscape—the landscape becomes the place where value judgments are ethical rather than aesthetic. If this landscape still inspires, it inspires the depiction of a new landscape—one that has been altered by man and is at risk, in transition, and in question. Contemporary artists from inside and outside the North offer a compelling narrative for its relevancy in creating a global reflection of man's evolving relationship to and with the landscape.

History, too, is connected to the landscape. People shape and view their surroundings in ways that bridge the natural and the cultural. The landscape is not purely a pristine natural environment in which separate cultures live and extract resources. Humans adapt to and manipulate the environment, and landscapes are a process—they are places in which people seek, in diverse ways, to realize the possibilities of their cultures.

Science is intricately connected to the North. To study the northern landscape over its millennia, scientists gathered information from field surveys, maps, literature, sketches, and photographs. Today, satellite images and remote sensing offer new approaches to study the land. Scientific exploration, resource extraction, environmental change, and governmental intervention have been at work in the North for generations. The difference between indigenous and Western knowledge has formed the underlay of conflict in many realms of study, and the science of the far North today recognizes and begins to integrate the continuing existence and value of indigenous and local knowledge.

Traditional knowledge is much more than information that indigenous peoples have about the land and animals with which they have a special relationship—it is a deeper, common understanding of life and connection to landscape. Knowledge is the condition of knowing something with familiarity gained through experience or association. The traditional knowledge of northern indigenous peoples is part of the northern landscape and comes from life experience gained over thousands of years.

Many of the objects, artworks, and images in *North* are from the collection of the Anchorage Museum. The museum's collection began with the founding of the museum in 1968, but has grown exponentially, particularly as the museum added history and science to its mission in addition to art. Collectively, the diverse objects in this publication are part of a greater museum narrative of the North that combines with other disciplines to convey the complexity of the people and landscape of the North. Objects and artworks offer senses of place—a space between disciplines; between art, history, geography, archeology, sociology, and other fields. Landscapes, whether vernacular or other, can be comprehended only if we carefully examine the places, the people who interact with them, and the ways in which those landscapes were created as well as how they change. A sense of place requires immersion, through lived experience and intimacy—an acquired knowledge based on topography but also so much more. *North* is offered as a glimpse of Alaska as place and landscape, as a land long occupied, and looks to the futures we may someday inhabit.

THE
ROMANTIC
LANDSCAPE

JULIE DECKER

n 1879, the naturalist and writer John Muir mused, "To the lover of pure wildness, Alaska is one of the most wonderful countries in the world."[1] Like many, he was drawn to a land of raw beauty.

Almost forty years later, Rockwell Kent, one of America's most significant graphic artists, settled into a primitive cabin on an island near Seward, Alaska (see figure 1.1). In a letter to the art critic Dr. Christian Brinton, Kent wrote:

I came to Alaska because I love the North. I crave snow-topped mountains . . . and the cruel Northern sea with its hard horizons at the edge of the world where infinite space begins. Here skies are clearer and deeper and, for the greater wonders they reveal, a thousand times more eloquent of the eternal mystery than those of softer lands. I love this Northern nature, and what I love I must possess. And so this sojourn in the wilderness is in no sense an artist's junket in search of picturesque material for brush or pencil.[2]

While Kent enjoyed the isolation, other artists in the nineteenth century—like the Hudson River School painters Thomas Hill (see figure 1.2) and Albert Bierstadt, who painted the grandeur of the extreme America West, including Alaska—were indeed on junkets in search of picturesque material for brush or pencil.

Artists have long depicted Alaska—whether to document, respond to the market, capture the landscape, romanticize, or provide a personal narrative of observation. For Alaska Native cultures, "art" was well integrated into making, taking a variety of forms, from baskets to wood and stone works. When early visitors to Alaska expressed interest in acquiring Native-made objects, a new genre of art object began to evolve—from small totems to moccasins and button blankets in Southeast Alaska; carved ivory, jade, and bone pieces and intricate dolls in western and northern Alaska; and baskets and elaborate beadwork in the central and southwestern parts of the state. As more and more people visited Alaska during the 1920s and 1930s, Alaska Native art became more

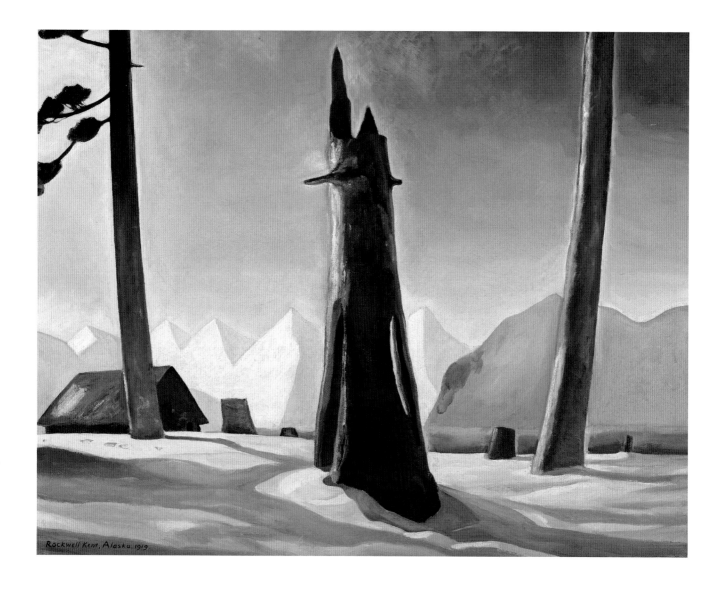

Rockwell Kent, Alaska. 1919

FIGURE 1.1 Rockwell Kent, an early modernist and colleague of painters George Bellows and Edward Hopper, created a collection of Alaska landscapes. An adventurer, artist, illustrator, and writer, Kent did not come to Alaska in search of something tangible, like gold, but rather in search of something grander—a "dreamer's search," as he described it. Arriving in Seward, Alaska, with his nine-year-old son in 1918, Kent stayed in an abandoned cabin on an island.

Rockwell Kent, American, 1882–1971, *Alaska Winter*, 1919 (Fox Island, Alaska). Oil on canvas, 97 × 122 × 8 cm. Collection of the Anchorage Museum.

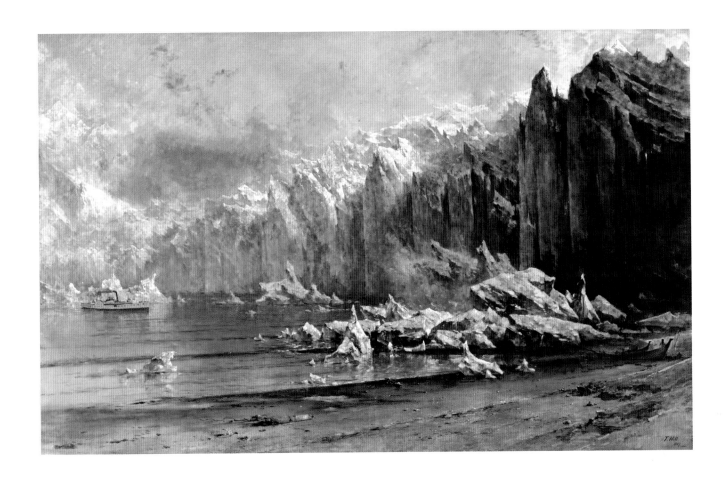

FIGURE 1.2 Arriving in Alaska in 1887, Thomas Hill was commissioned by naturalist John Muir to paint Muir Glacier, now part of Glacier Bay National Park and Preserve in south-eastern Alaska. This was one of several large works that Hill completed in his California studio after the trip. In keeping with the Hudson River School philosophy, Hill's landscape is characterized by a detailed and idealized portrayal of nature.

Thomas Hill, American, 1829–1908, *Muir Glacier,* 1887. Oil on canvas, 174 × 260 × 11 cm. Collection of the Anchorage Museum.

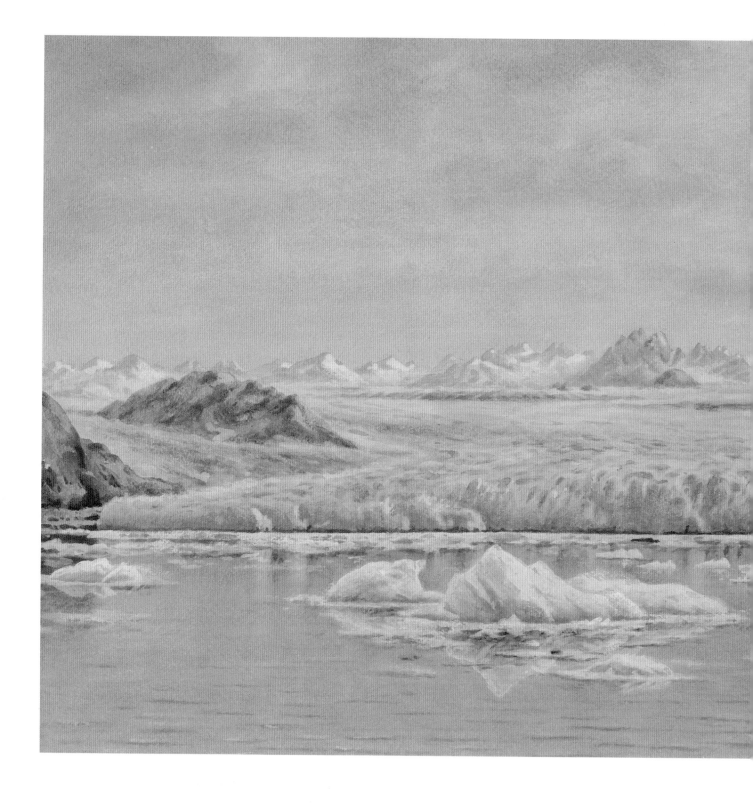

| JULIE DECKER

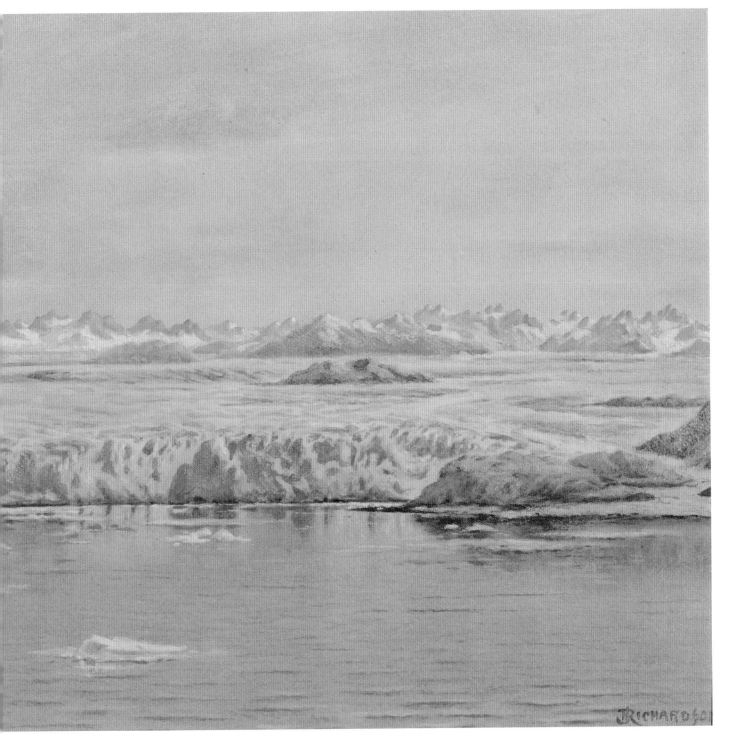

FIGURE 1.3 Every snow-capped peak and valley of snow on Muir Glacier is represented by Theodore Richardson from observations he made while camping there.

Theodore J. Richardson, American, 1855–1914, *Muir Glacier,* c. 1900. Watercolor, 57 × 95 cm. Collection of the Anchorage Museum.

and more of a commodity. The US Bureau of Indian Affairs created the Alaska Native Arts and Crafts cooperative to assist villages with marketing items, and the cooperative opened stores in Anchorage, Juneau, and Seattle.

Painting the landscape of Alaska was a common theme in the late 1800s and early 1900s. American painters went farther and farther west in the third quarter of the nineteenth century, focusing on the landscape rather than relegating it to a mere backdrop for ethnographic portrayal. The mid-nineteenth century saw the proliferation of the American landscape painting tradition, and ambitious artists such as Theodore Richardson began visiting the territory of Alaska to adapt these new styles to the Alaskan landscape (see figure 1.3).

In 1899, Edward Henry Harriman, an American financier and railroad executive, assembled an elite group of scientists and artists and took them on a two-month survey of the Alaskan coast. The expedition was the largest and most famous the world had seen, with crowds of people cheering its departure and newspapers around the globe featuring the story on front pages. The expedition returned with over one hundred trunks of specimens and more than five thousand photographs and colored illustrations.

Frederick Dellenbaugh was one of the Harriman expedition artists. Dellenbaugh became interested in landscape painting and mapmaking at an early age. At seventeen, he was skilled enough to be chosen for John Wesley Powell's second expedition down the Colorado River, serving as both artist and assistant mapmaker. Dellenbaugh subsequently traveled widely, to Iceland, Norway, the West Indies, and South America. His paintings sold well and were often published as illustrations for natural history books. Using material from his private journals, he wrote and illustrated several books about the western United States. So Dellenbaugh was a seasoned traveler when he joined the Harriman expedition to Alaska in 1899. Several of his paintings from the trip were used as illustrations for the first two volumes published after the Harriman expedition. He made hundreds of pencil drawings, oil sketches, and photographs on the expedition, illustrating his intense interest in the color, shape, and light of the landscape (see figure 1.4).

Many other trained artists followed, on their own individual adventures rather than as part of organized expeditions—such as Sydney Mortimer Laurence, Eustace Paul Ziegler, Ted Lambert, and Rusty Hurlein (see figure 1.5). Laurence is often credited with being the first professionally trained artist to live and work in Alaska, beginning in 1903 in Juneau, where he first found work as a photographer. Within a year, Laurence was on the move to Valdez to prospect for gold. Eventually, painting became his primary calling; he produced his first major work in 1912 and worked as both a photographer and painter in Anchorage, where he lived until 1925. In 1915, when the city of Anchorage was just being established, Laurence opened his studio in the lobby of the Anchorage

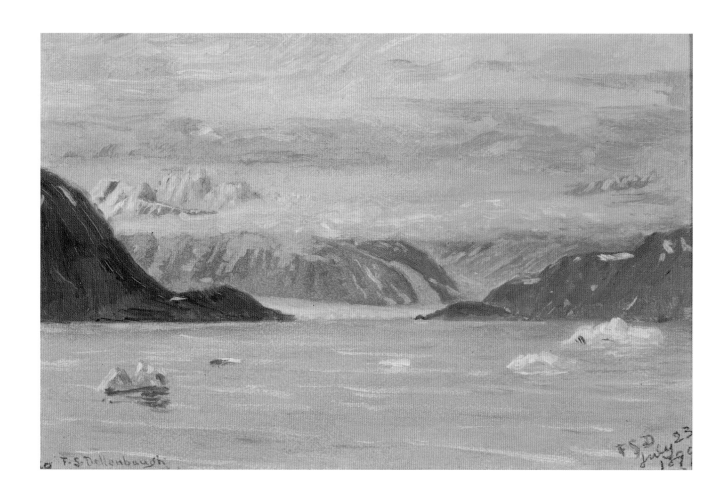

FIGURE 1.4 View of Disenchantment Bay, near the
Hubbard Glacier in Alaska.

Frederick Samuel Dellenbaugh, American, 1853–1935, *Entrance,
Disenchantment Bay*, 1899. Oil on board, 15 × 23 cm. Gift of Mr. and
Mrs. Elmer E. Rasmuson. Collection of the Anchorage Museum.

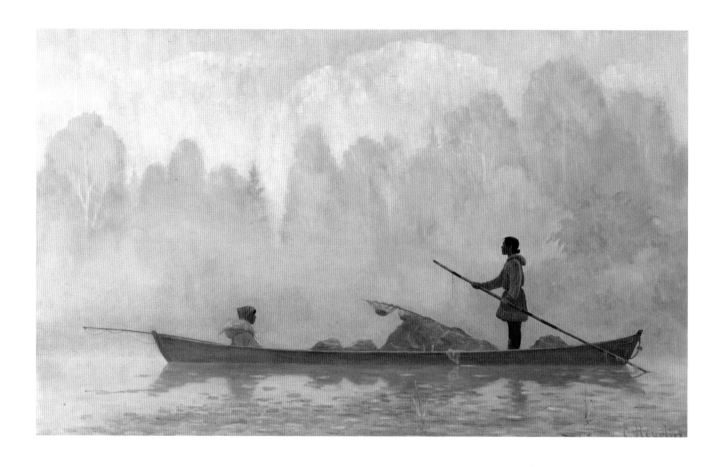

FIGURE 1.5 "Rusty" Heurlin first came to Alaska in 1916. World War I service took him to Europe, after which he spent several years working in Connecticut as an artist-illustrator. In 1924, he returned to Alaska, finally settling in a small village near Fairbanks, where he lived out the rest of his long life. He spent time in several Alaska Native villages, learning about whaling and other Native activities.

Magnus Colcord "Rusty" Heurlin, American, 1895–1986, *After Fishing*, c. 1960. Oil on board, 87 × 127 × 5 cm. Collection of the Anchorage Museum.

Hotel and took an upstairs apartment, hanging his shingle as the Sydney Laurence Co. As a photographer, he is responsible for recording many of the earliest images of Anchorage.

In his later years, Laurence began to spend winters in Los Angeles, where he created finished paintings from the sketches he captured during his summers in Alaska. In the 1930s he lived in Seattle, where the market for his Alaska works expanded. Laurence painted a variety of Alaskan scenes in his prolific career, including scenes of sailing ships and steamships; totem poles in Southeast Alaska; the headlands, coves, and streams of Cook Inlet; and cabins and caches under the aurora borealis. He is most often associated with paintings of Denali, and he became the quintessential romantic painter of Alaska. He worked to capture landscapes at dawn or dusk, during autumn, winter, or spring, because he saw the light at those moments as both natural and exaggerated. Laurence returned to paint and sketch Denali again and again, in often hazardous conditions, at times battling both pneumonia and mosquitos and crossing land and rivers to arrive at his vantage point. He applied to his paintings the tonalist techniques he had learned in New York and Europe. *Tonalism* was an artistic style that emerged in the 1880s when American artists began to *paint* landscape forms with an overall tone of colored atmosphere or mist. Between 1880 and 1915, dark, neutral hues such as grays, browns, and blues often dominated compositions by artists associated with the style (see figure 1.6).

Another icon in traditional Alaska painting is Eustace Paul Ziegler, who arrived in Alaska in the winter of 1909, when he was twenty-eight years old. Peter Trimble Rowe, the Episcopal bishop of Alaska, recruited Ziegler, who first traveled to Cordova, where he was to manage the Red Dragon club for railroad workers as well as serve as a missionary. In Cordova, Ziegler painted murals on the walls of the mission and around the rotunda of the local theater. He began to sell his paintings to tourists who arrived in the small town via the Alaska Steamship Company and even organized a small exhibition of his work in the dining room of the Kennecott Mine. Unlike Laurence, Ziegler often placed people as a central feature into his paintings and landscapes—and he became known for his portraits of Alaska Native people and people navigating the frontier land with dogs and pack animals (see figure 1.7). Native Alaskans, priests, miners, trappers, fishers, and others living in the new territory became increasingly notable as subjects for other artists as well.

In 1923, land was cleared near Anchorage's city center to allow "bush pilots" to fly into town in small, open-cockpit airplanes, and soon these pilots began to build homes along the airstrip. Anchorage began to grow into a place more urban, with a resident rather than simply a transient population. But the population and economic growth in Anchorage and across Alaska was stunted by the dawn of the Great Depression, which suppressed art production as well. In 1937, a dozen artists were sent to paint the

FIGURE 1.6 Sydney Laurence made several paintings of Denali (then Mount McKinley), becoming the iconic painter of the mountain and Wonder Lake. He forged a distinctly personal style by applying the tonalist techniques he had learned in New York and Europe to the wilderness of the North.

Sydney Mortimer Laurence, American, 1865–1940, *Mount McKinley*, 1913. Oil on canvas, 50 × 77 × 10 cm. Collection of the Anchorage Museum.

FIGURE 1.7 Eustace Ziegler's work captured the daily lives and occupations of early Alaskans. The figures are hard at work within the landscape—crossing rivers, prospecting, mining, and fishing.

Eustace P. Ziegler, American, 1881–1969, *Pack Train Near Mt. McKinley*, c. 1930. Oil on canvas, 147 × 313 cm. Gift of the Atwood Foundation. Collection of the Anchorage Museum.

Alaska Territory by the Federal Artists Project, a predecessor program to the Works Progress Administration (WPA) that put artists to work painting murals in post offices and libraries across the country during the Depression. In Alaska the artists were to paint the wilderness, with the intention that the works of art created would be part of a major exhibition that would tour the United States to promote tourism and industry. Since Alaska didn't have the professional artists needed for the project, they were imported from the Midwest, New York, and New England, arriving by ship in Ketchikan. The exhibition never took place, and many of the Alaska Expedition paintings were dispersed, but the artists—including Prescott M. M. Jones (see figure 1.8), Karl Fortess, and Merlin Pollock—still made their mark. They toured the state, from the fishing industry towns along the coast to the mines at Juneau and Fairbanks to the farms in the Matanuska Valley. They also went north to Cordova and Valdez, up the Richardson Highway to Paxson, to Fairbanks and as far as the Arctic Circle.

Fred Machetanz was a painter and illustrator who bridged the era in Alaska from territory to statehood. He first came to the territory in 1935, when he traveled to Unalakleet to visit his uncle, who ran a trading post. He spent two years developing an Alaska portfolio. After leaving Alaska, he spent some time as an illustrator in New York, but he returned to Alaska in 1942 after volunteering with the US Navy and requesting a posting to the Aleutian Islands during World War II. After the war, he trained for a short time at the Art Students League in New York, studying lithography, and then returned to Unalakleet, Alaska, in 1946. Machetanz eventually settled in Palmer, Alaska, in 1951, publishing books with his wife, Sara Dunn, and collaborating on films for

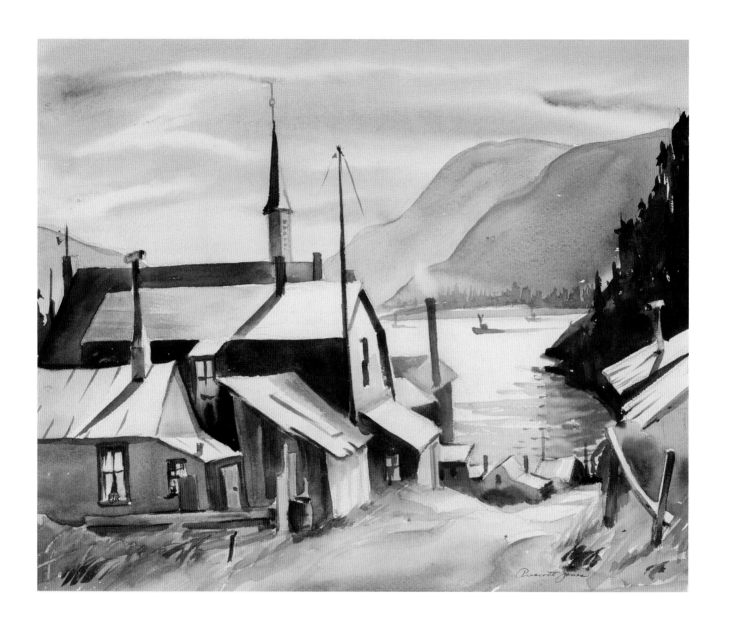

FIGURE 1.8 Southeast Alaska village with church.

Prescott M. M. Jones, American, 1904–1981, untitled, c. 1937.
Watercolor on paper, 44 × 54 cm. Collection of the Anchorage Museum.

Walt Disney, the Territory of Alaska, and the Encyclopædia Britannica. Machetanz and Dunn also made many promotional and lecture tours through the United States from 1948 through 1960. The turning point in Machetanz's painting career came in 1962, when Bob Atwood, editor and publisher of the *Anchorage Times* newspaper, arranged for a one-man show of his paintings. The works sold quickly, and the success allowed Machetanz to pursue painting full time.

Machetanz was a colorist—intense color being the primary impression of his work. He most often painted on hardboard, which was prepared with layers of an ultramarine blue base using a large brush. He then applied a transparent oil glaze technique to build up layers, emphasizing areas of color and form, and giving his works a quality that he felt reflected the environment of the Arctic. Machetanz captured a romantic view of the North—as a place of heroic adventure, astounding beauty, distinct people, and mystery—all with his comparatively narrow color palette (see figure 1.9).

World War II increased art production in Alaska—the military forces stationed there included artists, photographers, and filmmakers. Employed to document, the visual recordings are significant in their depictions of landscape and history. Joe Jones, Henry Varnum Poor, and Lieutenant William F. Draper (one of five combat artists assigned by the navy) were some of the enlisted artists who produced many works in Alaska.

Construction of airfields and highways in World War II made Anchorage the transportation hub of the territory, and military construction continued after the war because of Alaska's strategic geographic position relative to the Soviet Union. By 1950, thirty thousand people lived in the Anchorage area, and this increasing population prompted politicians and developers to demand statehood for Alaska—a request that resulted in the passing of the Alaska Statehood Bill in 1958. By 1960, oil had begun to flow from the Swanson River field on the Kenai Peninsula, and Anchorage became the headquarters for the oil industry—although that progress was dealt a temporary shock in 1964 when North America's largest recorded earthquake, with a magnitude of 9.2 on the Richter scale, struck south-central Alaska.

Construction of the Trans-Alaska Pipeline began in 1973, and by the late 1970s Anchorage's population was booming again. Capital improvement projects, supported by state grants, included a sports arena, convention center, library, performing arts center, golf course, recreation center, ice arena, parking and transit centers, animal control center, bike trails, and expansion to the Anchorage Museum (then the Anchorage Museum of History and Art). Along with the population boom came new and larger markets for artists' work. With the introduction of community colleges and the formation of the University of Alaska, art in Alaska featured more and more trained and professional artists. The 1980s also saw the introduction of commercial art galleries, as well as university-run and nonprofit art venues in Alaska's larger cities, providing

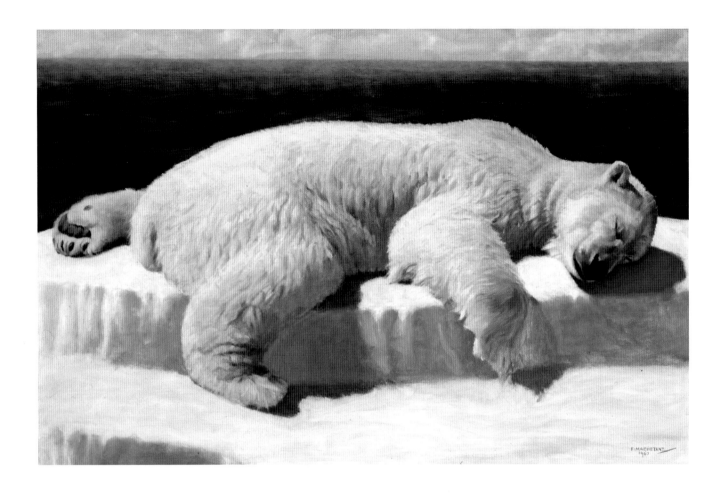

FIGURE 1.9 Fred Machetanz prepared his painting boards with layers of an ultramarine blue base, then applied a transparent oil glaze to build up layers—giving his works a quality that he felt reflected the environment of the Arctic.

Fred Machetanz, American, 1908–2002, *Mighty Hunter*, 1967. Oil on board, 98 × 139 × 5 cm. Collection of the Anchorage Museum.

artists with a small but significant infrastructure to both sell their work and take risks and experiment. By 1981, Anchorage was growing by a thousand people a month and experiencing a housing and building boom that continued until 1986, when the price of crude oil collapsed. Between 1987 and 1989, Alaska lost twenty thousand jobs and real estate values fell markedly.

While Alaska is now home and host to artists from around the world and exposed to each trend and movement of the art world, it is still most often associated with the romantic visions of an unspoiled northern frontier. In 1947, Ansel Adams traveled to Alaska on a Guggenheim fellowship and was taken to Denali (then called Mount McKinley). The National Park Service delivered him to a ranger cabin at Wonder Lake. There, he took an iconic photograph of the mountain—at 1:30 on an Arctic summer morning, the sun having set only two hours previously, at 11:30 p.m. Adams was deeply impressed with Alaska, calling it one of the most impressive reservoirs of beauty and wilderness and an inexhaustible resource for creative interpretation. Adams remarked that Alaska had been only lightly explored by serious artists in all media.

One of Alaska's many myths is that all of the state exists in total darkness during the winter months. While it's true that the sun does not rise above the horizon for sixty-seven days in Point Barrow, in more southern communities, like Anchorage or Fairbanks, the sun never entirely disappears. Even on the shortest day of the year, Anchorage still benefits from around five and a half hours of sunlight. This winter darkness is balanced by summer light, when Anchorage claims more than nineteen hours of daylight. It is the light that has captured many artists. Artworks in Alaska often explore the vast Alaskan sky—with its far-off vanishing point, endless expanse, dramatic cloud formations, changing light, and, of course, the aurora. Other artists stray from the vastness of the surroundings and instead depict the intricate details of the land—from the endless formations of ice and frost to the colorful variations of birch tree trunks, to the patterns found in the mud along Turnagain Arm. Alaska painters such as Kesler Woodward (see figure 1.10), Bill Brody, James Behlke, Byron Birdsall, Spence Guerin (see figure 1.11), and David Mollett (see figure 1.12) have become known as the later generation of Alaska landscape painters. The newest generation continues to evolve, particularly through digital and new media methods of capturing and depicting the surrounding landscape.

In romantic art, nature is recognized for its uncontrollable power, unpredictability, and potential for cataclysmic extremes—an alternative to the ordered world of Enlightenment thought. Representations of man's struggle against the awesome power of nature manifest the romantic sensibility. In many romantic paintings, man is dwarfed by the overwhelming scale of the landscape. A highly personal view of nature was embraced by romanticism—with an interest in the individual and subjective. Portraits became vehicles for expressing a range of psychological and emotional states in the

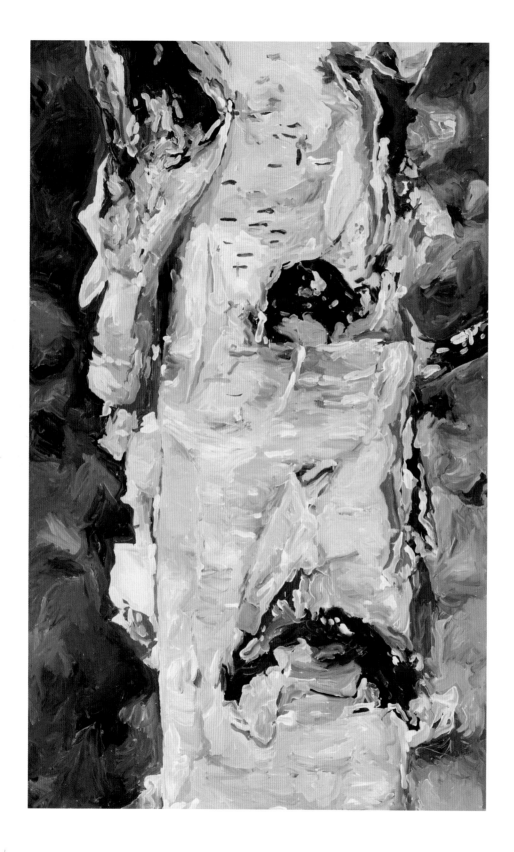

JULIE DECKER

FIGURE 1.10 (opposite) American painter Kesler Woodward is best known for his "portraits" of birch trees.

Kesler E. Woodward, American, born 1951, *Birch Portrait II*, 1983. Acrylic on canvas, 179 × 110 cm. Collection of the Anchorage Museum.

FIGURE 1.11 (above) A moonlit view over the tidal mudflats of the Matanuska River near Anchorage, with the mountains of the Alaska Range rising faint in the background. Spence Guerin worked in Alaska for fourteen years in the 1970s and 1980s.

Spence Guerin, American, born 1941, *Moon over Matanuska*, 1980. Acrylic on canvas, 131 × 199 cm. Collection of the Anchorage Museum.

FIGURE 1.12 David Mollett is one of a group of artists, many from the Fairbanks area, who flew into remote areas of northern Alaska or the Canadian Arctic to paint during the 1980s and early 1990s. This work was painted on location. One of Mollett's goals has been to demonstrate that the high Arctic is not a barren wasteland, and he continues his paintings of the landscape today.

David Mollett, American, born 1950, *Carnivore Creek*, 1988. Acrylic on canvas, 124 × 155 × 5 cm. Collection of the Anchorage Museum.

hands of romantic painters. Such explorations of emotional states extended into the animal kingdom, marking the romantic fascination with animals as both forces of nature and metaphors for human behavior. In short, romanticism was about a way of feeling rather than a choice of subject or an attempt to depict an exact truth.

While romantic painting is no longer the genre of the day, and the grandeur of the landscape has often been replaced with narratives about the precarious nature of the changing environment, it may be that Alaska is still dominated by art that represents a way of feeling.

Today, contemporary Native Alaskan artists explore the connections and boundaries between the traditional world and the modern world. Tlingit artist James Schoppert's abstract paintings from the 1980s were based on Tlingit imagery, while Iñupiaq and Athabascan artist Sonya Kelliher-Combs's contemporary combinations of natural and synthetic materials create images that relate to both rural and urban life today. Other current Alaskan artists make little reference to the natural environment in their work— they are urban artists who explore global themes and the role of the artist in a contemporary, ubiquitous place.

But many artworks continue to tell the stories of Alaska and the North—a place that combines isolation and remoteness with city life, lightness with darkness, urbanity with the ultimate grandeur of nature. It is a place of tradition and innovation, of diverse indigenous peoples who honor the land and animals on which they depend—and newcomers who learn how to respond to an environment that is often extreme and frequently unpredictable.

A more novel sense of romanticism has emerged in art today. A romantic inclination toward the tragic and the ominous can be applied to many more recent landscape works—a play between projection and perception, coherence and chaos. Contemporary landscape artists often present the commonplace with significance, the everyday with mystery, and the familiar with the aura of the unfamiliar. Today's romanticism is dissatisfied with a present that is increasingly uninhabitable and unknowable, and desires a future other than the one assumed. The new romanticism expresses a fondness for a place not yet left behind.

NOTES

1 John Muir, *Travels in Alaska* (Boston: Houghton-Mifflin Company, 1915).

2 Rockwell Kent, *Wilderness: A Journal of Quiet Adventure in Alaska* (Middletown, CT: Wesleyan University Press, 1996).

MATERIALS OF PLACE

ALAN BORAAS

When Butch Hobson, a Dena'ina elder form Nondalton, sets about to make a pair of traditional Dena'ina snowshoes, he first gathers the necessary materials. Everything he needs is available from the environment in which he lives, on Lake Clark: birch for the frame and cross braces, sinew for the webbing, and leather straps cut from moose hide for the foot-strap binding. Hobson will have already decided what type of snowshoes he will make—mountain snowshoes or running snowshoes, for wet snow or dry snow—and he will size the snowshoes for the person he is making them for. His tools are a saw, ax, knife, drill, and decades of practiced skill developed from traditional knowledge. He will shape the frame from newly cut birch when it is still soft. He will steam the white wood and gently bend it to the proper shape and insert the cross braces. He will dry the frame and, when it is hard, drill small holes into which he will thread the strong, pliable sinew webbing made from the backstrap of a moose or caribou, which he will then carefully lace into an octagonal web pattern for flotation—narrow gauge for cold, dry snow flotation; wide gauge for heavy, wet snow. Light, strong, durable, repairable, and from the land, Dene snowshoes are the epitome of winter travel technology in Alaska. And they cost little to make and nothing to operate for a day in the woods except healthy calories from a few sticks of dried salmon, also from the land, and a break or two for tea (see figure 2.1).

A number of years ago, a Kenai Peninsula College student in Alaska named Patrick Monroney opted to do a project rather than write a term paper for an anthropology class I taught. He chose to make traditional Dena'ina snowshoes. At the time, I thought this undertaking was too ambitious and suggested he try something less demanding—like write a twenty-page research paper. But he was adamant, and he had skills. He researched construction techniques and gathered the necessary materials. After some false starts, he succeeded in reproducing a fine pair of snowshoes from birch he cut and sinew from the backstrap of a road-kill moose.

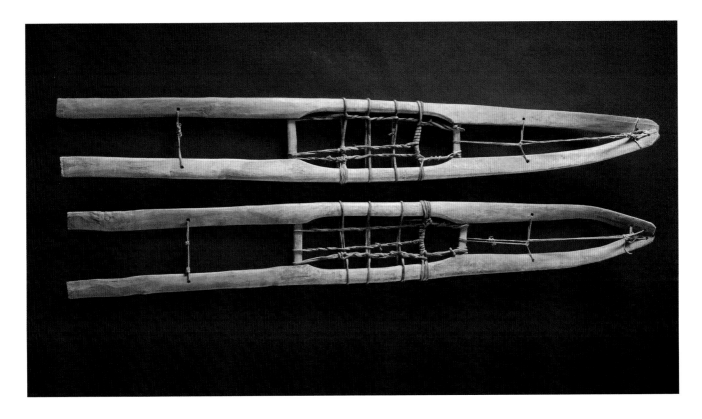

In many respects the snowshoes made by Hobson and Monroney are identical—except for one thing. When traditional Dena'ina finish a pair of snowshoes, the maker completes a final step—he or she performs a blessing ceremony. The maker will tie a piece of dried salmon to the tips of the shoes, put them on, and walk in a circle three times clockwise—the way the sun goes.[1] In contrast, Monroney, in keeping with Western tradition, conceives of his snowshoes as inanimate objects; they are not sensate and do not take in or express information. Although they certainly might elicit strong attachment after many of hours of winter travel, they remain inanimate objects.

Herein lies the difference in how many Alaskan Natives and most in Western culture understand the world of material things: in Native culture, snowshoes, baskets, beaded clothing, bentwood boxes, and virtually any item someone makes can have a spirit infused in it, often by prayers said during construction and further solidified by a ritual that may be as elaborate as the dedication of a Tlingit or Haida totem pole, or as humble as a solitary craftsperson alone in the woods going around three times the way the sun goes with a bit of salmon tied to newly finished snowshoes. The inanimate object is now animate.

FIGURE 2.1 These snowshoes are called *q'ishaqa* in Upper Cook Inlet Dena'ina. In English, the Dena'ina refer to this type as ski snowshoes, or "banjos." This type of showshoe was made when someone needed a pair quickly.

Dena'inaq, *Snowshoes*. Wood, hide, cotton string. Collection of the Anchorage Museum.

In March 2016, I interviewed Helen Dick of Lime Village, Alaska, for a project about traditional Dena'ina practices and beliefs that still apply in the modern world. When I asked her about praying or blessing something someone makes, she said: "Oh yes, you have to pray all the time, no matter what you make." Pointing to a birch bark basket that she had made for me, she said:

> I prayed over that a lot while it's making. . . . My Grandma told me everything I do, your heart has to be good. Everything you do, you have to pray. Even sewing, who's going to wear that hat? You have to sew it so good things will come to that hat and when they use it they feel good.

These beliefs extend to cooking. Ms. Dick said:

> If you cook for people, you have to have good feelings, you can't have bad feelings about anything you do. You can kind of tell when people are cooking, if they're mad, you can taste it: the food doesn't taste good. If people pray, the food tastes good.

Sharing or giving does not simply mean handing over something to someone. To Ms. Dick it involves connecting to that person. She said:

> It has to be good feelings. If you give things away you have to feel good about it. . . . You pray before you give the gift so they can feel you.

She went on to say that if someone made something while they were angry:

> It wouldn't carry good feeling. I think you could see it in the way it's made. If somebody didn't have a good feeling while making it you can see it in the item.

Recounting his Dena'ina elder's teachings, Peter Kalifornsky, a Dena'ina Athabaskan writer and ethnographer best known for his work in creating a written version of the Dena'ina language, wrote *etnenq' gu łuq'u yadi qilan,* "whatever is on earth is a person [has a spirit] they used to say."[2] In addition to humans, this would include animals, plants, places, and at least some of the things people make, although it is not entirely clear whether a nonhuman spirit is precisely the same as a human soul. Despite two centuries of colonial policies that would reorient their world view toward a logical positivist scientism that would reject the broad definition of Dick's and Kalifornsky's spirit world, Native Alaskans continue to interact with natural realms as well as the things

they make and use through the context of spirituality. Some mountains, rivers, and lakes are sacred. Animals are willful and plants are sensate. And things can have energy, information, or power.

In 1974, archaeologist William Workman and I excavated the remains of a *nichɫ,* a precontact Dena'ina house, at a village site by the Kenai River. At the time there had been few village site excavations, and I was enthusiastic about finding and analyzing artifacts and helping to define an archaeological culture by what could be inferred from those artifacts. Fifteen students worked two weeks and found one artifact. A second excavation the next year at precontact Kalifornsky Village produced the same results: almost no artifacts. At the time, some archaeologists observed that the Dena'ina must have been too poor to have much in the way of material things; others surmised that they were recent prehistoric migrants to Cook Inlet and artifacts had not accumulated at their village sites. Both points are wrong.

It was not until I worked with Kalifornsky and linguist James Kari on Peter's book, *K'tl'egh'i Sukdu: Remaining Stories,* that I learned why there are so few artifacts in Dena'ina sites.[3] The Dena'ina believed that information surrounding the use of an artifact could be absorbed in the tools that were used. If the information is bad, it is called *beggesh,* and if it is good, it is *beggesha* (the final *a* reverses the action of the verb in this case, from bad to good). That information would exude from the object like a scent, and that scent contained a history of the object's use. Spiritually aware individuals called *K'ech Eltanan* (true believers), shamans, and animals could detect information from the scent of an artifact, including one haphazardly left lying about.[4] If "good," the information could involve good feeling representing proper behavior. But if "bad," it could involve anger, hatred, or abuse, and the animals or spiritually aware Dena'ina could sense disharmony and be disquieted by its presence. Animals detecting *beggesh* were said to "leave the country," with dire consequences to a village, since the Dena'ina of this time period were hunters and gatherers dependent on wild species, primarily salmon, for food. The result is that no one left artifacts lying about except by accident, and we have numerous archaeological excavations to prove the lack of artifacts at pre-historic Dena'ina sites.

A tangible substance that is not an artifact can have spiritual qualities as well. A lucky agate was said to have *qbeggesha*—literally, "its good essence"—and holy water is *mi\ni beggesh qul'i,* or "water without a bad essence." These terms could also apply to intangible concepts. Kalifornsky used *N'izhi beggesh qul'i* in his translation of the Lord's Prayer in the phrase "hallowed be thy name" to refer to God's name as "your name + impurity + none," or "hallowed."[5] In some cases, the act of making a thing imbues it with power. Two examples are the Alaskan Unangan and Alutiiq bentwood hats and Yup'ik masks.

The North Pacific contains some of the most dangerous water in the world. The Aleutian Low is a semipermanent belt of repeated, storm-generating, low-pressure systems that sweep up the islands onto the Alaska Peninsula and the Kodiak Archipelago to Cook Inlet. Wind and waves are fierce, and ten-foot seas are not uncommon. Into this fray, indigenous Alutiiq, coastal Yup'ik, and Unangan (Aleut) kayakers—said to be the greatest kayakers in the world—traveled and pursued sea mammals they harpooned from their small, skin-covered craft. It was not for the faint of heart.

In addition to waterproof outer clothing, the coastal people made bentwood hats, which functioned to keep off the rain and spray. These hats were carved and shaped from wood, often driftwood, painted with various effigies and symbols.[6] To say that the hats were purely functional is to underestimate their significance. Lydia Black describes the belief that bentwood hunting hats were imbued by their maker with power to give the kayaker courage to face the rigors of the ocean.[7] She writes: "The young apprentices . . . learned at the old masters' feet to bend wood, to mix paints, to draw and to carve, as they learned the significance and meaning of each element—of the human-like figurines, of birds, of the killer whales, of the beasts of the sea, of the fabulous monsters who could aid or kill a man, and of the abstract signs that represented each or all of them and the faculty of "clear sight," the hunter's supernatural vision."[8]

The bentwood hat was also worn in internecine battles among Unangan villages, as well as in battles among Yup'ik and Alutiiq and later Russians, where it provided the wearer not so much with protection from darts, spears, or musket balls, but with courage. Black describes the wooden hat as functioning as a mask, helping the wearer to be "capable of braving the ocean and its dangers, it also hid his human identity and, at the same time endowed him with special vision. The elaborate 'hunting hat' was a very special mask. The wearer of this type of hat acquired the power to kill not only seals and other animals, but also the power to kill other human beings."[9]

While a bentwood hat gave the wearer courage, the Yup'ik mask was an expression of supernatural power. In a 1990 essay entitled "The Mask: The Eye of the Dance," cultural anthropologist Ann Fienup-Riordan describes the late twentieth-century resurgence of Yup'ik mask making in the Yukon-Kuskokwim Delta. Masks were powerful spiritual forces, and early twentieth-century missionaries opposed their use in traditional ceremonies because of their perceived pagan influence. As an indigenized version of Christianity, coupled with the influence of the American educational system, took hold, mask making fell into disuse. In the early 1980s, a series of workshops led by some of the last traditional craftspeople began to revitalize the practice of mask making and, with it, a renewed understanding of the power of the mask.

Yup'ik masks incorporate a number of circle and dot motifs. At one level, the surrounding wooden hoop defines the spirit, represented by the carved mask, entering the

human dimension from its unseen realm. Often a mask has multiple hoops, or *ellan-guat,* indicative of a layered cosmology with numerous ascending realms.[10] Within the mask are one or more circle-and-dot motifs called *ellam iinga,* or "eyes of awareness."[11] When a dancer dons the mask for a ceremony, he is not method acting; he is not consciously playing the part of the supernatural entity portrayed in the mask like an actor playing the part of a historic person. In some ceremonies such as the Bladder Festival, when a dancer dons the mask he becomes a vehicle for the spirit to enter the human world, and the eyes of the mask give vision to the spirit.[12]

Aaron Leggett, co-curator of the "Dena'inaq' Huch'ulyeshi: The Dena'ina Way of Living" exhibit at the Anchorage Museum and co-editor of the volume of essays of the same name, was charged, with co-curators and editors Suzi Jones and James Fall, to assemble Dena'ina artifacts from the world's museums for the first major interpretive exhibit in Alaska of Dena'ina culture. The exhibit would bring as many of the material items as possible back to their homeland—some had not been in Alaska for over a hundred years. For Anchorage and south-central Alaska it was more than an exhibit; it was a statement that this is Dena'ina territory with a proud and complex indigenous culture.

The work entailed assembling a spreadsheet of items by poring over books, journal articles, and Internet museum records and then traveling to the repositories that held them in the United States and Europe to see them firsthand and try to arrange their loan for the exhibit. Leggett is of Dena'ina heritage but was brought up in Anchorage without the cultural training that normally occurs by being raised in a village with the daily influence of elders and culture bearers and a majority of indigenous cohorts.[13] Initially, the items being gathered held a less visceral, more academic interest for him.

One of the items of interest is a shaman doll illustrated in *Ethnography of the Tanaina,* by curator and cultural scholar Cornelius Osgood, and subsequently pictured in the exhibit book.[14] Osgood called it a "doll," and it has been housed in the Peter the Great Museum of Anthropology and Ethnography in Saint Petersburg, Russia, since just after it was collected by Russian naturalist Ilya Voznesenki at Kenai in 1842. "Doll" is an unfortunate term, because it implies a plaything when it was, in fact, just the opposite: an effigy used by a shaman that had deep spiritual power ascribed to it by traditional Dena'ina. The Dena'ina word for a wooden medicine effigy is *chik'a qenin'a.*[15] The shaman, or *ele'gen,* was part of a pantheon of individuals with shamanic powers including the Dreamer, Sky Reader, Prophet, Doctor, and Gashaq—the latter a medicine-priest figure, the word derived, curiously, from Yup'ik or Sugpiaq. Shamans were said to be good or bad and were experts in healing through the use of herbal medicines and what Western culture would call psychosomatic means. Each shaman had a powerful animal familiar, commonly a brown bear or wolf; could engage in teleportation through dream states; and could affect events over great distances. Shamans

could perform telekinesis by transporting objects through space and time. Kalifornsky describes the Dena'ina shamans this way: "Their belief involved the spirit of every living animal and every living plant. Through prayer they would contact the spirit of the living being with their mind and they would start gathering the spirit of that thing through a transfer of power from one to another."[16] The medicine effigy was part of the equipment through which shamans interacted with the spirit world.

Leggett, Jones, and translator/anthropologist Evguenia Anichtchenko went to Saint Petersburg to examine the medicine effigy and other artifacts. In the museum's curatorial room, Leggett was examining a tunic with his back to the door through which the curator brought out the medicine effigy. Leggett said he felt a strong presence in the room that had not been there before, and when he looked at the medicine doll he had a strong urge not to touch it. The hair, now over 150 years old, was still shiny and black, and the expression intense. By Western standards, Leggett is a rational scholar. But at that moment he unexpectedly felt something very powerful exuding from the effigy. That experience has led him to cautiously believe in the possibility of energy being contained in matter through the willful actions of one steeped in indigenous shamanic practice.

The Russian Federation did not permit any museum objects to be transported to Alaska, including that medicine effigy, but two others, both from the late nineteenth century and housed in the National Museum of the American Indian and American Museum of Natural History, respectively, were included in the exhibit.[17] When the museum display was assembled, the two medicine effigies were strategically placed, constrained in a glass case in the back facing away from the center of the first display room. This was done for two reasons. First, traditional Dena'ina visiting the exhibit may have walked into the room and unexpectedly been affected by the power of the object, and second, the objects were given their own space out of respect. Many non-Native exhibit visitors passed by the medicine effigies, gave them a cursory view, and moved on to more interactive exhibits. Some Dena'ina visitors reportedly avoided the display.

Language interacts with spiritual things as well. Like other Dene or Athabascan speakers in the North, California, and the Southwest, the Dena'ina have a complicated grammatical structure, which, in part, involves the verb defining the cognitive category of the noun. This "noun gender" structure lumps concepts of similar type and is, in a sense, a grammar of schema—culturally defined categories of thought. One noun gender category lumps human, dog, Orthodox crucifix, and shaman medicine effigy in the same grammatical unit. While traditional Dena'ina believed that everything has a spirit, some things would seem to have their own unique sensate and willful personhood, and a child learning the language and its grammar would subconsciously learn this and bring it to adulthood. The Dena'ina classified dogs in a separate category from other animals. As today, dogs are the animal that lives with the Campfire People (humans).

Anyone who has had a dog is not surprised by their human-like qualities. That a sha-man medicine effigy should have human-like qualities is not, however, in the realm of Western world view, but it is perfectly reasonable to a traditional Dena'ina world view, in which an item can have power or even personhood. As Orthodoxy entered parts of Alaska in the late eighteenth and early nineteenth centuries, the power of a crucifix was contextualized as having similar qualities as a shaman effigy: a spiritually powerful entity, not merely a symbol of numinous power, but sacred power itself.

By the conceptualization of Western science, material items are not alive because they do not meet the criteria of life. A living thing metabolizes food to produce energy for organ function, reproduces, and is capable of mutating and reproducing the muta-tion. That's life. Technology—whether in the form of ancient artifacts, art, or a modern computer—does not meet the scientific criteria of biological life. But technology is also a biophysical organization of matter that is not determined by the carbon cycle, hydrologic cycle, rock cycle, or any of the other great cycles that shift matter or energy from one form of organization to another. Technology is geological or biological matter, but a highly improbable organization of that matter from the standpoint of natural processes. Any artifact, simple to complex, could not have come together without the organizing capacity of a human brain: a hemispherically specialized brain informed by cultural tradition to select the components and concatenate a sequence of events such that step one precedes step two, and so on, until the final product emerges as a tangible mirror of what was in the maker's mind to begin with.

The great Finnish-Swedish neurophysiologist Ragnar Granit wrote in detail about human intent in his book *The Purposive Brain*.[18] Nothing written since has changed his elegant analysis. Clearly, it takes intent to transform nature into technology or art. An item can be described from the standpoint of information theory as the degree to which it deviates from its most probable state in nature—if geological, how much an item varies from a sphere or, if biological, how much an item varies from its mature state. But can intent also be such that one can imbue stone tools, baskets, bentwood hats, masks, or snowshoes with a spirit, or something like it; taste the difference between lovingly made food and food made in anger; or detect if something was crafted with good or bad feelings? Can a bentwood hat bestow courage, or a Yup'ik mask allow a human to be guided by a subconscious action of a perception of a supernatural spirit for the duration of a ceremony? Are material things props for spirituality, or can they be an expressive repository of spirituality? (See figure 2.2.)

The idea that matter can absorb information from a human brain is contrary to both the laws of classical physics as well as a general notion of how the world works, from the standpoint of the Western world view. Alaskan Natives, or perhaps all indigenous people, have faced accusations that run the spectrum from their being primitively naïve

FIGURE 2.2 An Athabascan/ Dena'ina birch bark basket with willow root and folded corners.

Athabascan, Dena'ina, early to mid twentieth century, *Basket, Birchbark*. Birch bark, willow root, dye. Collection of the Anchorage Museum.

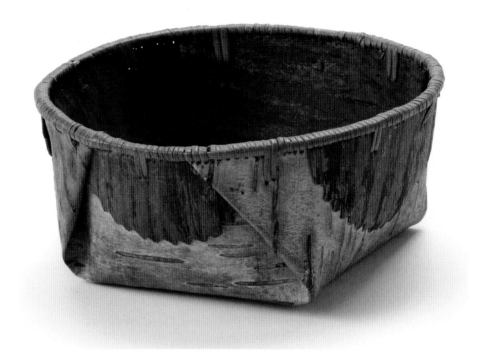

to satanic for their belief in the spirit in things. Consequently, many Alaskan Natives have been reluctant to discuss their traditional belief that artifacts or places can be a source of information other than the visual information of reflected light, or a medium of the supernatural. To do so is to risk belittlement, ridicule, or accusations of being superstitious, all of which are forms of marginalization and an assertion of dominance by the broader culture.

Science does, however, have something to say about information and matter in the form of quantum entanglements. Some of the great minds of twentieth-century theoretical physics, such as Niels Bohr and Erwin Schrödinger, reconfigured a scientific understanding of physics through quantum mechanics in which quantum entanglements occur. In some circumstances, electrons or molecules collide and then separate and become paired—for example, in their axis of rotation (one to the left, the other to the right), or in their momentum, or in other measurable physical properties. If one of the pairs is experimentally affected, almost instantaneously information will flow to the opposite particle or molecule and it will change its physical state even over hundreds of miles—they are entangled. Quantum entanglement is controversial because it requires information between the pairs to travel faster than the speed of light, which according

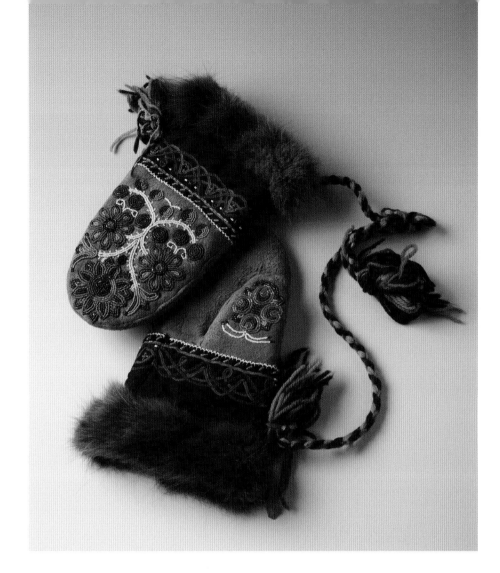

FIGURE 2.3 Catholic missionaries brought floral designs that spread westward from Canada into Alaska. These mittens feature the ornate floral patterns that developed during the nineteenth century and that continue to be used by Athabascan bead workers today. These mittens were made for the extreme cold weather of the Alaskan interior region.

Athabascan, mittens, c. 1920. Moose hide, beads, beaver, cotton satin, cotton flannel, yarn, 28 × 18 × 5 cm. Gift of Mrs. James Delaney. Collection of the Anchorage Museum.

to classical physics cannot happen. For this reason, Albert Einstein did not like quantum mechanics; he called quantum entanglements "spooky action at a distance."

Though quantum entanglements have been demonstrated experimentally, it is a huge leap from the idea of molecules affecting molecules to the notion that a willful brain can infuse matter with spiritual energy or any other similar interaction. I am not suggesting that quantum entanglement occurs when a Native Alaskan makes, say, beaver mittens and infuses them with love to be transmitted to the recipient, or by any other practice. But I am also not denying that something preternatural, something operating on natural principles that science has yet to explain, could be occurring when an Unangan kayaker dons a bentwood hat and gains the courage to face a hostile ocean, or when love is transferred to the recipient of a moosehide vest through the prayers of its maker. Until science reaches a conclusion, those with a staunch Western world view should not be too quick to marginalize the idea that information or power can be housed in matter, as has been an integral part of traditional Native Alaskan cultures (see figure 2.3).

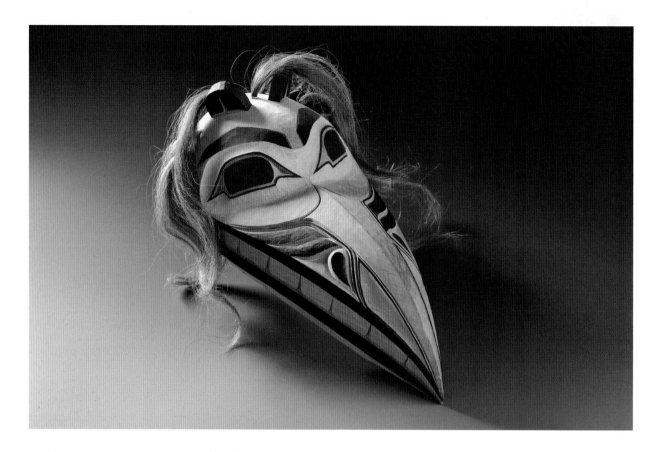

FIGURE 2.4 This mask was worn over the hand. In Tlingit mythology, Raven is both creator and something of a trickster.

Wayne G. Price, *Mask, Hand,* c. 1981. Wood, paint, human hair, 10 × 14 × 31 cm. Gift of British Petroleum. Collection of the Anchorage Museum.

Though Western science has deprived things of the perception of having a spirit, to Alaska's Native community, whether or not there is a scientific explanation for either spiritual power or information housed in, and exuding from, what to the Western world is an inanimate object is not an issue. Many Alaska Natives have sat through science classes and learned that the world of science is not the same as the world of their elders and their time-honored cultural traditions. Yet, like Leggett, they have experienced what science cannot explain, so they give up trying to reconcile science and traditional practice and accept each for what it is—its own kind of reality (see figures 2.4 and 2.5).

What is important is that many Native Alaskans have believed for millennia that the baskets, hunting equipment, vests, and spiritual artifacts they make can be infused with power or energy. That belief is a unifying force—a social entanglement—that brings together members of a culture in a unique world view and enriches their understanding of their place. Through the belief in the power of things, artifacts become just as much a part of place as language, the act of subsistence, and broader spiritual beliefs, Things of the place are part of the sacred ecology of indigenous Alaska (see figure 2.6).

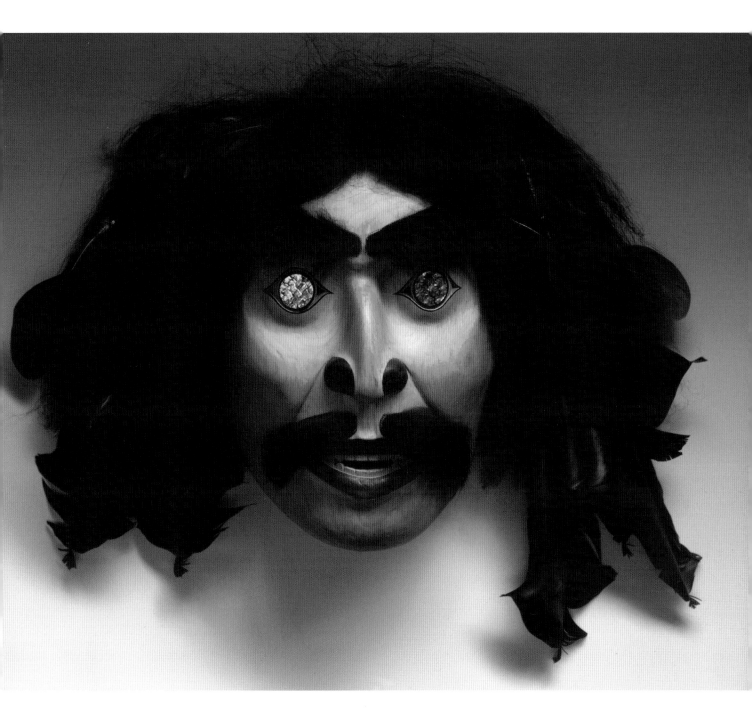

FIGURE 2.5 In Tsimshian culture, some masks were made as portraits of individuals, such as ancestors, shamans, warriors, and chiefs. The story dramatized by the mask is integral to knowing who the mask represents.

Jack Hudson, Tsimshian, born 1936, *Txä mshem*. Alder, goat hair, abalone shell, pigment, raven feathers, wool, 35 × 49 × 14 cm. Collection of the Anchorage Museum.

FIGURE 2.6 Masks were important accessories for dance dramas that included elaborate regalia (costumes) and the names, songs, and dances associated with the creature or individual being depicted. It is possible that shamans were the first to use these masks, which were then adopted for social ceremonial uses some time later. They continue to be an important form of expression.

Kathleen Carlo-Kendall, Athabascan, born 1952, mask, 1978. Yellow cedar, parakeet feathers, 26 × 23 cm. Collection of the Anchorage Museum.

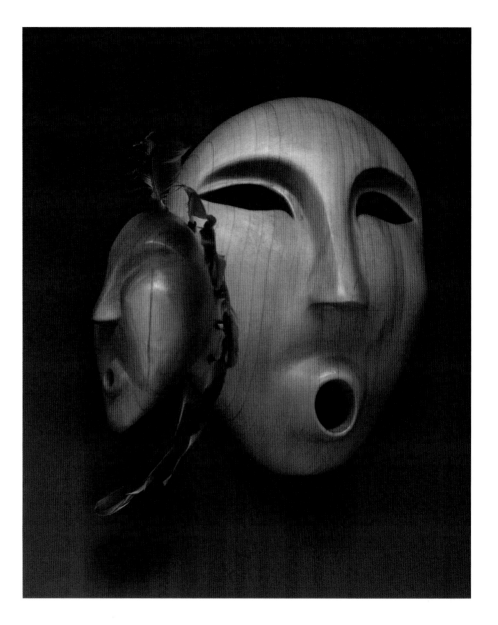

NOTES

1 Karen Evanoff, producer, "Nd Dena'ina Beaver Trapping at Qizhjeh Vena" (digital video), Nondalton Tribal Council and Lake Clark National Park and Preserve.

2 Peter Kalifornsky, *K'tl'egh'i Sukdu: The Collected Writings of Peter Kalifornsky*, ed. James Kari and Alan Boraas (Fairbanks: Alaska Native Language Center, 1991); James Kari and Alan Boraas, eds., *A Dena'ina Legacy— K'tl'egh'i Sukdu: The Collected Writings of Peter Kalifornsky* (Fairbanks: Alaska Native Language Center, University of Alaska Fairbanks, 1991), 12–13.

3 Kalifornsky, *K'tl'egh'i Sukdu*.

4 Alan Boraas, "'What Is Good, What Is No Good': The Traditional Dena'ina Worldview," in *Dena'inaq' Huch'ulyeshi: The Dena'ina Way of Living*, ed. Suzi Jones et al., 103–120 (Fairbanks: University of Alaska Press, 2013); Alan Boraas and Donita Peter, "The Role of Beggesh and Beggesha in Pre-contact Dena'ina Culture," *Alaska Journal of Anthropology* 6, nos. 1–2 (2009): 211–224.

5 Kalifornsky, *K'tl'egh'i Sukdu*, 414–415.

6 Lydia T. Black, *Glory Remembered: Wooden Headgear of Alaska Sea Hunters* (Juneau: Alaska State Museums, 1991).

7 Ibid., 13.

8 Ibid., 12.

9 Ibid., 13.

10 Ann Fienup-Riordan, "The Mask: The Eye of the Dance," in *Eskimo Essays*, 49–67 (New Brunswick, NJ: Rutgers University Press, 1990).

11 Ibid., 52.

12 Ibid., 65.

13 Aaron Leggett, "Gunhti Stsukdu'a: Ki Nch'uk'a 'Tanaina' Ghayeł̇e" This is My Story: 'Tanaina' No More," in *Dena'inaq' Huch'ulyeshi: The Dena'ina Way of Living*, ed. Suzi Jones et al., 142–153 (Fairbanks: University of Alaska Press, 2013).

14 Suzi Jones, James A. Fall, and Aaron Leggett, *Dena'inaq' Huch'ulyeshi: The Dena'ina Way of Living* (Fairbanks: University of Alaska Press, 2013), 249. *Tanaina* is an archaic spelling of the more phonologically accurate *Dena'ina*. Russian American scientific documents were often published in German, the scientific lingua franca of the nineteenth century. In the process of going from *Dena'ina* to Russian to German, the initial *d* sound became a *t*, and the glottal stops disappeared.

15 James Kari, *Dena'ina Topical Dictionary* (Fairbanks: Alaska Native Language Center, 2007), 307.

16 Kalifornsky, *K'tl'egh'i Sukdu*, 19.

17 Jones, Fall, and Leggett, *Dena'inaq' Huch'ulyeshi*, 102, 117.

18 Ragnar Granit, *The Purposive Brain* (Cambridge, MA: MIT Press, 1977).

CULTURE AND CONTINUITY

NADIA JACKINSKY-SETHI

For centuries, Alaska's indigenous peoples have expressed themselves through the arts, including petroglyphs and pictographs, engraved bone tools, drawings in the mud, basketry, regalia, jewelry, beadwork, clothing, sculpture, and other artistic traditions. Customary Alaska Native arts continue to be practiced today alongside newer art forms that incorporate contemporary materials, stories, and uses; all of these forms share information about indigenous identity and presence. As a vehicle of expression, artworks are more than just material, inanimate things. They are a powerful means to sustain and express community and individual values, to tell stories and remember history.

The flourishing existence of Alaska's Native arts scene today is significant given the complex history of colonization. As with other places around the globe, in Alaska, the process of colonization has had a profound and lasting impact on indigenous populations—our land, languages, cultures, and art practices. Newcomers to Alaska often tried to erase the identities of the indigenous peoples they encountered by imposing new systems of law, language, education, spirituality, resource management, and cultural ways of being. A great deal of traditional knowledge and practice was undermined in this process. Yet, despite centuries of change as a result of colonization, political oppression, cultural appropriation, and exploitation, Alaska Native peoples have maintained our unique cultural identities and have kept the culture alive by passing on our world view, knowledge, and arts, rituals, and performances from one generation to the next. The distinct identities of Alaska's Native peoples are expressed in language, subsistence practices, art, cultural traditions, and technology.

The last few decades have seen growth in expressions of pride for Alaska Native art and culture. Since the passage of the Alaska Native Land Claims Settlement Act (ANCSA) in 1971, Alaska Native organizations have worked to increase knowledge of traditional arts, creating workshops to preserve Alaska's indigenous languages, and encouraging elders to pass on their knowledge to youth. Bilingual schools have been established to support the survival of Alaska's indigenous languages. Many communities

have started culture camps that pass on indigenous knowledge and traditional skills, such as fish cutting, seal processing, and wood carving. There are artist workshops, community archaeology programs, exhibitions of culture in smaller village museums and in urban settings around the state, and heritage festivals that celebrate Native culture through dance, visual art, and storytelling.

These activities are impressive given that, previously, many had assumed that Alaska's indigenous traditions and culture were in the process of dying, if not already dead. Publications from the 1930s and earlier had forecast that many of the remaining traditional arts of Alaska's indigenous cultures would soon disappear. In the 1970s, these sentiments were still present. A 1972 catalog from the Anchorage Museum, for example, recorded, "Despite attempts to preserve the one notable remaining craft of basket weaving, it seems [probable] that this too will soon become a lost art. Perhaps the surprising thing is not how little is left of Tlingit and Haida crafts, but that anything persists at all. . . . It can only be hoped that a few ideas and artifacts unique to these people will survive the process of homogenization."[1] In 1981 the late Dorothy Jean Ray, a scholar of Alaska Native art, echoed this sentiment when she described the arts situation in southern Alaska thus: "Scarcely any ethnic handicrafts come from the Aleutians, Kodiak Island or Prince William Sound despite the earliest souvenirs having come from there as long ago as the 1790s."[2] A 1982 study by the Alaska State Council on the Arts found that many visual arts, such as doll making, boat building, and skin tanning, were "endangered."[3]

Thankfully, these statements are not valid today. Across the state of Alaska, there is a thriving indigenous art scene. Some artists' work follows culturally distinctive art forms, with the creation of objects such as masks, regalia, kayaks, and totem poles. Other artists' work incorporates ancestral art forms with contemporary media—there are blown-glass hats made in the style of nineteenth-century Tlingit spruce root hats, and Yup'ik masks made from recycled car parts. There are conceptual based artists who address contemporary issues, such as the status of Arctic global warming and the history of legislation affecting Native peoples, through diverse media such as film, sculpture, photography, fashion, mixed media, installation, and performance art. There are artists whose work integrates traditional materials, such as sea mammal gut, caribou fur, and fish skin, and create new genres and art forms using these materials. All of these arts assert a Native identity and draw attention to the Native presence. By actively making, and in some instances reclaiming, artistic practices that are rooted within Alaska Native culture through designs, materials, and stories, artists create an opportunity to perpetuate Alaska Native traditions in a form that is relevant to contemporary Native peoples' lives. Through their work, artists play an especially important role in helping to maintain cultural identity while communicating information about indigenous ways of life and aesthetic systems.

The topic of revitalization in Alaska ties in with a larger indigenous movement of social, political, and economic activism. Cultural renewal projects are also present among American Indians throughout the United States, where Native people express pride in Native identity, politics, and art as a way to "recover from the ravages of centuries of systematic racism."[4] Growth in cultural renewal among Native Americans became especially prevalent during the American Indian/Red Power political activist movement of the 1960s and 1970s. This was aided by the passage of federal legislation, such as the Indian Education Act (1972), the Indian Self-Determination and Education Assistance Act (1975), the Native American Religious Freedom Act (1978), and various Native American land claims settlements, as well as by the increase in federal spending on Indian affairs, which made Native American identity a more attractive ethnic option.[5] With this movement, art has become an increasingly important tool to reaffirm cultural identity and reinforce cultural pride.[6]

Indigenous peoples from other regions in the world have also been involved in cultural revitalization, defying historical predictions that indigenous cultures were set to vanish under the pressures of colonization and assimilation.[7] Changing governmental policies and international treaties, such as the Universal Declaration on Indigenous Rights, which was first drafted in 1982 and adopted by the United Nations General Assembly in 2007, have aided this process. Along with the right to self-governance and the right to be protected from genocide, the document recognizes indigenous rights to own and control heritage objects.[8] All over the world, indigenous communities have been involved in reevaluating the value and meaning of their material culture for their own political and cultural needs.

In some instances, indigenous revitalization has been promoted by government involvement. In New Zealand, for example, since the 1980s, the government has supported the opening of Maori schools that teach in the indigenous languages.[9] In Australia, indigenous Australian artists have been sponsored through government funding since the 1970s that has created opportunities for aboriginal art markets and training workshops.[10] The Canadian government has supported the development of schools focused on First Nations art, such as the Kitanmax School of Northwest Coast Indian Art in 'Ksan, British Columbia, and the development of arts marketing programs among the Canadian Inuit. In Alaska, governmental funding for Native art through programs such as those offered through the Alaska State Council on the Arts has encouraged Alaska Native artists to continue to pass on their craft through apprenticeship programs.

Tourism has also played a role in helping the cause of indigenous revival and survival. Among the Ainu in northern Japan and the Maori in New Zealand, tourism is credited with "saving" aspects of traditional art by creating an enthusiastic art market.[11] Other examples of global revitalization demonstrate that indigenous peoples create the

impetus for these movements on their own. In Guatemala, a renewed interest in traditional costume making was spurred in conjunction with the re-creation of traditional dance festivals.[12] On the Marquesas Islands, people have been involved in traditional arts and tattooing in response to the opening of the local cultural association Motu Haka.[13] In Alaska, the tourist market for Alaska Native art has contributed to the preservation and revival of some of Alaska's indigenous art forms by creating a continuous demand for Alaska Native crafts.

It is significant that Alaska Native revitalization coincided with other global indigenous revitalization projects. Alaska Native people have benefited from the support that this has created. While generating an environment to empower indigenous people globally, attention to indigenous peoples' rights has resulted in a change in policies; there has been a marked increase in indigenous involvement in international politics and a stronger indigenous presence in the public eye.

With the Alaska Native revitalization movement described above, how has the art itself changed? In many cases, artists reuse forms and designs from their ancestral canon but create new uses for them that are meaningful in a contemporary context. Artists incorporate into their artworks a range of new materials like plastic, metal, and glass in conjunction with customary materials like feathers, furs, driftwood, and ivory. In some cases, artists highlight the materials used in traditional arts but experiment with new uses for those materials. Some artists' works are flush with commentary, such that the message expressed by a work of art is more important than the artwork's aesthetic concerns. The following sections examine some of the prevalent forms, function, and materials that are used by today's Alaska Native artists.

Much of the work produced today in Alaska relies on historical forms for inspiration. Some artists subtly borrow from historical forms. Others create forms that so closely resemble historical examples that the resulting piece could be considered a replica, although the work might be made from new media, take on different proportions, be presented in a nontraditional forum, or have a new function.

One example is a mask by Sylvester Ayek (Iñupiat) that decorates the lobby of the Alaska Native Medical Center in Anchorage. The mask, which closely resembles nineteenth-century examples, is colossal. Made from laminated pieces of fir, with its protruding feather-shaped appendages it stretches twenty feet across. Obviously, this mask was never meant to be worn; instead, it serves the purpose of welcoming people to the center and immediately alerting visitors that they are in a Native place. Similarly, Da-ka-xeen Mehner's (Tlingit-N'ishga) sculptural welded daggers, some of which stand more than three feet tall, demand a viewer's attention. No longer functional as daggers, they take on symbolic value as they recall experiences, histories, and uses associated with their form.

Rather than replicating an entire form of an artifact, some artists' use of historical work for inspiration is more selective, with artists quoting only sections of a historical work. For example, some of Iñupiat artist Larry Ahvakana's work is inspired by Iñupiat clothing designs; however, instead of working in textiles and furs, like the pieces he cites from, he isolates the design patterns used on parkas and translates the imagery into a glass medium (see figure 3.1). According to Ahvakana, this change in use does not detract from the tradition of the object. As he explains: "My culture is a living thing. It is not a static or dead way of life but an ever changing metamorphosis of adaptation. . . . The tools may be modern, the material perhaps foreign to my grandfather, but the final statement would be the same."[14] Susie Silook (Yup'ik/Iñupiaq), an ivory carver originally from Saint Lawrence Island, borrows designs from prehistoric Saint Lawrence Island artifacts in her work. Her ivory figurines are often embellished with curvilinear designs reminiscent of those found on Okvik artifacts (see figure 3.2). For Silook, using images from her culture is an obvious choice: "Since my culture is incredibly rich, not just in content but also in imagery, I went to the ancient artifacts for my inspiration as a carver."[15] These artists stay close to their culture by echoing motifs found on historical examples while transforming the art into a contemporary aesthetic.

Some artists integrate aspects of historical Alaska Native art forms with global art traditions or pop culture in their work to create hybrid art forms. For example, Danny Varnell's (Haida) totem poles *Taisia* and *Taku* (2005), which decorate the exterior of Ptarmigan Elementary School in Anchorage, merge Japanese manga style with Northwest Coast design patterns. According to Varnell, "When people look at totem poles they think of classical forms, although this is only one of several stages in the growth of the art."[16] Larry McNeil (Tlingit) sometimes presents his work as billboards or in conjunction with written word or photographs. His work references Tlingit culture, but he also addresses other Alaska Native and Amerindian cultural groups in his work. For example, the style of his 2005 digital print *Vanishing Race 101* is based on imagery from the 1930s–1960s *Lone Ranger and Tonto* comic strip. The image depicts Tonto giving American photographer and ethnologist Edward Curtis a smack across the face with a comic bubble reading, "Your 'Vanishing Indian' paradigm just doesn't fit our Native Epistemology. Here is to deconstructionist theories." In the artist's statement accompanying this work, McNeil explains that, in his art, he transforms Tonto "from something of a dimwitted sidekick to the proverbial main hero character. He transforms right before our eyes and starts kicking butt in the postcolonial world, setting disgusting and repugnant people like Edward Curtis straight, with one mighty punch."[17] McNeil succeeds in reversing a stereotype about Native American peoples that is perpetuated by the *Lone Ranger* comic strip, in which Native people are depicted as complacent about the changes of colonization.

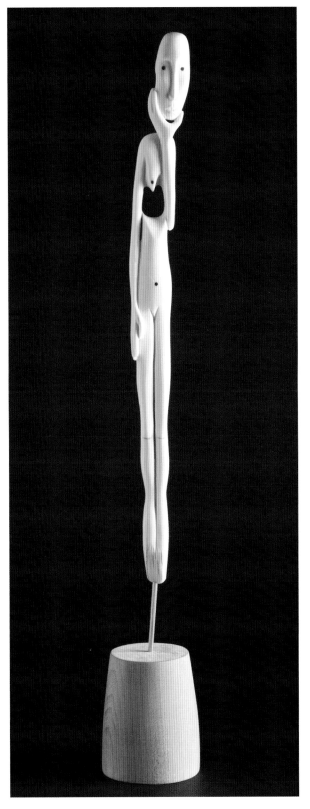

FIGURE 3.1 The design represents the animal gut window enclosing the opening in the top of an igloo. The window was called the *kinguk*, or nose of the structure. The trim design represents the intricate piecework made from tiny pieces of light and dark leather or fur.

Larry Ahvakana, Iñupiat, born 1946, *Kinguk with Fancy Kupuk Trim*, 2011. Glass.

FIGURE 3.2 The ancestral ivory dolls of Saint Lawrence Island, traditionally carved by men, are the basis of Susie Silook's work. While she works in the traditional media of ivory and whalebone, her themes are the contemporary issues confronting Alaska Natives, particularly women, with a specific focus on violence against Native women. Silook also departs from tradition by depicting women, rather than the animals most commonly rendered by men, in her carvings.

Susie Silook, Yup'ik/Iñupiaq, born 1963, *Keeping My Head*, 2007. Walrus ivory, brass, pigment, baleen, wood, 68 × 10 × 10 cm. Collection of the Anchorage Museum.

FIGURE 3.3 Alvin Amason paints the animals found on and near his childhood home of Kodiak Island. He titles his works with phrases from stories, conversations, and anecdotes.

Alvin Amason, Sugpiaq, born 1948, *Good to See You*, c. 1984. Oil paint, canvas, extruded polystyrene, roplex, 122 × 183 × 18 cm. Collection of the Anchorage Museum.

Some artwork by contemporary Alaska Native artists is not immediately recognizable as Native art because it does not rely on historical forms for inspiration or refer directly to Alaska Native stories or places. Without being labeled as "Alaska Native," there is no obvious way for a viewer to recognize the work as such. Alutiiq artist Alvin Amason creates large-scale brightly colored oil paintings of seals, bears, and other animals that incorporate attached sculptural elements and text (see figure 3.3). These works make no overt references to his Alutiiq heritage. When Amason describes his paintings, however, his close knowledge of the local landscape and his experiences growing up in Kodiak become apparent.

A diverse variety of themes show up in contemporary Alaska Native art. Many artists use their work to make social commentary with an Alaska Native perspective on issues ranging from the legacy of colonization political events or environmental concerns, such landscape destruction and the harvesting and use of local resources. Some contemporary art is used as a vehicle to document a changing way of life or to record personal or family memories.

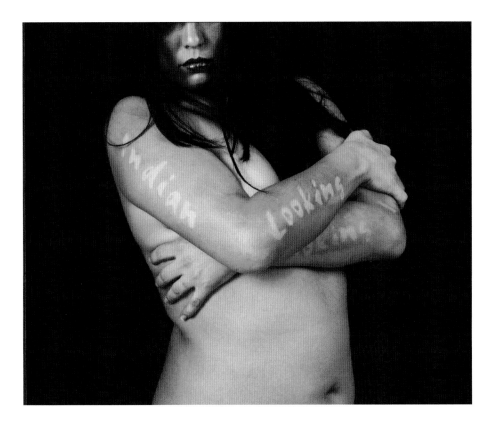

FIGURE 3.4 Erica Lord's work is inspired and informed by her multicultural (Athabascan, Iñupiaq, Finnish, Swedish, English, and Japanese) heritage. Lord suggests that the government-regulated definition of "Indian" creates an unachievable concept. Her art explores cultural examination and new ways to demonstrate cultural identity.

Erica Lord, American, born 1978, *Native Looking*, 2005. Ink, paper, 44 × 54 cm. Collection of the Anchorage Museum.

One of the more prevalent themes that contemporary Alaska Native artists address in their work is self-identity and stereotype. Artists use their work as a space to question and challenge stereotypes about their Native identity and culture. Authored by indigenous artists, the re-presented stereotypes have an opportunity to change the meaning of the images and to reverse the power of how indigenous peoples are represented by taking charge of the handling, ownership, and interpretation of their culture.

A series of four photographs in the series *The Tanning Project* (2005–2007) by Athabascan/Iñupiat artist Erica Lord is a good example. For this series, Lord tanned phrases onto her skin and photographed herself nearly naked. With the words "Half Breed" inscribed across her chest, "Colonize Me" written along the side of her thigh, and "I tan to look more Native" tanned across her back, Lord changes the power dynamic behind what would typically be regarded as derogatory phrases by taking authorship of them (see figure 3.4). Her performed image is not that of a submissive indigenous person, because she is in control of how she is represented. By advertising her status as a woman of mixed blood and representing this characteristic as something alluring,

she transforms the negative connotation of these words/phrases and her heritage into something worth making public. Through the re-presented stereotypes, Lord's viewers are encouraged to question the meanings embedded within them.

Many artists reference the governmental definitions for Native identity based on blood quantum measurements in their work. For example, Da-Ka-Xeen Mehner's (Tlingit-N'ishga) multimedia series *Blood Work* (2006) includes a photographed image of Mehner's half white–half black beard (which grows naturally) superimposed over the top of his Certificate of Indian Blood. Tlingit artist Tanis S'eiltin's installation *Resisting Acts of Distillation* (2002) includes a screen of test tubes filled with symbolic blood alongside plaques representing the twelve Alaska Native Regional Corporations in reference to the stipulation that enrollees had to prove that they had at least a quarter Alaska Native blood. For both of these artists, the governmental definition for a Native individual limits Native peoples' abilities to define themselves. According to Mehner, his work invites Native people "to look at these systems that are placed upon us and really look for our own definitions of who we are."[18]

The effect of social problems, such as alcoholism, is another common theme in contemporary artists' work. For example, Iñupiat Ron Senungetuk's *Self Portrait* (1978) is a carved wooden panel in the shape of a traditional Yup'ik mask with a toothy, asymmetrical grin. Senungetuk incorporated beer bottle caps and strips of Budweiser cans as decorative elements to make the piece more than simply a representation of a mask. According to Senungetuk, the piece was made in response to a series of articles in the *Anchorage Daily News* titled "A People in Peril," which described social problems among Alaska Native peoples during the twentieth century. In Senungetuk's work, "the Budweiser cans are made to be tears coming down [the artist's] face."[19] Other artists who address problems with alcoholism within Native communities include Iñupiat artists Holly Nordlum, who has made a series of sculptures in the form of masks made from beer bottle caps (2011), and Susie Bevins-Ericson, whose Plexiglas and aluminum sculptural group *People in Peril-Bound by Alcohol* (1988) is a personal response to her own battle with alcoholism (see figure 3.5).

Another prevalent theme in contemporary Alaska Native art is concern over environmental destruction. Several artists have addressed the legacy of the 1989 Exxon Valdez oil spill in their work, including Iñupiat painter Gretchen Sagan and Alutiiq carvers Sven Haakanson Jr., Jerry Laktonen, and Mike Webber. Painter Ayayo Moore (Yup'ik) and multimedia artist Anna Hoover (Unangan) create work to raise awareness of the possible effects of Pebble Mine, a proposed mine that could threaten the critical salmon habitat in Bristol Bay. Tlingit artist Tanis S'eiltin's installation *Princess Slurry* (2008) shares her concerns about the pollution of Alaska's waters due to the cruise ship industry. Joseph Senungetuk's lithograph *Self Portrait* (1970) references the effects of drilling for oil in the Arctic.

FIGURE 3.5 This work was created as a personal response to a Pulitzer Prize–winning journalism series called *People in Peril*, which looked at social issues affecting Alaska Native communities, run by the *Anchorage Daily News* in 1988.

Susie Bevins-Ericsen, Iñupiaq, born 1941, *People in Peril-Bound by Alcohol*, 1988. Wood, aluminum, plexiglass, rawhide. Anonymous gift. Collection of the Anchorage Museum.

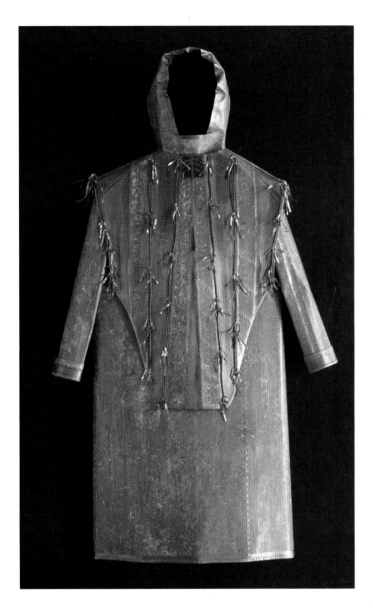

FIGURE 3.6 For artist Rebecca Lyon, clothing of metal represents strength and longevity. The use of nontraditional materials in representing traditional clothing moves the visual dialogue to the present, a way Lyon honored the women of the North for their ability to survive natural and cultural adversity, and for their artistry.

Rebecca Lyon, Unangan/Athabascan, born 1955, *Woman of the North*, 2004. Copper, glass, shell, patina, 173 × 102 × 21 cm. Collection of the Anchorage Museum.

Some contemporary Alaska Native art is infused with nostalgic representations of historical cultural practices. Siberian Yupik artist Umara Buchea, originally from Saint Lawrence Island, makes caribou-skin masks that are decorated with women's facial tattoo designs. Although women on Saint Lawrence Island traditionally had their faces tattooed at puberty, few women wear facial tattoos today. Buchea explains her use of the tattoo designs on her nontraditional masks as a way to record these designs: "The elderly women encouraged me to touch their tattooed faces so that I could feel the designs, but now all of them have passed away. I create the masks because I want future generations to remember the tattoos, to remember these traditions."[20] Another artist who works with nostalgic representations is Athabascan/Aleut artist Rebecca Lyon. In her series *Women of the North* (2004), Lyon interprets Alaska Native women's clothing into copper sculptures (see figure 3.6). The three-dimensional life-size sculptures—a button blanket, parka, and Alutiiq-style tunic—are sewn together with copper wire and mounted on wooden frames. According to Lyon, these dresses make up for the absence of such traditional garments in her own family: "I lament that no personal artifact or mementos from my great-grandmothers or the women before them have been passed down in my family."[21] In these examples, the artists memorialize traditions that are no longer practiced within their communities.

Sometimes artists use traditional materials to create art forms that were not historically practiced in their communities. Sonya Kelliher-Combs (Athabascan/Iñupiat) often uses sea mammal gut to make mitten forms that she uses in installations, or frames encased in acrylic polymer. Joel Isaak (Dena'ina Athabascan) creates fish-skin sculptures and clothing, which highlight the textures and patterns on the skin from salmon and halibut species (see figure 3.7). By using traditional materials, these artists pay homage to their culture, the

FIGURE 3.7 Sonya Kelliher-Combs's diverse background—Athabascan, Iñupiaq, Irish, and German—influences her artwork, which mixes Western with traditional Native culture, organic with modern materials, and human with nature.

Sonya Kelliher-Combs, Athabascan/Iñupiat, born 1969, *Graphite Secret*, 2004. Mixed media, 98 × 77 × 5 cm. Collection of the Anchorage Museum.

FIGURE 3.8 Performance/ artist intervention by Alli- son Akootchook Warden in the Alaska gallery of the Anchorage Museum, 2015.

Photograph by Michael Conti.

NADIA JACKINSKY-SETHI

importance of using recourses from their homeland, and the practice of harvesting animals and plants. Using such local materials maintains a connection to place and cultural continuity.

In some instances, artists use materials that look like traditional materials but are made from more easily accessible materials that do not require specialized knowledge to process or harvest. Heather Hanak (Athabascan) imitates the appearance of gut, a material historically used to make clothing, containers, and window coverings, in her work. Her faux gut is composed of silk fabric colored with layers of wax and pigments and then sewn into strips in imitation of the strips found on gut parkas. Rebecca Lyon (Athabascan/Aleut) uses plastics in place of sea mammal whiskers on some of her sculptural work, noting, "The use of nontraditional materials moves the visual dialogue into the present."[22] Teri Rofkar (Tlingit) is currently working on a bulletproof ravens-tail weaving using Kevlar, and another that will be woven from optical fiber in place of the customary mountain goat wool. For Rofkar, this is meant to "symbolically address issues such as homeland security and the loss of land by tribes across the country."[23]

Some artists borrow from colonial media and create works that were never historically practiced in their communities. There are artists who use performance art, photography, and installation to address issues around Alaska Native experience and identity. Allison Warden (Iñupiat) uses performance to provide commentary about issues that are pressing for Native people today, such as healing from the effects of past generations' boarding-school experiences, the loss of indigenous languages, the exploitation of Alaska's natural resources, and global warming. One example, *Ode to the Polar Bear,* addresses the loss of important habitat for the polar bear through rap and dance. For Warden, "Kaktovik is on the forefront of climate change," and she notes that being able to inform viewers about what is happening in her community is like "having an-on-the ground reporter."[24] Another performance piece, *Wait, Let Me Finish Putting on My Armor,* makes a critique about how tourists continue to hold on to romantic beliefs about Indigenous cultures. Such work has the power to reach out to and engage younger audiences, who easily connect with Warden's humor and music (see figure 3.8).

Contemporary Alaska Native art provides a space to create experiences and express opinions about identity, history, and culture. Alaska Native artists are no longer imagined as a "vanishing" people, but rather are free to experiment with creating artistic expressions as they relate to contemporary society and aesthetics. By sharing Alaska Native perspectives through contemporary art, Alaska Native artists affirm Native presence in the present and communicate who they are and how they fit in the world. Such work is important for the project of decolonizing Alaska's indigenous people. Contemporary Alaska Native art acts to empower Native people by presenting Alaska Native perspectives in a venue that can be shared widely, all the while helping to strengthen collective and individual Alaska Native identities.

NOTES

1 Anchorage Historical and Fine Arts Museum, *An Introduction to the Native Art of Alaska* (Anchorage: Anchorage Historical and Fine Arts Museum, 1972), 7.

2 D. J. Ray, *Aleut and Eskimo Art: Tradition and Innovation in South Alaska* (Seattle: University of Washington Press, 1981), 58.

3 S. Hauck, *Master Artist and Apprentice Grant Program Evaluation* (Juneau: Alaska State Council on the Arts, 1989), 2.

4 D. McFadden, *Changing Hands: Art without Reservation* (London: Merrell, 2002), 82.

5 J. Nagel, "American Indian Ethnic Renewal: Politics and the Resurgence of Identity," *American Sociological Review* 60, no. 6 (1995), 947.

6 Native American Center for the Living Arts, *American Indian Art in the 1980s* (Niagara Falls, NY: Native American Center for the Living Arts, 1984), 5.

7 M. Ames, *Cannibal Tours and Glass Boxes: The Anthropology of Museums* (Vancouver: University of British Columbia Press, 1992), 77.

8 G. Alfredsson, "International Discussion of the Concerns of Indigenous Peoples: The United Natives and the Rights of Indigenous People," *Current Anthropology* 30, no. 2 (1989), 255–265.

9 F. de Varennes, "Minority Aspirations and the Revival of Indigenous Peoples," *International Review of Education* 42, no. 4 (1996), 318.

10 F. Merlan, "Aboriginal Cultural Production into Art," in *Beyond Aesthetics: Art and the Technologies of Enchantment*, ed. C. Phinney and N. Thomas (Oxford: Thomas, Berg, 2001), 209; F. R. Myers, *Painting Culture: The Making of an Aboriginal High Art* (Durham: Duke University Press, 2002), 64.

11 Chisato Dubreuil, "Ainu Journey: From Tourist Art to Fine Arts," in *Ainu: Spirit of A Northern Peoples*, ed. W. Fitzhugh (Washington, DC: Smithsonian Institution Press, 1999), 335; A. J. M. Henare, *Museums, Anthropology and Imperial Exchange* (New York: Cambridge University Press, 2005), 189.

12 M. Krystal, "Cultural Revitalization and Tourism at the Moreria Nima' K'iche," *Ethnology* 39, no. 2 (2000), 149–161.

13 C. Ivory, "Art Tourism and Cultural Revival in the Marquesas Islands," in *Unpacking Culture: Art and Commodity in Colonial and Post Colonial Worlds*, ed. R. Phillips and C. Steiner, 316–333 (Berkeley: University of California Press, 1999).

14 R. W. Hill, *Creativity Is Our Tradition: Three Decades of Contemporary Indian Art at the Institute of American Indian Arts* (Santa Fe, NM: Institute of American Indian and Alaska Native Culture and Arts Development, 1992), 11.

15 S. Silook, "Gifts from My Ancestors," in *Gifts from the Ancestors: Ancient Ivories of Bering Strait*, ed. W. Fitzhugh, A. Crowell, and J. Hollowell (New Haven, CT: Princeton University Art Museum, 2009), 294.

16 P. Porco, "South East Carver Combines Influences to Inspire Elementary Students," *Juneau Empire*, October 31, 2005.

17 Larry McNeil, "Vanishing Race, 101," http://larrymcneil.blogspot.com/2008_04_16_archive. html, retrieved November 6, 2013.

18 S. Henning, "Fairbanks Artist's Work Fuses Contrasting Materials, Experiences and Messages," *Anchorage Daily News*, July 15, 2007, H8.

19 J. Decker, *Found and Assembled in Alaska: A Catalogue to the Exhibition Organized by the Alaska State Museum, Juneau* (Anchorage, AK: Decker Art Services, 2001), 186.

20 J. Welton, *Native Artists in the Americas: National Museum of the American Indian Native Arts Program: The First Ten Years* (Washington, DC: National Museum of the American Institution, Smithsonian Institution, 2007), 50.

21 Ibid., 38.

22 Ibid., 38.

23 S. Haughland, "Sitka Native Artist Mixes Science with Art," *Juneau Empire*, January 6, 2013, L4.

24 V. Barber, "Rapping Inupiaq Culture around Her," *First Alaskans Magazine*, November 2009.

THE
TECHNOLOGY
OF ADAPTATION

WALTER VAN HORN

Alaska's vast landscapes, varied resources, and diverse climates have presented considerable challenges to its inhabitants, from the distant prehistoric past to the rapidly changing present. Today, about 15 percent of Alaska's population, or roughly 100,000 people, are indigenous residents inhabiting almost three hundred settlements throughout the state. Together, they represent a diversity of cultures and languages that reflect Alaska's vast and varied environment.

Stretching from the Arctic Ocean in the North down to the Gulf of Alaska and the Southeast Panhandle, and from the Aleutian Island chain stretching 1,200 miles west toward Siberia, Alaska includes treeless tundra, temperate and boreal forest, massive rivers, mountains, glaciers, and rich marine environments. Eleven major Native cultures are found across Alaska—Unangax̂ Alutiiq (Sugpiaq); Iñupiaq; Saint Lawrence Island Yupik; Central Yup'ik; Cup'ik/Cup'ig; Athabascan (Ahtna, Dena'ina, Deg Hit'an, Holikachuk, Koyukon, Upper Kuskokwim, Tanana, Tanacross, Upper Tanana, Hän, Gwich'in); Eyak; Tlingit; Haida; and Tsimshian.

In the past, living in the North required a close adaptation to the environment. However, the technology with which people make that adaptation, as well as the sources of what they use to live here, have changed radically, particularly since the time of Euro-American contact beginning in the mid-eighteenth century.

During the prehistoric period, which began to end in Alaska with Bering's exploration voyages on behalf of Russia in 1741, Alaska's Native people developed local adaptations. Their technology was based largely on local materials and took advantage of local resources for food, shelter, clothing, and raw materials. Some traditional Native technologies, such as the bow and arrow, were developed elsewhere but were found to be effective in the North with some adaptation—such as piecing arrows together using several pieces of wood, where wood was scarce in the high Arctic. Other technologies, such as the toggling harpoon, may have developed along the coastal shores of eastern Siberia and coastal Alaska. Not all material was local. Trade routes existed

for the exchange of desired nonlocal material, be it tiny amounts of iron from Siberia or copper from eastern Alaska's Copper River drainage for tools and weapons, or fish oil for furs, or jadeite and obsidian for making blades, but this did not alter people's overwhelming dependence on their local territory (see figure 4.1).

Alaska's varied landscapes and climate resulted in great permutations in the resources Alaska's native peoples had available to them. Even groups living adjacent to one another might have access to slightly different resources and therefore use different technologies. The reliance on wood for substantial houses and great dugout canoes found among the Tlingit and Haida, living at the edges of the great rain forests of Southeast Alaska, for example, contrast strongly with the treeless Aleutians and Arctic Ocean coast, where the Unangan, Yup'ik, and Iñupiat relied on driftwood brought by ocean or river currents.

With the arrival of Euro-Americans and Western technology, changes came at an accelerating, but uneven, rate across Alaska. Trade initially brought better materials in greater quantities to Alaska's Native peoples—such as iron and steel for knives, adz blades, and sewing needles, as well as new decorative prestige materials, such as colorful glass trade beads. These were materials that improved on, but did not essentially change, traditional technology. The imperatives of the international fur trade, which devastated some Alaska Native groups (Unangan, Alutiiq) and enriched others (the various Tlingit groups and the Dena'ina Athabascans) who acted as middlemen in the trade, led to increasing social change and dependence on outside technology and materials (see figure 4.2).

Native peoples along Alaska's coasts first encountered Euro-American explorers, fur traders, and commercial whalers during the late eighteenth and nineteenth century. These people brought firearms, steel traps, blankets, tobacco, beads, cloth, alcohol, kerosene lanterns, enamelware, and many other objects—useful, prestigious, or decorative. Deep inland, initial contact with Euro-American objects came through trade

FIGURE 4.1 This is a typical high Arctic–style bow, with customary bow case, quiver, and arrows, possibly used by the Canadian Inuit, who lived on the Arctic coast east of the Alaska–Canada border. The bow is heavily backed with sinew cables to strengthen it, permitting a deeper pull that would impart greater speed and hitting power to the arrow. The hunter carried the bow in a sea mammal hide bow case; arrows were kept in an attached quiver. According to an early observer, these bows were powerful enough to drive an arrow nearly through a caribou. Perhaps because of the shortage of wood (most of the Arctic Ocean coast is far north of where trees grow), the arrow shafts are made of several pieces of driftwood carefully glued and fitted together. Native copper found along the Coppermine River in western Canada provided metal for arrow points and knives, and was traded widely.

Inuit, Arctic bow, c. 1910. Spruce wood, seal rawhide, caribou sinew, antler or bone, 129 × 4 × 5 cm. Gift of the Estate of Alma E. Lahnum in memory of Alma E. Lahnum and Willard W. Lahnum. Collection of the Anchorage Museum.

FIGURE 4.2 This set of summer-weight clothing made of caribou skin and decorated with glass beads comprises a pullover tunic, trousers, a separate hood, and mittens. The trousers may originally have had attached feet that have subsequently been cut off. The clothing probably dates to the late nineteenth century and comes from either interior Alaska or adjacent western Canada. Interior Alaska and Canada can be very warm in the summer, and the hood and mittens may have been worn as much to keep off voracious insects as to keep the wearer warm. The beads were not only decoration but would indicate that the wearer was a prosperous individual, well able to buy this coveted trade good.

Athabascan, Dena'ina, tunic, late nineteenth century. Caribou hide, glass beads, sinew, 129 × 58 × 2 cm. Gift of the Anchorage Museum Foundation. Collection of the Anchorage Museum.

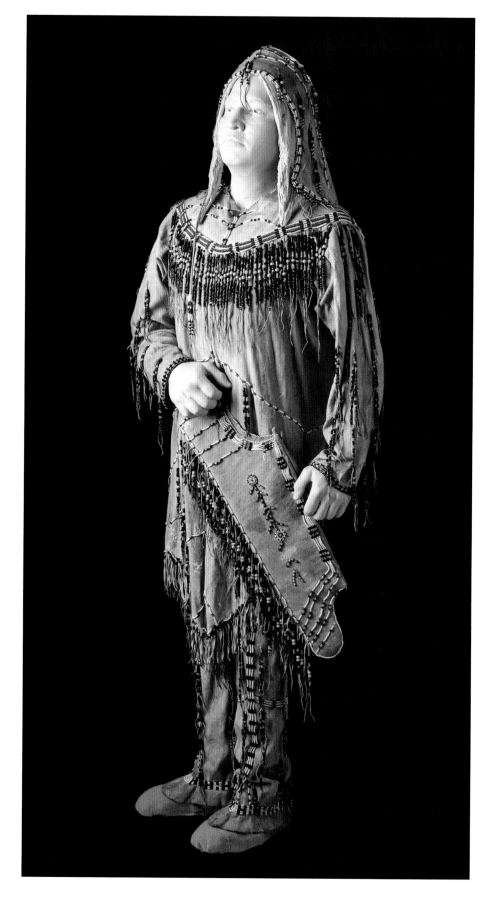

over well-established Native trade routes. Gradually, a few non-Native traders involved with the fur trade filtered into the Interior. Contact accelerated in the late nineteenth century, as the Gold Rush and the search for other minerals, such as copper, brought Euro-Americans into Native territories in the Interior in locally large numbers.

Euro-American settlement in Alaska and the Arctic has mostly been dependent on Western technology and objects (such as tools, weapons, clothing, shelter, transportation, and food) developed and made elsewhere and imported to the North. This dependence on outside technology and material culture has only increased with time. Alaska Natives who maintain a subsistence lifestyle, in which they obtain much of their food from traditional local resources such as fish and game, have adapted non-Native Western technology such as rifles, Gore-Tex clothing, steel traps, outboard motors, metal skiffs, snow machines, and all-terrain vehicles to hunt, trap, and fish. Today, Alaska's Native people, while holding on to their traditional social culture and language, must also live in the Western world and adapt to the political and economic world as adroitly as their ancestors who lived on Alaska's waters and land did.

TRADITIONAL NATIVE CLOTHING

People have successfully lived in Alaska and the circumpolar North for thousands of years. Some of the adaptations and inventions people made in order to survive and prosper in the North can only be inferred—for example, no clothing exists today from the earliest human residents, but it is widely believed that early people developed carefully made tailored fur clothing (complex parkas with hoods, trousers, socks, boots, and mittens) that would protect the wearer from the seasonally severe Arctic cold and permit the freedom of movement necessary for hunting, fishing, and gathering.[1] This implies not only the development of sewing and tanning skills and tools, but knowledge of what materials (generally animal pelts and hides) provide the greatest warmth, lightest weight, or maximum waterproof and wind-resistant flexibility. As clothing researcher Betty Kobayashi Issenman wrote, ideal Arctic clothing "conserves heat, eliminates humidity, controls temperature, prevents ingress of water and wind, and has durability" (see figure 4.3).[2]

Over thousands of years, a deceptively simple tool kit evolved that was used to make clothing in the Arctic and Subarctic. The kit was composed of scrapers, knives, awls, sinew combs and twisters, needles, needle cases, thimbles, and thimble holders. Materials used to make these tools consisted of bone, ivory, wood, and stone; metal replaced stone, or bone and ivory, when it became available. Edged tools, used to cut skins, were initially made from chipped stone, such as flint or chert. Skillfully flaked stone blades were inserted in bone, ivory, or wood handles.[3] Later, a technique for grinding stone such as

FIGURE 4.3 Arrows were run through the diamond-shaped hole to prevent or counteract warping of the wooden shafts. This piece is made of mastodon or wooly mammoth ivory in the form of a kneeling reindeer, an animal that was often hunted with bows and arrows. The large glass bead eye would indicate that it was made in the nineteenth century. While a utilitarian piece, "sympathetic magic" may be partly responsible for the animal shape of this tool. The hunter may have believed or hoped that an arrow run through the arrow shaft straightener carved to resemble a caribou might soon, in reality, run through a caribou.

Iñupiaq, arrowshaft straightener, nineteenth century. Mastodon ivory and glass, 6 × 18 × 4 cm. Collection of the Anchorage Museum.

FIGURE 4.4 This carefully carved skin scraper was made to fit a woman's hand with a blade of chipped chert or flint.

Eskimo, scraper, c. 1900. Wood and chert or flint, 7 × 5 × 16 cm. Donated in memory of Richard Metz. Collection of the Anchorage Museum.

slate or jadeite became more prominent for making sharp knife blades. Good-quality stone was not always abundant, and trade in materials such as jadeite, prized for its toughness and ability to hold an edge, developed early (see figures 4.4 and 4.5).

Once a hide was cut from an animal's body it had to be treated so that it would remain flexible and not rot. Generally, the arduous and time-consuming task of scraping and tanning was done by women. Scraping tools were developed to work the fat and flesh off that would otherwise cause skins to deteriorate. Once a skin was scraped it was rubbed with one or more tanning mixtures, including a water and animal brain solution, human urine, fish eggs, a feldspar compound, or alder bark. Tanning stabilized the skin and allowed its continued flexibility. Athabascan people also smoked moose or caribou hides as part of the tanning process; smoking helped keep the hides soft if they became wet again. Using their knives, women then carefully cut the furs, fish skins, bird pelts, and sea mammal or bear intestine into complex shapes that were then sewn into various forms of tailored clothing or household and hunting gear.[4]

Early accounts of the Tlingit also refer to "cloaks" of animal hair, which anthropologist Frederica de Laguna considered to be made of mountain goat wool and which might be examples of the rectangular woven robe known later as a raven's tail robe or Swift blanket (named after an early non-Native collector).[5] The rectangular geometric designs on raven's tail robes were similar to those found on spruce root basketry, and they may have evolved from the Northwest Coast Indian tradition of twined basketry.[6] Both the raven's tail and the Chilkat robe were important, prestigious ceremonial garments, worn like shawls over the back with the sides of the robe gathered in front of the wearer's torso. They were often considered communal property owned by a house or clan and were presented as an emblem of the group during important ceremonies such as potlatches.[7]

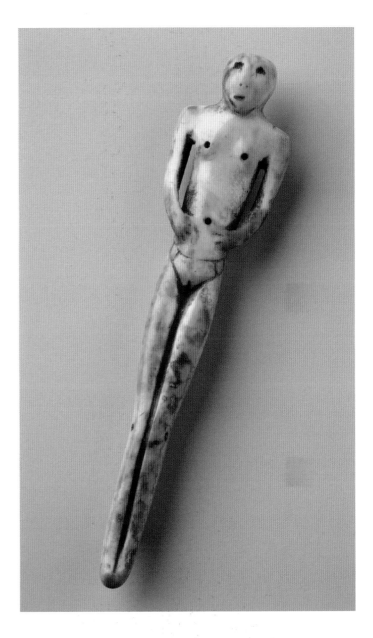

FIGURE 4.5 A prehistoric walrus ivory needle case carved as a human figure. A large hole was drilled from the head down almost to the feet of the figure. Needles, made of finely shaped slivers of bone or walrus ivory, nearly the thinness of steel needles but not as strong, would be inserted into a thin hide strap that could be pulled in and out of the figure, protecting them from damage.

Yup'ik, needle case, date unknown. Ivory, 14 × 4 × 2 cm. Gift of the Rasmuson Foundation. Collection of the Anchorage Museum.

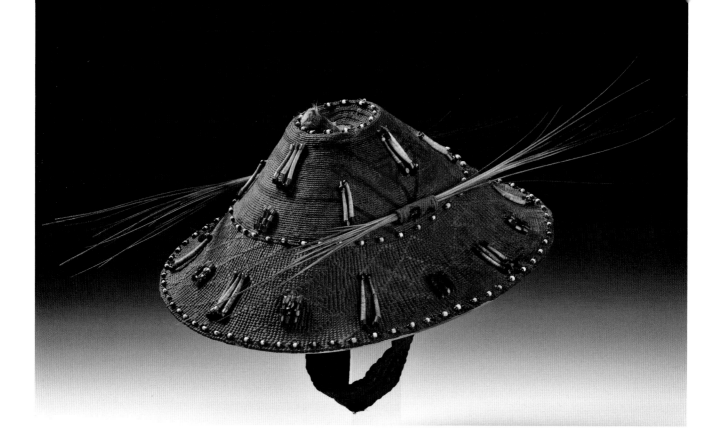

FIGURE 4.6 A twined spruce root hat with painted totemic-style design indicated prestige and achievement. The bundle of sea whiskers and dentalium shells indicates that the owner was wealthy and a successful hunter. The form of the hat is similar to those made by Northwest Coast Indians and indicates the contact between the two groups.

Alutiiq, hat, c. 1850. Spruce root, pigment, dentalium shell, glass beads, wool cloth, and cotton cloth, 15 × 66 × 36 cm. Collection of the Anchorage Museum and the Alutiiq Museum.

By the mid-nineteenth century, the rectangular raven's tail robe seems to have been supplanted by the pentagonal Chilkat robe (named for the Chilkat Tlingit, who were known for making these robes in the nineteenth century).[8] Northwest Coast Indians made other garments out of spruce root or cedar bark, particularly broad-brimmed twined spruce root basketry hats and poncho-like rain capes. The spruce root hats served the practical use of shedding rain, but they were also made as ceremonial garments with attached basketry rings to denote the importance of the wearer (see figure 4.6).[9]

Chilkat robes were woven by women on a simple upright frame, working from a pattern painted on a board showing a totemic design significant to the clan or house. Chilkat weaving used an uneven weft to create rounded, rather than rectangular, geometric designs. The greater design flexibility inherent in this rounded weave was expressed in the totemic symbols that skilled weavers could make. Use of various dye colors on weft strands allowed the totemic designs to be colored, creating a more striking visual statement. Dyes included black (from marsh mud), reddish-brown (from hemlock bark), yellow (from tree or wolf moss), and greenish-blue (from a copper oxide). The dyes were mixed with mountain goat wool and boiled in urine.[10] Unlike raven's tail robes, which were made of mountain goat wool, the warp on a Chilkat robe was made of a core of cedar bark, around which was rolled a layer of mountain goat wool.[11]

Local materials were not always perfect. Fur clothing had to be kept dry to prevent bacterial growth that would rot the clothing. Before entering a warm dwelling, people were careful to brush off snow or water to reduce the likelihood of this happening.

In winter, fur garments that were wet were often left outside to freeze. The frozen fur clothing was then beaten to jar the ice off the garment.[12] Bird-feather parkas shed feathers and gradually became ineffective. Gut or fish skin could tear or wear thin. Caribou fur would become brittle and break off and rarely lasted more than a year when worn by an active person. But seasonally there would be more birds, fish, sea mammals, and caribou, and Native seamstresses could replace worn-out clothing each year. Today, most Native people wear store-bought clothing that uses tough, abrasion-resistant nylon cloth or waterproof fabrics like Gore-Tex to help keep them dry, but they also continue to make and use traditional skin and fur clothing forms to retain their cultural identity and maintain their expertise in using traditional materials.[13]

HOUSING

Alaska covers a number of differing climatic zones, ranging from seasonal extreme cold in the North and the interior to more temperate but often much wetter and windier conditions in the Aleutians and Southeast Alaska. In spite of these differences, all eleven cultures in Alaska used variations on the semi-subterranean dwelling to provide necessary shelter, particularly in the winter.[14] For the Iñupiaq, Unangan, Saint Lawrence Island Yupik, Central Yup'ik, Cup'ik and some Athabascan groups, like the Deg Hit'an and Holikachuk, pit dwellings (called *barabaras* by the Russians) were made by digging a pit several feet deep into the ground and then raising a framework of sturdy, vertical wooden posts that supported a lattice of logs and poles thickly covered with grass mats, with dirt and sod over the mats. Such dwellings could be heated by the residents' own body heat, with fires fed with wood, and, where wood was scarce (such as in the Bering Sea or Arctic Coast), by shaped clay or pecked stone lamps that used a lichen wick to burn sea mammal oil to provide heat and light. Several households might live in one winter dwelling. The Unangan built similar but usually larger dwellings that housed multiple households. Some groups lived in this type of structure for most, if not the entire, year. In some areas, the partially thawed ground in summer led to a high water table, flooding the houses and making them uninhabitable during warm weather (see figures 4.7 and 4.8).

There were several entry types to semi-subterranean houses. Entry to an Unangan dwelling was often from a hole in the roof down a ladder made of a notched log. Among the Saint Lawrence Island Yupik, Iñupiaq, and Yup'ik, the entry might be in the side of the dwelling during the warm months and through an entry tunnel, lower than the floor of the dwelling, during the winter months. Such a tunnel would act as a cold trap to prevent cold air and wind from seeping into the living area. Many such dwellings used split logs to provide walls, floors, and ceiling. Wooden platforms built up along the walls were used as beds, with pits and spaces under the platforms used

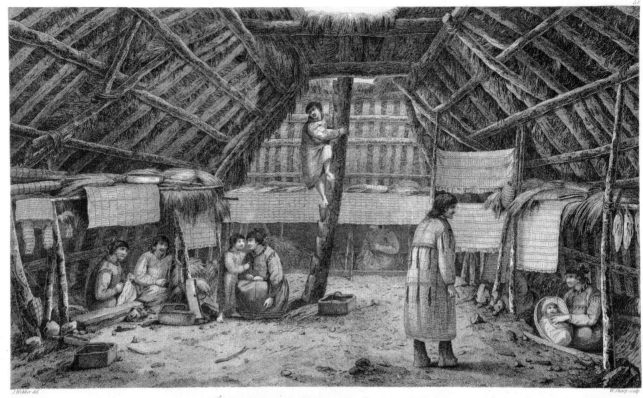

The INSIDE of a HOUSE, in OONALASHKA.

FIGURE 4.7 John Webber was the official artist on British captain James Cook's third and last voyage of exploration in the late 1770s. Cook was attempting to locate the long-sought Northwest Passage over North America that would shorten trading voyages to the Orient. Webber drew this interior of a communal semisubterranean dwelling on the island of Unalaska. The entry was through an opening in the roof. Individual families lived in small compartments ranged along the walls. The central area was a communal space. Webber's illustration clearly shows the wooden beams that supported the earthen roof. Such dwellings were relatively warm, but dark.

John Webber, British, 1750–1793, *The Inside of a House in Oonalashka*, 1784. Ink on paper, 26 × 42 cm. Collection of the Anchorage Museum.

FIGURE 4.8 Lamps that burned sea mammal oil were used
in coastal regions to illuminate and warm semisubterranean
dwellings. They were made of pecked stone or thick clay,
usually in the form of shallow bowls. Wicks were made of moss,
which had to be carefully tended to prevent the lamps from
smoking. This type of lamp was made along the North Pacific
coast in the Kodiak, Kenai Peninsula coast, and Prince William
Sound area, and it was known as a Kachemak lamp. It is one of
the few examples of stone figural work known from prehistoric
Alaska. This lamp was found on Elizabeth Island in Kachemak
Bay when the Good Friday Earthquake of 1964 exposed the
lamp to view.

Alutiiq, lamp, c. 1000. Stone, 12 × 23 × 26 cm.
Collection of the Anchorage Museum.

for storage. A space was left in the roof of these dwellings for a translucent gut window to provide light. In some Iñupiat dwellings, a hollowed-out whale vertebrae set into the wall allowed the entry of fresh air. Saint Lawrence Island Yupik, Iñupiaq, and Yup'ik sometimes built temporary rectangular snow-block structures or windbreaks in winter, but the domed snow house (igloo) emblematic of "Eskimo" dwellings in the Euro-American mind was only made in the Canadian Arctic by the Inuit, where its advantage was the use of available material, its ease and speed of construction, and subsequent rapid abandonment if local resources failed.

There were regional variations. On rocky, steep King Island, dry stone winter houses were built, often overshadowed by summer dwellings: square hide tents perched on wooden poles jammed into the steep slopes. Siberian Yupik on Saint Lawrence Island and the adjoining Siberian coast along the Bering Strait used a wood-sided, skin-roofed dwelling along the coast. Because of the heavy winds that sometimes struck the coast, the skin roofs were often crisscrossed with thick walrus-hide lines, to which were attached large, heavy rocks, to keep the winds from tearing off the roofs. Travelers using umiaks often turned the open skin boats on their side and used them as an impromptu shelter. Both along the Artic coast and in the tundra and interior of Alaska, travelers used hide tents—coastal structures were often conical, where in the interior they tended be a low dome shape.

The log cabin, whether of rounded or squared logs, was copied by Alaska Natives, initially from the Russians (and other Europeans like the Finns, who were employed by the Russian America Company), and later from American prospectors. Semi-subterranean housing was largely abandoned by the mid-nineteenth century.

Dwellings built by the northern Northwest Coast Indians (Tlingit, Haida, Tsimshian) were perceived as the embodiment of the group's social structure—based on clans and represented by houses. Particularly in winter villages, these houses were large rectangular structures with substantial post-and-beam frames, with thick vertical and horizontal planks forming the walls and sheets of bark and thinner boards forming a gabled roof. The planks were made by splitting wood using heavy mauls and wedges. Another technique was to chop into a living tree and then insert a wedge to begin splitting the wood. When the wind flexed the tree, the split would grow longer, and eventually a plank could be wrenched off. A large sunken fire pit located in the center of the house was a communal center. Above the fire pit would be a smoke hole in the roof that could be baffled to blunt the force of the wind and prevent smoke from blowing back into the house. There were no windows; light came from the fire, the smoke hole, and the small doorway. The entry was on the gable end facing the sea and was often small, requiring a person entering to stoop. Such a dwelling housed a large extended family, with the most important members of the family positioned farthest from the small front entryway.

TRANSPORTATION

Depending on the season, northern people developed a variety of means to move themselves and their goods to various parts of their territory. All Native people in Alaska depended on boats, and over thousands of years, they developed a variety of forms that could be made and repaired with available material, were seaworthy and fast, and, particularly in the case of skin boats and bark canoes, were very light.

In the North and in the Interior, once ice drained from the rivers and lakes and retreated on the Arctic Ocean, travel occurred by boat. Saint Lawrence Island Yupik, Iñupiaq Unangan, and Alutiiq people often used large skin-covered open boats, popularly known as *umiaks* or *baidars.* American naval architect Howard I. Chapelle writes that: "Eskimo skin boats possess remarkable advantages for their employment and condition of use. Their hulls are light in weight, simple to build, and relatively easy to repair, yet they are highly shock resistant. They can carry large loads, yet are fast, they are capable of being propelled by more than one means, and they are exceptionally seaworthy."[15]

Alaskan open skin boats had a mortise-and-tenon driftwood frame that was tightly lashed together. The frame was covered with split walrus hides or other sea mammal skins sewn together with a waterproof stitch. Umiaks were used to carry people to seasonal fish and hunting camps, and on long trading voyages along sea coasts and navigable rivers. Large umiaks transported trade goods (furs, metal, reindeer hides) between Siberia and Alaska across the Bering Strait. Along the Arctic Ocean coast and off Saint Lawrence Island, umiaks were also crucial to the hunting of bowhead whales, which were sought during the whales' spring and fall migrations. Walruses were also hunted from umiaks.

The Dena'ina Athabascans, Alutiiq, and Unangan people built similar wood-framed, skin-covered open boats with distinctive local designs. The Unangan-style boat was used into the early twentieth century on the Pribilof Islands. Alutiiq skin-covered open boats seem to have gone out of use in the nineteenth century. By the nineteenth century, simple sails were in use on umiaks. Research done on Saint Lawrence Island indicates that the oldest sails were made from walrus stomach, and after Euro-American contact, were replaced with canvas. Whether sails were used before contact with Euro-Americans is not known.[16]

Athabascan Indians living in the Alaska Interior used a different style of boat—the birch bark–covered, wood-framed canoe. Used widely across northern North America, the birch bark canoe consisted of a light wooden framework with a birch bark cover. The framework provided rigidity, while sheets of birch bark sewn together over the frame provided a waterproof cover. The seams between the birch bark sheets (at least in south-central Alaska) were then coated with a compound made of spruce pitch and moose hair. The mortise-and-tenon wooden framework used by the Athabascans more closely resembles the traditional Iñupiaq umiak than the bent rib and plank frames of

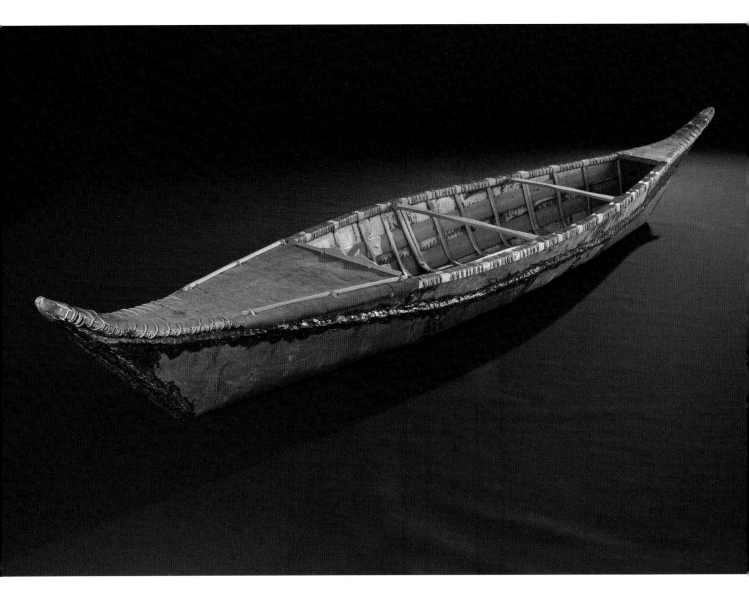

FIGURE 4.9 Bark-covered, wood-framed canoes were built across North America, but those built by the Athabascans of interior Alaska and adjacent Canada were known for their distinctive light wooden frames. This canoe was designed to be used by an individual traveling to hunt or fish. An early illustration of an Athabascan hunter shows him in a birch bark canoe driving a knife down on a swimming caribou.

Randy Brown, American, born 1959, canoe, 1985. Birch bark, spruce wood, spruce pitch, moose hair, and spruce root, 477 × 78 × 55 cm. Collection of the Anchorage Museum.

other Indian bark-covered canoes to the east and south in North America. Athabascan hunters' canoes, built for hunters and trappers ranging along rivers, lakes, and sloughs in Alaska, were light, nimble, and very fast. Larger canoes could be used to carry families and gear to their destinations, such as fish camps (see figure 4.9).[17]

Along the Northwest Coast, where red cedar and, to a lesser degree, hemlock grew to great girth, the Haida, Tlingit, and Tsimshian Indians carved dugout wooden canoes of several sizes for different uses. According to George Thornton Emmons, an ethnographic photographer who spent years studying the northern Northwest Coast Indians in the late nineteenth century, canoe makers sought trees that grew on well-drained soil with straight grain and few knots. Emmons speculated that great effort was required to fell a large tree using stone tools.

After Euro-American contact, iron and steel blades were used for boat construction. If the log was a distance from the water, the exterior hull shape would be carved, and excess wood, along what would become the top of the boat, would be cut away. The canoe form would then be dragged over rollers to the shore. The canoe maker took pride in carefully shaping the exterior of the hull so that adz marks were uniform and worked in parallel rows. Once the hull was shaped, rows of tiny holes were drilled into the hull from the exterior, to be filled either with a mixture of powdered charcoal and seal oil, or spruce or cedar roots. The holes were drilled to precise depths to alert the canoe builder when the interior had been sufficiently hollowed out using adzes and sometimes fire. When the boat was placed in the water, the wet wood would swell, closing these holes. After the canoe was hollowed, the interior of the boat was steamed with water and hot rocks to make the wood more pliable. The sides of the dugout were carefully spread with boards when wet and then allowed to dry, hardening into position. Permanent thwarts were inserted into the widened boat. Propelled by paddles and simple sails, the largest canoes were used to travel hundreds of miles up and down the Pacific coast. When not in use, canoes were carefully stored, sometimes in a trench dug adjacent to a house. Wet cedar-bark mats or blankets covered the boat to keep it from drying out and cracking.[18] Smaller dugouts were used in sheltered waters or rivers. The Yakutat Tlingit used a unique type of dugout, called a forked-prow canoe, to hunt seals and sea otters that congregated near tidewater glaciers in their territory.[19]

Despite the cold, storms, and snow, winter was the best time to travel for the Iñupiaq, Yup'ik, Cup'ik, and Athabascans. It was often easier to travel over snow and ice than through summer's swampy terrain. Heavy loads were carried on wooden sleds, made using mortise-and-tenon construction reinforced with rawhide lashing. This type of construction made the sled strong and flexible, able to withstand the hard abuse of a rocky or icy trail. Wooden sled runners were often shod with bone or ivory to prevent wear. Although some materials have changed, contemporary wooden sleds are made

using primarily the same construction techniques of the nineteenth century. Dogs were kept to pull sleds; where dogs were unavailable, people pushed or pulled them. In deep snow, a person often had to walk ahead of the sled to break trail so that the sled would not bog down. Weather observer Edward Nelson recorded Yup'ik and Iñupiaq teams consisting of about seven dogs along the Bering Sea coast at the end of the nineteenth century. At the same time, Athabascans began using more dogs in order to run long trap lines, but teams of four dogs were typical. In the summer, dogs were trained to carry packs. Dogs were often taken along in umiaks, where they were used to pull the craft upriver or against the wind and current along a coast (see figures 4.10 and 4.11).[20]

Another adaptation was the snowshoe, again made in a variety of forms. Athabascan hunters often wore snowshoes almost as tall as they were, intricately meshed with thin hide, to pursue moose and caribou. The long snowshoes prevented the hunter from sinking more than a few inches while pursued animals would exhaust themselves attempting to run in the deep snow.[21] Iñupiaq and Yup'ik hunters would sometimes use a short snowshoe to provide more support on thin sea ice. Such snowshoes used a thick rawhide webbing to resist the abrasion of the tough sea ice that could readily cut through the fine webbing used on snowshoes meant for powder snow. The Tlingit, particularly traders traveling inland to trade with Athabascans, also used snowshoes, styled after or made by Athabascans.[22]

HUNTING, FISHING, TRAPPING, AND GATHERING

The Native people of Alaska depended on hunting, trapping, fishing, and gathering for their food and for many of the raw materials needed to live—such as furs, hides, antler, bone, and seal oil. To obtain what they needed to survive, they combined extensive knowledge of the local plants and animals with a broad range of tools and techniques used to acquire them. Equipment used for hunting, trapping, and fishing traditionally consisted of bows and arrows, spears, harpoons, traps, snares, hooks, and nets.

The earliest evidence for the use of bows and arrows in Alaska is from about four thousand years ago.[23] Three types of bows were used along Yup'ik and Inupiat territory during the recent past. All were made of local wood—spruce, birch, willow, and larch—which was often strengthened to increase its draw weight. The simplest type of bow was the so-called self, or "D," bow, in which the bow is a simple elongated crescent. The second type of bow was the "D" bow strengthened by running a sinew cable down the back of the bow. Such a bow could be "subjected to much greater stresses of compression and tension," which would result in an arrow being shot with much more force.[24] A third style is what researcher John Murdoch called the "Eskimo" bow, with the bow tips characterized by what he called *siyahs*—separate pieces attached to the

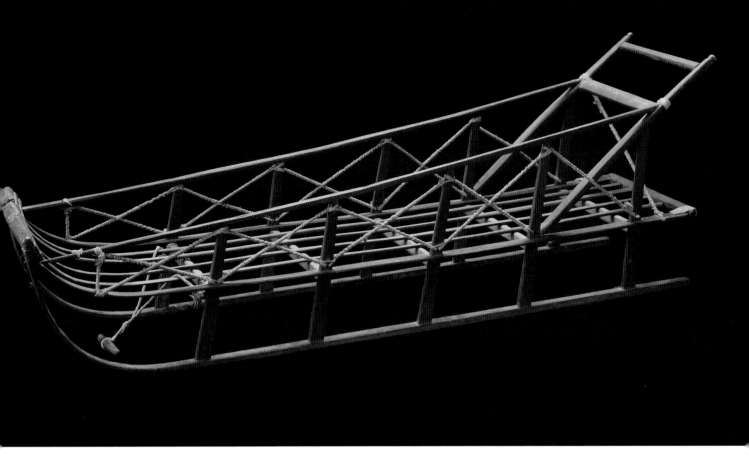

FIGURE 4.10 (top) Dogsleds were a common means of transportation among the Eskimos along the coast and the Athabascan Indians of the interior. They were used to carry trade goods, food, trapping and hunting gear, firewood, and people. This sled model was made for members of the Kilbuck family, Moravian missionaries in southwestern Alaska, by an old Yup'ik Eskimo man who was in a hospital in the Pacific Northwest.

Yup'ik, dogsled, c. 1920. Wood, pigment, string, metal, and bone, 32 × 23 × 94 cm. Collection of the Anchorage Museum.

FIGURE 4.11 (bottom) Athabascan dog blanket from Alaska or western Canada, one of a set of four embroidered blankets designed to show the owner's wealth and prestige (and the skilled sewing of the family's women). Dog teams were often quite small, and most sets of dog blankets made around the turn of the twentieth century consist of four pieces, indicating a small team.

Athabascan, dog blankets, late 19th–early 20th century. Wool cloth and yarn, silk, embroidery floss, wool felt, and rawhide, 53 × 56 × 1 cm. Gift of the Anchorage Museum Foundation. Collection of the Anchorage Museum.

end of the central part of a sinew cable–backed bow, the overlap point reinforced with a block of bone or ivory. "The siyah functions as a lever on the end of the bow arm," permitting a heavier pull. When the string was released on such a bow it moved faster, projecting more energy to the arrow.[25] A strong sinew cable–backed bow was capable of driving an arrow through a caribou.[26]

The Athabascans developed a distinctively different bow, virtually straight, made of willow or birch, often with a distinctive projecting piece called a string arrestor—a bone, antler, or wood block that prevented the bowstring from snapping down on the hand holding the bow.[27] The Chugach Alutiiq used sinew-backed bows to shoot miniature harpoon arrows with detachable points at small seals and sea otters.[28] Various arrows were used, depending on the animal or purpose. Blunt arrows were used to stun small animals and birds without penetrating their pelts. Arrow points were often made of long pieces of bone, antler, or ivory, barbed, and often with a separate ground-slate blade inserted as the arrow point. Such arrows were used to hunt large game such as caribou and bear. The Tlingit used a variation of the throwing board, the "whip sling," which comprised a straight stick with a line at one end. The end of the string fit in a notch on the arrow and the arrow was cast with a forward motion of the stick. According to Emmons, the whip sling "casts the arrow a long distance."[29]

Caribou were among the most important land animals for people in Alaska and the far North. They provided meat, antler for tools, sinew and hair for sewing and embroidery, and furs for clothing. Caribou spread out during the summer but coalesced into migrating herds during the spring and fall.[30] A caribou hunting technique widely used by Nunamiut Iñupiaq and the Athabascans of Alaska's interior was to build miles-long fences of logs and brush along trails used by the migrating caribou, funneling the animals into a corral where they could be caught in snares, then speared or shot with arrows.[31] Several families might spend weeks or months in the summer repairing and extending these fences, then driving the migrating caribou into the corral.

Black, grizzly, and polar bears were sought for their fur, used to make clothing and bedding and, in the spring and fall, for food. Hunters used spears or bows and arrows as well as traps, snares, and deadfalls, to actively hunt bears. The purpose of snares and deadfalls was to immobilize the animal and, if possible, kill it. Set on a trail frequented by a bear, a Tlingit snare would be attached to a heavy log that was set up off the ground; when the bear pushed into the snare the movement would throw the log off, raising and either strangling or immobilizing the bear.[32] Other groups in Alaska also used snares to catch large and small animals.[33] It is likely that remote harvesting techniques (snares, traps, deadfalls) produced as much or more food and furs than did the activities limited to hand weapons.[34] The deadfall—usually a variation on a delicately balanced heavy log that would drop and either crush or immobilize an animal—was

used in many parts of Alaska.[35] Animals caught in deadfalls by the Tlingit included wolf, fox, wolverine, land otter, martin, mink, rabbit, and marmot.[36] Wolverines and wolves were sought for their fur but were not eaten.

Tlingit hunted Sitka blacktail deer with bows and arrows above the tree line, and used dogs to drive deer onto beaches where they could be shot from canoes.[37] Mountain goats and sheep were also sought for their meat, fur, and horns, and were either stalked and shot with arrows or taken with snares. Spring traps, which stored energy in two cords twisted together to power an arm equipped with a sharp spike at one end, were used by the Alutiiq and Yup'ik on various sized game, depending on the size of the trap.[38]

In the Arctic Ocean in spring, currents and winds began to open water leads in the ice near the shore, allowing migrating bowhead whales to move north. Whales were traditionally hunted from umiaks. The seven- to ten-man whaling crew would haul their umiak and their hunting and camping gear to the edge of the sea ice—a sometimes difficult, several-mile trip through jumbled sea ice. The lightness and flexibility of the umiak made it an asset in this situation. Knowing the contours of the coast, the prevailing currents, and the effects of the wind on the ice, whaling captains could predict where the leads would develop. Crews would wait for the bowhead whales to appear, then paddle quietly, as close to the slow-moving whale as possible. The whaling harpoon was made of a long wooden shaft, to which was secured a heavy bone or ivory socket piece. An ivory rod would be inserted into the socket piece; at the other end of the rod, a toggling harpoon head would be set, held on by friction. A line would run through the center of the harpoon head that would attach to one or more blown-up seal skins, which would act as floats and drags. The harpoon would be thrust or thrown at the whale, driving the harpoon head into the animal. The toggling head would separate from the shaft, and a tug on the line would cause the head to turn ninety degrees in the wound, making it very difficult for the animal to dislodge. The floats would slow the wounded whale, and at the same time indicate its location on the surface. Other boat crews would join the pursuit, and the hunters would use lances to kill the whale. After the whale died, the crews would tow the whale back to the edge of the lead for butchering and distribution. Whaling continues to be a very important practice in several northern villages, both as a cultural activity and for the large amounts of meat it can provide (see figure 4.12 and 4.13).[39]

An important hunting tool used to hunt sea mammals and birds, for fishing and in some places for hunting caribou in lakes, was the wood-framed, skin-covered boat called the *kayak* and its associated gear. Kayaks were used from the North Pacific coast beginning in Prince William Sound, west and north around the coast of Alaska, and then across the Arctic Canadian coast to Greenland. Kayaks are also found in a few places on the eastern shores of Siberia among the Siberian Yupik, the Chukkchi, and

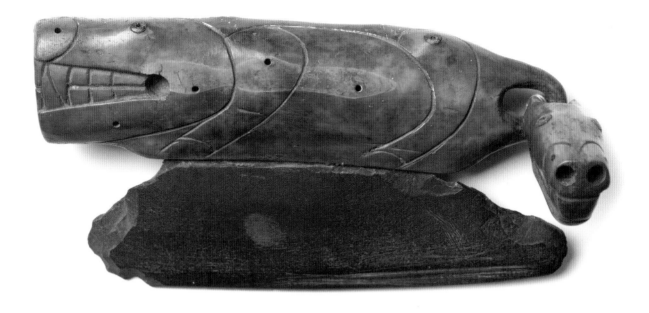

FIGURE 4.12 (top) The Eskimo ulu, or woman's knife, dates to the early first millennium AD, and is probably from Saint Lawrence Island. The handle is carved as a large toothed predator, possibly meant to assist in the butchering of animals or the cutting of hides. The blade is made of slate ground to a relatively sharp edge. Eskimo women still use ulus as all-purpose knives.

Eskimo, ulu, 5th–8th century. Ivory and slate, 8 × 14 × 3 cm. Collection of the Anchorage Museum.

FIGURE 4.13 (bottom) Eskimo, harpoon head, date unknown. Bone and slate, 24 × 7 × 7 cm. Collection of the Anchorage Museum.

the Koryak. Among the Unangan and the Alutiiq of the Pacific coast, a Russian word for small boat, *baidarka,* has become the common term for this kind of boat.[40]

Kayaks developed over many centuries, and there was considerable regional variation in Alaska. European explorers were impressed by how light, fast, and seaworthy the kayak was, and how skilled its occupants were.[41] Among the Alutiiq and Unangan, the kayak was made in one- and two-hatch versions; during the Russian period, a three-hatch kayak, or *baidarka,* was used to carry a Russian official or priest.[42] Whether the three-hatch baidarkas were developed to accommodate the Russians or were in use prior to contact is a subject of debate.[43] To build a kayak, a complex measuring system was developed based on the body of the hunter who would use the boat. According to one early Russian explorer, Sarychev, it could take as long as a year to gather the wood and then build a kayak frame, although the wooden kayak frame might last many years.[44] The cover was made of sea mammal hides sewn with a waterproof stitch. The cover typically wore out faster than the frame, and would need to be replaced several times over the life of the kayak.

The Unangan baidarkas, in particular, had a reputation for speed and seaworthiness, and Unangan men trained from childhood to become expert hunters in their boats. Some Unangan baidarka frames include bone plates that were set where the wood overlapped, so that the flexing of the frame would not result in the wood wearing through. In addition, bone socket pieces with bone balls would be set into the wooden members in order to "increase speed."[45] Ballast stones, distributed throughout the boat, were used to stabilize the very narrow Unangan boats.[46]

Although no longer used in a traditional manner, the kayak form has become popular for recreation in Euro-American culture, being redeveloped in the mid-twentieth century in folding forms for easier transport to recreation sites, and more recently in contemporary materials such as Kevlar and fiberglass, using computer-aided design programs to create hulls that focus on speed or cargo capacity. The snowshoe, another traditional northern design, has also been adopted using contemporary industrial, rather than local, materials.

One technique for hunting sea otters, used by the Koniag Alutiiq, the Unangan, and the Yakutat Tlingit, was to sweep a group of kayaks or canoes forward in a broad line. When a hunter saw a sea otter, he would use his throwing board to launch a light harpoon at the animal, and would then paddle to the spot where the otter dove. The other members of the group would then form a large circle around the first hunter and wait for the animal to surface.[47] Farther north, a hunter would use a kayak to travel from ice lead to ice lead in the spring, pulling the kayak across ice floes on a sled that would be stowed on the rear deck of the kayak when the hunter was on the water. Harpoons for smaller sea mammals would be secured under straps that crossed the deck. The hunter

might also carry a three-pronged bird dart. Often he would carry both a single-bladed paddle for use in paddling slowly and quietly up to animals, and a double-bladed paddle for when speed was necessary. The hunter often wore a waterproof gut parka, the hem of which was carefully tied down around the hatch to render it difficult for water to get into the boat. Once the parka was secured, water could get into the interior of the boat only from the hunter's wrists and the opening of his hood.[48] Hunters would sometime also use kayaks to move along rivers and sloughs to hunt beaver and muskrat. Caribou could be driven into lakes and then lanced by hunters pursuing them in kayaks.[49] Field-butchered game could be stored inside the roomier boats, such as those used along the Bering Sea coast and the Bering Strait, or, in the case of larger animals, lashed alongside the kayak.[50]

Coastal hunters developed several different types of harpoons to hunt sea mammals. Small seals were often hunted from kayaks with light harpoons thrown with throwing boards to increase the force of the cast. These harpoons were often tipped with a dart head, which was held in the wound with side barbs. The dart head was attached to the harpoon shaft by a line. An inflated section of intestine, stomach, or bladder was often attached to the shaft to make the shaft float upright, and also to help mark the location of the wounded animal.[51] Among the Unangan, the maximum range for an accurately thrown dart harpoon was about 120 feet.[52]

In winter, Iñupiaq hunters used dogs to sniff out ringed seal breathing holes on the sea ice.[53] The hunter would wait, sometimes for hours, standing on a tiny three-legged stool to help keep his feet warm, staring at the hole for the seal to rise up to breathe. As the seal rose, it pushed up water in the hole, allowing a light rod or a stalk of grass placed by the hunter in the hole to also rise. This was the signal for the hunter to strike with his harpoon. If successful, the hunter would then enlarge the breathing hole and pull out the seal.[54]

Seal-hide nets were used in the summer to catch and drown small seals in shallow water. In winter, several holes would be dug into the ice, and then nets would be worked under the ice and weighted so they hung vertically in areas where hunter knew seals would congregate. Nets were also used to catch beluga whales in the fall, when storms cause silt to cloud the waters, making the nets difficult to see. People watched the nets, and when a seal or beluga became ensnared, they would use an umiak to retrieve it.[55] In Kotzebue Sound, where belugas congregated in large numbers close to the shore, Iñupiaq hunters in kayaks and umiaks would drive the whales to shallow water, where they could more easily be harpooned or speared.[56] Yup'ik, Iñupiaq, Saint Lawrence Island Yupik, and Athabascan hunters also sought migrating birds that traveled north in huge flocks in the spring to their nesting and feeding grounds. These were struck by thrown spears, immobilized by flung bolos, or snared in nooses

and in fishnets when they molted and were unable to fly. An arrow with three serrated prongs on the end, or a light spear with a long central point at one end and three prongs partway down the shaft, were also used to take birds. Decoys made of wood or a stuffed bird pelt attracted birds to where they were netted or shot with arrows. Small birds were often the first game hunted by small boys. Eggs were sought from nests. In places like Nunivak Island, hunters would lower themselves down cliffs on long lines to collect eggs. On Little Diomede Island, special stone shelters were built along the rocky slopes to hide hunters and the nets they used to capture birds. A gorge—a short bone rod sharpened at both ends—was baited and used to catch sea gulls. When the bird swallowed the bait (and the rod), a hunter would pull the line tied to the middle of the gorge to turn the gorge in the bird's throat, impaling it. Bird pelts were made into warm parkas, socks, and bags. Bird meat could be dried for future use, although in early spring, when winter food stocks were low, fresh bird meat was relished.[57]

Another usually periodic resource was fish. Various species of fish are of importance to virtually all Alaska Natives. For some groups, such as the Tlingit and Tsimshian, and for many Yup'ik, fish were traditionally the primary food source.[58] The five species of salmon were of particular importance. Salmon began returning from the ocean in spring, moving up freshwater streams and rivers to spawn and die. Salmon runs continued in some places to early fall. People eagerly anticipated their return, and often traveled to areas where fish concentrated to establish summer fish camps to net, spear, gaff, and trap them, eating them fresh or smoking or drying the fish for the months ahead.[59] Tlingit fishermen often dammed part of a stream to funnel salmon into conical fish traps.[60] Similar funnel traps were used by Athabascans and some Yup'ik people to catch salmon and other species of migrating fish, such as blackfish. Some of these traps were quite large, requiring several men to pull them from the water.[61] Funnel traps would be used during both the summer and the winter.[62]

The Tlingit built stone walls, or lines of wooden posts adjacent to the shoreline, that the salmon could swim over at high tide but would impound them when the tide ran out. The trapped salmon could then be speared, gaffed, or harpooned.[63] Yup'ik people often used gill nets made from the sinew of various animals, caribou skin, or willow bark. Wooden floats would be attached to the top of the nets, often wood carved as birds or seal heads; to the bottom would be attached weights to keep the net floating perpendicular to the surface of the water. The bird-shaped floats sometimes attracted birds that might also be taken, providing another food source. Fish nets could be pulled in to remove the fish, or a kayak or umiak could be paddled out to remove fish from the net. Among the Yup'ik, a net was a large investment of time and resources, and was carefully maintained.[64] A type of trap known as a fish wheel was a Euro-American technique that was adopted by the Athabascans and some riverine Yup'ik early in the

twentieth century. Fish wheels were made up of four mesh scoops mounted on arms rotating around a central axle. These were mounted on a raft moored near the shore where migrating fish passed. The river current forced the arms to rotate, and in silty waters like the Yukon or the Copper, the migrating salmon did not see the scoops before they were caught, lifted, and slid into a collection box.[65]

Salmon and other fish were air-dried or smoked with fires built of birch, cottonwood, and alder. Drying and smoking removed moisture from the fish, reducing bacterial action or mold that could spoil it. Smoking also helped to harden the surface of the fish, making it more difficult for flies to deposit eggs and spoil the fish.[66] Among the Yup'ik, some dried fish was packed in pokes of sea mammal or fish oil, or in grass baskets for future use. Some fish was fermented. Women processed the fish, splitting and scoring it to expedite drying or smoking.[67] Smokehouses were used by the Tlingit, Haida, and Tsimshian, as well as by the Athabascans and the Yup'ik.[68] The goal was a winter supply of fish for consumption by both people and, in some areas, by the dogs that pulled sleds in the winter and packed goods and pulled boats in the summer.

Other fish species were also migratory and were seasonally important. In the spring, herring and herring eggs were important along the Northwest Coast to the Bering Sea coast. Herring mass in early spring to spawn, and were caught with rakes—herring eggs were deposited on seaweed, which was collected, or on spruce boughs deposited specifically to collect eggs.[69] Another important small fish along the Northwest Coast was the eulachon, which was also caught with rakes and rendered for its oil, which was used with most foods and even drunk.[70] Other targeted species that massed or moved seasonally were smelt, pickerel, whitefish, blackfish, burbot, and lamprey eels. Depending on the species, these could be caught in dip nets or gill nets, trapped in funnel traps, speared, shot with special fish arrows, or caught with hooks.[71] People followed migration cycles and intercepted the fish at choke points to maximize catchment.[72]

Another important fish to the people of the Northwest Coast and the Alutiiq was the halibut, a bottom-feeding flatfish that could weigh hundreds of pounds. A common way of fishing for halibut was to use an ingenious V-shaped hook that had been developed specifically to catch these fish, based on knowledge of their feeding habits. Halibut are bottom feeders that suck their prey into their mouths. When it sucked in the baited V-shaped hook, a bone, and later a metal spike, angled on one arm would catch the inside of the halibut's mouth. A line attached to the hook was attached to a wooden float, which would be pulled underwater as the hooked halibut swam away, thus notifying the fisherman that a halibut had been caught. The wooden arms of the V-shaped hooks were usually carved to represent a spirit helper (see figures 4.14 and 4.15).[73]

In winter, fishing through the ice was practiced by Yup'ik, Iñupiaq, and Saint Lawrence Island Yupik and Athabascans. Among those living along the ocean coast,

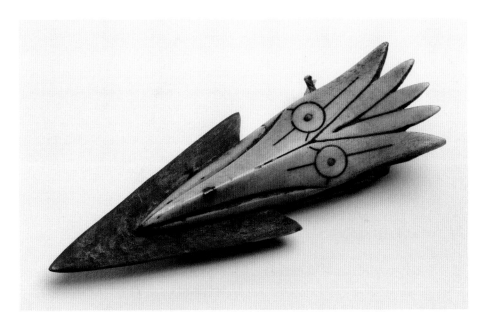

FIGURE 4.14 This toggling harpoon head was designed to be driven into a sea mammal, and then, when tugged by a line, to turn ninety degrees in the wound, making it very difficult for the thrashing animal to dislodge.

Eskimo, toggling harpoon head, c. 1900. Bone or antler and brass, 9 × 3 × 2 cm. The Floyd and Gladys Allen Collection. Collection of the Anchorage Museum.

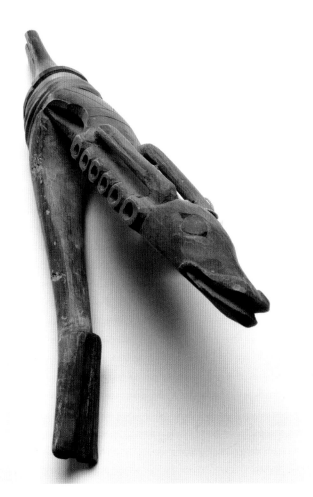

FIGURE 4.15 A distinctive V-shaped hook was used by Northwest Coast Indians and some Pacific Eskimo to catch bottom-feeding halibut. Among the Tlingit, the arms of the hook were often finely carved with the images of spirits to help the fisherman. Among the Northwest Coast Indians, each arm of the hook was made of a different wood, which pleased the halibut, according to nineteenth-century researcher Lieutenant George Emmons.

Tlingit, halibut hook, late 19th century. Wood, cedar bark, commercial string, and unknown material, 32 × 15 × 6 cm. Collection of the Anchorage Museum.

a hole was chipped through the sea ice and bait or a lure lowered into the water. Fish attracted to a lure might be speared. A hook was often connected to one of two short sticks, called fishing jigs, one held in each hand. When a fish was hooked, the fisherman would skillfully double the line again and again between the two sticks until the fish was pulled out. While most of the hooks used in ice fishing were very simple, hooks for sculpin tended to be complex and colorful, being made of pieces of ivory and colored stone, orange auklet sheath, and colored beads. The pieces were carefully lashed together with a bird feather quill. A slush scoop using a baleen mesh that would not ice up was used to dip slush from the fishing hole to prevent it from freezing over. This type of fishing could be done by almost any able-bodied person in a community during favorable weather, providing an outing for people as well as sometimes necessary fresh food. Athabascans would submerge large funnel traps made of thin, flexible wood strips through holes laboriously chopped in the ice on a stream or river to impound burbot, blackfish, and pike. Athabascan fishermen would periodically dig through the ice and pull up the funnel traps, emptying their catch.[74]

Native people in Alaska and the circumpolar North were skilled at working with solid materials, such as wood, antler, stone, ivory, bone, and even copper. Stone was flaked, ground, pecked, or sawed to form a variety of tools and objects. Stone, as a raw material and as a finished tool, was among the earliest trade goods, because sources of usable materials were scattered geographically. Tools used to work stone included other stones (grinding, pecking, chipping, sawing, sharpening) and antler points (for pressure flaking). Working stone required little in the way of tools but required skill, experience, and good raw materials. Stone ulu blades were sometimes drilled to facilitate lashing the blades to handles (see figure 4.16).[75]

Alaska Natives developed a deceptively simple tool kit to make surprisingly complex objects out of solid materials. A maul was used to drive bone or antler wedges to split a log into usable pieces, or even to split a board off a living tree. Adzes, originally stone bladed and later fitted with a metal bit, were used to shape wood and sometimes to cut down trees. A crooked knife, with a short curved blade and a relatively long handle, was used to do finish work and to hollow out objects. Often the handle on a crooked knife was made of a thin piece of polished bone that could be used to split thin strips off straight-grained wood. Beaver teeth were traditionally used to make a chisel. An awl was used to start a hole in the wood. Either a strap drill or a bow drill would be used to drill holes through any of the solid materials. An important part of woodworking activity was the steaming and bending of wood, used to make the elaborate visors and hunting hats found among the Unangan, the Alutiiq, and the Yup'ik, or to make the sides and rims of bentwood boxes, bowls, and buckets found among all cultures in Alaska. An engraving tool with a fine stone or metal point would be used to mark

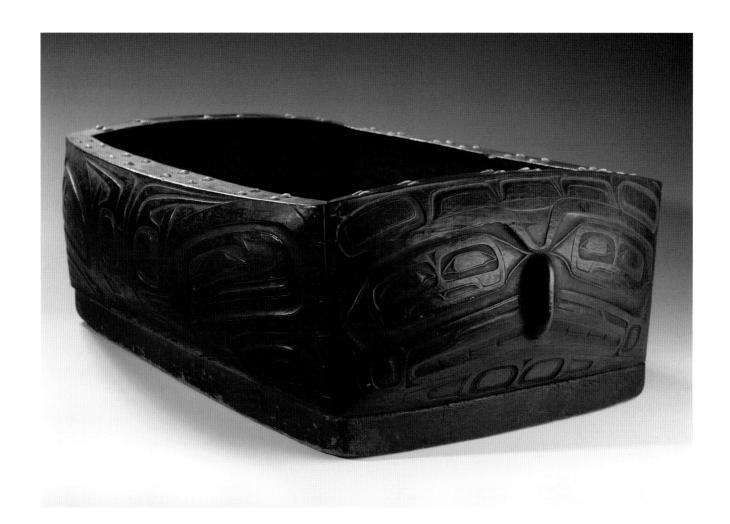

FIGURE 4.16 This carved northern Northwest Coast Indian feast dish—possibly Haida, with its curved bentwood sides—shows how expertly Indian craftspeople could shape, carve, and bend wood. The sides of this container are made of one piece of wood, with L-shaped notches cut into it to facilitate bending the wood after it was steamed. Where the ends of the board met, the wood was sewn together with spruce root to lock in the sides' rectangular shape.

Haida, Indian feast dish, c. 1850. Yellow cedar, spruce root, opercula shells, metal, 24 × 50 × 70 cm. Collection of the Anchorage Museum.

decorative lines on hard materials like walrus ivory. A variety of types of stone were used as whetstones to sharpen blades.[76]

Among the Yup'ik, Iñupiaq, and Saint Lawrence Island Yupik, men would often work in the men's house, usually a large semi-subterranean structure that functioned as a communal center where men and older boys spent much of their time while in the village. Even large objects such as a kayak frame or dog sled would be worked on and assembled in the men's house. Boys would watch and learn from the men how to work with tools.[77]

Women from Alaska Native groups made baskets using the techniques of folding, coiling, twining, and plaiting, using spruce root, cedar bark, grass, birch bark, and willow root. While often beautifully made, basketry was functional, made to collect or store food (berries and fish) or to hold household goods. Mats were made for a myriad of purposes.

Eyak, Tlingit, Haida, and Tsimshian women were well known for their finely made twined spruce root baskets. Gathering spruce root and preparing it to be woven into baskets was a tedious process. Roots were traced from trees, carefully dug out, then roasted over a fire to separate the bark from the core, then split and carefully dried. At the time of weaving, the roots were soaked to make them pliable and might also be more finely split. Baskets were decorated in geometric patterns with slips of maidenhair fern or "straw" (grass), using a technique known as false embroidery or imbrication, which was done on the surface of the weave rather than around it. False embroidery was visible on the outside but not on the inside of the basket. Some of the embroidery material was dyed. Dyes were made from the mud from sulphur springs for black, alder for red, blueberries and huckleberries for several dark shades, a lichen for yellow, and copper oxide and hemlock bark for blue-green. [78]

Several types of twined weave were used on the Northwest Coast. One of these, the so-called "close together weave," could be so tightly done that the weave is water tight. Many Tlingit baskets were cylindrical, although shallow bowl-shaped work baskets, conical spruce root hats, and thin spoon bags were also made. Basketry was functional, with the vast majority of baskets being made to collect food (berries) or to store household goods (spoon bags). When not actually in use, twined spruce root baskets could be soaked and then folded flat for easier storage. When they were needed again, they were soaked to make them flexible and then opened up. Some of the older work baskets in the Anchorage Museum's collection were undecorated, although very finely woven.[79]

Some baskets were used for cooking. According to Selina Peratrovich, a Haida elder who saw this done when she was a small girl, a heavily made basket would be placed in a hole in the sand. A wooden disk would cover the interior bottom of the basket. Hot rocks from a nearby fire and water would be placed inside the basket, resting on

the wood disk. A layer of skunk cabbage leaves would then be laid on the surface of the water, followed by the fish, and finally by another layer of skunk cabbage leaves. In this technique, the food would be steamed rather than boiled.[80]

Unangan twined baskets were made primarily of ryegrass (*Elymus mollis*) with a wide variety of secondary materials (spruce root, baleen, and sea mammal gut), traditionally used as decorative accents. Unangan women wove grass into a variety of baskets, often with heavily reinforced rims. Great quantities of mats were made, to function as floor coverings and as partitions for nuclear family compartments within communal homes. Unangan women gathered grass in the fall and then carefully dried it for use in the winter. They made particularly finely woven baskets, which, in the late nineteenth century, became popular with American collectors. As women wove more and more of their baskets for the collector market, the form of the baskets changed. Cigarette/cigar cases, made of two flat baskets—one smaller than the other and meant to slide into the larger basket, and one known as a "May" basket for its similarity to the Euro-American type—became popular on the commercial market. Most of the baskets made for the collector market were flat-bottomed, cylindrical baskets, usually woven around a form like a wooden disk or a tin can.[81] Decoration, in the form of geometric or floral designs done in silk embroidery thread or fine wool yarn, became more prominent.

Both Yup'ik and Iñupiaq peoples made grass baskets in the nineteenth century. Among the Yup'ik, grass was collected in great quantities in the fall and brought back to the winter villages, where it was spread out to dry and then stored. If the grass was not completely dry when it was twined, it might break. Combs with widely spaced teeth were used in Yup'ik territory to remove debris from grass strands. Some of the earliest Yup'ik baskets in the Anchorage Museum's collections are finely twined utilitarian grass baskets with flat bottoms and cylindrical sides, decorated with simple horizontal lines of willow fibers. Grass bags held personal possessions, food, and clothing. The grass was twined to make line, used to hold herring as it dried, to make dog harnesses, or for other utilitarian purpose. Grass socks were worn in boots to wick moisture from feet, keeping them warm; grass liners were used in fish-skin mitts for the same reason. Grass bags were even made into small fish traps. Simple mats were made in large numbers but rarely preserved. They were used on bedding, as dividers, and in the construction of sod-roofed dwellings, where they were laid down between the rafters and the sod. Rapidly made, large-meshed twined baskets, jokingly called "Yup'ik garbage bags," are made in some villages today for a one-time use, such as storing fish. Coiled grass baskets, which were traditionally made to store possessions, are now made almost exclusively for the collector market (see figure 4.17).[82]

FIGURE 4.17 Eskimos made boot and mitten liners out of grass to insulate boots and to wick moisture away from the body, helping to keep the feet and hands warm.

Eskimo, socks, early 20th century. Grass, 15 × 26 × 11 cm. Gift of Fred and Sara Machetanz. Collection of the Anchorage Museum.

Athabascans made two different types of baskets. One type, generally for open containers, used birch bark that was carefully cut, then folded to form watertight bowl forms and vertical-sided containers. The top and upper side were usually reinforced with a thin wooden rod that was bent into a circular form, while spruce root was used as a lashing material. There was great variation in the size of birch bark baskets, partly because of the size of bark sheets that can be obtained from a large birch tree. Folded birch bark baskets were used as containers for fishing nets, as berry buckets, to hold urine for cleaning and tanning, and to carry drinking and cooking water. Except for one type of basket (a boiling basket, used to cook or to make spruce gum glue), the interior of the bark forms the interior of the basket.[83] The second Athabascan basket type was made of willow root stitched around a willow rod, using a technique known as rod and coil construction.[84]

Alaska Natives were aware of metal prior to Euro-American contact. Along Alaska's Copper River and the Coppermine River in western Canada, pure nuggets of copper were found and pounded into projectile points and knife blades that were prized and widely traded. A distinctive knife with a single or double volute decoration above the grip is identified as being Athabascan in origin. Iron was traded in small quantities through Native trade networks over the Bering Strait from Siberia, beginning at least one thousand years ago, and was used in tools such as gravers to incise decorative lines in objects made of walrus ivory and antler. Georg Steller, a scientist who accompanied Vitus Bering on his second expedition in 1741, noted that several Unangans had long iron knives of a non-European design; by the time British explorer Captain James Cook sailed along the Northwest Coast in 1778, he found that many Tlingit men carried one or more iron knives.[85] Some of the iron may have come from the wreckage of Oriental ships borne on the Japan current across the North Pacific to the North American coast.

Alaska is a varied and complex place that necessitates adaptation, a place where technologies have been developed and refined, allowing people to thrive in the landscape since time immemorial. The material and cultural traditions that manifest in a landscape that many consider inhospitable or extreme continue to adapt, finding longevity and purpose despite a rapidly changing social, economic, and physical landscape. The details of how to live, how to hunt, and how to thrive in Alaska are evident in the materials and skills of Alaska's Native cultures, and continue to be a beacon, showing how to continue adapting and thriving in a landscape that is ever changing, and constant in that change (see figure 4.18).

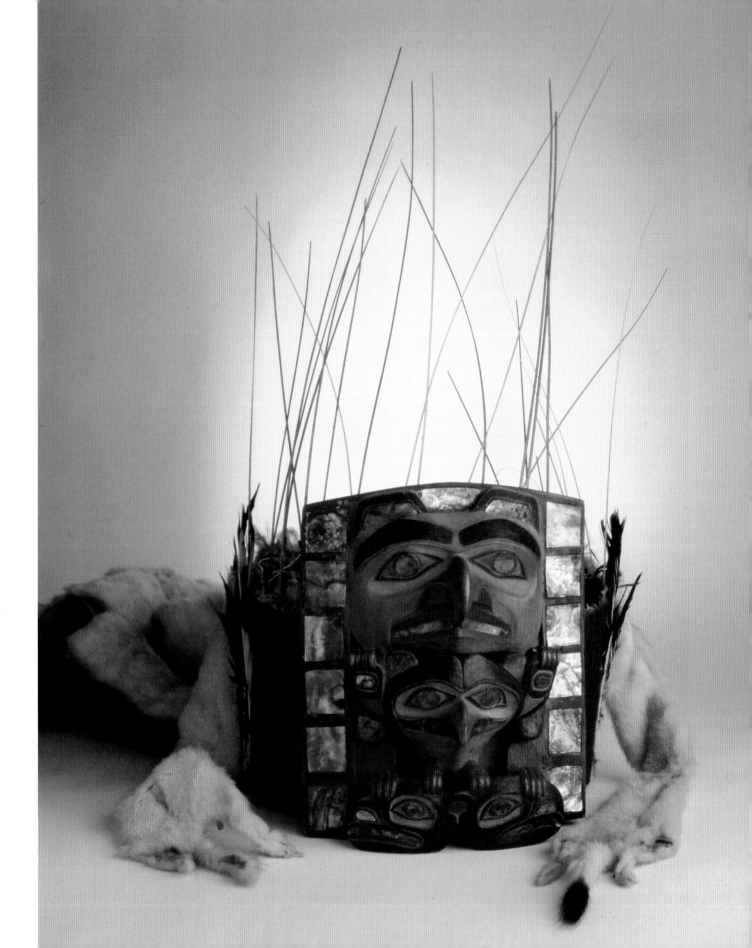

NOTES

1 In a recent survey of Arctic clothing, Betty Kobayashi Issenman refers to Russian scholar A. P. Okladnikov, who believed that "hunter and gatherer societies had to create tailored fur clothing to be able to hunt in winter" in the North between thirty and forty thousand years ago. Issenman refers to the archaeological record to show when ulus (women's knives), scrapers, needles, and needle cases appeared, and to figurines that imply styles of clothing. See Betty Kobayashi Issenman, *Sinews of Survival* (Vancouver: University of British Columbia Press, 1997), 13.

2 Ibid., 37.

3 Ibid., 9.

4 Jill Oakes and Rick Riewe, *Alaska Eskimo Footwear* (Fairbanks: University of Alaska Press, 2007), 29–39; William W. Fitzhugh and Susan A. Kaplan, *Inua: Spirit World of the Bering Sea Eskimo* (Washington, DC: Smithsonian Institution Press, 1982), 130–143.

5 Cheryl Samuel, *The Chilkat Dancing Blanket* (Seattle: Pacific Search Press, 1982), 75–81.

6 Cheryl Samuel, *The Raven's Tail* (Vancouver: University of British Columbia Press, 1987), 17.

7 George Thornton Emmons, *The Tlingit Indians,* ed. Frederica de Laguna (Seattle: University of Washington Press, 1991), 228.

8 Ibid., 228, 234.

9 Ibid., 221, 237.

10 Ibid., 225–226.

11 Samuel, *The Raven's Tail,* 16.

12 Issenman, *Sinews of Survival,* 42.

13 Oakes and Riewe, *Alaska Eskimo Footwear,* 55, 102, 109.

FIGURE 4.18 Frontlets were worn on the head as a prestige garment during Northwest Coast Indian ceremonies. They were made of a baleen frame decorated with flicker feathers and sea lion whiskers. The long train worn down the back would be of ermine skins. The carved totemic designs on the front were important emblems of the wearer's house or clan. The hollow crown of the hat held eagle down, which was intended to be shaken out of the hat to float around the wearer as he danced.

Edward Albert Edenshaw, Haida, Kaigani, 1810–1894, headdress, frontlet, late 19th century. Baleen, commercial paint, abalone, wool felt, and cotton thread, 50 × 32 × 104 cm. Collection of the Anchorage Museum.

14 For Iñupiaq and Yup'ik structures, see Molly Lee and Gregory A. Reinhardt, *Eskimo Architecture: Dwelling and Structure in the Early Historic Period* (Fairbanks: University of Alaska Press, 2003). Good information about several Athabascan structures can be found in several books by Cornelius Osgood, such as *Ingalik Material Culture* (New Haven: Yale University Publications in Anthropology, reprinted by Human Relations Area Files Press, 1970), 290–340 and *The Ethnography of the Tanaina* (New Haven: Yale University Publications in Anthropology, 1937). Margaret Lantis's "The Aleut Social System, 1750 to 1810, from Early Historical Sources," in *Ethnohistory in Southwestern Alaska and the Southern Yukon,* ed. Margaret Lantis, 182–189 (Lexington: The University Press of Kentucky, 1970), provides succinct information on Aleut structures. George Thornton Emmons, *The Tlingit Indians,* ed. Frederica de Laguna (Seattle: University of Washington Press, 1991), 50–78, combines the knowledge of two preeminent researchers on Tlingit culture.

15 Edward Tappan Adney and Howard I. Chapelle, *The Bark Canoes and Skin Boats of North America* (Washington, DC: Smithsonian Institution Press, 1964), 174–190.

16 William Fitzhugh and Susan A. Kaplan, *Inua: Spirit World of the Bering Sea Eskimo* (Washington, DC: Smithsonian Institution Press, 1982), 60–66; Stephen R. Braund, *The Skin Boats of Saint Lawrence Island, Alaska* (Seattle: University of Washington Press, 1988), 17, 74.

17 Adney and Chapelle, *Bark Canoes and Skin Boats* 158–168.

18 Emmons, *The Tlingit Indians,* 89–94, 97.

19 Ibid., 84–85.

20 Fitzhugh and Kaplan, *Inua,* 99; Cornelius Osgood, *Ingalik Material Culture,* 352–358; Kate Duncan, *Northern Athapaskan Art: A Beadwork Tradition* (Seattle: University of Washington Press, 1989), 94–97.

21 James W. VanStone, *Ingalik Contact Ecology: An Ethnohistory of the Lower-Middle Yukon, 1790–1935,* Fieldiana Anthropology 71 (Chicago: Field Museum, 1979), 29–32.

22 Emmons, *The Tlingit Indians,* 99–100; Fitzhugh and Kaplan, *Inua* 101.

23 Don E. Dumond, *The Eskimos and Aleuts,* Ancient People and Places 87 (London: Thames and Hudson, 1977), 87.

24 T. M. Hamilton, *Native American Bows,* ed. Nancy Bagby (York, PA: George Shumway, 1972), 71.

25 Ibid., 78–79.

26 Fitzhugh and Kaplan, *Inua,* 104; Ann Fienup-Riordan, *Yuungnaqpiallerput: The Way We Genuinely Live; Masterworks of Yup'ik Science and Survival* (Seattle: University of Washington Press, 2007), 169.

27 Cornelius Osgood, *Contributions to the Ethnography of the Kutchin,* Yale University Publications in Anthropology 14 (New Haven, CT: Human Relations Area Files Press), 82–84.

28 S. A. Korsun, *The Alutiit/Sugpiat: A Catalog of the Collections of the Kunstkamera* (Fairbanks: University of Alaska Press, 2010), 326–341.

29 Emmons, *The Tlingit Indians,* 129.

30 VanStone, *Ingalik Contact Ecology,* 129–130.

31 Ibid., 21, 29; Raymond V. LeBlanc, "Northern Yukon Caribou Fences," 2013, www.thecanadianencyclopedia.ca/en/article/northern-yukon-caribou-fences/, accessed July 16, 2014.

32 Emmons, *The Tlingit Indians,* 133–136.

33 Osgood, *Ingalik Material Culture,* 243–244; Fienup-Riordan, *Yuungnaqpiallerput,* 167–168; 200–201; Fitzhugh and Kaplan, *Inua,* 103; Richard K. Nelson, Kathleen H. Mautner, and G. Ray Bane, *Tracks in the Wildland: A Portrayal of Koyukon and Nunamiut Subsistence* (Fairbanks: National Park Service and the University of Alaska, 1982), 55–82.

34 Nelson, Mautner, and Bane, *Tracks in the Wildland,* 55.

35 Osgood, *Ingalik Material Culture,* 244–250.

36 Emmons, *The Tlingit Indians*, 135.

37 Ibid., 137.

38 Fitzhugh and Kaplan, *Inua,* 103.

39 William W. Fitzhugh and Aron Crowell, *Crossroads of Continents: Cultures of Siberia and Alaska* (Washington, DC: Smithsonian institution Press, 1988), 163; John Bockstoce, *Whales, Ice, and Men: The History of Whaling in the Western Arctic* (Seattle: University of Washington Press, 1986), 136–142.

40 Fitzhugh and Crowell, Ibid., 158–159; Dumond, *Eskimos and Aleuts,* 118; Adney and Chapelle, *Bark Canoes and Skin Boats,* 190–211.

41 Dean Littlepage, *Steller's Island: Adventures of a Pioneer Naturalist in Alaska* (Seattle: Mountaineers Books, 2006), 98–102.

42 William S. Laughlin, *Aleuts: Survivors of the Bering Land Bridge*, Case Studies in Cultural Anthropology (New York: Holt, Rinehart and Winston, 1980), 34–41.

43 Archaeologist and anthropologist William Laughlin states that three-hatch baidarkas did not exist prior to Russian contact; historian and anthropologist Lydia Black comments that three-hatch baidarkas were seen by early Russian explorers in the mid-eighteenth century on Attu. See ibid., 34; Lydia Black, *Atka: An Ethnohistory of the Western Aleutians*, Alaska History 24 (Kingston, ON: Limestone Press, 1984), 57.

44 David W. Zimmerly, *Qajaq: Kayaks of Siberia and Alaska* (Juneau: Alaska State Museum, 1986), 20.

45 Ibid., 22–23, referring to research done by Joseph Lubishcer and quoting Makary Zaochney.

46 Ibid., 25–26.

47 Yury Lisiansky, *A Voyage Round the World in 1803, 4, 5, & 6 in the Ship Neva* (London: Hamilton, Weybridge, Surrey, 1814), 203–204, as quoted in George Dyson, *Baidarka* (Edmonds, WA: Alaska Northwest Publishing Company, 1986), 43–44; Emmons, *The Tlingit Indians,* 124; Korsun, *The Alutiit/Sugpiat*; Ivan Veniaminov, quoted in Zimmerly, *Qajaq,* 23–24.

48 Fitzhugh and Kaplan, *Inua,* 60–85; Fienup-Riordan, *Yuungnaqpiallerput,* 87–115.

49 Ernest S. Burch, Jr., *The Iñupiaq Eskimo Nations of Northwest Alaska* (Fairbanks: University of Alaska Press, 1998), 73.

50 Fitzhugh and Kaplan, *Inua*, 62; Burch, *Iñupiaq Eskimo Nations*, 93.

51 Fienup-Riordan, *Yuungnaqpiallerput*, 137–138.

52 Laughlin, *Aleuts*, 32.

53 Burch, *Iñupiaq Eskimo Nations*, 46.

54 Ibid., 76.

55 Ibid., 298; Fitzhugh and Kaplan, *Inua*, 70, 77–78, 89.

56 Charles V. Lucier and James W. VanStone, *Traditional Beluga Drives of the Iñupiat of Kotzebue Sound, Alaska*, Fieldiana Anthropology n.s. 25 (Chicago: Field Museum of Natural History, 1995), 67–75.

57 Fitzhugh and Kaplan, *Inua*, 108–113; VanStone, *Ingalik Contact Ecology*, 22, 28; Fienup-Riordan, *Yuungnaqpiallerput*, 197–204; Nelson, Mautner, and Bane, *Tracks in the Wildland*, 52.

58 Emmons, *The Tlingit Indians*, 5; Fienup-Riordan, *Yuungnaqpiallerput*, 175.

59 Emmons, *The Tlingit Indians*, 103–114; Fienup-Riordan, *Yuungnaqpiallerput*, 175–189; VanStone, *Ingalik Contact Ecology*, 24–28.

60 Emmons, *The Tlingit Indians*, 105–107.

61 VanStone, *Ingalik Contact Ecology*, 25; James A. Fall, "Introduction to Dena'ina Culture and History," in *Dena'inaq' Huch'ulyeshi: The Dena'ina Way of Living*, ed. Suzi Jones, James A. Fall, and Aaron Leggett (Fairbanks: University of Alaska Press, 2013), 22; Fienup-Riordan, *Yuungnaqpiallerput*, 282–284.

62 VanStone, *Ingalik Contact Ecology*, 29; Fienup-Riordan, *Yuungnaqpiallerput*, 278–284.

63 Emmons, *The Tlingit Indians*, 106–107.

64 Fienup-Riordan, *Yuungnaqpiallerput*, 175–189.

65 VanStone, *Ingalik Contact Ecology*, 183.

66 Fienup-Riordan, *Yuungnaqpiallerput*, 183.

67 Ibid., 175–183.

68 Jones, Fall, and Leggett, ed., *Dena'inaq' Huch'ulyeshi: The Dena'ina Way of Living*, (Fairbanks: University of Alaska Press, 2013), 121–127.

69 Ann Fienup-Riordan, *The Nelson Island Eskimo: Social Structure and Ritual Distribution* (Anchorage: Alaska Pacific University Press, 1983), 90, 92–110; Emmons, *The Tlingit Indians*, 117–119.

70 Emmons, *The Tlingit Indians*, 117–119, Kalervo Oberg, *The Social Economy of the Tlingit Indians*, The American Ethnological Society 35 (Seattle: University of Washington Press, 1980), 69–70.

71 Fitzhugh and Kaplan, *Inua*, 86–97.

72 Emmons and de Laguna, *The Tlingit Indians*, 103–114; Fienup-Riordan, *Yuungnaqpiallerput*, 175–189.

73 Emmons and de Laguna, *The Tlingit Indians,* 115–117.

74 Fitzhugh and Kaplan, *Inua*, 94–97; Fienup-Riordan, *Yuungnaqpiallerput*, 274; VanStone, *Ingalik Contact Ecology*, 29; Osgood, *Ingalik Material Culture*, 229–233.

75 Emmons and de Laguna, *The Tlingit Indians,* 165–172.

76 Fienup-Riordan, *Yuungnaqpiallerput*, 67–75; Osgood, *Ingalik Material Culture*, 84–87, 96–104.

77 Fienup-Riordan, *Yuungnaqpiallerput*, 31, 36, 39–44.

78 Emmons, *The Tlingit Indians,* 213–219.

79 Ibid., 213–219.

80 Selina Peratrovich to Walter Van Horn, personal communication, 1978.

81 Lydia Black, *Aleut Art: Unangan Aguqaadangin*, 2nd ed. (Virginia Beach: Donning Company, Publishers, Aleutian/Pribiloff Island Association, 2003), 144.

82 Fienup-Riordan, *Yuungnaqpiallerput*, 217–243.

83 Osgood, *Ingalik Material Culture*, 133–142.

84 Susan W. Fair, *Alaska Native Art: Tradition, Innovation, Continuity,* ed. Jean Blodgett (Fairbanks: University of Alaska Press, 2006), 104, 106.

85 Emmons, *The Tlingit Indians,* 184.

THE NORTHERNER

PRISCILLA NAUNĠAĠIAQ HENSLEY HOLTHOUSE

am a person of the North. This is by birth and by ancestry. My father was born on the shore of Kotzebue Sound. His mother was Iñupiaq, the first people of Kikiktagruk. His biological father sailed around the world from Vilnius to Northwest Alaska, operating trading posts. *Time* magazine, in 1936, described my father's father as "a bright eyed little Jew." His son, my father, was adopted and raised by older relatives. That is one tributary of my bloodstream. And here's another: My mother's mother was born in Anchorage, a daughter of early twentieth-century pioneers. My mother's father came up on a motorcycle to work in canneries, and stayed. My mother was born at Providence Hospital—the old one that overlooked the park strip.

My family history knits together the indigenous with "pioneers" drawn here for love, duty, money, and adventure. I live in Anchorage, the place my mother's people headed north to from Montana, North Dakota, and Washington—states already pressed up against their country's northern border with Canada. Five hundred and fifty miles northwest of the city where I live is the land of the tribe I belong to, the Kikiktagrugmiut. When my cousin writes to me from his home on the edge of Kotzebue Sound, forty miles beyond the Arctic Circle, he refers to where I live as "down there." Anchorage is the point on which my own compass pivots.

I was born on July 4, 1974, all of these rivulets running down through time to me pumped by the heart of circumstance and choices. Indigene and interloper, colonizer and colonized. All of this at once. Simultaneously.

This is what it is to be a northerner—to be part of an ongoing dance among people making homes, taking resources, staking claims. It is, in turn, brutal and beautiful, like the land itself.

About four million people live in the Arctic.[1] Using the expanded definition of the UArctic Atlas, a learning resource developed by the University of the Arctic providing information about the northern circumpolar region, we find that about 13.1 million people live in the circumpolar North.[2] In Alaska, there are about 150,000 indigenous

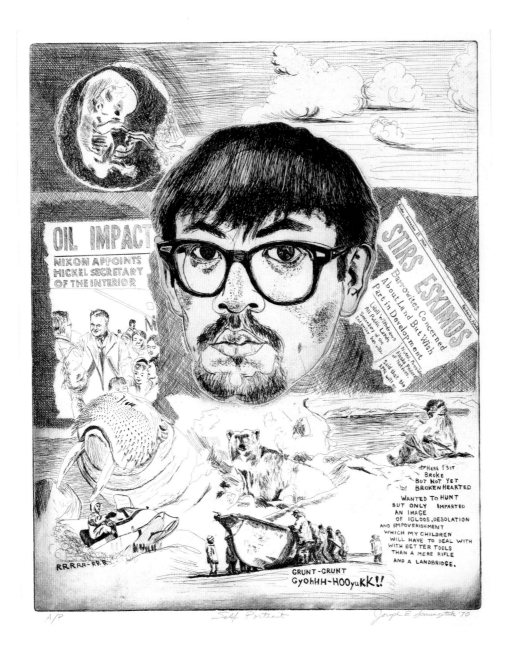

FIGURE 5.1 Iñupiaq artist Joe Senungetuk's work often comments on both rural and urban life.

Joseph Engasongwok Senungetuk, Iñupiaq, born 1940, *Self Portrait*, 1970. Paper, 54 × 45 cm. Gift of Saradell Ard. Collection of the Anchorage Museum.

people, representing approximately 20 percent of the population of 737,000. What is it to be among these people? What does it mean to be "northern?" Is it just being in the North? How do we present and imagine ourselves as northerners? (See figure 5.1.)

A compelling set of stories has been told about the North and northerners in books, movies, legend, news, and song. These intersecting narratives are believed around the world and, here in Alaska, are often present in defining a northern identity. In some of the loudest, most enduring narratives, the North is the ultimate West: a place arrived at, attained, claimed. The North as a worthy opponent. The North as a place of promise—still unknown, still conquerable. The North as a depopulated, idealized landscape one can write one's own story upon. Past romantic notions continue to color how many imagine the North, and Alaska—a place where you can live the wildest version of the American dream.

At the same time, the North is immovably and irrefutably the homeland of indigenous peoples for whom it is not a direction or an achievement, not somewhere beyond the compass's points. Despite the efforts of nature, nations, government agents, missionaries, teachers, prospectors, boarding schools, disease, famine, and innumerable other forces, this is where we are, and where we are from. This is our shared truth no matter the many other ways we are separate tribes and individuals.

Movement is part of life in the North and always has been. Not aimless wandering or random meandering, but purposeful, questing, human movement. The migration of people into and across the North helped populate the Western Hemisphere and, later, spread what's come to be Inuit culture across the circumpolar region. Despite popular misconception, the North is not static or frozen, nor are the people and cultures therein (see figure 5.2).

Consider these two ideas about Alaska Native people—first, that, in precolonial days, we walked around the tundra just hoping to see something we could kill and eat. That's insulting and inaccurate. Instead, indigenous people developed deep understanding of their environments over long periods of observation and experience, and used applied knowledge in order to live. Second: that we either are frozen in time like free-range museum pieces, or should be so that we can better reinforce other people's ideas of who we are and how we should behave. An oft-heard example is that we are not real Natives if we use rifles to hunt. Sharing information and making use of what's useful has served us for a long time. Thule culture would not have spread from Alaska all the way to eastern Greenland and persisted for a thousand years if it wasn't vital, near-viral cultural information.

The lives and seasonal movements of Alaska Native people were interrupted by the faces and forces of colonialism. Families in Northwest Alaska, and elsewhere, became

tethered to communities formed around schools and churches. In the midst of so many other changes, this shifted our relationship to moving across the land.

More recently, economic and social factors appeared to result in an "out-migration" of people from villages into Alaska's urban centers. This caused worry that the villages would be emptied. While those concerns are worthy of investigation, I can't help but also think about movement and change being part of life in the North as long as there's been life in the North.

I think about how movement, both historical movement and my own, resulted in my existence, but also in my experience as an Iñupiaq. I have lived mostly in Anchorage, but I have also spent many summers up in Kotzebue, and I lived there for a few years in my adolescence. I don't know how to do many of the things a woman my age should know how to do. I've never rendered seal blubber into oil; I don't know how to sew skins or speak much Iñupiaq. In some ways this is a result of movement and immigration into our traditional lands, and of the disruption of our ways by invisible hands and manifest

FIGURE 5.2 Erica Miller, American, born 1966, *Snow Drift*, 2002. Pastel pigment, 58 × 82 × 4 cm. Rasmuson Foundation Art Acquisition Fund purchase. Collection of the Anchorage Museum.

FIGURE 5.3 This work represents a Tlingit woman's dress panel and is part of series of works by artist Rebecca Lyon honoring women of the North through representations of traditional clothing.

Rebecca Lyon, Unangan/Athabascan, born 1955, *Women of the North*, 2004. Copper, glass, shell, and patina, 173 × 102 × 21 cm. Rasmuson Foundation Art Acquisition Fund Purchase. Collection of the Anchorage Museum.

destiny and Sheldon Jackson (the Presbyterian minister and missionary who arrived in the new territory of Alaska in 1867). In some ways, it's a result of personal choices. I'm not blaming anyone in particular; it just strikes me as odd that the same forces I look at as having exploded our world are the ones that helped create me in it.

Incomers' movement began far beyond the eastern shores of North America, driven by curiosity, greed, and a human hunger for something more, something else. This wave across the ocean eventually crashed over what's now the United States, meeting foam to foam with its sister sea, the Pacific, and, with nowhere else to go, and energy yet unspent, swept north. Now, everyone in Alaska knows someone who "came up for a vacation/season/year and stayed" (see figure 5.3).

People come and go.

For a while, I went. I moved to Alabama, following love in the same way my great-grandmother followed hers up to Alaska in 1918. When I was in the Deep South, I didn't introduce myself as a northerner. I called myself an Alaskan. It was safer. Simpler. (See figure 5.4.)

In Alaska, there's often a good bit of elbow throwing over who is a "real" Alaskan. Folks eyeball one another trying to gauge how long someone else has been here, or how well or awkwardly they seem to fit the land, and there's often a degree of satisfaction when they don't measure up in one way or another. People compare bona fides in a battle to be the real-est Alaskan. Characteristics, knowledge, or life experiences such as dog sledding; trapping; wearing the proper outdoor gear; wearing no jacket at all; surviving northern extremes, including cold, dark, and solitude; and proximity to notable Alaskans are often played for points in such contests (see figure 5.5).

For all the stereotypes we must counter and racism we must contend with, at least Native people do always get to win the "Who's a Real Alaskan" contest. One just has to deal with the "Who's a Real Native" contest,

FIGURE 5.4 Paul Steucke, American, born 1940, *Heading Home*, 1983. Watercolor on paper, 70 × 87 × 5 cm. Gift of Paul Landis. Collection of the Anchorage Museum.

FIGURE 5.5 This work refers to Jack London's short story *To Build a Fire*, which perpetuated some of the stereotypes of northerners and the North.

Michael Conti, American, born 1971, *Turn in the Trail*, 2007. Photograph, pigment ink print, 52 × 62 × 3 cm. Rasmuson Foundation Art Acquisition Fund purchase. Collection of the Anchorage Museum.

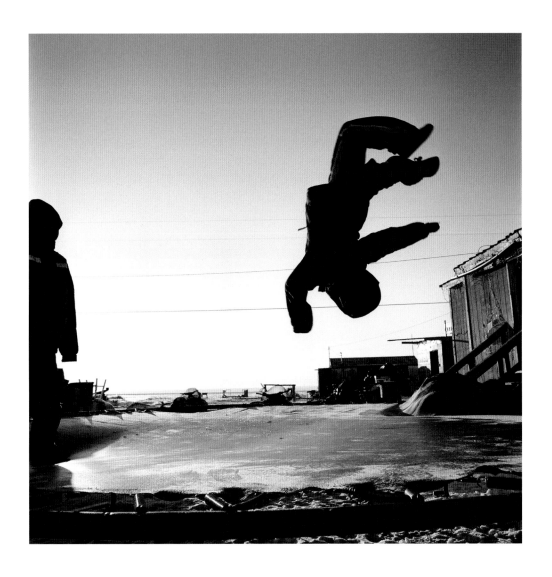

FIGURE 5.6 Image from the town of Kivalina, on the
western shore of Alaska.

Brian Adams, Iñupiaq, born 1985, *Kivalina Back Flip,* 2007. Photograph,
ink on paper, 42 × 52 cm. Collection of the Anchorage Museum.

which is a great delight (not really). Challenges to the veracity of one's being Native can come from anywhere or anyone, and at any time (often from other Natives). Someone might say, "You don't *look* Native." Or you might have to fill out a form declaring just how much "Indian blood" your heart pumps.

Perhaps unsurprisingly, the label *northerner* doesn't always resonate with Native people. For me, I kind of like it because I think of it more laterally—less as a longitudinal thing than as a connection across the circumpolar region (see figure 5.6).

For one Iñupiaq friend from Northwest Alaska, whom I've known for most of our lives (she's about ten years younger than I am), the term *northerner* doesn't mean much. She wrote, "I am not sure that I have really considered 'Northerner' as a label before. Both for myself and in general. I often think of directional labels with respect to the Lower 48. Someone calling themselves from the 'Northwest' or 'Northeast.' I think I consider myself Iñupiat and an Alaskan, someone who is from the Arctic and returned to the Arctic."[3]

For another friend, also Iñupiaq, *northerner* carries too much colonialist baggage to be a label she'll even consider. She wrote, "I tend to distance myself from terms like 'North to the Future' and 'The Last Frontier' because they perpetuate invisibility of the fact that our people have been here 10,000+ years, and I feel Northerner falls along those lines for me."[4]

This reminded me of some terms that have gone by the wayside but were, for a time, meaningful to Alaskans and part of the mythos of Alaska and this frontier mentality. *Sourdough* and *cheechako* have fallen out of use but indicate the casual rating system around being an Alaskan. Prospectors in the late 1890s brought the term *sourdough* north to Alaska from California gold fields; it easily entered the northern lexicon and mythology. Now unused, it's not that the jockeying for position has changed; rather, the terms just started to seem hokey and old-timey. Originally, a sourdough was supposed to be someone who'd been up here long enough to know to keep their sourdough starter in a container on their person. It evolved to just mean someone who'd lived in Alaska long enough to no longer be a *cheechako,* or newcomer (see figure 5.7).

Cheechako is a Chinuk Wawa/Chinook Jargon word for "newcomer." *Chee* means "new," and *chaka* means "come" or "become."[5] Aside from simply producing a word used to identify greenhorns in Alaska, Chinuk Wawa was a trade pidgin spoken from Southeast Alaska to Northern California, and it was an amalgam of the many indigenous languages in the area, plus bits of English, French, and other languages introduced through colonialism, trade, and industry. Utilized initially for facilitating communication and trade among diverse people, Chinuk Wawa is wrapped into matters of northwestern and local indigenous identity. It's now formally taught in Native communities such as Grand Ronde, Oregon.[6] Among non-indigenous people in the Pacific

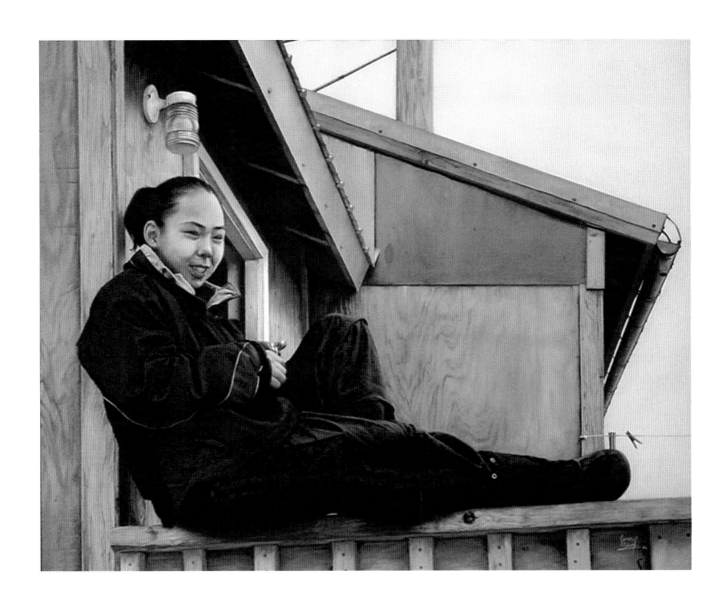

FIGURE 5.7 James Adcox, American, born 1922, *Helen*, 2006.
Oil paint on canvas, 79 × 94 cm. Collection of the Anchorage Museum.

Northwest, use of the pidgin became part of their identity, and a way to distinguish themselves from Johnny-come-latelies.[7]

As recently as the 1980s, a hundred years or so after their introduction, these were terms that people new to Alaska used with pride as they came into their new identity as northerners.

Note that a shift in identity was taking place. This doesn't happen for everyone, and I have one friend who still considers herself a midwesterner after twenty-two years in Alaska. She's also a fine dipnetter, is more attuned and informed about Arctic and Alaska Native issues than most, and is someone I'd be willing to claim as a northerner—if she wanted the label.

Humans decorate ourselves in order to fit in or stand out, to be anonymous or to telegraph our allegiances. Myself, I feel a little funny when I put on an *atikłuk,* one of the cloth overshirts that have come to be pretty standard garb among Iñupiaq women and girls (it's called a *kuspuk* in Yup'ik and is not that different from the Athabaskan *bets'egh hoolaanee.*)[8] As a red-haired, pale-skinned, forty-something Iñupiaq, I feel like I look like a non-Native teacher in rural Alaska, they so often take to wearing the garment. Plus, *atikłuks* often have a sort of flounced skirt, which simply doesn't suit my style. Conveniently, they're a flexible format and it's becoming easier to find one that better cleaves to my personal fashion sensibilities.

As observers, we try to decode other people's dress and figure out who we think they are. It is, in some ways, a method fraught with peril since people change how they look depending on how they're feeling or what they feel like communicating that day, and may have aspects of their person not easily ascertained with just a glance. Take my example of the *atikłuk,* for instance.

A friend I've known since high school, who was born in Alaska, said she can spot other Alaskans when traveling back from other US cities. She noted that as she gets closer to Alaska she sees more facial hair and leather and fewer pairs of designer jeans. There's an interesting parallel between this and how traditional indigenous clothing telegraphed information about a person.

Clothing in the North is a mix of practicality, insouciance, fashion, freedom, and cultural connection. What's worn on the outside helps signal who we are or who want to be or be seen as, in addition to keeping us warm and covered. It is an element of our constructed and experienced identity (see figure 5.8).

FIGURE 5.8 This mask is part of Nicholas Galanin's series *Imaginary Indian,* in which he camouflages Indian art and artifacts with traditional European ceramic designs.

Nicholas Galanin, Tlingit/Unangan, born 1979, *S'igeika'awu: Ghost,* 2009. Ceramic and horsehair, 23 × 21 cm. Collection of the Anchorage Museum.

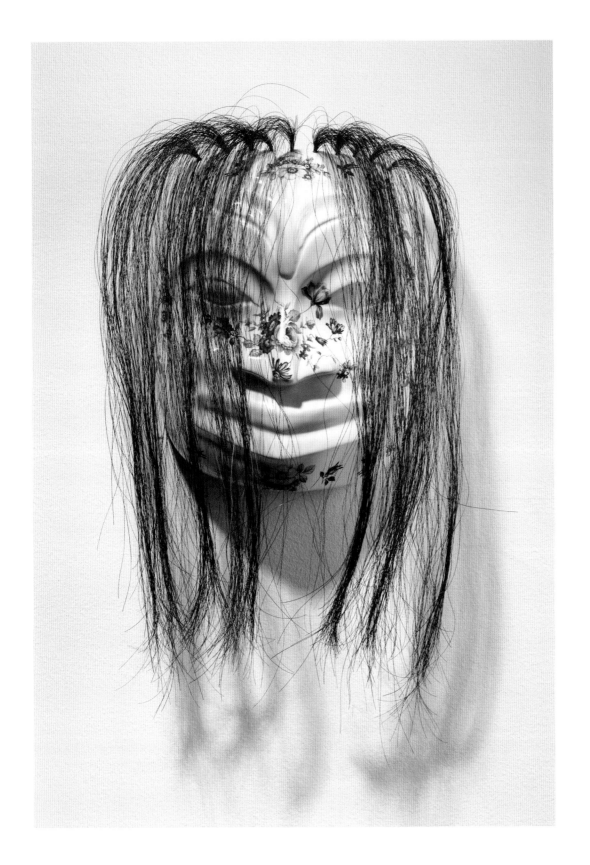

Because clothes are so eminently malleable, we shape them to construct our appearance. There is an experiential dimension to the power of clothing, both in its wearing and viewing (O'Connor 2005). Our lived experience with clothes, how we feel about them, hinges on how others evaluate our crafted appearances, and this experience in turn is influenced by the situation and the structure of the wider context (Woodward 2005).[9]

In the indigenous traditions of the circumpolar North, one's dress carried a great deal of information. Anthropologist Betty Kobayashi Issenman wrote: "Inuit clothing presents a great diversity of styles. The attire tells the knowledgeable onlooker which country and which part of the country the person comes from, and in some instances the kin group, the person's sex, age, and often, for women, marital status."[10]

Even at a very basic level, without getting into family designs or those of a specific community, one can tell differences among Inuit parkas. For example, in Alaska the hem is straight across. As one looks east, one begins to see *amauti,* which are parkas made for mothers to carry babies and small children in.[11] Farther on, the best-known of the Greenlandic styles are the highly beaded and colorful "national costume" that includes very tall boots.[12]

Outside the example of traditional Inuit clothing, other aspects of dress have factored into the development of a northern identity at various times. These include the mackinaw coat that the Canadian government required all gold prospectors to bring; Xtra-tuf boots worn by fisherpeople, oil workers, and urban Alaskans alike; Carhartt pants; and trapper hats, the style of which has been suggested was inspired by Charles and Anne Lindbergh's aviator hats and adopted in fur by Alaskan and Canadian Inuit.[13]

These, and other iconic items or styles of dress, are part of our collective idea of what we, as northerners, should look like and be like. We want to be seen as self-sufficient, as weather-smart and prepared. At the same time, as evidenced by our addiction to sweatshirts and jeans, we're relaxed and casual. Again, considering practicality, one respondent to my informal survey said, "Real Northerners know the dangers of cold. Dress weather-wise. And no, flip flops or high heels in the snow will not work." Many northerners are gear-obsessed in their quest to ensure they have just the right jacket for every possible type of weather. As one friend, a man who lives in Greenland, said, "I have at least six parkas for all kinds of snow temperatures."[14]

Responding to my inquiry about how she'd recognize other northerners, one of my Iñupiaq friends included relationships with other people, animals, and the environment, saying, "The attitude might be more centered on being self-sufficient, but also having good relationships for sharing/trading. Their dress might include different sets of clothes for each of the seasons with a slant towards function and durability. Probably more of a willingness to use fur and other animal parts on clothing or jewelry."[15] My earring collection agrees (see figure 5.9).

FIGURE 5.9 Image from Baffin Island, Canada.

Acacia Johnson, American, born 1990, *Driving Into Night
(The Last Time We Saw the Sun),* 2014. Print, 87 × 72 cm.
Collection of the Anchorage Museum.

Several years ago I went to Finland to celebrate the marriage between my brother and his new wife, a Finnish woman. Standing outside the old hall where the party was held, I looked around at birch trees and snow, shining with reflected light, and suddenly felt I was in some kind of layered reality, it was so much like being in the woods in Anchorage.

There was something truly remarkable about how similar the surroundings were that night. It was startling. I didn't know I'd travel so far to also feel so at home. Cultural differences—language, history—aside, there were many similarities beyond just the trees. A shared approach to the seasons is one similarity. As my sister-in-law described recently, in summer we northerners live life and sleep less, in fall we calm down and get ready for the darkness, in winter we hibernate, and in spring we wake up and "try to get more energy for the coming summer."[16] It's a familiar rhythm, the cadence of life in the North (see figure 5.10).

As we observe and adapt to the new realities of a changing climate, and increased global interest in the Arctic, it seems we've come to a new section in the song. As others look to the Arctic, we increasingly seem to be looking to one another. Aided by the Internet and travel, we see more of each other, and how we live—the similarities, the differences. I admire the bright houses of Greenland compared to our dully painted homes, Inuit Tanya Tagaq's winning Canada's Polaris prize, the multitude of ingenious ways people sustain themselves, one another, and our brilliant northern cultures, every day.

This isn't an easy place, here in the northern latitudes. The weather and climate feel strange now, though still hard. Our relationships—all of them, from intimate, personal ones to those writ large on a global political scale—are challenging.

So we dance together. Me, and those like me, embodying the collision of cultures, along with everyone else here, to live, love, take, give, try, fail, build, and destroy. We keep moving to this Arctic song, swaying to our shared seasons, listening as the song shifts, stumbling as the steps change, but dancing.

FIGURE 5.10 Image from the town of Tiski, located in the Russian Arctic.

Evgenia Arbugaeva, Russian, born 1983, untitled. Digital photograph. Collection of the Anchorage Museum.

NOTES

1 "Arctic Indigenous Peoples," Arctic Centre, University of Lapland, www.arcticcentre.org/EN/communications/arcticregion/Arctic-Indigenous-Peoples, accessed May 13, 2016.

2 "Population Density," UArctic, accessed May 23, 2016, http://research.uarctic.org/resources/atlas/peoples-cultures-and-societies/population-density/.

3 Liz Qaulluq Cravalho, personal correspondence, May 5, 2016.

4 Jorie Paoli, personal correspondence, May 4, 2016.

5 Mike Cleven, "Chinook Jargon Phrasebook: Common Phrases & Words," *Ikt Chinook Wawabook (A Chinook Phrasebook and Glossary)*, www.fortlangley.ca/chinook%20jargon/common.html, accessed May 17, 2016.

6 "Elementary Chinuk Language Program," The Confederated Tribes of Grand Ronde, www.grandronde.org/departments/education/elementary-chinuk-language-program/, accessed May 23, 2016.

7 Kenneth Greg Watson, "Tenas Wawa* Chinook Jargon," *White River Journal: A Newsletter of the White River Valley Museum,* July 2002, www.wrvmuseum.org/journal/journal_0702.htm, accessed June 15, 2016.

8 Angela Gonzalez (Athabascan Koyukon), "Athabascan Word of the Week: Summer Parka," *Fairbanks Daily News-Miner,* July 27, 2013, www.newsminer.com/features/our_town/athabascan_word_of_the_week/athabascan-word-of-the-week-summer-parka/article_6900c7d4-f674-11e2-89dc-0019bb30f31a.html, accessed May 23, 2016.

9 Karen Tranberg Hansen, "The World in Dress: Anthropological Perspectives on Clothing, Fashion, and Culture," *Annual Review of Anthropology* 33, no. 1 (October 2004): 369–392, doi:10.1146/annurev.anthro.33.070203.143805.

10 Betty Kobayashi Issenman, *Sinews of Survival: The Living Legacy of Inuit Clothing* (Vancouver: UBC Press, 1997).

11 Phillip Bird, *Inuit Women's Traditional Knowledge Workshop on the Amauti and Intellectual Property Rights: Final Report* (Nunavut: Pauktuutit Inuit Women's Association, 2002), www.wipo.int/export/sites/www/tk/en/igc/ngo/amauti_report.pdf, accessed June 15, 2016.

12 "The Arctic Landscape - Greenland," *A Step Into the Bata Shoe Museum* (blog), March 2, 2016, http://astepintothebatashoemuseum.blogspot.com/2016/03/the-arctic-landscape-greenland_2.html, accessed June 15, 2016.

13 "Ton of Goods," Klondike Gold Rush National Historical Park (US National Park Service), www.nps.gov/klgo/learn/historyculture/tonofgoods.htm, accessed May 23, 2016; Issenman, *Sinews of Survival.*

14 Jan de Vroede, personal correspondence, May 18, 2016.

15 Liz Qaulluq Cravalho, personal correspondence, May 23, 2016; Hanna Eklund, personal correspondence, May 23, 2016.

16 Hanna Eklund, personal correspondence, May 23, 2016.

PLACE OF PERIPHERY

KIRSTEN J. ANDERSON

Here is remote.

When I first moved to Alaska, it was to Fairbanks, to help my partner find a place to live as we started graduate school. We had heard that "dry" cabins are best to rent, a romantic and anachronistic idea that I played over in my head—a cozy wood cabin, an iron stove, quiet reflection and thinking in white drifts of snow. The reality was a cabin slightly cleaner and better kept than other apartments, without the need for plumbing in below-freezing conditions. The reality of a dry cabin meant a small shack constructed of T1–11 siding, with poor insulation, next to the Pizza Hut or other odd urban/rural juxtaposition. It meant taking showers on campus or at the office—which have public showers because plumbing is a luxury in the permafrost (see figure 6.1).

The reality of living at the end of the road (so to speak) became clear, and it was nothing like the romantic howls of a wolf. It was messy, it was domestic and opportunistic, it was suburban in a weird caricature of what "urban" looks like—gravel-covered cul-de-sacs, chain stores, strip malls, and restaurants in the midst of no plumbing and endless black spruce, the Alaska range in the distance.

Much of what Alaska and the North conjures in the minds of many is a nostalgia for a place of extreme living, of remoteness. A place elsewhere, different from the familiar rhythms of the center.

But this idea of Alaska and the North comes from a remote perspective—of the center looking out from a distance. Remote is a measure of view and distance—of looking across from an opposite shore, defined by the need for an opposite: for there to be a North, there must, by definition, be a south; for a frontier, a metropolis; for a periphery, a center. Like Newton's third law, for every journey out, there must be a return. For Alaska and the North to be a place that is remote, it is fundamentally being defined from somewhere else. It requires a return to the center to confirm that it is truly remote. Legends grow only about places rarely visited.

In the good old winter time Nome Alaska.

And remote is not only the daydream of a center looking to the edge. It is a reality that is harsh and unforgiving in the most crowded of places. Many live in urban areas and feel remote from their villages. Native Alaskans enlisted in the army and found themselves in the remote and crowded corners of the southern United States. Soldiers at Nike Site Summit during the Cold War could see the lights of Anchorage, but wrote of long boredom and fatigue with living above the city, assigned to stand watch while the isolation for months at a time during the winter became real.

The idea of remote, at its most basic, is about distance—in time, place, and improbability. About looking across from the center. And, conversely, looking back to the center from remote places can cause the light to bend across that distance, to clarify the landscape both within and without (see figure 6.2).

FIGURE 6.1 Otto Daniel Goetze, American, 1871–?, *In the Good Old Winter Time, Nome, Alaska*, 1899. Original plate glass negative, 21 × 26 cm. O. D. Goetze Collection. Collection of the Anchorage Museum.

FIGURE 6.2 Frank H. Whaley, American, 1906–1997, *Tourist Standing on a Giant Ice Cake on the Arctic Ocean off Point Barrow*, 1968–69. Photograph, 21 × 26 cm. Wien Collection. Collection of the Anchorage Museum.

The border between space and time is not clean or defined. I began writing this tonight at ten o'clock on a late May evening. The sun is full and high and still beckoning. Children's voices can be heard outside the open windows, playing at a time of night that many from a more southerly latitude would say is too late for kids to be out.

When I realized by the time and the light that it looked like mid-afternoon, I had a familiar flash of recognition—that the light means we are close to the solstice, that by late June, the darkness would begin to press its return sooner than we ever expect. The familiar momentary lull that a flood of daylight can give, of feeling that it is long, constant, and here to stay—and then the sudden remembrance that nothing in the North stays the same for long.

I crave constancy and seek it out living in the North. I cling to latitude. Of light and dark, of sunset and dawn merged together, the sun sewing light back and forth on the horizon, of twilights that last longer than afternoons. Alaska and the North is a place of continued transition and paradox. The light changes swiftly, birds move through one week to the next, the shift of seasons following as quickly. Monochrome landscapes turn to full green in a weekend—a surprise each year, because no matter how much you understand the tilt of the poles and the earth's movement around the sun, there is part of you that each year still doubts that spring will come (see figure 6.3).

Norwegian writer Karl Ove Knausgaard writes that "the division between night and day is a border, perhaps the most fundamental one we have, and up [north] it was abolished, first in an eternal night, then in an eternal day."[1] The northern latitude marks this transition to a remote place, an edge that invokes a sense of the

FIGURE 6.3 Steve McCutcheon, American, 1911–1998, *Arctic Circle Sign, Yukon River*, date unknown. Black-and-white negative, 11 × 13 cm. McCutcheon Collection. Collection of the Anchorage Museum.

unfamiliar, of the possibility of the supernatural, of places beyond the known world. The expected rhythms and routines of the center—the city, the temperate, the middle—are overturned, and suddenly the feelings of the unknown are what crowd and take shape.

The twilights of northern latitudes leave a long transition in between the move from light and dark. In Greek, the word for dusk is *lykophos,* meaning "wolf-light"— a descriptive also referenced in French, of twilight being "the time between dog and wolf."[2] The shift between domestication and the possibility of wildness and other-ness—the familiar bark of a dog turning to the uncontrollable howls of a wolf. The idea is reflected in outsider-created mythologies of Alaska—Jack London crystallizing the metaphor in *Call of the Wild*—that a dog is always being called back to wolf, that what is true and real and unfettered is what exists beyond the twilight transition between day and night, urban South and remote North (see figure 6.4).

Whether it is foolishness to try to live on one's own in the extreme corners of the world—the North, where the elements are entirely and gloriously indifferent to our success or failure—is unclear. There is no easy agriculture or harvest in Alaska. There is the possibility of individual riches, but really that belongs to previous generations—to outsiders coming in, striking gold, and leaving quickly, receding into myth. What remote living offers for outsiders today is what Walden offered Thoreau, and what Alaska offered to many people, including Christopher McCandless, Timothy Treadwell, Richard "Dick" Proenneke, and Allen Hasselborg—the idealized challenge of living alone in the "wilderness," where "a man can make his soul" (see figure 6.5).[3]

The irony of this self-challenge, of existential ideas of wildness and remoteness, is that it is an illusion, like the fata morgana—mountains that polar explorers would claim and locate on maps only to never relocate. The idea of solitude and remote living evaporates as you get close to it.

The reality of living successfully in remote places means that you rely more than ever on being connected to others. At the core of every success and failure to live in remote places is the need for community, both physical and mental. For Dick Proenneke, it was a remote community who supported his solitary life at Twin Lakes (now a part of Lake Clark National Park) with supplies and correspondence flown in regularly. For Chris McCandless, who is written about in Jon Krakauer's *Into the Wild,* it was others who helped him get to his final remote place, and the isolation that ultimately became part of his demise. No one lives remotely alone (see figure 6.6).

A friend of mine who went on a guided trip in the Brooks Range tells the story of an older man from Chicago who was a member of their group. In the middle of the trip, he panicked when he realized that his cell phone would not work. They were on their own, unconnected, without a net. He had pushed outside his own boundaries to

FIGURE 6.4 Frank H. Whaley, American, 1906–1997, *Point Hope, Alaska Sign*, 1965. Photograph, 21 × 26 cm. Wien Collection. Collection of the Anchorage Museum.

FIGURE 6.5 Edward C. Adams, 1895–?, *A Miner's Home in the Arctic*, 1905. Photograph, 8 × 14 cm. John Urban Collection. Collection of the Anchorage Museum.

experience remoteness, and yet when the reality of remoteness crashed in on him, he experienced a sunlit, nightlong panic regarding what could happen to him or anyone else if they were injured. He never fully relaxed for the rest of the trip, despite a community of people with varied experiences and skills living alongside one another, day in and day out. What we rely on to connect us, and the boundaries we recognize, are not always reality either (see figure 6.7).

New realities raise questions of whether or not we can live remotely any longer (or whether the definition has become so marginalized and familiar that it now distinguishes only working from home rather than in the office). Where film cameras and journals accompanied Proenneke and documented his remote living, modern-day Proennekes set out for solitary living with remote communities in tow. Newspaper writer and outdoorsman Craig Medred wrote:

Four months have passed since Chuck Baird went into the wild to the not-so-remote islands in Alaska's Prince William Sound. The goat is dead. The dog is

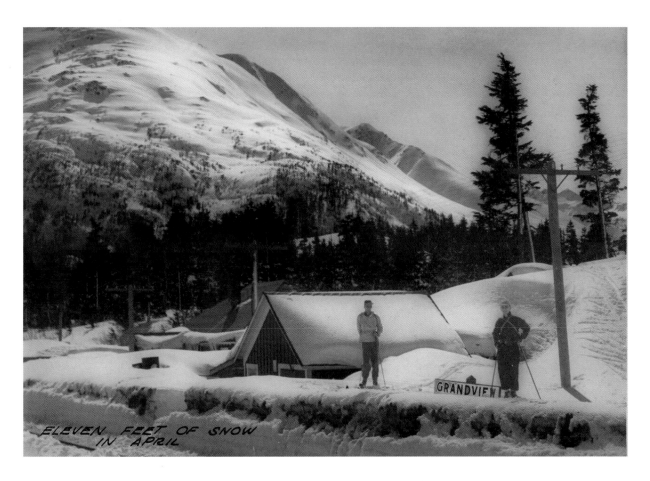

FIGURE 6.7 Sidney Hamilton, American, 1886–1964. *Eleven Feet of Snow April*, 1945. Photograph, 13 × 18 cm. Sidney Hamilton Photograph Collection. Gift of Emily Turner. Collection of the Anchorage Museum.

sick. Baird has lost 35 pounds. But the Internet is working great. And Baird now has more than 5,825 "likes," with the number increasing daily, on Facebook, where people check in on his almost-daily jottings on living the pioneer life. Well, sort of, if the pioneers had been equipped with lasers, night-vision optics, motion-sensing cameras, solar cells, wind turbines, battery banks, computers, iPhones, DVDs, Kindles, video cameras, telephoto lenses, chainsaws, plywood and more. Baird confessed in an August video that the "Alaska Pioneer" name of his adventure "is probably a misnomer," but added that "it's close enough to what I'm doing." He says his sojourn is a re-enactment of pioneer days.[4]

Living remotely now means that we no longer enter into wild and remote places alone—we remotely bring the community with us. The edge and center are compressing, leaving a lack of distance through which to see clearly—the sharpened vision that comes with distance. With remote control becoming a part of remote life, the distance that has led so many to live in remote places no longer exists (see figure 6.8).

FIGURE 6.8 Steve McCutcheon, American, 1911–1998, *Seward,* 1960. Black-and-white negative, 6 × 6 cm. McCutcheon Collection. Collection of the Anchorage Museum.

KIRSTEN J. ANDERSON

FIGURE 6.9 Sidney Hamilton, American, 1886–1967. *Snowbound Cache, Palmer, Alaska*, date unknown. Photograph, 13 × 18 cm. Sidney Hamilton Photograph Collection. Gift of Emily Turner. Collection of the Anchorage Museum.

And for the center, what does it become without an edge to define itself by? The merging of remote and center leaves little room for clarity. British nature writer Robert Macfarlane writes that "the north represents not a retreat to an imagined distance, but rather a means of seeing more clearly and thinking more lucidly."[5] If distance collapses, and remote becomes resigned to periods of disconnection from a literal network, the world becoming hyper-local, can we still recognize distance? Can we still recognize the earth's curve, of what is real, without defining edges?

Seeking out remote places is often an act of resistance, of reform and dissidence—removing yourself from the present to find an alternative history. From not only a crowded center, but from a distance in time as well, to an idealized past where a new path forward can be invented.

For Alaska and the North, too often, idealizations of remote overshadow the reality—where the center decides the remote is frozen in the past. Yet there is something to the idea that in living in the remote corners of the world there can be an alternative future, that by retreading steps to the past, finding our way through the observations of daily living on a more immediate level with the landscape—and with a landscape that is unignorable—there is a clarity, a groundedness, and a new way forward (see figure 6.9).

The allure of living "remotely" has been a focus of pilgrimage, of ascetic principles, of living in a way that is free from a society that is considered too much. Medieval monks would seek out remote places to find purity of thought, contemplation, and

FIGURE 6.10 *Front Street, Kotzebue*, 1959. Photograph, 11 × 13 cm. Wien Collection. Collection of the Anchorage Museum.

wisdom. The transcendental movement brought similar principles to Thoreau and others looking to remove themselves from what they disliked about the world, to find a clarity that crowds and mechanization weren't offering. They wanted to reinvent the world for themselves, to remove to a remote place both in space and time. Remote, by these accounts, is aspirational, the daydream of a crowded center that superimposes an ideal of reality, an effort to wipe clean a dissatisfaction with the present.

Remoteness is cited as a form of clarification, of observance, and of melancholy—to grow comfortable with the night, "unite the viewer and the view," in a way that the inner landscape is explored as much as the outer landscape.[6] And the largest part of what remote living offers is a challenge between the dog and the wolf, or between life and death. Author Eva Saulitis wrote before her own untimely death: "Death may be the wildest thing of all, the least tamed or known phenomenon our consciousness has to reckon with."[7] Living in remote corners forces a confrontation with the realities we are ultimately faced with everywhere, and which the center—when fortunate—is adept at ignoring. The unknown boundary of ourselves is what is sought in remote places (see figure 6.10).

American poet and educator John Haines withdrew, living for twenty-five years in remote Alaska and writing about the time, the days, and the landscape he witnessed there. His poetry speaks to the existential ideal of remoteness, of supporting oneself and observing, finding clarity in the distance away from society, writing of the minute details of the world like the "glass arrangement of the wind." A reviewer of his poetry writes that Haines:

> may have withdrawn physically from the human community, but not spiritually or emotionally. This, of course, is the greatest risk of solitude. For if the exile goes into the bush (or tundra) with the intention of tracking down internal truths that are of no wider currency—if, that is, the wanderer returns bearing verities only narrowly his own—the trip wasn't worth it. John Haines's journey has paid off: it has borne the fruit of a poetic journey into the "cloudlit stillness" at the center of all our lives. To this cloudlit stillness the pilgrims come, reading prayers from a guidebook—to see, to question, and depart.[8]

And yet not all find this clarity. For some, without the mirror of community, the network to define yourself by, clarity is not an easy reward. Author Neil Ansell, after living alone in a remote cabin for five years, learned that although clarity is the aspiration of remote living, it was not the reality. Instead, he lost himself; the identity and definition of who he was receded into the landscape. The clarity of his own existence was what became remote, nearly invisible:

You might think that such protracted solitude would lead to introspection, to self-examination, to a growing self-awareness. But not for me. What happened to me was that I began to forget myself, my focus shifted almost entirely outwards. . . . During my years in the hills I kept a journal. For the first year it is a conventional diary; places I had gone, things I had done. By the second year it is little more than a nature journal; what birds I had seen that day, perhaps some notes on the weather. By the third year it is no more than an almanac, marking the turn of the seasons by the comings and goings of migrant birds and their nesting dates, interspersed by the occasional detailed depiction of a moment, perhaps the flight of a single bird. I am an absence, a void, I have disappeared from my own story.[9]

Remote control has become so seamless in our lives that the mechanics of how it works—the pulses of radiation connected to a network—has become ignorable. But its definition—of being accessed by means of a network—informs the reality of remote living.[10] Community is what makes people successful in remote places, and is a part of what northern living is about—the storytelling, the support of community, of leaning on others to survive despite of, or because of, an indifferent landscape. The return journey—whether relayed through film, photography, or poetry, whether from fish camp to village, from city to country, from remote to center—is paramount. Without the recognition that the return brings, we cannot limn the edges of our known world. We can't absorb the clarity we seek without others to share our resources, our company, our words and stories, our observations (see figure 6.11).

Ironically, remote places cause connection because of their distance. The connection between Alaska and the center of the United States is much closer than its physical proximity. The magnitude of its remoteness and the resources it holds keep it squarely with a direct line to the center. It is distance that actually necessitates connection—to go back to the development of remote controls that began in the 1950s, the "device" being controlled needs access (see figure 6.12).

One of the first wireless connections was invented in Alaska because of the distance that Alaska presented and the need to connect people who lived in places that were becoming increasingly remote. Radio and telephone lines were brought to rural Alaska in the 1970s, with new technologies that were developed specifically to reach across distances amid Arctic conditions. These conditions later informed the invention of Wi-Fi, the wireless network that now supports nearly every remote connection:

[Alex] Hills . . . brought telephones for the first time to many rural villages, adapting satellite and radio technology to new purposes in a new environment. . . . For the first time, young men away in the military could call home. The

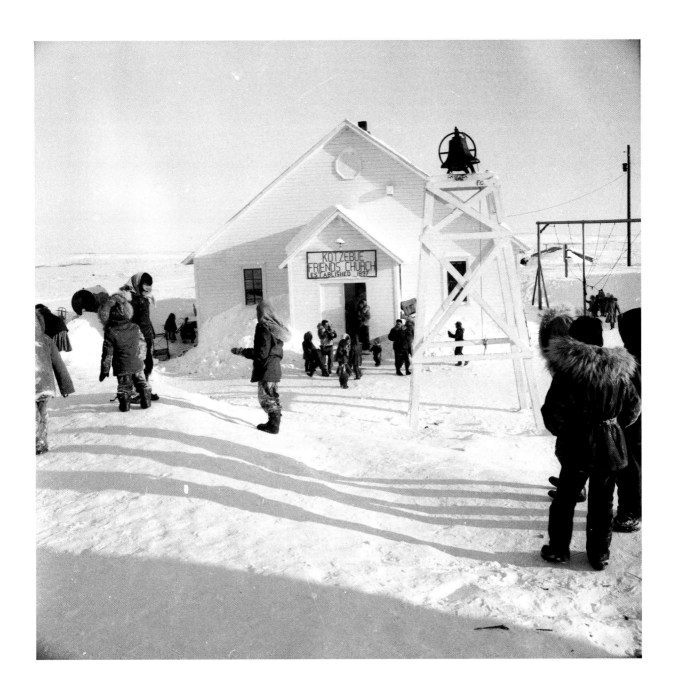

FIGURE 6.11 Kids, Kotzebue.

Steve McCutcheon, American, 1911–1998, untitled, date unknown.
Black-and-white negative, 6 × 6 cm. McCutcheon Collection.
Collection of the Anchorage Museum.

FIGURE 6.12 Seal hides at Teller, Alaska.

Steve McCutcheon, American, 1911–1998, untitled, 1957.
Black-and-white negative, 6 × 6 cm. McCutcheon Collection.
Collection of Anchorage Museum.

FIGURE 6.13 Girls talk by radio on call to hospital for medical advice.

Steve McCutcheon, American, 1911–1998, untitled, 1964. Black-and-white negative, 6 × 6 cm. McCutcheon Collection. Collection of the Anchorage Museum.

emotion of those first calls flowed to the technicians who had just put in the phones. Most village kids were going off to boarding school for high school, because they could only go up to the eighth grade in the villages. "The parents really missed their kids," Hills said. "When we did the village telephones, that gave the parents the chance to at least call the kids and hear their voice over the phone."[11]

The distances between remote places and the center call to each other. No matter how much we idealize the remote for solitude and clarity, the distance we create—that we name and gaze at—is what dares us, seeks us out, demands connection. The fragment mourning for the center (see figure 6.13).

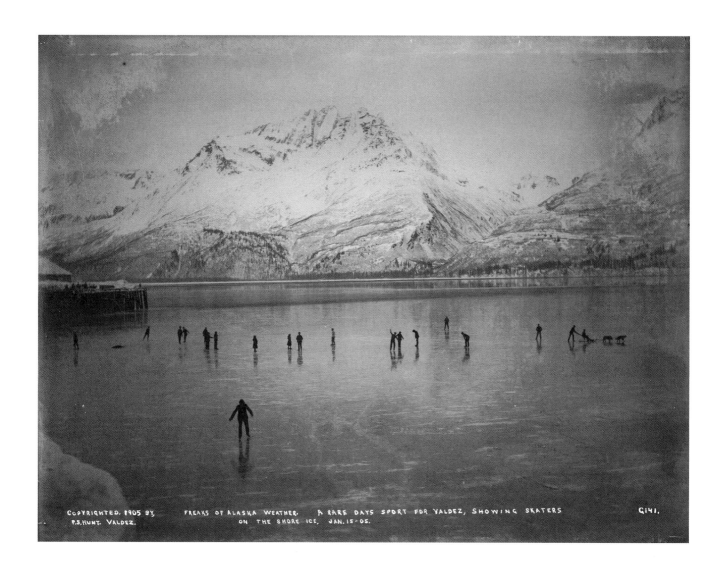

COPYRIGHTED. 1905 BY. FREAKS OF ALASKA WEATHER. A RARE DAYS SPORT FOR VALDEZ, SHOWING SKATERS G141.
P.S. HUNT. VALDEZ. ON THE SHORE ICE, JAN. 15-05.

FIGURE 6.14 Phinney S. Hunt, American, 1866–1917,
Freaks of Alaska Weather, 1905. Photograph, 21 × 26 cm.
Crary-Henderson Collection. Collection of the Anchorage Museum.

Remote is a struggle, because it can be so many things. It is here and there. It is internal, external, far away, local. And it can be the Arctic, the North, the tropics, an island, the city, the desert. Alaska has no monopoly on what is remote.

Alaska is both startlingly away from and hyper-near. It brings out the physicality of being away from the center, of living on the edge of where most people live (from a certain point of view)—to realizing that because of that far distance, we are more connected here than ever—both to one another and to the center (see figure 6.14).

Alaska has more federal involvement and access to government than many places in the Lower 48, due to its remoteness and its relationship to the northern world. President Barack Obama visited Alaska in 2015 because the center recognizes how impactful the North and its remoteness have become. Alaska's remoteness is now informing the rest of the world about what is happening on its edges, what is creeping toward the center (climate change), and what issues, opportunities, and technologies (erosion control, wildness, the Northwest Passage, resource development) it presents.

And remote areas offer economic opportunities, attracting development and transitory rushes of movement and attention from the center—the push-pull of quick development, a return to the center, and then back again.

The rushes of frenzy that occur in remote places are the ebb and flow of what is important at a given time. Shifts from furs, to gold, to fish, to oil, to mining, tourism, individual existentialism, eco-tourism, remote seekers. All of it is a shifting currency for remote places. It is inconstant, but constant in its inconstancy, its swings from center to edge (see figure 6.15).

And all is defined and began with the identification of Alaska as remote, a place distant from the center that gave it a new name. First it was remote from Moscow, then from Washington, DC. For the people who have lived here forever, it is not remote. It has been home since time immemorial. Yet the center continues to define the remote places of the world. And remote places stand by and watch. We wait as the center swings back to the names that were originally given to remote places and announce the decision like a new discovery.[12] Like the poles, there is a pattern of magnetic shift, where the center and the edge reverse position.

Remote control reaches across to access a device without wires, without visible connectors, with pulses of light and radiation, controlling from a distance. From which end of the distance, and whether there is clarity in between, is always in question.

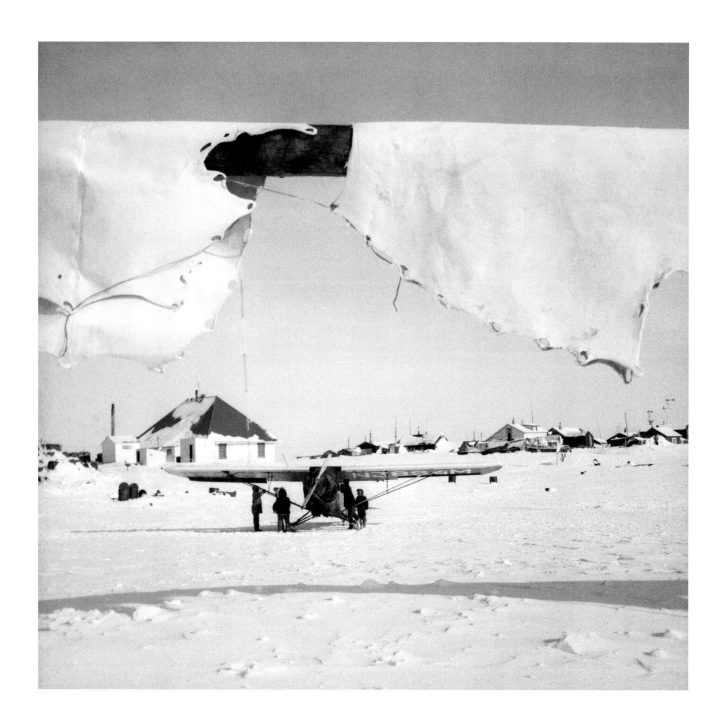

FIGURE 6.15 Shishmaref.

Steve McCutcheon, American, 1911–1998, untitled, 1957.
Black-and-white negative, 6 × 6 cm. McCutcheon Collection.
Collection of the Anchorage Museum.

NOTES

1 Karl Ove Knausgaard, "The Magical Realism of Norwegian Nights," *New York Times*, February 28, 2013.

2 Peter Davidson, *The Last of the Light: About Twilight* (London: Reaktion Books, 2015), 17.

3 Peter Davidson, *The Idea of North* (London: Reaktion Books, 2005), 10.

4 Craig Medred, "Tough Four Months Surviving Alone on Remote LaTouche Island," *Anchorage Dispatch News*, November 18, 2012.

5 Robert Macfarlane, *Landmarks* (London: Penguin/Random House, 2015), 212.

6 Vladimir Vladimirovich Nabokov, *Pale Fire: A Novel*, reissue ed. (New York: Vintage Books, 1989).

7 Eva Saulitis, "Wild Darkness," *Orion Magazine*, March 17, 2014.

8 Robert Richman, "Polished Surfaces and Difficult Pastorals," *New York Times,* November 25, 1990.

9 Neill Ansell, "My Life as a Hermit," *The Guardian*, March 27, 2011.

10 *Oxford English Dictionary*, 2nd ed., 20 vols. (Oxford: Oxford University Press, 1989).

11 Charles Wohlforth, "Inventor of Wi-Fi Got Insight from Connecting Alaskans," *Alaska Dispatch News*, February 27, 2016.

12 See, e.g., Erica Martinson, "McKinley No More: North America's Tallest Peak to Be Renamed Denali," *Alaska Dispatch News,* August 30, 2015.

JUST NORTH OF WILD

JULIE DECKER

Wild land is land beyond the frontier. The myth of the wilderness is that of a place where one can retreat from civilization, reconnect with the earth, and find meaning. America saw the development of a distinctive form of the romantic movement known as American transcendentalism in the late 1820s and 1830s. Ralph Waldo Emerson's *Nature* was the seminal text for the movement. In it, Emerson explored the importance of solitude, the beauty of nature, and the significance for both of these for understanding God. Emerson's influence on and relationship with Henry David Thoreau, the first major figure and intellectual of the wilderness tradition, spurred America's wilderness preservation movement.

Perceptions of wild places shift over time. During European settlement of America, wilderness was feared—perceived as a dark place with wild beasts. Cultivating land was a way of civilizing a wild America. Public views later shifted toward a perception of wilderness as harmony with nature.

At the time, America was two billion acres of undeveloped land. Today, five hundred or so years later, wild places are increasingly scarce. In the 1950s and '60s Americans piled into cars, trains, and planes to travel across the country, and concern grew for water and air quality. People began to appreciate the value of wild and natural places. This was the era of landmark conservation battles, such as the opposition to the Echo Park Dam in Dinosaur National Monument. Americans began to designate some public lands as "wilderness." In the 1930s Bob Marshall, an early forester, conservationist, and cofounder of the *Wilderness* Society, had proposed protecting public lands through a law passed by Congress. By the 1950s Americans were more open to the idea, though it took nine years of rewrites and public hearings for the Wilderness Act to be passed. In August 1964, President Lyndon B. Johnson signed the Wilderness Act into law. The intent of the act was to preserve some of the country's last remaining wild places—some 110 million acres—and to protect their natural processes and values from development; the result of the act was that wilderness now had a legal definition.

Since Congress passed the Wilderness Act, over 130 individual wilderness bills have designated more than 680 wilderness areas. These areas total over 106 million acres in forty-four states. Of this acreage, more than 57 million acres are in Alaska. Alaska has been associated with wild places for hundreds of years. In the 1700s, scientific expedition accounts were published in books, magazines, and newspapers, spurring an interest in places considered remote. After the purchase of Alaska from Russia in 1867, articles about Alaska increased. The US Army and the Smithsonian Institution published descriptions of Alaska, and early tourists to Alaska wrote about their travels—mostly adventures with landscape, cold, and wildlife.

In 1879 John Muir made the first of several trips to Alaska, and he wrote about Alaska extensively. He relied on Tlingit guides during his 1879 visit and was the first Euro-American to explore Glacier Bay. Muir Glacier was later named after him. The guides called him "the great ice-chief," and Muir deeply respected the Tlingit for their relationship with the natural world. Muir popularized geology and introduced glaciology to a wider audience. He also gave America a new view of Alaska—and Alaska a new view of itself, too.

In 1899 Muir made his last trip to Alaska—this time as part of the Harriman Expedition. He was sixty-one and by then a best-selling author. When Muir died in 1914, the manuscript for *Travels in Alaska,* detailing the discoveries in his 1879 and 1880 trips to Alaska, was on his bedside table. By espousing Alaska as a place of beauty with a healthy climate that any traveler could and should experience, Muir launched a new era of tourism in Alaska—particularly around the idea of tourism to wild places. He wasn't the only one. In 1890, Frank Leslie's *Illustrated Newspaper* sent an exploring party to Alaska headed by E. H. Wells. The reporters traveled through the Inside Passage to the Chilkat River, Chilkat Valley, and Yukon River in search of adventure stories. Some went to western Alaska and others to Fortymile. Upon their return to New York, the articles of their adventures proved extremely popular. Alaska's wilderness was acclaimed.

It was also just the beginning of the selling of the Alaska wilderness. Pulp novels about Alaska increased after the 1867 purchase. Robert Starbuck (Augustus Comstock), who had been aboard a whaling ship off Alaska, wrote *The Blue Anchor* (also called *The Lost Bridge*). Set in the Aleutian Islands, the book was reprinted twice, so Starbuck wrote two others about Alaska: *The Ice Fiend* (or *The Hunted Whaleman*), in 1871, and *Old Tar Knuckle and His Boy Chums* (or *The Monsters of the Esquimaux Board, A Tale of Adventure on Our Northwest Coast*), in 1884. Alaska's ability to be a best-seller only expanded during the Klondike Gold Rush, when more than a hundred dime-store novels about Alaska popped up on bookstore shelves around the country. Author Jack London was present for the Rush. London crossed the Chilkoot Trail, rafted down the Yukon River in 1897 and 1898, and wintered in the Klondike. When he returned to

California, he wrote several stories about the North. Most notable was *The Call of the Wild*, published in 1903. In London's novels, life in the North was portrayed as a struggle for survival among the harsh elements—a place where only the strong and hardy could find great adventure. For audiences in American cities, the stories of gold and cold in Alaska were gripping. London's novels, among others, helped perpetuate some of the stereotypes of the Alaskan wilderness that are still prevalent today.

Alaska as wild was further cemented by Rex Beach, who wrote novels about mining, the railroad, the Matanuska Colony, hunting, and the Klondike in Alaska in which he encouraged development of Alaska's resources. All of his novels, and many of his short stories, about Alaska had been made into films by 1939, putting Alaska on the big screen as well as on bookshelves. Poet Robert Service was adopted by Alaska, though his poems were set in Canada's Yukon. "The Cremation of Sam McGee," "The Trail of '98," and "The Shooting of Dan McGrew" are still thought of as theme songs for Alaska during the Gold Rush. During the early 1900s Americans were reading magazines in addition to books, and Alaska was again a popular subject—*Alaska Yukon Magazine* was one of the first and *Alaska Life* began in the 1940s. The *Alaska Sportsman* began publication in 1935 and still exists today as *Alaska* magazine. These magazines were written for people who did not live in the North, and they promoted Alaska's wilderness and resources.

While many writers portrayed the wilderness of Alaska as cold and inhuman, others placed the people of Alaska into their writing. Hudson Stuck, the Episcopal archdeacon of the Yukon from 1904 to 1920, published *Voyages on the Yukon and Its Tributaries* and *A Winter Circuit of the Arctic Coast* about his personal experiences in Alaska. Stuck wrote about traditional Alaska Native customs and lifestyles with less of an attempt to "Americanize" than was popular at the time. Stuck also wrote *The Ascent of Denali* about his 1913 climbing expedition. Frederick Whymper, an Englishman and artist with the scientific team on the 1867 Western Union Telegraph Expedition, published a book about Alaska in 1869 to describe how the purchase of Alaska was a bargain for the United States. Whymper also described Native clothing and dancing. He was another writer who talked about Alaska's wilderness as a place with many possibilities for development.

Alaska's "wildness" was also perpetuated through a continuing European and American fascination with cultures and people different from them. In the 1800s, Americans became interested in knowing more about Alaska Native populations, and a number of anthropologists collected Alaska Native artifacts. Some also recorded traditional stories. Scientists—largely in the earth sciences, such as geology and geography, but also in zoology, botany, and astronomy—were also sent to Alaska to study the "new" land. The American government sent many scientists to Alaska to survey coastlines and resources, such as gold and coal. George Davidson, an astronomer and surveyor employed by the US Coast Survey, was one of the first American scientists to come to Alaska after 1867. He traveled Alaska's coast, compiling hundreds of pages of data about Alaska.

Scientists were also greatly interested in Alaska's animals. So were hunters. Charles Sheldon, the most noted American big game hunter of his time, was fascinated by Alaska's zoology. He observed wildlife in the Denali area in 1906, 1907, and 1908, documenting thirty species of mammals and sixty-two species of birds. Adolph and Olaus Murie also studied animals in Alaska. Olaus traveled to Western Alaska in 1920 to study caribou and map their migratory routes, and he later made two summer expeditions to the Aleutian Islands to study nesting birds. His brother, Adolph, studied wolves near Denali.

Alaska's wilderness also attracted less traditional studies, such as the 1932 Carpe expedition, organized at the University of Chicago, to study cosmic rays from higher altitudes on Denali. This was one of the many parties to use science as the reason for summiting Denali once the area was designated a national park. The Carpe party was also the first group to land on Denali by airplane.

Alaska as extreme wilderness was also promoted through sports and outdoor activities—from skiing to dog-team racing. A kennel club was established in Nome in 1907, and the next year the club initiated the All-Alaska Sweepstakes Dog Race, during which mushers raced 360 miles from Nome to Candle (and back). Musher Leonard Seppala won the race in 1915, 1916, and 1917 (the race's last year), creating the notion of musher as sports celebrity. This was furthered in 1973, when the 1,049-mile Iditarod Trail Sled Dog Race from Anchorage to Nome was established and began to draw an international audience and participants from around the globe.

Denali's summit has attracted many outdoor wilderness enthusiasts. In 1910, Peter Anderson, Tom Lloyd, Charley McGonagall, and Billy Taylor—all miners—set out to climb North America's tallest mountain. At least two of them made it to the summit of the north peak, at 19,470 feet, where they planted an American flag. Three years later, Hudson Stuck and his team successfully climbed the higher south peak of Denali at 20,310 feet. Before the lure of Denali dominated the sport, expedition teams climbed other peaks. The best known was the 1897 climb led by Luigi, Duke of the Abruzzi and Prince of Savoy, up Mount Saint Elias—thought to be the highest mountain in North America at the time.

Of course, Alaska's wilderness as sport is most closely associated with game hunting and sport fishing. The Wilderness Act of 1964 describes wilderness in contrast with those areas where man and his own works dominate the landscape—as an area where "the earth and its community of life are untrammeled by man, where man himself is a visitor who does not remain." The idea of wilderness has played a curious and crucial role in American and Alaskan culture, especially in the rise of American environmentalism. Conquering wilderness has been central to colonial and pioneer narratives of progress. Reverence and nostalgia for wilderness became tangled with American nationalism at the end of the nineteenth century, with the end of the frontier. Alaska's designation as "the Last Frontier" became embedded in place narrative. America's

great wilderness has been a point of pride and national identity. Similarly, Alaska has a great stake in its identity as a place of natural beauty and natural resources.

Frontier nostalgia remains strong in Alaska. National bestsellers about Alaska as America's ultimate west were published in the 1970s—by John McPhee, who wrote *Coming Into the Country,* and Joe McGinnis, who wrote *Going to Extremes.* In 1996, Jon Krakauer wrote *Into The Wild,* a controversial account of a young man named Chris McCandless, who was found dead in a long-abandoned bus north of Denali National Park and Preserve. The book prompted discussions of McCandless's motivations and the authenticity of the tale, but it also brought Alaska into the forefront again as a wild place where people still go to escape or to undergo the ultimate tests of their ability to survive. The death of Timothy Treadwell in 2003 also brought Alaska's wilderness renewed international attention. Treadwell, an aspiring actor, along with his friend Amie Huguenard, were killed by a bear in Katmai National Park. Beginning in 1989, Treadwell, from California, spent thirteen summers camping with brown bears. During that time, he established a reputation as a bear man and as an educator of children about bears, and as an author and filmmaker. Treadwell's death was debated as tragedy vs. foolishness and a confirmation of the power of Alaska and the nature that Alaskans (and visitors to Alaska) inhabit. The stories of McCandless and Treadwell reinforced the notion that if one tests wilderness too much, wilderness wins. In 2002, James A. Michener published his book *Alaska,* which brought Alaska right back into its comfort zone—the wilderness of the northernmost American frontier, with rugged terrain and a survivalist history.

Today, Alaska's wilderness is wildly more accessible. Tour buses bring visitors to the state to the entrances to national parks, paths to glaciers are paved, cruise ships extend into the Arctic sea ice, and small planes fly everywhere in the great outdoors. Fishers line up elbow to elbow along some Alaskan rivers, and the wilderness, marketed for more than a hundred years, can be reached through numerous agencies and ticket offices. In the three decades since the passage of the Wilderness Act, wilderness visitors have multiplied. The wilderness experience, as defined by the Wilderness Act, was to provide opportunities for solitude. That solitude now must be shared with an increasing number of users in most designated wilderness areas. The act also defined wilderness as an area where "the earth and its community of life are untrammeled by man," which "retains its primeval character and influence, without permanent improvement or human habitation."

The notion of the untouched wilderness has never been accurate in Alaska or the international Arctic—indigenous people have adapted to the landscape for millennia. In his book *The Wild Places,* Robert Macfarlane wrote, "I thought about how the vision of wildness with which I had begun my journeys—inhuman, northern, remote—was

starting to crumble from contact with the ground itself. . . . The human and the wild cannot be partitioned. Everywhere that day I had encountered blendings and mixings." Indigenous cultures have evolved within "wild lands" through subsistence hunting and gathering—to them, these lands are not wild, but home. Alaska Natives have sustained a harvest of resources from the lands without altering nature—with a belief in being part of nature rather than separate. With an increasing global interest in the Arctic, with melting sea ice representing not just climate change but opportunities for commerce, the indigenous ways of living are key to understanding and examining Arctic futures. Today, more than four million people, of many cultures, live in the Arctic across the world. The idea of the "untouched landscape" suggests a place never adapted to by indigenous peoples and a remote, barren place lacking in life. It remains inaccurate.

For most people in Western society today, wilderness is a concept, the reality of which they have not personally experienced. The image of wilderness in the minds of many urban Americans is derived from historical narratives and from television. More than twenty reality television shows are filmed in Alaska. *The Deadliest Catch* began much of the frenzy in 2005, depicting commercial fishing in Alaska. At a time when Alaska is part of a global Arctic conversation, when almost every "remote" area has Wi-Fi and 4G broadband, the television programs renew the stereotypes of Alaska as a frontier of extreme places and extreme people, a land wild and unexplored. Popular with people outside the state in cities and suburbs, the programs do not depict reality so much as a perception and an idea, presenting Alaska's wilderness with limited complexity. Wilderness is a human invention and a social construction, often built on myths.

Outside of literature, journalism, and television, artists in all media have given visual form to the wilderness. From romantic painters, who presented the pristine wilderness, to photographers who worked to capture wild places, artists, too, were exporters of notions of the wilderness for those Americans who never wished to experience the wilderness firsthand but were fascinated by it nonetheless. In Alaska, painters such as Sydney Laurence created the vision of Alaska as a place unpopulated, where nature dominates man. For artists presenting a romantic view, wilderness was about beauty and solitude (see figure 7.1). Rockwell Kent escaped to Alaska to be at one with the wilderness, in the tradition of transcendentalism (see figure 7.2).

Others exported a visual narrative of a barren, frozen landscape, where man battled nature and where only the strongest and most adventurous could succeed. The white nothingness was the image for the Arctic, with winter, cold, and an endless horizon—inhospitable and uninhabitable. Depictions of indigenous people in historical photos and historical paintings often exoticized and romanticized them, suggesting "otherness" (see figure 7.3).

FIGURE 7.1 Sydney Mortimer Laurence, American, 1865–1940,
Aurora Borealis, c. 1929. Oil on board, 41 × 51 cm.
Gift of Freda M. Huncke. Collection of the Anchorage Museum.

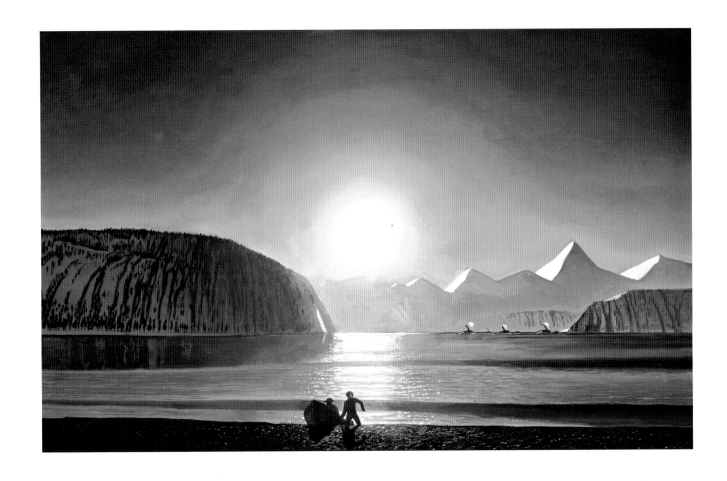

FIGURE 7.2 Rockwell Kent came to Alaska with his son in 1919 and spent a year on the then-remote Fox Island in Resurrection Bay, near Seward. The pair stayed in an abandoned cabin that once housed goats.

Rockwell Kent, American, 1882–1971, *Resurrection Bay, Alaska,* 1965. Oil on canvas, 88 × 128 × 3 cm. Gift of ATZ Travel, ERA Helicopters, Dr. and Mrs. Lloyd Hines, Mr. Bruce Kendall, and Alyeska Pipeline Service, Co. Collection of the Anchorage Museum.

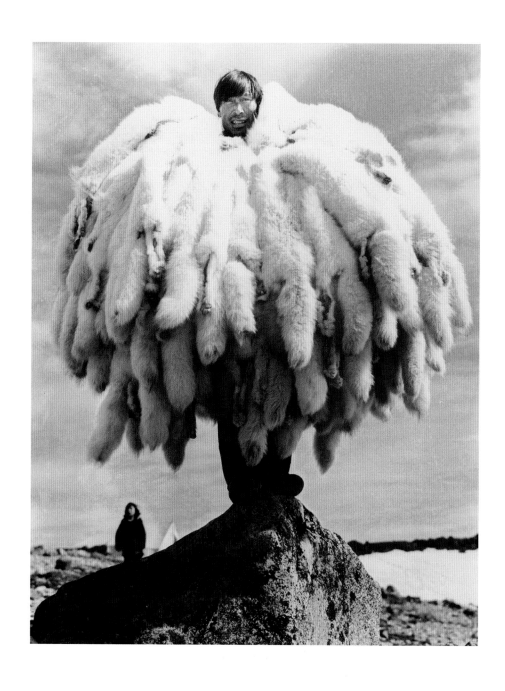

FIGURE 7.3 Richard Harrington, German, 1911–2005, *Eskimo Holding Bundles of Arctic Fox Skins*, 1951. Silver gelatin print, 51 × 40 cm. Collection of the Anchorage Museum.

Contemporary artists work to convey both the extremes of the environment (see figure 7.4) and the interplay of humans and nature (see figure 7.5). Some present the classic notion of the wilderness, such as Jon Van Zyle's meticulous portraits of human interaction with nature (see Figure 7.6), while others play off the stereotypes. Photographer Michael Conti developed a series of manipulated photographic images based on the writings of Jack London and commenting on the idea of a male-dominated, cold, and formidable North (see figure 7.7). Mariano Gonzales created a photograph depicting the "wilderness" experience as cooking a hot dog over a virtual campfire as seen on a television screen (see figure 7.8). Other artists, from photographers such as Tim Thomas (see figure 7.9) to painters such as David J. Woodie and Spence Guerin (see figure 7.10) highlight the beauty of nature contrasted with the presence of the manmade—with panoramic views interrupted by road signs and rest stops. In the 1960s, British cartoonist Ronald Searle drew the ALCAN Highway cluttered with station wagons and wild animals (see figure 7.11). Photographer Mark Daughhetee (see figures 7.12, 7.13, and 7.14) recreated the typical wilderness experiences in miniature inside his studio, and painter Dan DeRoux created fantastical scenes combining Alaska with other tourist destinations, such as his painting *Mt. McKinley as Seen from the Grand Canal Rialto Bridge,* which depicts a Venetian canal occupied with glacier ice, with Denali looming in the background (see figure 7.15). In popular culture, the city of Anchorage marketed itself as the gateway to the wilderness, populated by friendly wild animals ready to greet visitors. The great outdoors has been ubiquitous in the art of Alaska, but contemporary artists, such as photographer Brian Allen, offer new and often ironic takes, reflecting the contrasts of cultures and the push-pull between embracing the wildness of Alaska and poking fun at the ways in which it has been incorporated into popular culture and lifestyles (see figures 7.16 and 7.17). The "Wild About Anchorage" advertising campaign worked to attract Americans to Alaska, with an anthropomorphized wilderness that was inviting rather than formidable (see figure 7.18).

More and more, artists work to portray the Arctic of Alaska in all of its complexity—not as an untouched landscape or a wild place, but as a rapidly changing environment inhabited by people. Photographer Brian Adams has created several series documenting Alaskan villages and people (see figure 7.19), and many photographers work to capture a place where people have existed for a long time (see figure 7.20). Ken Lisbourne, born in 1957 in Point Hope, a village in northwestern Alaska on the Chukchi Sea, creates watercolors documenting both traditional and contemporary village life. His images range from scenes of harvesting bowhead whales (see figure 7.21) and seals (see figure 7.22) to the harsh realities of the North, which include alcoholism, suicide, and abuse (see figure 7.23).

Alaska's wildlife is featured as a source of subsistence (see figure 7.24) and a source of inspiration. While many paint and photograph Alaska's wild animals with great realism,

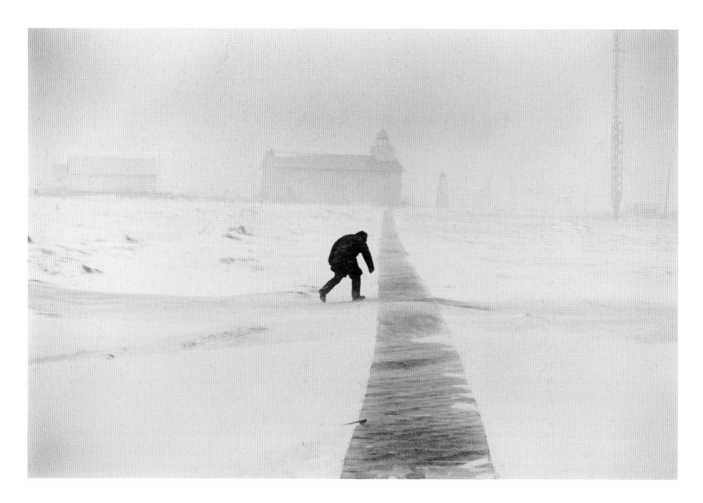

FIGURE 7.4 James H. Barker, American, born 1932. *Owen David Bends into a Bethel Storm*, 1976. Silver gelatin print, 56 × 71 cm. Collection of the Anchorage Museum.

it is Sugpiaq painter Alvin Amason who is perhaps best known for capturing their spirit. Born in Kodiak, Alaska, Amason has developed a distinctive style of painting with a distinctive subject mater. His expressionist paintings feature strong color, paint drips, and three-dimensional projections. They are portraits of the animals that Alaska's indigenous people have long depended on and honored—from bears to seals, fish, and birds (see figure 7.25).

The idea of Alaska as one of the last extreme wild places on Earth, a place of the future of America's wilderness, attracts contemporary artists and contemporary commentary from around the globe. Alaska's wilderness today represents rapid change. While the human relationship with the wilderness is ever precarious, as Macfarlane writes, "the wild prefaced us, and it will outlive us" (see figure 7.26).

FIGURE 7.5 David J. Woodie, American, born 1951, *Boulder Creek*, 2005.
Oil on wood, 106 × 182 cm. Collection of the Anchorage Museum.

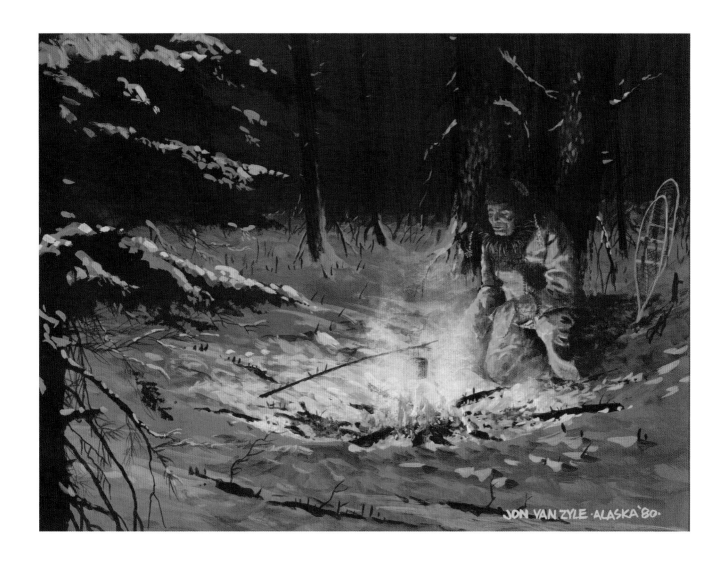

FIGURE 7.6 Jon Van Zyle, American, born 1942, *Cold Night Fire*, 1980. Acrylic on board, 51 × 61 cm. Gift of Floyd and Barbara Smith. Collection of the Anchorage Museum.

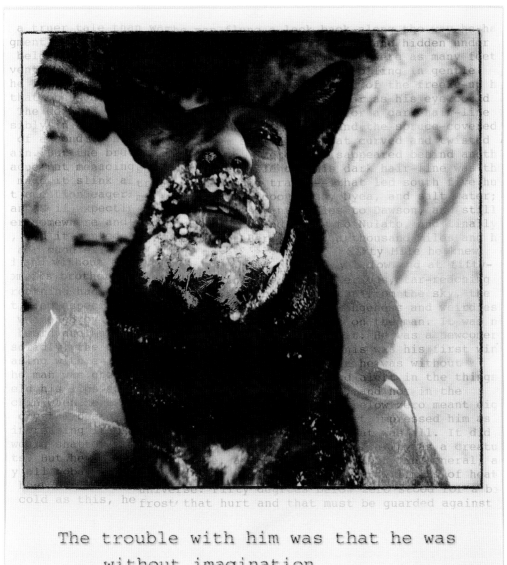

The trouble with him was that he was
without imagination.

FIGURE 7.7 Michael Conti, American, born 1971. *Without Imagination*, 2008. Inkjet on paper, 26 × 30 cm. Collection of the Anchorage Museum.

FIGURE 7.8 (opposite) Mariano Gonzales, American, born 1951, *Life in the Frozen North*, 1985. Photograph, 41 × 49 cm. Collection of the Anchorage Museum.

FIGURE 7.9 (below) Tim J. Thomas, American, born 1948, *Polychrome Pass*, 2004. Pigment ink print, 37 × 122 cm. Collection of the Anchorage Museum.

FIGURE 7.10 Spence Guerin, American, born 1941, *You Get a Chance to See Mt. McKinley on a 5-Day Tour*, 1979. Ink on paper, 57 × 77 cm. Collection of the Anchorage Museum.

FIGURE 7.11 Ronald Searle, British, 1920–2011, *ALCAN Highway,* 1962.
Ink on cardboard, 51 × 39 cm. Collection of the Anchorage Museum.

FIGURE 7.12 (top) Mark Daughhetee, American, born 1951, *Dick Lands the Big One, 1,* 1984. Silver print, handcolored, 52 × 62 cm. Collection of the Anchorage Museum.

FIGURE 7.13 (middle) Mark Daughhetee, American, born 1951, *Dick Lands the Big One, 2,* c. 1986. Silver print, hand-colored, 52 × 62 cm. Collection of the Anchorage Museum.

FIGURE 7.14 (bottom) Mark Daughhetee, American, born 1951, *Dick Lands the Big One, 4,* c. 1989. Silver gelatin, pigment, paper, 52 × 62 cm. Collection of the Anchorage Museum.

FIGURE 7.15 Dan DeRoux, American, born 1951, *Mt. McKinley as seen from the Grand Canal Rialto Bridge*, 1982. Acrylic on canvas, 90 × 128 cm. Collection of the Anchorage Museum.

FIGURE 7.16 (opposite) Brian K. Allen, American, born 1953, *Christmas Lights with Car Plug-In*, 1982. Silver gelatin print, 25 × 33 cm. Collection of the Anchorage Museum.

FIGURE 7.17 (above) Brian K. Allen, American, born 1953, *Alaska Tent and Trap*, 1981. Silver gelatin print, 28 × 35 cm. Collection of the Anchorage Museum.

FIGURE 7.18 Wild About Anchorage cartoon from advertising campaign of the Anchorage Convention and Visitors Bureau, 1980. Graphite, paper, and ink, 27 × 32 cm. Gift of the Anchorage Convention and Visitors Bureau. Collection of the Anchorage Museum.

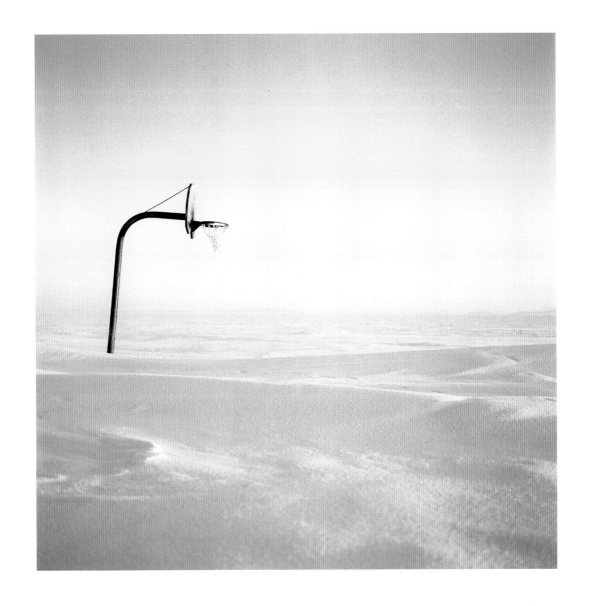

FIGURE 7.19 Brian Adams, Iñupiaq, born 1985, untitled, 2011.
Inkjet on paper, 41 × 41 cm. Collection of the Anchorage Museum.

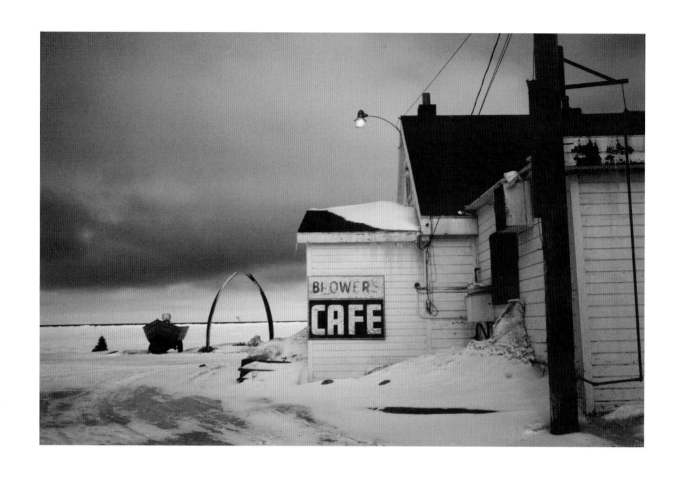

FIGURE 7.20 Karen Michel, American, born 1951, *Brower's Café*, 1983. Inkjet on paper, 26 × 21 cm. Collection of the Anchorage Museum.

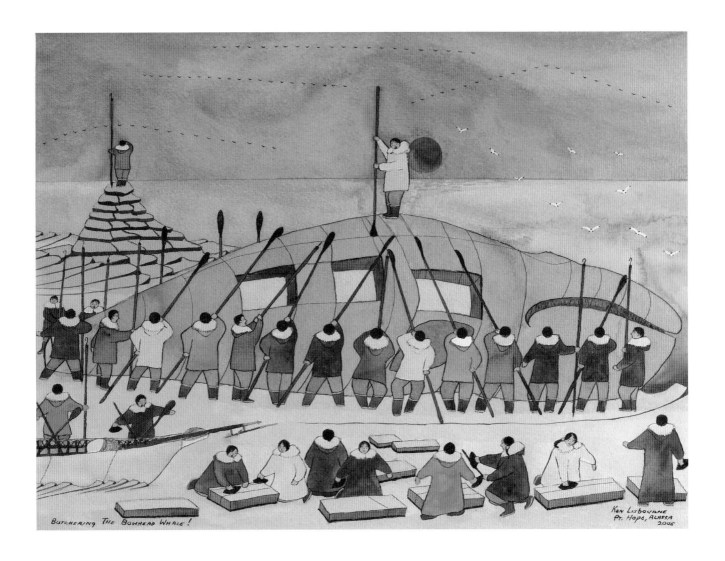

BUTCHERING THE BOWHEAD WHALE!

KEN LISBOURNE
PT. HOPE, ALASKA
2005

FIGURE 7.21 Point Hope is one of the oldest continually occupied sites in North America. Whale hunting has been a tradition there for centuries and continues to be a vital subsistence and cultural practice there today.

Ken Lisbourne, Iñupiaq, born 1950, *Butchering the Bowhead Whale*, 2005. Watercolor, ink, and paper, 30 × 40 cm. Collection of the Anchorage Museum.

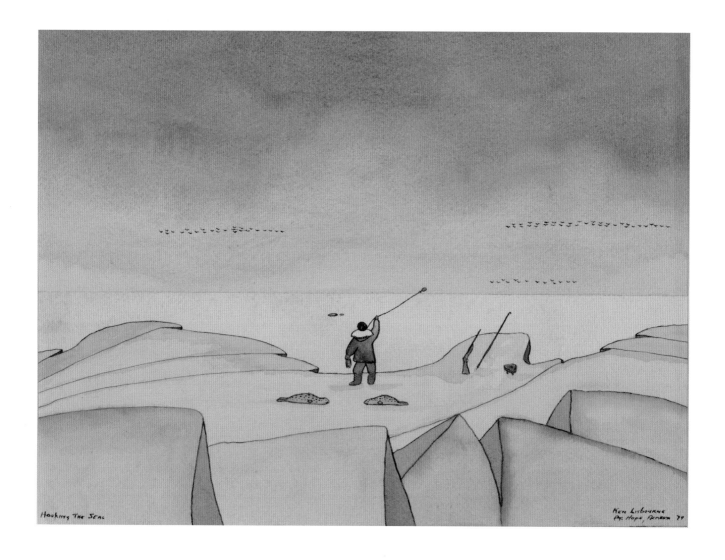

Hooking the Seal

Ken Lisbourne
Pt. Hope, Alaska 79

FIGURE 7.22 (above) Ken Lisbourne, Iñupiaq, born 1950,
Hooking the Seal, c. 1979. Watercolor, 74 × 49 × 5 cm.
Collection of the Anchorage Museum.

FIGURE 7.23 (opposite) Ken Lisbourne, Iñupiaq, born 1950,
Alcohol, 2015. Watercolor, paper, and ink, 44 × 28 cm.
Collection of the Anchorage Museum.

JULIE DECKER

FIGURE 7.24 This image is part of a series depicting Iñupiaq village life and whaling taken by Bill Hess over a period of years. The photos were published as *The Gift of the Whale*. This image depicts a winter feast called Kivgiq. For days, there is dancing and gift giving. Food—bowhead whale, beluga whale, caribou, fish, ducks, geese, and seal—are all shared abundantly.

Bill Hess, American, born 1950, untitled, c. 1983. Inkjet on paper, 31 × 47 cm. Collection of the Anchorage Museum.

FIGURE 7.25 (above) Spence Guerin, American, born 1941, *Mobile Home TV*, 1979. Charcoal on paper, 65 × 80 × 2 cm. Collection of the Anchorage Museum.

FIGURE 7.26 (opposite) Alvin Amason, Sugpiaq (American), 1948, *Agripina Day, From Two Rainbows*, 1976. Oil on canvas, 122 × 122 cm. Collection of the Anchorage Museum.

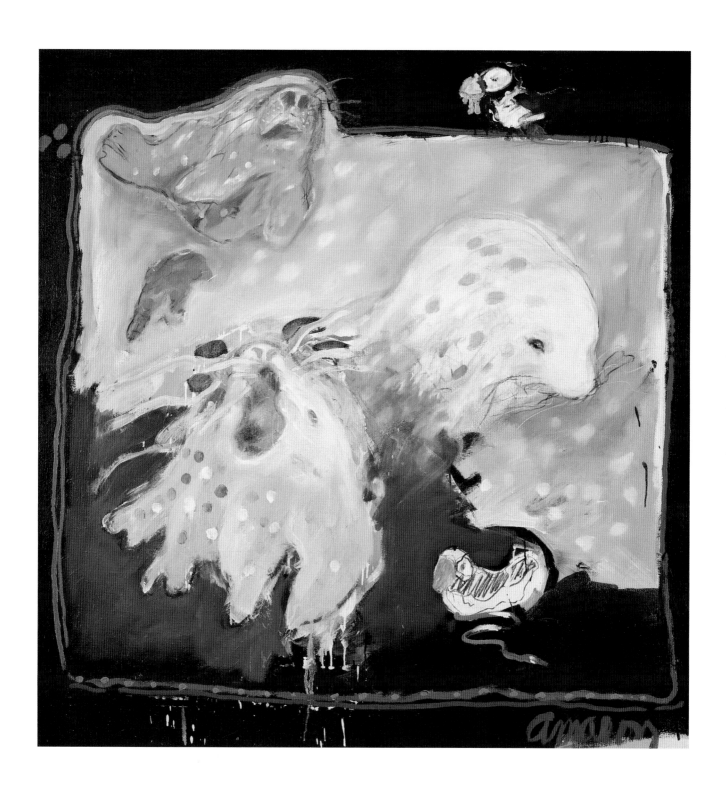

COLD
AS HELL

DAVID HOLTHOUSE

They came from the North. Pale skin. Blue eyes. Cold, infinite evil. Uncountable, unstoppable, and without mercy. For every one slain, three took its place.

No one knew why they came. They just descended from the Lands of Always Winter, a polar waste beyond the map's edge. Under their tow was never-ending darkness, famine, and a year-round winter that shrouded the world for a generation. Bards dubbed it the Long Night.

In the well-known *Game of Thrones* fantasy book and television series, a crone named Old Nan describes the Long Night's frigid horrors: "Kings froze to death in their castles, same as the shepherds in their huts; and women smothered their babies rather than see them starve, and wept, and felt the tears freeze on their cheeks. In that darkness the White Walkers came for the first time. . . . They swept through cities and kingdoms, riding their dead horses, hunting with their packs of pale spiders as big as hounds."[1]

Game of Thrones lore describes rival kingdoms in the mystical world of Westeros joining forces against the White Walkers, driving the ice zombies back to the uttermost, haunted North, then sealing off the Lands of Always Winter from the lands of men by constructing a 700-foot high, 300-mile long barricade of solid ice: the Wall (see figure 8.1).

"Beyond the Wall, the monsters live," Old Nan warns. "The giants, and the ghouls, the stalking shadows, and the dead that walk."[2]

Though Westeros mortals prevailed in the War for the Dawn, its climate never recovered. Seasons changed for the worse. Sunlight returned, but winters became longer, crueler, and colder than ever. Starvation remains a constant threat in the inhabited lands of Westeros just below the Wall, known as the North—a vast land with a small population, owing to a desolate environment where agriculture is impossible for much of the year, except in a few greenhouses built on geothermal vents.

The North is ruled by the House Stark, and the House Stark has a motto: "Winter is coming." This motto references the need for constant vigilance against the prophesied return of the White Walkers, as well as the need for constant preparation to

survive in the North: the gathering and storing of food, the mending of cloaks, and the upkeep of shelters.

The Long Night is just one of several conspicuous examples of endless winter empowering malevolent forces in the most popular English-language fantasy worlds of page and screen in the last century. In these worlds, which have been translated for hundreds of millions worldwide, the North is a stronghold of evil, white is the color of wickedness, and snow is a harbinger of doom.

Most of these stories are set in worlds created whole cloth from a writer's imagination. One noteworthy exception is *30 Days of Night,* the cult phenomenon graphic novel adapted to hit film in 2007. Its premise is that a rogue coven of Nosferatu—ancient vampires from Eastern Europe—invade Barrow, Alaska, during the monthlong polar night of deep winter. Movie trailer narration for *30 Days of Night* explained: "They have lived in the shadows. They are the last of their kind. But above the Arctic Circle, where night lasts for thirty days, their time has come again."[3]

FIGURE 8.1 Still from *Game of Thrones,* featuring Sean Bean, August 23, 2013.

Image courtesy of WENN US/ Alamy Stock Photo.

FIGURE 8.2 Hobbit signpost showing East and West Farthing, on *The Hobbit* film set in New Zealand.

Photograph courtesy of Doug Houghton, NZ/Alamy Stock Photo.

The vampires send a minion to Barrow to prepare for their arrival. He sabotages the town's airport and communications satellites, cutting it off from the outside world. (The Hollywood-ized version of Barrow, a town on the very northern edge of Alaska, is even more isolated than in reality.) Just before the vampires appear, the already-low temperature plummets. "That cold you feel, that ain't the weather," the minion warns a local cop. "That's death approaching."[4] The Nosferatu have skin as white as pack ice and souls as black as their eyes. Relieved of the need to sleep during the day to avoid sunlight that's lethal to their kind, the vampires turn Barrow into a feeding frenzy. But the residents fight back, using, among other improvised weapons, ultraviolet SAD lamps popular among people of the Arctic to ward off seasonal affective disorder in months of low (or no) sunlight.

The rays of dawn are likewise fatal to certain monsters of the cold and dark in Middle-earth, the fantasy world invented by author J. R. R Tolkien. Daylight kills Middle-earth trolls by turning them to stone, and disintegrates Barrow-wights—gaunt, pale-skinned phantoms with cold, shimmering eyes and icy, skeletal grips. Barrow-wights bewitch unwary travelers, leading them, spellbound, to a chilly underground tomb. Once there, wights bind their victims in chains of gold, drape them in white fabric, and sacrifice them to sinister gods using a ceremonial sword (see figure 8.2).

All the while, they keep up a tortured chant: "Cold be hand and heart and bone, and cold be sleep under stone: never more to wake on stony bed, never, till the Sun fails and the Moon is dead. In the black wind the stars shall die, and still on gold here let them lie, till the dark lord lifts his hand over dead sea and withered land."[5]

Tolkien drew inspiration for Barrow-wights from *Hrómundar saga Gripssonar,* or *The Saga of Hromund Gripsson,* an Old Norse legend that originated in what is now Iceland. Throughout modern Scandinavia, folklore to this day describes *vetter* (wights) haunting Viking burial mounds, or barrows.

Akin to the Lands of Always Winter, the far north region of Middle-earth is a snowy hell named the Northern Waste, ruled over by the dark lord Melkor in his dark fortress Utumno. Demons live in the Northern Waste, along with Cold-drakes—dragons that lack the ability to breathe fire. Every two or three centuries in Middle-earth, a vicious blizzard that lasts for years descends from the Northern Waste, carrying unspeakable horrors on its bitter winds. Feral packs of White Wolves ravage the famine-stricken land. When the blizzard stops at last, Middle-earth is flooded by snowmelt, compounding the devastation (see figure 8.3).

FIGURE 8.3 (opposite) White Alice Communications System site, Nome, Alaska.

Photograph courtesy of Tom Thulen/ Alamy Stock Photo.

Tolkien recorded these eras of suffering in the fictional history of Middle-earth with names like the Fell Winter and the Long Winter. The eminent wizard Gandalf describes many thousands of hobbits of the Shire (benevolent, diminutive, magical humanoids) dying in the latter. "I began to have a warm place in my heart for [hobbits] in the Long Winter, which none of you can remember," Gandalf tells a group of Shire-folk near the beginning of *The Fellowship of the Ring*. "They were very hard put to it then: one of the worst pinches they have been in, dying of cold, and starving in the dreadful dearth that followed."[6]

The Old Norse legends that inspired Tolkien's Barrow-wights also describe a cataclysmic winter reminiscent of Middle-earth's, as well as of the Long Night in *Game of Thrones*. Norse myths tell of a *Fimbulveter* (often rendered in English as Fimbulwinter), or "Mighty Winter," a series of three successive winters, barren and brutal, with no seasons of warmth or harvest in between. To this day, in Denmark, Norway, and Sweden, the term *fimbulvinter* is used to describe any winter that is colder and snowier than usual.

In the myths, Fimbulveter is an epic blizzard powered by supernatural forces. The snow flies and winds howl from all directions, sometimes at once, defying natural law and blocking out the sun. This relentless winter precedes the Norse version of Armageddon, called Ragnarök, which has been translated as "destruction of the gods," "doom of the gods," or the poetic "twilight of the gods." Ragnarök is a time of relentless war and natural disasters that brings about the death of major gods including Thor, Odin, and Loki.

Scholars place the possible origins of Fimbulveter and Ragnarök in the real-life extreme weather events of 535 and 536 AD, which resulted in a severe drop in temperature across northern Europe, likely caused by a volcanic eruption throwing so much ash and dust into Earth's atmosphere that it blocked the sun. The recorded effects were crop failures, widespread starvation, and the cruelest winter of the last two thousand years. Its legacy may have cascaded through the centuries in the form of cold representing evil in stories that became literature that became comic books and films.

In the Old Norse tales, Ragnarök ends with the entire world submerged in water (or, in some tellings, blood), reminiscent of the snowmelt drowning Middle-earth, and of the civilization-ending flood motif in many other myth systems around the world, including the story of Noah in the Book of Genesis.

In some variations of Ragnarök, the only survivors are sinister frost giants from Jötunheimr, a mythical dominion of primordial cold, popularized in the Marvel comic series *Thor* as "a cold and barren world with very little sun light and almost perpetual winter."[7]

The frost giants of Jötunheimr in Old Norse stories are called Jötunn, which became Eoten in Old English, and then Ettin, two-headed cold weather monsters that are well known to fans of the role-playing game Dungeons and Dragons, and to readers of the classic fantasy novel *The Lion, the Witch and the Wardrobe.* In that work by C. S. Lewis, Ettin are henchmen of perhaps the vilest eternal winter villain of them all—more cunning than White Walkers, more ferocious than White Wolves: the White Witch of Narnia (see figure 8.4).

"Her face was white," Lewis writes. "Not merely pale, but white like snow or paper or icing sugar, except for her very red mouth. It was a beautiful face in other respects, but proud and cold and stern."[8]

The White Witch rules over Narnia, a land of talking beasts and magic. She was banished long ago to the far North of the world as punishment for her evil sorcery, but she returned and usurped the throne by murdering the rightful king and his sons. For a century, Narnia has been under her spell, cast into one hundred years of endless cold and snow called the Age of Winter (see figure 8.5).

The character Lucy, one of the four children who discover a portal to Narnia in the titular wardrobe, describes the White Witch to a fellow adventurer:

> She is a perfectly terrible person. . . . She calls herself the Queen of Narnia though she has no right to be queen at all, and all the Fauns and Dryads and Naiads and Dwarfs and Animals—at least all the good ones—simply hate her. And she can turn people into stone and do all kinds of horrible things. And she has made a magic so that it is always winter in Narnia—always winter, but it never gets to Christmas. And she drives about on a sledge, drawn by reindeer, with her wand in her hand and a crown on her head.[9]

FIGURE 8.4 Still from *The Chronicles of Narnia: The Lion, the Witch and the Wardrobe,* 2005, directed by Andrew Adam and featuring Tilda Swinton.

Affiche du film, artwork. Photograph courtesy of Photos 12/Alamy Stock Photo.

FIGURE 8.5 (next spread) Military Distant Early Warning (DEW) Line site, Alaska.

Photograph courtesy of RGB Ventures/SuperStock/Alamy Stock Photo.

Coldness signals evil to any in her presence. When the children encounter the White Witch for the first time, they feel "shudders running down their backs at the sight of her face; and there were low growls among all the animals present. Though it was bright sunshine everyone suddenly felt cold."[10]

When challenged, the White Witch conjures a monstrous army to rival the fiendish menagerie from north of the Wall described by Old Nan: "Summon all our people to meet me here as speedily as they can. Call out the giants and the werewolves and the spirits of those trees who are on our side. Call the Ghouls, and the Boggles, the Ogres and the Minotaurs. Call the Cruels, the Hags, the Spectres, and the people of the Toadstools. We will fight."[11] (See figure 8.6.)

In the fantasy worlds of Middle-earth, Narnia, and Westeros, a cold, almost lifeless wasteland at the northern edge of the world is ceded to the forces of evil. Then, as inevitably as the changing of the seasons, evil grows tired of being contained in the North. So it descends, overwhelms, terrorizes (see figure 8.7).

As a theme, invasive evil from the cold North echoes throughout ancient history and modern pop culture. Its roots extend back to the Middle Ages, when Vikings came south from Scandinavia to ravage, pillage, and burn. "Immigrant Song," by the 1970s rock band Led Zeppelin, begins with a bone-chilling war cry, followed by lyrics written from the perspective of Viking raiders oaring south with bloodlust (see figure 8.8):

> *We come from the land of ice and snow.*
> *From the midnight sun where the hot springs blow.*
> *The hammer of the gods will drive our ships to new lands.*
> *To fight the horde, singing and crying: Valhalla, I am coming!*
> *Oh we sweep with threshing oar . . .*
> *How soft your fields of green, can whisper tales of gore.*
> *Of how we calmed the tides of war. We are your overlords* [12] (see figure 8.9)

Even more distant in time, the northern lands of Celtic and Germanic barbarians were specters on the map of the Roman Empire. In Asia, the Mongol hordes descended from the frigid steppes and cold Gobi Desert.

To Africans of the seventeenth and eighteenth centuries, European colonialists must have seemed like White Walkers: a pale-faced horde from a faraway and hostile land, driven by insatiable hunger for conquest, that just keeps coming, no matter how many are killed. (To extend the comparison, in *Game of Thrones* White Walkers destroy everything and everyone in their path, then reanimate the dead as soulless minions to do their bidding, sort of the ultimate in cultural assimilation.)

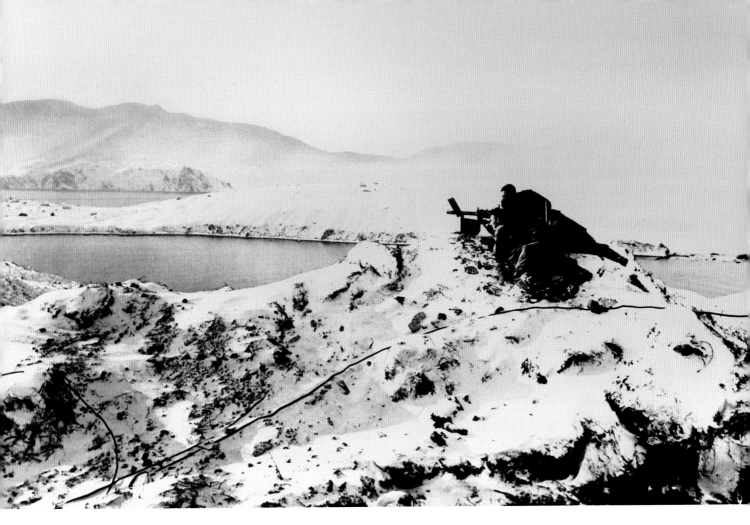

FIGURE 8.6 US Marines man a machine gun at a lookout post on Attu, in the Aleutian Islands, Alaska.

Photograph courtesy of Everett Collection Inc/Alamy Stock Photo.

FIGURE 8.7 A robotic vehicle undergoes mobility testing on a bump course at the Cold Regions Test Center at Fort Greely, Alaska.

Photograph courtesy of 615 Collection/ Alamy Stock Photo.

FIGURE 8.8 Base camp on the Ruth Glacier, interior Alaska range, during a snowstorm.

Photograph courtesy of Design Pics Inc/Alamy Stock Photo.

FIGURE 8.9 Iceland Viking Village old historical museum in Hafnarfjordur, with Viking design hanging on wall.

Photograph courtesy of Bill Bachmann/Alamy Stock Photo.

As with the home territory of the White Walkers, the Lands of Always Winter, the extreme North is often depicted in popular imagination as inhospitable not only to goodness, but to life itself, due to cold temperatures that preclude vivid flora, let alone agriculture.

Likewise, cold is associated with the death stage of the cycle of seasons, as well as the cycle of life, in most of the world's major religions, which originated in warm climates with agrarian civilizations that cultivated the land: Judaism and Christianity in Mesopotamia and the Levant; Islam in the Arabian Peninsula; Hinduism and Buddhism in India; Taoism and Confucianism in China; and Shintoism in Japan.

In these places, human life grew dependent on growing seasons. Cold and darkness came to equal death. But in Alaska and the rest of circumpolar North, extended cold and darkness have never been more or less than simple facts of life, essential to the identity of place and culture, in a land of extremes.

Cold was respected but not feared by the original inhabitants of the circumpolar North. Cold meant stable ice on which to hunt, and subterranean permafrost in which to store food to survive. And in the circumpolar North, the White Walkers of colonialism did not descend from the North. They rose from the South, from warmth. That invasion may pale in comparison to what's coming next for the North, with all of its open land, fresh water, increasingly temperate climate, and generous summer growing seasons (see figures 8.10 and 8.11).

Fear and peril in our North are not indicated by cold so much as heat, that which melts the ice and thaws the frost.

Summer is coming.

FIGURE 8.10 White Walker's ice sword from *Game of Thrones*.

Photograph courtesy of Stephen Barnes/*Game of Thrones*/Alamy Stock Photo.

DAVID HOLTHOUSE

NOTES

1 George R. R. Martin, *A Game of Thrones* (New York: Bantam Books, 1996).

2 Ibid.

3 *30 Days of Night*, dir. David Slade (Sony, 2007).

4 Steve Niles, Ben Templesmith, and Bill Sienkiewicz, *30 Days of Night* (San Diego, CA: IDW Publishing, 2007).

5 J. R. R. Tolkien, *The Lord of the Rings* (London: Allen and Unwin, 1954).

6 Ibid.

7 Matt Forback, *Marvel Encyclopedia: The Definitive Guide to the Characters of the Marvel Universe* (New York: DK Publishing, 2015).

8 C. S. Lewis, *The Lion, the Witch and the Wardrobe: A Story for Children* (New York: Macmillan, 1950).

9 Ibid.

10 Ibid.

11 Ibid.

12 Led Zeppelin, "Immigrant Song" (vinyl recording, 1970).

FIGURE 8.11 An Iditarod musher is shrouded in steam while ladling hot water heated by a wood-burning barrel at night in Takotna, Alaska.

Photograph courtesy of WorldFoto/Alamy Stock Photo

ENVIRONMENT AND SCIENCE

Observing and Discovering Alaska

JOHN PEARCE and
SANDRA TALBOT

We could not observe what we wished, but had, on the contrary, encountered what we had not expected.

Naturalist George W. Steller, from *Journal of a Voyage with Bering, 1741–1742*, translated by M. A. Engel and O. W. Frost

The kayak (or *baidarka*) is not typically classified as a scientific discovery. We usually think of scientific discoveries being made in laboratories or during archaeological digs. However, imagine being a hunter, standing in what is now Alaska, thousands of years ago. From a rocky coastline you see a sea otter bobbing just offshore. You know from experience watching and hunting that this animal holds the potential for food and clothing. The development of the baidarka came from early observations and questions. The baidarka arose from hours of observation of an environment, out of creativity, testing, and refinement—and likely numerous wet, experimental trials in the surf. But eventually, the baidarka became a highly efficient craft. Western explorers in the seventeenth and eighteenth centuries marveled not only at the ingenuity of its construction, but also at how the vessel was used for a unique style of hunting patterned after animal behavior (see figure 9.1) that indigenous people had observed for generations. Thus the baidarka, like many other human inventions in Alaska, was developed out of keen and constant observation of the environment, followed by ideas that were tested and retested, indicating that the original people of Alaska can be counted among the world's first scientists.

THE SURROUND

A fleet of Sea-otter Hunters in the North Pacific, South of Saanak Island : marking the Wake of an Otter at the Moment of its Diving

Many observations and discoveries changed the course of how we do things, the way we perceive our northern world and function within it: gold, the annual cycle of the bowhead whale, the whaling boat (or *umiak*), the calculation of the 20,308-foot elevation of Denali, subduction zones of tectonic plates in the Gulf of Alaska that generated the 1964 Great Alaska Earthquake, and the Dena'ina method of hunting Cook Inlet beluga whales by driving an upturned tree stump into the mud to form a hunting stand protected from the high tide. While we may think of scientific discoveries as coming from a person in a laboratory, many discoveries are also made through a quiet watching of the natural world. Discoveries come from observations: the visual and mental identification of a pattern and problems, followed by questioning, creativity, and often just plain luck.

FIGURE 9.1 Aleuts hunting sea otter south of Saanak Island. The baidarkas are waiting for the otter to rise again.

H. W. Elliott, American, 1846–1930, drawing on paper, 1987. Image courtesy of the National Oceanic and Atmospheric Administration (NOAA) Fisheries Collection.

FIGURE 9.2 Detail of Steller's sea cow (*Hydrodamalis gigas*). The Steller's sea cow is an extinct herbivorous marine mammal. Its closest living relatives are the dugong and the manatee. It reached up to thirty feet in length, making it among the largest mammals other than whales to have existed in the Holocene Epoch. Although the sea cow had formerly been abundant throughout the North Pacific, by 1741, when it was first described by Georg Wilhelm Steller, chief naturalist on an expedition led by explorer Vitus Bering, its range had been limited to a single, isolated population surrounding the uninhabited Commander Islands. Within twenty-seven years of discovery by Europeans, the slow-moving and easily captured Steller's sea cow was hunted to extinction.

Drawing on the map Sven Waxell made of Vitus Bering's voyage to America, 1741–1742. Russian State Archives of the Navy, Saint Petersburg. Photography by Chris Arend.

Discoveries are also rooted in the environments from whence they came: patterns of weather, vegetation, and wildlife. Because of the location of Alaska in the North, the logistical challenges of observation have left much of the region uncharted and undocumented. Stunning and unique discoveries to the Western world, such as the discovery of the now-extinct Steller's sea cow in 1741 (see figure 9.2) remain possible even today.

A HISTORY OF OBSERVATION IN ALASKA

The history of observation and scientific discovery in Alaska roughly conforms to the following timeline: development of Alaska's indigenous cultures, followed by colonization by Eurasian ancestors (with scientific curiosity initially playing a secondary role to identification of natural resources); expeditions by other Western nations with major goals to find a Northwest Passage, precious minerals, and cartography, followed by a description of geological resources leading to the purchase of Alaska by the United States in 1867. Subsequent scientific observations were aimed at resource inventories. Eventually, some American scientific explorations took place purely for curiosity, like the Harriman Expedition of 1899, and documentation of the fauna of Alaska by the Murie brothers and flora by Eric Hultén, both in the early 1930s.

THE FIRST DISCOVERERS

While the number and timing of migrations to the Americas continues to be determined, most researchers agree that Alaska must have been the point of entry for some

of the earliest explorers that moved into North America from locales in northeastern Asia. Humans are thought to have been present in Alaska for at least 12,000 years, and perhaps much longer.[1] Eurasian ancestors of the indigenous people of Alaska—the Iñupiat, Yup'ik, Unangan, Eyak, Tlingit, Haida, Tsimshian, and a number of northern Athabaskan cultures—may have immigrated into what is now Alaska in one to three different waves. These waves of colonization occurred during periods of dynamic climate change at the end of the Pleistocene era, and eventually led to colonization elsewhere in northern North America. As inhabitants of these changing landscapes, ancestors of indigenous Alaskans became keen observers of their component flora and fauna, adapting to challenging environments and climates. Such observation of the natural world has long been suggested as a commonality among human cultures, linked to problem solving in both science and art. Given that human survival depended on sharp observation of surrounding environments and the interpretation of observed patterns within a predictive context, Paleolithic humans could thus be viewed as the world's first scientists. This close relationship between art and science has endured in indigenous peoples in Alaska and elsewhere, but the two disciplines began to diverge in Western civilization following the Enlightenment of the late seventeenth and eighteenth centuries, with its emphasis on reason and empiricism.

Europe was just entering the period of Enlightenment when Alaska was "discovered" by Western civilization, via the ill-fated Second Kamchatka Expedition of 1741, led by Captain-Commander Vitus Jonassen Bering. The expedition was one of the largest organized exploration enterprises in history, and it resulted in the mapping of most of the Arctic coast of Siberia, some parts of the North American coastline, and the Japanese islands. The expedition commenced in 1733 and ended a decade later, but the events leading to the discovery of Alaska began in the summer of 1741, when the sister ships *St. Peter* and *St. Paul* left Avacha Bay on the east coast of Kamchatka and headed east into uncharted waters.

Imagine being a naturalist standing on the deck of the *St. Peter* as she steered through the narrow mouth of Avacha Bay 275 years ago. Looking east, you see myriad flocks of gulls, kittiwakes, and cormorants circling overhead. An hour passes, then two, and you look back and see that the coastline has disappeared from view. Turning back to face east, you wonder how long it will take to see another shore; what landforms you will see; what plants and animals live there, and if they are different or similar to the plants you've left behind. These are presumably very different questions than the indigenous person asked himself 15,000 years ago, standing on that rocky shoreline, watching the sea otter and determining how to hunt it. But they are all questions emerging from observation.

Although other expedition members kept daily records, Bering's Second Kamchatka Expedition is most fully described in the journal of German naturalist George Wilhelm Steller (1709–46), who accompanied Bering aboard the *St. Peter* as a physician and

mineralogist. Steller's journal, dated from 1743, is a source document of incalculable historic and scientific importance. It also provides a narrative of bitter nationalistic rivalry and conflict, overwhelming physical and psychological adversity, and eventual deliverance from death—largely because of the courage and ingenuity of Steller, Lieutenant Sven Waxell, and their surviving shipmates. As such, Steller's journal is a fitting beginning to the recorded scientific and general history of Alaska.

Vitus Bering's 1741 expedition is one of history's most mythic voyages. Still considered terra incognita in many respects, Alaska defied exploration and punished harshly those who dared to try. According to Steller, Bering's expedition was able to explore only a few islands off the southern coast of southeast Alaska and the Aleutian Islands before the *St. Peter* was forced to turn back toward Kamchatka because of storms and scurvy.[2] Meanwhile, the *St. Peter*'s sister ship, the *St. Paul,* captained by Aleksei Chirikov, had become separated early in the expedition, and was similarly forced to turn back to Kamchatka following the disastrous and mysterious loss of both the *St. Paul*'s longboats and its crew on what is now called Baranof Island in Alaska's Alexander Archipelago. The *St. Peter* was eventually shipwrecked on the island that now bears the captain-commander's name, and on which he and over half the crew died of scurvy. Steller was the first European naturalist to describe a number of New World species observed throughout the expedition, including the nine months they were shipwrecked on Bering Island, which are meticulously recorded in his journals. Many of these species now bear his name: Steller's sea lion, Steller's jay*,* Steller's eider, Steller's sea eagle, and the now-extinct Steller's sea cow.

SCIENTIFIC EXPLORATION AT THE CROSSROADS OF EMPIRES

Following the "discovery" of sea otters, and seeing the potential for a lucrative wild fur industry and colonial expansion, Russian privateers and frontiersmen advanced into the Aleutian Islands and southwestern Alaska in the 1770s. Concurrently, other European explorers approached Alaska from the southeast. In the final decades of the eighteenth century, the English explorer James Cook sailed to the Pacific in three voyages, reaching Sitka and then sailing on to Prince William Sound, the Alaska Peninsula, and the Norton Sound in the third voyage (1778). Initially intent on discovering the fabled Northwest Passage, Cook set the standard as the first captain to record the principal geological features of the Alaska coastline.

The international race toward scientific discovery in support of colonialism was fierce: Spain sent frigates north from New Spain (California) in a failed attempt to ascertain the Russian penetration of Alaska, find a Northwest Passage, and intercept Cook in Prince William Sound. That voyage surveyed and generated maps of what became Bucareli Bay

in southeastern Alaska, as well as the coastline north to Port Etches on Hinchinbrook Island, Cook Inlet, and the Kenai Peninsula. England and Spain's voyages were followed in turn by France's Jean-François de Galaup, Count of La Pérouse, who (using maps created from the Arteaga and Bodega y Quadra expedition) visited the Gulf of Alaska in 1786 and traded with local inhabitants near Mount Saint Elias while exploring the environs and charting glaciers in Lituya Bay. Spain sent a second voyage to Alaska, captained by Alejandro Malaspina, that was well outfitted with botanists, cartographers, astronomers, and artists for coastal examinations, and that had goals similar to those of Cook's and La Pérouse's voyages: find a Northwest Passage and precious minerals, and map any settlements along the Northwest Coast. Other voyages of scientific exploration included the Billings-Sarychev Expedition (1785–1792), which described the northernmost coast of the Chukchi Peninsula, Aleutian Islands, and northwestern Alaska—an expedition that included the use of Aleut (Unangax) baidarkas to survey the coast of the eastern Aleutians and the Alaska Peninsula;[3] the Vancouver Expedition (1791–1795), which included the exploration of the southern coast of Alaska (April to August 1794), from Cook Inlet through the Alexander Archipelago and then south; the inaugural Russian circumnavigation of the globe (1803–1806), which included Yuri Lisiansky's voyage to Kodiak Island, the Gulf of Alaska, and Sitka; Otto Van Kotzebue's two voyages (1815, 1823) into the northern North Pacific in search of the Northeast Passage; Frederick William Beechey's expedition to Point Barrow (1825–1828) as part of an attempt to rendezvous with the failed Franklin Expedition; and Russian explorer, naturalist, and artist Ilya Voznesensky's ten-year (1839–1849) Russian Imperial Academy of Sciences–sponsored expedition to Russian America (Alaska and California).

SCIENTIFIC EXPLORATION AS RESOURCE INVENTORY

Scientific expeditions, sponsored by numerous American federal agencies and private institutions, continued immediately prior to and following the purchase of Alaska from Russia in 1867. These explorations were largely directed to inventory and collect examples of biological, archaeological, and ethnological resources (see figure 9.3). One American agency instrumental in supporting early scientific exploration in Alaska was the US Army Signal Corps. The corps established meteorological stations and observers throughout Alaska, providing incidental support to the Smithsonian Institution via the collection of scientific specimens. Beginning in the late 1890s, C. Hart Merriam of the US Biological Survey and the US National Museum directed surveys throughout the vast territory, which were then followed by other survey researchers, including Clark P. Streator, Albert Kenrick Fisher, Wilfred H. Osgood, Edmund Heller, and Olaus J. Murie. In 1898, Joseph Grinnell, who would later become the first director of

the Museum of Vertebrate Zoology at the University of California, Berkeley, joined gold prospectors and explored the Kobuk River and Kotzebue region, which led to the organization of the 1907–1909 Alexander Expeditions to southeastern Alaska and Prince William Sound. Expeditions supported by the American Museum of Natural History and others continued to augment scientific knowledge of the vast Alaska Territory from 1901 to 1959, the year Alaska gained statehood.

In 1917, the University of Alaska was established in Fairbanks, and in 1926, Charles E. Bunnell established a university museum and sent Otto W. Geist across remote regions of Alaska to collect archaeological and paleontological material. In 1946, the Geophysical Institute was established by the US Congress at the University of Alaska Fairbanks, with the mission to study the physical environment at high latitudes. In 1950, the Alaska Cooperative Fish and Wildlife Research Unit was created at the university, with the mission to understand the ecology of fish, wildlife, and their habitats.

THE ROLE OF OBSERVATION BY WESTERN EXPLORERS, SCIENTISTS, ARTISTS, AND NATURALISTS

During many of the expeditions and explorations that continue to the present day, scientists use their observational and creative thinking skills to document and analyze the physical environment (see figure 9.4). This documentation is often in the form of photographs, drawings, maps, or other graphical forms, as words alone are often insufficient to describe what is observed. Likewise, for Western scientists and artists surveying Alaska following Steller's voyage in 1741, the indelible impressions and information passed on about the lands and people of the North provided exceptional visual legacies that have both great artistic value and great scientific worth. During these expeditions, scientists and even ship's officers often provided their own artistic interpretations. Similarly, artists provided images of great scientific and historic value.

The desire to explore, record, and systematize knowledge emerging from the Enlightenment had a meaningful impact on Western art, including the close collaboration between artists and practitioners of the emerging methods of scientific reasoning based on the integration of deductive and inductive reasoning (leading eventually to what is now called the scientific method of hypothetical-deductive reasoning). European and American voyages of scientific exploration, inspired by this new confidence in science and reason, invariably included both scientists and artists, and these expeditions provided knowledge deemed necessary for the colonization of newly discovered lands followed by expansion (e.g., colonialism), the establishment of new trade routes, and the extension of diplomatic and trade relations to new territories. The Enlightenment provided a new motive for exploration—scientific curiosity—which added to

FIGURE 9.3 Spectacled eiders wintering in polynya in the central Bering Sea.

Photograph courtesy of the United States Geological Survey (USGS).

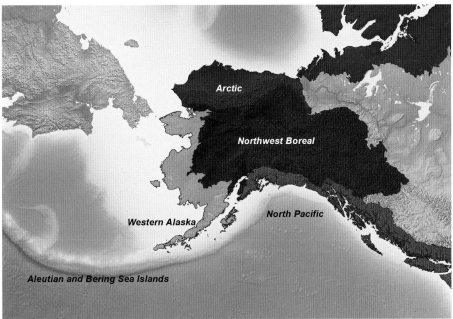

Arctic

Northwest Boreal

Western Alaska

North Pacific

Aleutian and Bering Sea Islands

FIGURE 9.4 Map of the five broad ecoregions of Alaska. Pearce and Talbot.

Image courtesy of the US Fish and Wildlife Service.

the commercial and political ambitions of the past.[4] Thus, while it was true that earlier (Russian) scientific explorations were concerned largely with exploration in support of colonialism and used the Imperial Navy—a military organization—to conduct those explorations, there was much support by Peter the Great and, at least early on, by Catherine the Great, in the quest for scientific knowledge.

Scientific expeditions conducted under the category of scientific curiosity played important roles in the theoretical underpinnings of scientific fields. For example, Olaus Murie's explorations of the Aleutian Islands led to a cautionary report of the vulnerability of native insular biota to the introduction of exotic predators, giving rise to the field of conservation biology.[5] Eric Hultén's recognition that flora on both sides of the Bering Strait was a major contribution to an understanding of the origin, history, and biogeography of plants of the Arctic laid the foundation for a deeper understanding of the importance of Beringia as a continental crossroads, as well as a cauldron of diversification of high-latitude species.[6]

WAR AND SCIENCE IN ALASKA

The geographic position of Alaska, where the continents of North America and Eurasia approach each other most closely, figured heavily in the military and technological developments of the twentieth century. The strategic importance of the region has long been recognized, leading to the establishment of naval and air bases in the Territory of Alaska prior to and during World War II, as well as to an increase in scientific and engineering support of military activities, including the largely forgotten Aleutian Island Campaign (June 1942–August 1943) during World War II. The Aleutian Campaign, which took place over a thousand miles of the archipelago, eventually ousted the Japanese, who had erected garrisons in the islands of Attu and Kiska—the only US soil held by the Japanese in the Asiatic-Pacific Theater. Research looking at historical data has determined that, while mass overwhelming compact power was the decisive factor in driving the Japanese from the region, extreme weather along the Aleutian arc disrupted all areas of battle (sea, air, and ground), necessitating joint operations that were nevertheless often rendered futile (Wilder 1993). Lessons learned in engineering, health, meteorology, and transportation technologies from the Aleutian Campaign facilitated the later US victory elsewhere in the Pacific Theater.

After World War II, it became clear that tension was building between the United States and the Soviet Union, leading to threats of intercontinental nuclear war. Given Alaska's geographic location between Siberia and the Lower 48, it was recognized that Alaska would be the first stop for Soviet bombers headed for the coterminous United States. As a result, the United States initiated a vast empire of complex technological

structures across remote Alaska, from the far western Aleutians to the Arctic coast. These included the Distant Early Warning (DEW) line, comprised of a network of long-range radars to provide early warning of a Soviet bomber attack. Another program of this era was the Nike Hercules air defense system, which replaced the aging anti-aircraft batteries remaining from World War II and provided a "nuclear shield" for strategic Alaskan military bases located near Fairbanks and Anchorage between 1959 and 1979.

In the 1950s, Alaska had only basic telephone communications systems. The White Alice Communications System (WACS) was a US Air Force telecommunications network of eighty radio stations, constructed in Alaska during the Cold War. The large, parabolic White Alice antennas, arranged in the landscape in a way that is strangely reminiscent of Stonehenge (see figure 9.5), used tropospheric scatter for links over the horizon and smaller microwave dishes for shorter line-of-sight links. The system connected remote US Air Force sites in Alaska, including the DEW Line and Ballistic Missile Early Warning System, but became obsolete following the advent of satellite communication. Elmendorf Air Force Base in Anchorage also had the AN/FLR-9, a large circular antenna array for high-frequency direction finding (or HF/DF) of high-priority targets that was built in nine locations worldwide during the Cold War. The worldwide network, collectively called "Iron Horse," could listen in on high-frequency communications anywhere on earth. Due to the AN/FLR-9's large, circular size (which included 1,056 vertical steel wires supported by ninety-six 120-foot towers), the antenna was often referred to as the Elephant Cage. The last remaining operational FLR-9 antenna array, located at Elmendorf Air Force Base, was decommissioned in 2016.

The Aleutian island of Amchitka was used as an airfield by US military forces during the Aleutian Islands Campaign of World War II. Amchitka was later selected by the US Atomic Energy Commission to be the site for three separate underground detonations of nuclear weapons, including the largest underground test ever conducted in the United States. The tests were highly controversial; public groups were concerned that they might cause severe earthquakes and tsunamis. Given that Amchitka is located directly over a fault, those concerns were not unfounded.[7]

Not all Cold War projects were intended for defense against a Soviet attack. In 1958, the Atomic Energy Commission proposed Project Chariot—a project that would have constructed an artificial harbor at Cape Thompson on the North Slope of Alaska by burying and then detonating a string of nuclear devices. The project was part of a research project, Operation Plowshare, that attempted to find peaceful uses for nuclear explosives. Project Chariot was championed by Edward Teller, a theoretical physicist known as the "father of the hydrogen bomb." The project was supported by Alaskan political leaders, newspaper editors, church groups, and the University of Alaska's

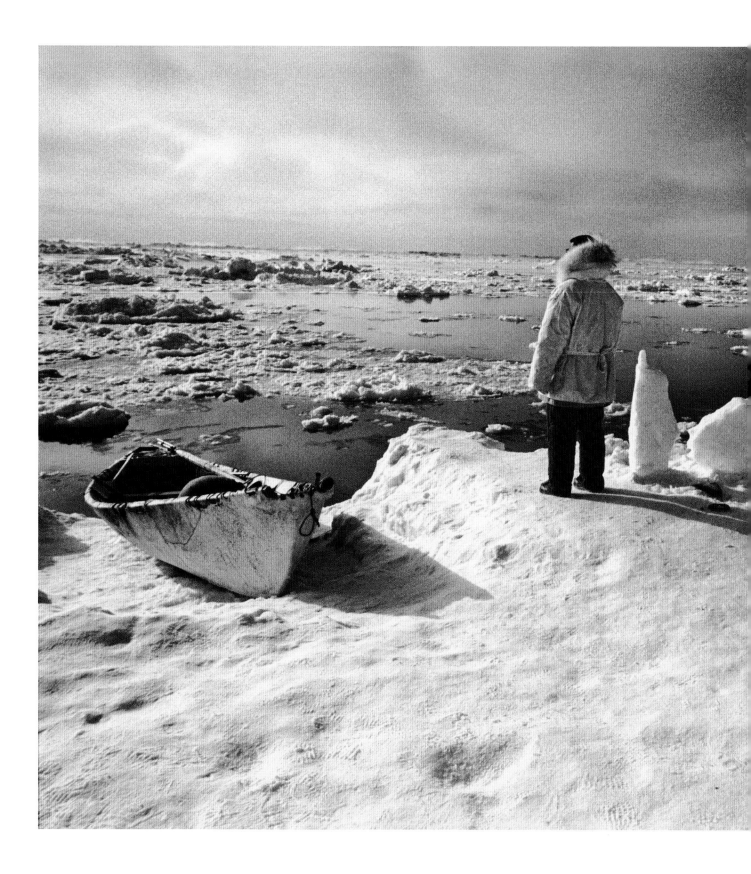

JOHN PEARCE AND SANDRA TALBOT

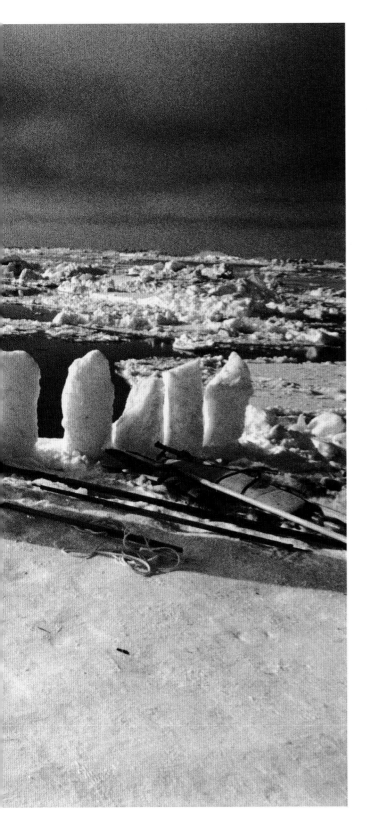

president at the time, but was opposed by local citizens of the Iñupiat village of Point Hope, among others. Iñupiat artist Ken Lisbourne was just a boy growing up in Point Hope when his grandmother joined the opposition to Project Chariot. His work, which consists largely of watercolor paintings, derives primarily from what he knows and has observed in reality and in his dreams. In one of his dreams, he observed what might have been the impact on the local ecosystem if Project Chariot had come to fruition (see figure 9.6).

Another postwar innovation that arose from Alaska's unique climate and logistical challenges was the Arctic Aeromedical Laboratory, based at Ladd Air Force Base (which later became Fort Wainwright). The laboratory comprised a team of civilian and military researchers directed to increase efficiency in waging war in cold conditions. Examples of the "quirky and creative" studies of the Arctic Aeromedical Laboratory include the "Walk-Around Sleeping Bag," which allowed the user to walk around during a survival situation, and "bunny boots" and gloves powered by a seven-pound battery vest that helped the wearer stay warm while remaining still at −40°F.[8] Other research included development of cold-climate housing, studies of hibernating animals, a simulated survival trek from Anaktuvuk Pass to the Arctic Ocean by military staff, and research on the mental well-being of soldiers posted in northern latitudes.

The most controversial project undertaken by the Arctic Aeromedical Laboratory was a thyroid function study in 1956, which used radioactive iodine to trace thyroid activity in nineteen volunteer military personnel and 102 Alaska Natives from five northern villages.

FIGURE 9.5 Image of Iñupiaq whaling.

Bill Hess, American, born 1951, untitled, 1983. Photograph, 32 × 47 cm. Collection of the Anchorage Museum.

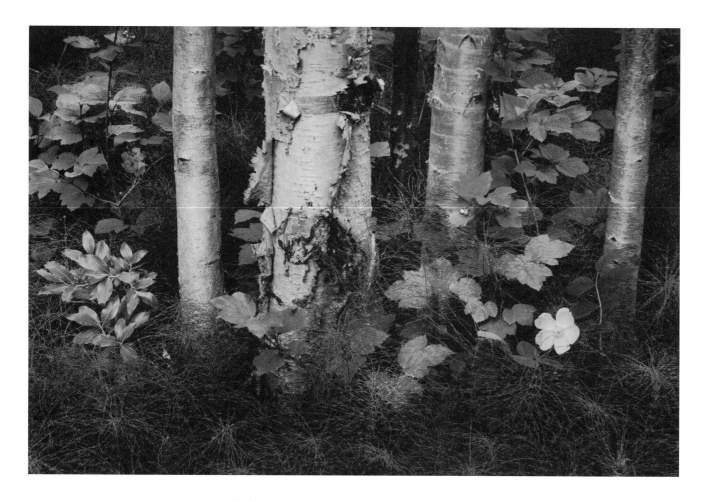

FIGURE 9.6 Birch tree bark, boreal forest.

Barry McWayne, American, 1943–2010. Photograph, 41 × 51 × 2 cm. Collection of the Anchorage Museum.

In the 1990s, Congress requested an independent investigation of the study and an evaluation of its appropriateness. The evaluation made several recommendations, finding a lack of cultural sensitivity and flaws with the informed consent process used in the study. The legacy of such studies is a difficult history to overcome, and communication remains a priority for conducting scientific pursuits in Alaska and understanding the significance of those resources for the many people who rely on healthy environments for subsistence and cultural activities.

THE ENVIRONMENTS OF ALASKA

Flying from Anchorage to Barrow, Bethel, Dutch Harbor, or Ketchikan, one can create a mind map of the fabric and structure of the regions that people from different

JOHN PEARCE AND SANDRA TALBOT

communities recognize as home. But visitors, whether from outside Alaska or from a different part of the state, likely look at the unfamiliar land and begin to search for patterns, to imagine what the land would look like up close and what one might find there. Visiting scientists and hunters describe "straining their senses" when entering a new landscape to make sense of the unfamiliar, to organize sights and sounds into patterns that can then be better understood, or to determine a pathway forward to discovery.

The name Alaska is derived from an Unangan term *Alakshak,* which refers figuratively to the mainland, or "place to which the action of the sea is directed."[9] Thus, the name arose from observations of ocean patterns. The name is also attributed to *Alyeska,* the Unangan word for "the great land." Greatness comes not only from the vast and open landscape, but from the diversity of land types—a result of the unique positioning of Alaska on the shoulder of North America, with an outstretched arm of islands reaching across the North Pacific. Geologic, climatic, and geographic history has led to a diverse array of environments in Alaska, contributing to many of the region's most significant scientific discoveries: the world's spectacled eiders wintering in the central Bering Sea in holes in the pack ice (see figure 9.7), the Bering Land Bridge, the movement of the earth's tectonic plates (which led to the 1964 Great Alaska Earthquake), and the major petroleum-bearing rock formations of Arctic Alaska that continue to drive oil exploration and economic, political, and land management practices in the region.

MAJOR LAND CLASSES

Studies of Alaska's environmental regions, or "eco-regions," have identified between nineteen and thirty distinctive land types.[10] These eco-regions were categorized by bringing together information on climate, geology, soils, permafrost, glaciation, hydrology, and vegetation. Additionally, thirty eco-regions have been named for the marine areas of the Arctic Ocean, Bering Sea, and Gulf of Alaska that surround Alaska, determined by differences in ocean bottom topography, current flow, and patterns in animal distribution.[11] On a broader scale, five major land classes—the Arctic, the Northwestern Boreal Forest, Western Alaska, Aleutian and Bering Sea Islands, and the North Pacific (see figure 9.8) and four large marine ecosystems—the Beaufort Sea, the Chukchi Sea, East Bering Sea, and the Gulf of Alaska—are recognized.[12]

The Arctic is perhaps the best known of all of the land classes, and it is also the most enigmatic (see figure 9.9). The Arctic is identified by many as "ground zero of climate change," where effects of climate warming are being observed. Climate warming is occurring more rapidly here, up to twice the rate as elsewhere on the planet, and ecosystems are responding in both positive and negative ways. The Arctic is a circumpolar

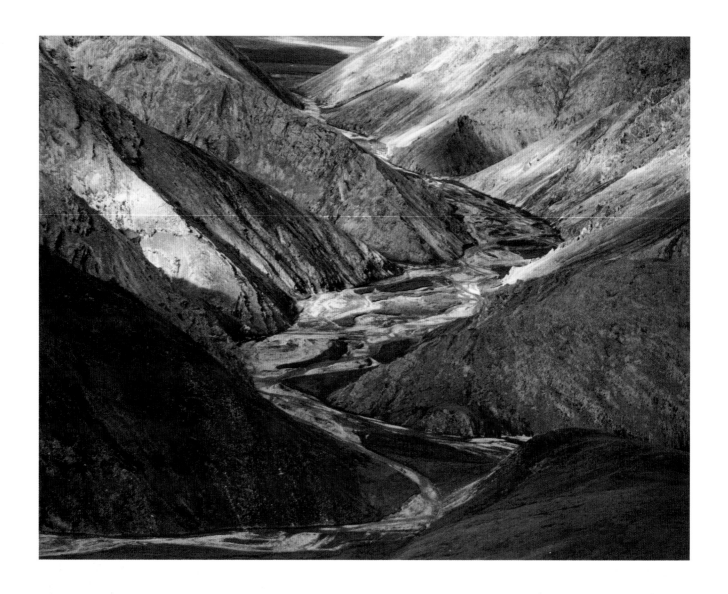

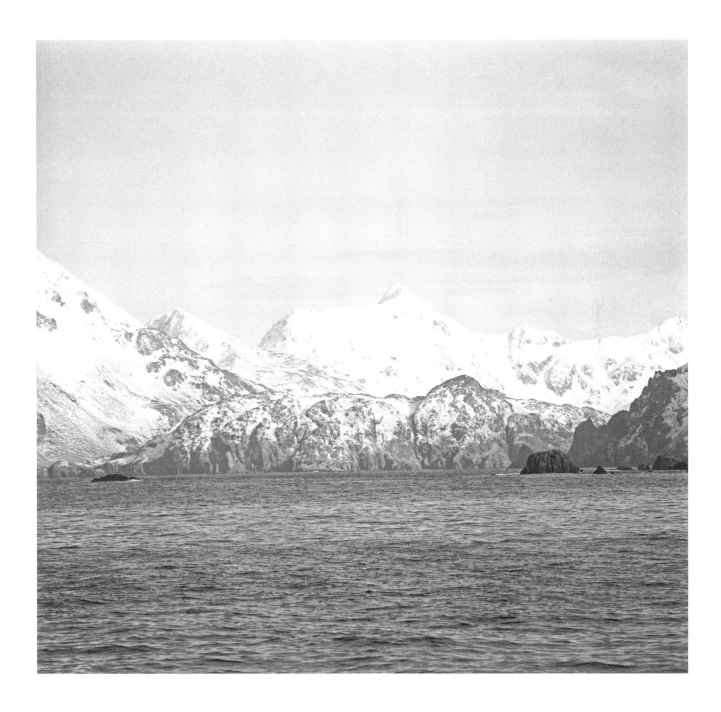

FIGURE 9.8 Adak, Alaska, March 1963.

Steve McCutcheon, American, 1911–1998, untitled. Photograph, black-and-white negative, 6 × 6 cm. Collection of the Anchorage Museum.

FIGURE 9.9 Debris washed up on the beach.

Photograph courtesy of iStock.

region that has been defined geographically as latitudes above 66 degrees north—any land north of the Arctic Circle. Numerous other definitions also exist, however, since similar environmental and natural resources occur outside this boundary.

In Alaska, the political border of the Arctic (established by the Arctic Research and Policy Act of 1984) extends south to include all of the Bering Sea, as well as parts of western and northwestern Alaska. This southern extension to Alaska's definition of the Arctic includes the interconnectedness of the Arctic Ocean and the Beaufort, Bering, and Chukchi Seas. These marine areas are known for changing sea ice patterns and ocean currents that fuel a spectacular array of life, including algae, plankton, bivalves, crabs, fish, marine mammals, and sea birds. On shore, coastal tundra rises as one moves inland, meeting the foothills and peaks of the Brooks Range. Continuous permafrost is found across the region, except under large rivers and thaw lakes, and contributes to

JOHN PEARCE AND SANDRA TALBOT

a variety of land surface features such as pingos, ice-wedge polygonal tundra, and lakes that are oriented in the same direction due to wind. The abundance of these lakes and highly saturated soils contributes to vast isolated and interconnected wetlands that are used by numerous species of fish and migratory birds.

The North Slope of Alaska also serves as the summer calving range for four caribou herds whose population exceeds nearly half a million. But recent declines in caribou numbers, particularly in the Western Arctic caribou herd (which has decreased from 490,000 animals in 2003 to around 200,000 today), raise questions about climate-related changes to summer and winter food resources. In contrast, shrinking sea ice has created beneficial conditions for geese in the Arctic. Loss of sea ice has increased ocean wave action, leading to erosion and saltwater inundation of coastal habitats. Saltwater-tolerant plants are now thriving in these areas, and this appears so far to be a positive outcome for geese in the Arctic. This finding is in contrast to the negative effects that declining sea ice is having on habitats of ice-dependent animals, such as polar bears and walruses. These and other ice-dependent marine mammals are facing new choices: stay with the ice and confront new polar environments where food may be harder to find and access, or spend more time on land. Land use by walruses and polar bears has increased in recent years, with walruses hauling out onshore (instead of on pack ice) regularly since 2007, and polar bears becoming more frequent visitors to coastal communities.

Just to the south of the Arctic region is the Northwest Boreal Forest (see figure 9.10), which crosses international borders to include parts of Alaska, the Yukon Territory, northern British Columbia, and the western Northwest Territories of Canada. The Northwest Boreal region is characterized by discontinuous permafrost and vegetation, and is dominated by black and white spruce, birch and aspen woodlands, and tussock and scrub bogs. Historically, forest fires have played a significant role in ecosystem dynamics in this massive forest. Recent research suggests that boreal wetlands are largely resilient to fire events. While it has been predicted that forest fires will become more frequent or intense in the warming climate, it is unknown whether (or which) wild species can adapt to such alterations in fire regimes. In boreal forest systems that are currently well adapted to shallow soils, limited by permafrost and lower winter temperatures, it is unknown yet what the likely responses of millions of migratory songbirds (warblers, sparrows, and woodpeckers) and water birds (grebes, loons, ducks, geese, and swans) that breed in the region will be. Recent research suggests some resiliency to these changes, with evidence that ecosystems can withstand and adapt to ongoing changes. But other research finds evidence for major shifts in boreal forest

biodiversity, with plant, bird, and small mammal populations shifting northward to the Arctic to maintain their affiliation with colder climates.

Western Alaska—the Seward Peninsula, the Yukon-Kuskokwim Delta, and the Bristol Bay and Alaska Peninsula region—are thought to be the regions that the Unangan named "Alaska." This is the land that the sea is directed toward, on the doorstep of the Bering Sea, the Bering Land Bridge, and Eurasia (see figure 9.11). Beringia was a large, ice-free refugium during prior glacial advances, and multiple species are thought to have recolonized the Arctic from Beringia after the ice sheets receded.[13] Beringia was itself recolonized by species expanding out of glacial refugia, mostly from the South.[14] Thus, the region has long been hypothesized as playing a central role in the diversification of populations of Arctic biota.[15] The Bering Land Bridge that connected Eurasia and North America during glacial periods facilitated transcontinental migration of plants, animals, and humans. Eastern Beringia (largely Alaska) has represented a true crossroads of the continents for tens of thousands of years. Strong ecological affinities to Eurasia remain with the presence of long-distant migrant birds (e.g., gray-headed chickadee, yellow and white wagtails, and bluethroat) and similar resident plant and small mammal populations. The strong geographical connectivity to Eurasia also allows for movement of microscopic travelers between continents. Following the outbreak of H5N1, a highly pathogenic avian influenza, in China in 2005, research identified Western Alaska as a likely portal for foreign-origin pathogens. No highly pathogenic avian influenza has been detected in Alaska, but up to 70 percent of the other avian influenza viruses isolated in this area were found to contain genetic material from Eurasia—likely all due to migratory bird flyways that have connected continents there for generations.

Each landscape in Western Alaska has its own unique identity. The Seward Peninsula is rugged and mountainous, with coastal lowlands and interior areas of tussock tundra and large rivers. A remnant of the Bering Land Bridge, the peninsula is a piece of what once was a thousand-mile-wide bridge of land that connected Eurasia to mainland Alaska during the Pleistocene epoch.

Shrubs are increasing their coverage in habitats on the Seward Peninsula. Recent findings suggest that increases in shrub cover and density will negatively affect abundance of only a few bird species and may potentially be beneficial for many others. But as shrub height increases further, a considerable number of tundra bird species will likely find preferred habitats increasingly unsuitable.

Farther south, the Yukon and Kuskokwim Rivers meet and fan out into a broad delta region that drains into the Bering Sea. The Yukon-Kuskokwim Delta is a vast and highly productive estuarine environment dominated by brackish marshes, wet meadows, and tundra underlain by continuous permafrost of varied thickness. Autumn storm surges are known to push saline waters far inland over the low delta.

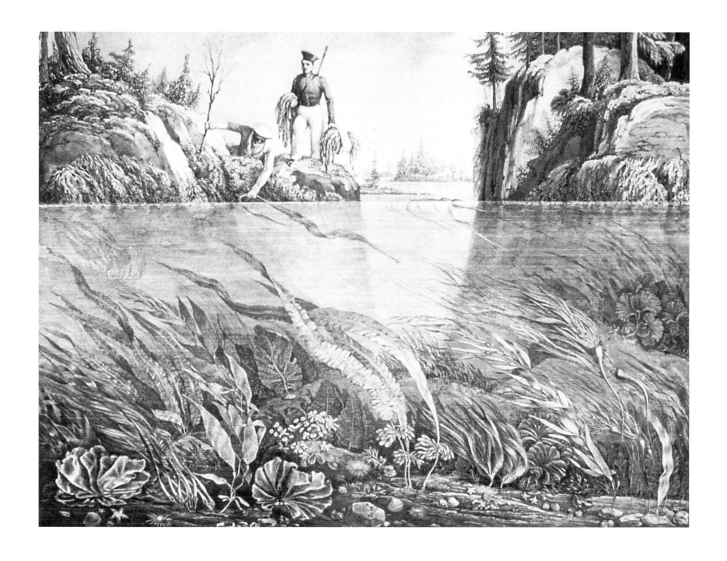

FIGURE 9.10 This image shows naturalist Karl H. Mertens, left, and a seaman from the Seniavin collecting fresh algae in a tidal pool in Sitka Sound in 1827.

Lithograph in A. Postels and F. Ruprecht, *Appleton's Library Manual: Containing a Catalogue Raisonné of Upwards of Twelve Thousand of the Most Important Works in Every Department of Knowledge* (San Bernadino, CA: Ulan Press, 1847). Collection of the New York Botanical Garden.

FIGURE 9.11 Field expedition journal covers.

Photograph courtesy of R. Gill Jr., research wildlife biologist, United States Geological Survey (USGS).

Several historically abandoned village sites lie within the area of the largest flood events. With projected sea level rise, and the expectation that large storms may become more frequent and cover larger areas, it's likely that there will be both positive and negative effects on freshwater ponds, nonsaline habitats, permafrost, and landscapes used by nesting birds and local people. Dense concentrations of wetlands, lakes, and ponds in the delta support thousands of nesting waterfowl and shorebirds, including Pacific black brants, emperor geese, tundra swans, sandhill cranes, Sabines' gulls, black turnstones, and western sandpipers.

One more giant step south, and the ragged coastline gives way to the Bristol Bay region, a flat to gently rolling lowland that contains a large concentration of lakes, ponds, meandering rivers, and wetlands. This region supports the largest run of sockeye salmon in the world, with the annual return of spawning salmon from the Pacific Ocean bringing rich marine-derived nutrients into the watershed that fuel both aquatic and terrestrial food webs. The Bristol Bay region provides habitat for diverse wildlife, including at least 29 fish species, more than 40 terrestrial mammal species, and more than 190 bird species.

The Aleutian and Bering Sea islands are isolated volcanic mounts spread across the ocean space between Alaska and Russia. Known as the birthplace of winds, the Aleutian Islands are a western continuation of the Aleutian Range on the Alaska Peninsula, comprising fourteen summits that rise from the water to form a perforated wall between the North Pacific and the Bering Sea, reaching from the Alaska Peninsula to the Kamchatka Peninsula of Russia. Five primary island groups are found in the Aleutian Island archipelago: the Fox Islands, the Andreanof Islands, the Islands of the Four Mountains, the Rat Islands, and the Near Islands.

The Aleutian Island arc and deep sea trench are products of the Pacific crustal plate subducting, or descending, beneath the North American crustal plate. This is one of the most seismically and volcanically active areas in the world. There are over seventy-five major volcanoes in the archipelago, many of which have been active since 1760, and recent reports find geological evidence for large earthquake-generated tsunamis, occurring on average every 300 to 340 years. The Bering Sea Islands (comprising the Pribilof Islands, Saint Lawrence Island, the Diomede Islands, Saint Matthew Island, and several other uninhabited islands) sit in the shallower areas of the Bering Sea. The oceanography and ecology of the entire region results in a highly productive habitat that provides

approximately 40 percent of the US commercial fisheries catch, with a value exceeding $3 billion annually, according to the Northern Pacific Research Board. The rocky and vegetated cliffs of the Aleutian and Bering Sea islands provide nesting habitat for over 40 million sea birds of more than thirty species. Staggering numbers of birds are drawn to these islands by the rich productivity of surrounding oceans, which provide forage to sustain adults and their young. Some subspecies of birds of the Aleutians are found nowhere else (six subspecies of rock ptarmigan are found only in the Aleutians), as are some endangered and threatened marine mammals, such as the Steller sea lion. The islands were free of land-based predators until the eighteenth century, when Russian fur traders introduced foxes and continued maritime traffic introduced rats to the islands. These introductions drastically reduced many seabird colonies.[16] Recent efforts have eliminated or greatly reduced previously introduced predators on some islands, and seabird numbers have rebounded as a result. Additional invasive species are known, such as hawkweed on Adak Island, as well as marine invertebrates carried by warmer waters and in the ballast waters of international vessels that pass through the region.

The North Pacific stretches south from the Kodiak Archipelago, through the south-central portions of Alaska that include Cook Inlet and Prince William Sound, and south to the Southeast Panhandle of Alaska. Fjords, glacial valleys, and tall mountains dominate the coastline. Hundreds of salmon-bearing streams, riparian wetlands, spruce forests, and alpine meadows occur here. Ocean currents figure prominently in this eco-region; the Alaska current moves north along the coast and then back south into the North Pacific, a counterclockwise pattern that stems from the much larger North Pacific Subtropical Gyre (NPSG). The NPSG has received attention recently, as the eddy-like effects of the gyre retain pollutants in its center.

Following the December 2011 tsunami in Japan, plastic debris, invasive species, and other flotsam highlighted the ocean current connection between Asia and North America. Substantial debris traveled eastward on the NPSG to the West Coast of the United States in 2012. Some of the debris then tracked north along the Alaska gyre, resulting in tons of plastic trash on the shores of Alaska. It is rumored that the plastic "soup" within the center of the NPSG is anywhere from the size of Texas to the size of the entire United States. The gyre has also received attention because of the El Niño currents carried north along the Pacific coast of the United States, which is thought to have been responsible for the "blob"—a large patch of warm water that has driven forage fish stocks to deeper, colder water and led to a massive die-off of seabirds throughout the North Pacific, largely due to starvation. This conveyor belt of ocean currents from Asia and the continental United States makes the North Pacific region a potential gateway for invasive species into Alaska. Agencies and the public are on the lookout for marine invasive

species in this region, such as *Didemnum vexillum,* or *D. vex.* This colonial sea squirt, found in Sitka, has the potential to smother native organisms growing on the seafloor, a habitat that is economically important for groundfish. It is expected that European green crab—a voracious predator of native shellfish and crabs, including juvenile Dungeness crab—may also spread north from British Columbia to Alaska through larval transport.

Onshore, much of the coastline of this region is bordered by the northern limit of the temperate rainforest in North America. A coastal foreland extends from the Copper River Delta southeast to Icy Point. Coastal islands add to the region's biocomplexity. Kodiak Island hosts a genetically distinct population of brown bears that have been isolated for twelve thousand years. Along with the bears of the nearby Alaska Peninsula, they are the largest bears in the world—a large male can stand over ten feet tall when on his hind legs and weigh up to fifteen hundred pounds. Farther south, the Alexander Archipelago extends three hundred miles offshore and comprises more than a thousand islands. The Alexander Archipelago is thought to have provided an ice-free Pleistocene refugium for numerous species on southern outer islands, as well as a possible marine dispersal corridor for humans moving southward from Beringia.

While this list of major marine and terrestrial environments of Alaska is convenient, it does not reflect the importance of transition zones (or ecotones) that occur where different habitats and landforms meet. In the North Pacific eco-region, it is said that glaciers essentially talk to oceans with glacier-fed streams that have unique biological, chemical, and physical traits that are carried and passed on to freshwater and ocean systems downstream. Glacial runoff helps maintain cool water temperatures in streams during the warm summer months, fueling phytoplankton growth at the bottom of the food chain and carrying the dissolved oxygen required for spawning salmon and other fish and aquatic organisms. The difference in temperature and density between glacial runoff and ocean water also helps drive the Alaska Coastal Current. Like a giant conveyor belt, the current carries nutrients and organisms throughout the Gulf of Alaska, passing the Aleutian Islands into the Bering Sea. This is just one example of the energy flow between ecosystems, but there are countless other examples, such as the Yukon River, the current flow from the North Pacific to the Bering Sea, and the caribou migration from boreal forest to Arctic tundra each spring and back again in the fall.

The high environmental and ecological diversity of Alaska is unique among similarly sized landscapes elsewhere in the world. The abundance of unusual features yields a fantastic trivia list suitable for any geography quiz:

- Land that extends across 17 degrees of latitude and 43 degrees of longitude;

- 34,000 miles of tidal shoreline, 3 million lakes, 10,000 rivers and streams, and the 14 highest peaks in North America;

- Mount Shishaldin, a smoldering volcano in the Aleutian Islands that rises to 10,000 feet, forming the most perfect volcanic cone on Earth, even more symmetrical than Japan's Mount Fuji

- One of the world's largest tides: the tidal difference in Turnagain Arm, just south of Anchorage, can be more than 35 feet (10.7 meters) and boasts the world's largest and only bore tide in the North;

- Permafrost covering 188,320 square miles (487,747 square kilometers), mostly in northern, western, and southwest regions;

- Glaciers comprising 5 percent of the state, an area larger than the thirteen smallest states in the Lower 48 combined; and

- Over 500 naturally occurring species of birds, 116 species of mammals, and over 1,700 varieties of vascular plants

This geographical abundance attracts rivers of migratory wildlife that travel hundreds, or sometimes thousands, of miles each spring to feed and reproduce in Alaska's ecosystems. Among birds, the bluethroat travels from Africa, the Arctic tern from the tip of South America, and the bar-tailed godwit from New Zealand. Humpback whales swim from Hawaii and Mexico, and salmon gather from throughout the Pacific Ocean. When fall arrives, the tidal surge of life pulls back and Alaska reverts to a less plentiful garden. However, even during that relatively quiet time of year, Alaska is not devoid of wildlife. Many animals remain throughout the winter: bears, walruses, Arctic foxes, numerous smaller mammals, ice seals, several fish and numerous bird species, and one frog. Many of these resident species have developed unique adaptations to persist through the cold Alaskan winters. Wood frogs in Alaska have adapted to winter temperatures by freezing and thawing in concert with external temperatures via a complex process that allows for ice accumulation within the body. The black-capped chickadee uses temporary hibernation or torpor to manage cold stress and reduce energy needs, while burning up to 10 percent of its body weight in fat to provide fuel for the night. The Alaska blackfish can tolerate hypoxic waters in both summer and winter conditions due to a modification of the esophagus that facilitates capture of atmospheric oxygen, and can be super-cooled to as low as −5°F for short periods. The ice worm thrives in the forever winter of Alaska's glaciers and adjacent ice fields, aided by the evolution of antifreeze genes that protect the it in the near-freezing temperatures. Some species are capitalizing on changes such as decreased winter sea ice and warmer temperatures to extend their annual stay in Alaska: the number of Pacific black brants spending the winter at Izembek Lagoon has increased from less than 5,000 birds in the early 1980s to greater than 50,000 birds in 2015.

All of this diversity sits on the northern end of the earth's axis, tilted toward the sun in summer and away in the winter. This to-and-fro axial tilt plays an important role in shaping the environmental diversity of Alaska. The significant shift in seasons fuels the tremendous in-and-out surges of productivity in oceans and on land during summer, which in turn facilitates animal migration and adaptation.

THE ENVIRONMENT OF ALASKA: A CRITICAL PLACE TO TEST NEW INNOVATIONS

Alaska's vast, diverse, and unique environment has always provided a critical testing ground for new innovations, such as the Unangan *baidarka,* and this crucible of creativity and problem solving continues today. From a recreational standpoint, development of modern fat bikes was stimulated by the first Iditabike race, which challenged riders to travel two hundred miles of Alaskan backcountry in winter, following snowmobile and dog mushing trails. The course follows the first section of the historic Iditarod trail, a trail that continues on with an additional one thousand miles to Nome. Conditions along the Iditabike trail are variable, from liquid water to snow and glare ice. These harsh conditions challenged riders to improve their equipment, which led to the development of a wider tire footprint.

Prompted by economic incentives, the discovery of vast oil reserves on the North Slope and offshore of Alaska has led to innovations in offshore oil drilling exploration, directional drilling, and the construction of ice roads and gravel pads to facilitate transportation into remote areas of the Arctic. LIDAR (or Light Imaging, Detection, and Ranging) technology has also been implemented in the design and planning of effective gas pipelines. Other forms of technological advancement have arisen in response to the need for better imagery and visualization across Alaska's remote landscapes. Alaska's drone test site is one of the nation's six research locations selected to develop guidelines for unmanned aircraft systems, and is currently testing drones for accuracy in locating, identifying, and counting large wild animals in remote Alaskan locales. Innovative application of ground-penetrating radar (GPR), which collects images of underground structures to study the formation of ice layers due to surface melting, uses a method similar to medical ultrasound imagery.

THE FUTURE OF SCIENCE AND ENVIRONMENT IN ALASKA

We don't yet know what the next significant scientific discoveries for Alaska will be, or whether all of the landscapes will be mapped, the species listed, and the unknowns of the natural world revealed. New observations and discoveries will undoubtedly

continue, largely for two reasons. The size of Alaska is immense, and the rate of change in Alaska's environments is rapid. There is limited road access to much of the state, and the often difficult weather conditions and logistics of mounting explorations and making new discoveries are challenging. It is difficult to fully characterize the complexity of ecological systems such as the Bering Sea, the Arctic, the boreal forest, and the relationships with sister ecosystems in Russia and Canada, particularly with the rapid rate of change taking place across Alaska's varied environments. For many areas, the types of changes and their implications into the future remain unknown, and thus these are fertile areas for creative thinking and discovery.

Valuable observations and contributions to science in Alaska are not limited to professional scientists. Informed community members and nonprofessional scientists are often the first ones to observe on-the-ground changes and provide important information about new or changing conditions. Networks such as the Alaska Native Tribal Health Consortium's LEO (Local Environmental Observer) Network has vested incredible power in local observers of change and new sightings. Similarly, we are in an age of digital expeditions and discovery, with a vast amount of data that is continually released and posted to discoverable sites. This is an age of citizen science: crowd sourced and community driven. Given the difficulty of tracking the rate of change in Alaska, such crowd-sourced observational science can greatly inform a broader community of professional scientists about current and emerging issues on the landscape. Such networks also serve to educate all of us about local identities and the value of the land and its resources to all Alaskans.

New science education and observation programs continue to support the idea that the North is an important component of the future of science and technology, with greater emphasis on STEM (Science, Technology and Mathematics) teaching and learning from all areas of Alaska. The Alaska Native Science and Engineering Program (ANSEP) is bridging the gap between Native Alaskan communities, conservation science, and natural resource management, providing a longitudinal education model that encourages and supports young Native Alaskan students' formal training in science and engineering. At international levels, the goals of the Arctic Council, an intergovernmental forum including Arctic states, indigenous communities, and other Arctic inhabitants, also echo important priorities for Alaska: to strengthen and integrate observations and data in the Arctic, to apply new scientific understanding of the Arctic to build regional resilience and shape global responses, and to use Arctic science as a vehicle for STEM education and community and citizen empowerment.

The state motto of Alaska is "North to the Future," which captures the history of opportunities and the promise that Alaska holds. "North to the Future" could apply to the millions of migratory wildlife that journey to the North each spring to raise young

in the productive northern ecosystem. Even geologic forms and plates have been moving north from faults deep in the Pacific Ocean as subduction zones, earthquakes, and volcanoes that define much of Alaska and contribute to its mineral and ecological wealth.

However, there are other movements into Alaska besides those from the south. Alaska was colonized by the eastward movement of species, including humans during cooling periods when the Bering Strait became the Bering Land Bridge. Alaska was also colonized from the east by the first European explorers, followed closely thereafter by immigrants from the South. Alaska is a destination for travelers from all directions and will continue to be a crossroads of continents.

The increased knowledge of ecological and geophysical/geochemical contributions of the Arctic has yielded the phrase "What happens in the Arctic doesn't stay in the Arctic." The Arctic Research Policy Act of 1984 extended the boundary of the Arctic in Alaska to include the entirety of the Bering Sea, recognizing how marine currents connect all of Alaska, the Arctic and sub-Arctic. Similarly, other currents from the Arctic extend to the continental United States. Residents of the eastern United States have recently experienced record snowfall and low temperatures due to a weakening of the polar vortex in the Arctic: a low-pressure system that builds in winter, which, in the past, has remained at high latitudes. But with a growing similarity of temperatures between Arctic and lower latitudes, the polar vortex is weakened and Arctic air flows farther south, creating unusual weather conditions in North America and Europe. Other resources in Alaska, such as the North Pacific fisheries and wildlife, and the energy resources of the boreal forest region, are also globally and continentally important.

As we explore and encounter the environments of Alaska, patterns emerge that we can use to help prepare for a future in the North. Certainly, the power of observation and subsequent creative thinking and discovery remains in all landscapes and situations, and the success of any hunter or scientist relies on observation. The question remaining is what we will do with our findings.

SUGGESTIONS FOR FURTHER READING

Fitzhugh, W. W., and A. Crowell. *Crossroads of Continents.* Washington, DC.: Smithsonian Institution Press, 1988.

Ford, C. *Where the Sea Breaks Its Back: The Epic Story of Early Naturalist Georg Steller and the Russian Exploration of Alaska.* Boston, MA: Little, Brown and Company, 1992.

Haycox, S., J. Barnett, and C. Liburd, eds. *Enlightenment and Exploration in the North Pacific, 1741–1805.* Seattle: University of Washington Press, 1997.

Hultén, E. *Outline of the History of Arctic and Boreal Biota during the Quaternary Period.* New York: Lehre J. Cramer, 1937.

O'Neill, D. *The Last Giant of Beringia: The Mystery of the Bering Land Bridge.* New York: Basic Books, 2004.

NOTES

1 C. M. Barton, G. A. Clark, D. R. Yesner, and G. A. Pearson, eds., *The Settlement of the American Continents: A Multidisciplinary Approach to Human Biogeography* (Tucson: University of Arizona Press, 2004); D. B. Madsen, ed., *Entering America: Northeast Asia and Beringia before the Last Glacial Maximum* (Salt Lake City: University of Utah Press, 2004); F. H. West, ed., *American Beginnings: The Prehistory and Palaeoecology of Beringia* (Chicago: University of Chicago Press, 1996).

2 O. W. Frost, ed., *Georg Wilhelm Steller: Journal of a Voyage with Bering, 1741–1742* (Stanford, CA: Stanford University Press, 1988).

3 A. L. Narochnitskii, *Russkie ekspeditsii po izucheniiu severnoi chasti Tikhogo okeana vo vtoroi polovine XVIII v. (sbornick dokumentov),* vol. 2 of *Issledovaniia russkikh na Tikhom okeane v XVIII-pervoi polovine XIX v,* compiled by T. S. Fedorova, L. V. Glazunova, and G. N. Fedorova (Moscow: Izdatel'stvo "Nauka," 1989).

4 L. Hackett, *The Age of Enlightenment: The European Dream of Progress and Enlightenment* (Chicago: University of Chicago Press, 1992).

5 O. J. Murie, "Fauna of the Aleutian Islands and Alaska Peninsula," *North American Fauna* 61 (1959): 91–94.

6 E. Hultén, *Outline of the History of Arctic and Boreal Biota during the Quaternary Period* (New York: Lehre J. Cramer, 1937).

7 E. R. Engdahl, "Seismic Effects of the MILROW and CANNIKIN Nuclear Explosions," *Bulletin of the Seismological Society of America* 62 (1972): 1411–1423, doi:10.2172/4687405.

8 N. Rozell, "North Lab Cranked Out the Quirky and Creative," University of Alaska Fairbanks Geophysical Institute, November 13, 2014, www.gi.alaska.edu/alaska-science-forum /northern-lab-cranked-out-quirky-and-creative.

9 J. E. Ransom, "Derivation of the Word 'Alaska,'" *American Anthropologist* 42 (1940): 550–551.

10 A. L. Gallant, E. F. Binnian, J. M. Omernik, and M. B. Shasby, *Ecoregions of Alaska*, US Geological Survey Professional Paper 1567 (Washington, DC: US Government Printing Office, 1995).

11 J. F. Piatt and A. M. Springer, "Marine Ecoregions of Alaska," in *Long-Term Ecological Change in the Northern Gulf of Alaska*, ed. Robert Spies, 522–526 (Amsterdam: Elsevier, 2007).

12 Large Marine Ecosystems of the World website, www.lme.noaa.gov, accessed May 28, 2016.

13 Hultén, *Arctic and Boreal Biota*.

14 J. R. Stewart and A. M. Lister, "Cryptic Northern Refugia and the Origins of Modern Biota," *Trends in Ecology and Evolution* 16 (2001): 608–613.

15 A. L. Rand, "The Ice Age and Mammal Speciation in North America," *Arctic* 7 (1954): 31–35; A. H. MacPherson, "The Origin of Diversity in Mammals of the Canadian Arctic Tundra," *Systematic Zoology* 14 (1965): 153–173.

16 D. D. Gibson and G. V. Byrd, *Birds of the Aleutian Islands, Alaska* (Cambridge, MA, and Washington, DC: Nuttall Ornithological Club and American Ornithologists' Union, 2007).

POLAR POP

A Perception
of Place

AARON LEGGETT

Whenever I meet somebody from outside of Alaska, I realize just how much of their perception of the place I call home is shaped by the portrayals and stereotypes of the last 150 years. I have also noticed that, at times, we Alaskans have also embraced these stereotypes—both to set ourselves apart from the rest of the country and to benefit, monetarily and otherwise.

In 1867, when the United States purchased Russia's interests in Alaska, the newspapers of the day lampooned the deal and gave it names such as Walrussia, Seward's Icebox, and Seward's Folly, and, for the next twenty years, it appeared to many that the naysayers were right. What Secretary Seward (see figure 10.1) knew, however, was that Alaska's land was teeming with resources waiting to be exploited. By the middle of the 1890s, with the discovery of gold, fish, and copper throughout Alaska, tens of thousands of people came to the state, all looking to get rich as quickly as possible. It was during this period that people throughout the world got their first glimpse of the Territory of Alaska in photographs, newspapers, and popular books. Writers such as Jack London and Robert Service wrote stories and poems that resonate with people even today. It is in these stories and poems that we see evidence of the creation of many of the stereotypes of Alaska and Alaska's culture and people. The iconic image of Alaska—the dog musher—is one such image that is based more on lore than reality. Mushing didn't begin until after European contact. Alaskan Natives did own dogs (see figure 10.2), and some groups did use them to pull small sleds, but few had more than two dogs because of the large amount of food required to care for them. It was only after contact and the introduction of guns, fish wheels, and steel traps that Alaska Natives started to learn from the Europeans how to mush large dog teams. Alaska Natives had many sophisticated forms of transportation that long predated dog teams.

There is no doubt that the romance of gold rushes in Alaska still plays a large part in Alaskan identity. Tourists can travel today on a recreated paddle-wheeler in Fairbanks

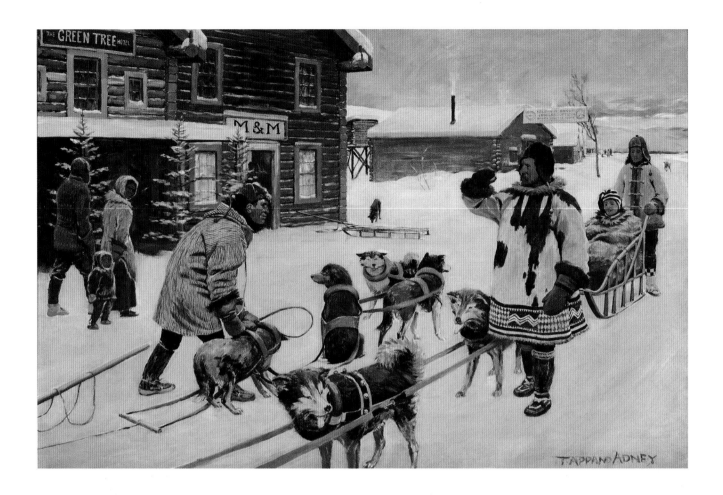

FIGURE 10.1 Edwin Tappan Adney was a writer, artist, and photographer. In his distinguished career, Adney was credited with recording some of the first images of the Klondike when *Harper's Weekly* sent him there in 1897. After returning from the Klondike in 1900, Adney published *The Klondike Stampede,* which is still highly regarded for the level of detail and the imagery he captured of the stampede and the indigenous Han Hwëch'in Athabascans living in the area.

Edwin Tappan Adney, American, 1868–1950, *Christmas in the Klondike,* c. 1998. Oil paint, canvas, 70 × 100 cm. Collection of the Anchorage Museum.

"WHEN BITERS WERE BITTEN" 4-22-

down the Chena River before being whisked off to "pan for gold" at the El Dorado Mine outside Fairbanks (see figure 10.3), and events and historical characters from the Gold Rush period often get mixed and matched to tell a particular story. In Disney's Uncle Scrooge comics, the character of Soapy Slick is based on the real-life character of Soapy Smith, a notorious con man who lived in Skagway and swindled unsuspecting miners. In the comic, Soapy Slick is transplanted to Dawson, where he tries to swindle Scrooge McDuck by various means over the years, but Scrooge "was smarter than the smarties and tougher than the toughies and that he made it square!"[1] Comics like this one are a distillation of the fantasy that someone who has nothing can come to the North and—by working hard, using practical skills, conquering the elements (see figure 10.4), resisting temptations, and applying a bit luck—can become the "World's Richest Duck." The idea that Alaska is an untapped place where a person can test one's mettle not only against nature and the elements, but also against oneself, persists today in many portrayals of northern culture.

Over the last ten years, cable television has been besieged by a large number of "reality" television shows that continue to tap into this mythology. *Deadliest Catch* was the first, and arguably the most successful, of this type of programing. The plot

FIGURE 10.2 This drawing by Eustace Ziegler captures all the romanticism of the lone gold miner toiling away in the hopes of one day hitting the mother lode and striking it rich.

Eustace P. Ziegler, American, 1881–1969, *When Biters Were Bitten*, c. 1958. Ink, graphite, paper, 44 × 54 × 3 cm. Collection of the Anchorage Museum.

FIGURE 10.3 Starting in the early part of the twentieth century, tour operators in Alaska and the Yukon were quick to offer experiences that recreate the various gold rushes. Here we see tourists panning for gold near Nome in the 1960s.

Tourists Panning For Gold. Photograph. Wien Collection. Collection of the Anchorage Museum.

AARON LEGGETT

FIGURE 10.4 Alic Edwards of Holy Cross made this set of dance props in around 1935. The gold pan, shovel, and pick, along with a mask (now missing), were made for a Deg Hit'an dance, which satirized old gold prospectors who came looking for gold. The Deg Hit'an are one of the few Athabascan groups known to make elaborate masks and other dance accessories, and although these items are modern tools, they exhibit many traits found on traditional masks and dance sticks in the way they are decorated.

Alic Edwards, Athabascan, 1911–? Deg Hit'an dance props, c. 1935. Birch bark, wood, feathers, metal, paint. Gift of Wilson and Barbara Jerue, Sr. Collection of the Anchorage Museum.

centers on various captains who brave the stormy waters of the Bering Sea in search of Alaskan crab (see figure 10.5). Crab fishing is a dangerous occupation. After the first season that *Deadliest Catch* aired, the State of Alaska implemented a new quota system, which replaced the older derby-style system in which there was a limited opening with all boats competing to get to the fishing grounds as quickly as possible—to catch as much as they could before the season closed. From 2006 to 2012, one fatality occurred among the fishing fleet, whereas during the 1990s there was an average of 7.3 deaths per year (see figure 10.6).[2] The television program is less documentary than sensationalism—playing off the inherent danger of the profession and old stereotypes of land and people. Like many others, it takes a surface look at Alaska as the "last frontier."

Eskimo kisses, igloo coolers, Eskimo pies, and Eskimo ice fishing shelters—these are just some of the products that have sprung up since "Eskimos" were "discovered" by mainstream America in the early twentieth century. When I was a child in Anchorage, there were only Indians, Aleuts, and Eskimos, while today we recognize the many distinctions within those groups of Indians (Tlingit, Haida, Tsimshian, Eyak, Athabascan), Aleuts (Unanagax and Sugpiaq), and Eskimos (Yup'ik, Cup'ik, Iñupiaq, and Siberian Yupik). What most people knew about Alaska Natives was based around the idea of "Eskimos." The Eskimo was presented as the primitive child of nature who eked out a meager living by constantly hunting for food. As a child, I was taught what an Eskimo kiss was and would practice with other kids, rubbing noses together. I grew up hearing that a really good salesperson could "sell ice cream to Eskimos." (Never mind that Alaska [see figure 10.7] has one of the highest consumptions of ice cream per capita.) The first mainstream records of these stereotypes are found in early newspaper articles and books written by visitors to Alaska. These accounts recorded the "simple life" of these happy-go-lucky people who constantly wondered where their next meal would come from. I felt distanced from my own Dena'ina Athabaskan culture, which I would "discover" for myself as an adult.

When the 1933 film *Eskimo* was released, MGM had a neon sign on Broadway that read "Eskimo Wife Trader! Weird Tales of the Arctic!" Smaller lobby cards for the film read: "The strangest moral code on the face of the earth—men who share their wives but kill if one is stolen" (see figure 10.8).[3] "The Ballad of Eskimo Nell," a limerick told in the style of poet Robert Service, opens with the line "Gather 'round, all ye whorey! Gather 'round and hear my story!" The film features the sexual exploits of Deadeye Dick and Mexican Pete as they try in vain to satisfy the sexual appetite of the title character, Eskimo Nell. Local stereotypes upheld such bravado: to be a true sourdough in Alaska you had to: (1) pee in the Yukon River, (2) shoot a moose or grizzly, and (3) make love to an Eskimo (see figure 10.9).[4] Conquering nature (in this case, Alaska Natives) was the name of the game.

FIGURE 10.5 Beginning in the 1940s, a large crab fishing industry developed on Kodiak Island. In its heyday in the 1960s, it resulted in over 100 million pounds of crab taken from the waters around the Gulf of Alaska each year. By the early 1980s, the fishery had collapsed—and it was shut down in 1982. Environmental change and overfishing are believed to have led to the collapse of this once-prosperous fishery. Today, most crab fishing takes place in the Bering Sea, made famous by the reality television series *Deadliest Catch*.

Wien Collection. Collection of the Anchorage Museum.

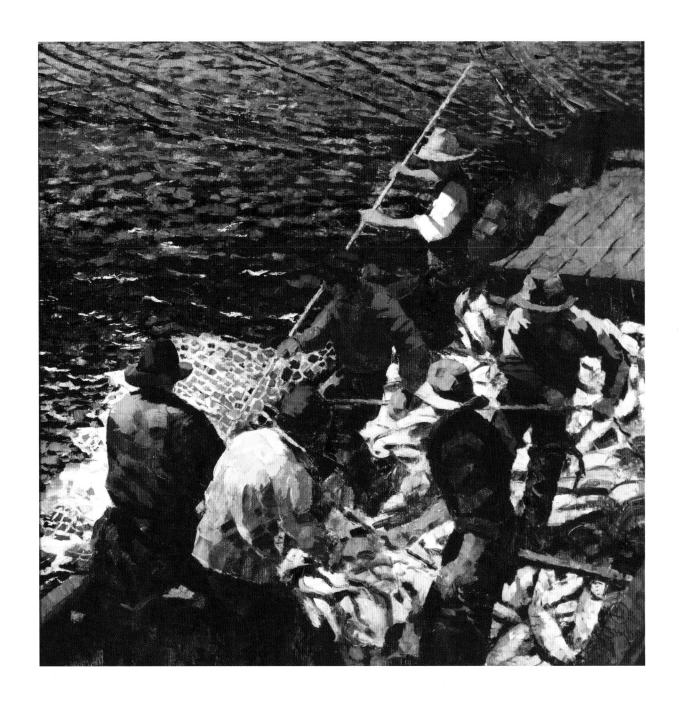

FIGURE 10.6 Eustace Ziegler painted this scene of men working hard to bring in their catch of fish.

Eustace P. Ziegler, American, 1881–1969, *Alaska Fisherman*, early–mid-20th century. Oil paint, canvas, 86 × 86 cm. Collection of the Anchorage Museum.

FIGURE 10.7 Diplom-Is is the largest manufacturer of ice cream in Norway. Since at least the 1930s the mascot for the company has been a girl that they call Eskimonika. The logo has undergone several revisions over the years, but it has always featured the yellow parka with the smiling face.

Aaron Leggett, Dena'ina, born 1981, *Eskimonika*, 2016. Photograph, 21 × 21 cm. Collection of the Anchorage Museum.

FIGURE 10.8 Since the camera was first brought to Alaska, Alaskan Natives have been a popular subject for photography. Here, Helen Hood stages a photo of an Iñupiat man at Barrow in his kayak in the 1960s.

Wien Collection. Collection of the Anchorage Museum.

FIGURE 10.9 Fred Henton came to Alaska as a stowaway on the SS *Corwin* in 1905. During his lifetime he was a mail carrier, big game guide, prospector, and dog musher. In 1935, he killed a record-sized Kodiak bear, which was mounted and displayed at the Los Angeles Museum. In 1959, artist Jim Barrett painted Henton and his bear, and this painting was donated to the Cook Inlet Historical Society in 1963.

Jim Barrett, American, dates unknown, *Fred A. Henton's Kodiak Bear,* 1959. Oil paint, canvas, 77 × 113 × 11 cm. Gift of Fred A. Henton. Collection of the Anchorage Museum.

As the late Svetlana Boym, author of *The Future of Nostalgia,* suggested, there are two types of nostalgic behavior. The first is reflective nostalgia, which is concerned with an imagined time in the past from whence all sorts of values and experiences have been lost.[5] An example of this type of nostalgia might be: "Before Alaska statehood, nobody locked their doors." The second is restorative nostalgia, which seeks to rebuild an imagined community and "manifests itself in total reconstruction of the monuments of the past."[6] Throughout Alaska, many businesses have selected names that invoke restorative nostalgia, mostly centered on the miners and the trappers (see figure 10.10). In Anchorage, there is or has been a Gold Rush Liquor, Yukon Liquor, Tobacco Cache, Gold Cache Bingo, Sourdough Mining Company, Sue's Sourdough Assisted Living, Sourdough Studios, Sourdough Tobacco and Internet, Mail Cache, Keyboard Cache, and Jewelry Cache. In the early 2000s, the City of Fairbanks decided to rename Alaskaland (which was built to celebrate the centennial of the Alaska purchase) as Pioneer Park to more accurately reflect the historical character of the park. In addition to miner- and trapper-related businesses, sacred objects for Alaska Natives have also been appropriated in the naming of businesses to convey a sense of being authentically Alaskan. Totem Rentals, Totem Ocean Trailer Express, Totem Theatre, and Totem Software are just a few examples.

When I was a teenager growing up in Anchorage, I remember reading about two individuals whose names would become famous—or infamous. These two men were Christopher McCandless and Timothy Treadwell, and they will forever be linked to Alaska, the search for wilderness, and their search for themselves within it.

McCandless came north after being inspired by the writings of Jack London and Henry David Thoreau; he wanted to walk away from his material possessions and find himself in nature. Treadwell left a life of drugs and partying to find himself among the grizzly bears of Katmai National Park. For both of these men, Alaska would ultimately prove to be fatal. For McCandless, this meant starving in the back of an abandoned bus near Denali National Park; for Treadwell, it meant that he and his girlfriend would be fatally mauled by a grizzly bear in Katmai National Park. Both of these men's stories were later the subject of popular nonfiction books and large-budget Hollywood films.

McCandless's story was first written about by Jon Krakauer, a well-known mountaineer and outdoors writer. In *Into the Wild,* Krakauer tells the story of McCandless, a young man from a well-to-do East Coast family who, in 1990, after graduating from college, donated all the money in his bank account to charity, renamed himself Alexander Supertramp, and began a journey across the West.[7] McCandless's remains were found in August 1992 (see figure 10.11). In the book, Krakauer draws parallels between his own experiences and motivations and those of McCandless. The book was later made into a movie of the same title directed by Sean Penn. The book and the real-life

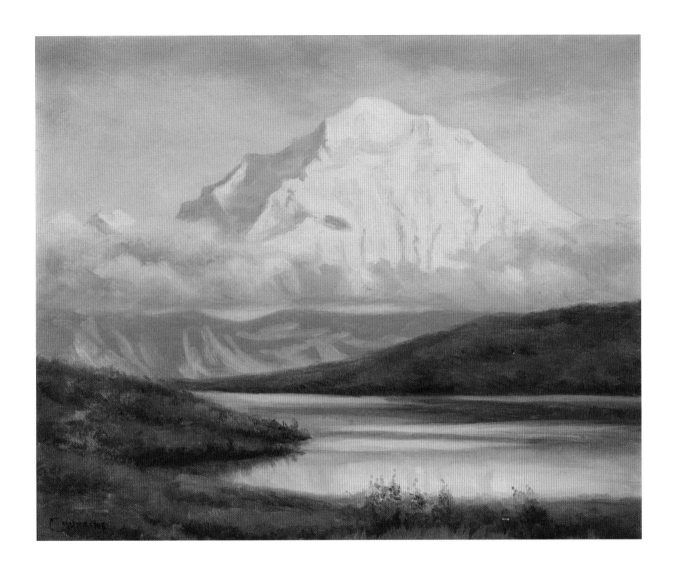

FIGURE 10.10 This romantic painting by Nina Crumrine of Denali (formerly Mount McKinley) is an example of a painting depicting an "untouched" wilderness near the mountain.

Nina Crumrine, American, 1889–1959, Untitled, c. 1957. Oil painting, canvas, 46 × 56 cm. Gift of the Atwood Foundations. Collection of the Anchorage Museum.

FIGURE 10.11 Fanny Quigley came to the North during the Klondike Gold Rush in 1900. During her time in the Yukon, she would load her sled with supplies that she could then use to cook for hungry miners. It was during this time that she earned the nickname "Fannie the Hike." In 1906, she headed to the Kantishna mining district where she eventually had a number of mining claims. She fell in love with the area and eventually married one of her mining partners, Joe Quigley, in 1918. In 1930, after a serious accident, Joe left Alaska, and eventually the two divorced. Fannie stayed at her homestead, where she was unable and unwilling to adapt to civilization. She died alone in her cabin in the summer of 1944.

Harvey B. Goodale, American, 1900–1980, *Fanny the Hike*, c. 1970.
Oil paint, canvas, 96 × 111 × 4 cm. Collection of the Anchorage Museum.

events have been the subject of much debate and speculation. Krakauer first proposed that Chris McCandless was poisoned by the seeds of the Indian potato (*Hedysarum alpinum*). Some twenty years later, there still isn't a consensus as to whether the seeds contributed to McCandless's death or whether he died from another cause or causes.[8] But the story remains compelling, and inextricably tied to the North.

Similar to McCandless, Treadwell sought adventure by attempting to live an unorthodox life in the wilderness. Treadwell spent thirteen summers living among the grizzly bears of Katmai National Park in Alaska in an effort to change the perception that bears are dangerously aggressive animals, before he and his girlfriend, Amie Huguenard, were fatally mauled in the park in October 2003.

McCandless and Treadwell epitomize the belief held by some that man can conquer nature and, in doing so, can find self-fulfillment. To many people, Alaska is still the last frontier—a place that is wild and untamed, and somehow different than the rest of the United States. In some ways, of course, Alaska is different. It is the only US state that has Arctic territory, and it is the largest state. It has a small population relative to the size of its land. For part of the year, most of the state is covered by snow and ice. But it is important to remember that it is not an untouched land. Alaska Natives have lived in Alaska for centuries and have figured out a way to work with the land while not trying to conquer it. One of the key differences between Western views of nature and Alaskan Native views is the idea of community. A Western view epitomized by McCandless and Treadwell suggests that only by escaping by oneself can one truly find salvation. Alaskan Natives and longtime Alaskans, by contrast, realize that for one to truly be successful in the wilderness, one needs the help and cooperation of others.

My father-in-law, Bill Goebel, came to Alaska in the mid-1970s from Cleveland after growing up on a steady diet of outdoor Alaska adventure novels. In some ways, he was like McCandless and Treadwell, wanting to escape mainstream America and live off the land. His Alaskan adventure brought him to the village of Eagle, where the Yukon River meets the Canadian border. While in Eagle, he met my wife's Han Athabascan family and quickly absorbed information from the elders of the village. Eventually, he married my wife's mother, and the family, including my wife, Shyanne, moved out into the backcountry. When they moved out of Eagle, they settled across the river, and Goebel built the family's first log cabin. It was lost in a flood in 1979, and another was rebuilt on higher ground. Goebel's income during those years was derived from trapping marten. The family had a dog team (see figure 10.12) that was used during the winter to travel along their trapline. Summer was spent trying to catch enough salmon to feed the family. Goebel did this for a number of years but eventually grew tired of it. I asked him once what the hardest thing was that he had to face during his trapping years. He told me it wasn't the cold, it wasn't the physically demanding work that it

| AARON LEGGETT

took to survive out on the land, and it wasn't the close encounters he had with bears, including the one he shot that landed at his feet. It was the loneliness he felt when he was by himself along the trapline. During the long spells away from his family, he came to realize what Aristotle meant about man and society: "Man is by nature a social animal; an individual who is unsocial naturally and not accidentally is either beneath our notice or more than human. Society is something that precedes the individual. Anyone who either cannot lead the common life or is so self-sufficient as not to need to and therefore does not partake of society is either a beast or a god."[9]

I believe that a person can have a transformative experience in nature and, for many, Alaska is the ideal place in which to have that experience. Nature, in whatever form it takes, is part of us. As humans, we can't attempt to exert from it what we think it should be, and we should prepare ourselves to be disappointed when it ultimately fails to live up to our expectations. If we fail to understand this, it can prove fatal.

Stereotypes and outside perceptions in the mainstream world shape the view of the place that I have called home all of my life. To some, Alaska is a place of untold riches, where someone with perseverance and a strong work ethic can stake a claim. To others, Alaska is an untouched wilderness that must be protected, if for no other reason than that there has to be some wilderness left on this planet. Having grown up here, I can see the allure in both sets of beliefs. But the path likely lies somewhere in the middle. I believe that there are some places that should be protected from development, especially where it concerns traditional landmarks to Alaska's first people. But I also believe that this land has provided for people for thousands of years, and that there has to be a way that we can sustainably use these resources to benefit the people who call this place home. My hope is that someday we will move beyond these two firmly entrenched sets of beliefs, and the outside world and the media will begin to reflect on Alaska as a complex place where development and wilderness can coexist, and where stereotypes provide little more than storytelling.

FIGURE 10.12 Sydney Laurence, one of Alaska's iconic painters, created this painting in 1914. In this scene we see the lone trapper out on a trapline as he encounters a wolf in a leg trap. This romantic scene captures the essence of the era, with the man alone in the wilderness as he attempts to conquer nature.

Sydney Mortimer Laurence, American, 1865–1940, *The Trapper*, 1914. Oil paint, canvas, 188 × 138 × 11 cm. Gift of Odsather and Simpson Insurance Inc. Collection of the Cook Inlet Historical Society.

NOTES

1 Carl Barks and Walt Disney, *Walt Disney's Uncle $crooge: "Only a Poor Old Man"* (Seattle, WA: Fantagraphics Books, 2012).

2 Les Christie, "'Deadliest Catch' Not So Deadly Anymore," CNN Money, July 27, 2012, http://money.cnn.com/2012/07/27/pf/jobs/crab-fishing-dangerous-jobs/index.htm.

3 T. P. Doherty, *Pre-Code Hollywood: Sex, Immorality, and Insurrection in American Cinema, 1930–1934* (New York: Columbia University Press, 1999).

4 M. P. Hogan and T. Pursell, "The 'Real Alaskan': Nostalgia and Rural Masculinity in the 'Last Frontier,'" *Men and Masculinities* 11, no. 1 (2008): 63–85.

5 S. Boym, *The Future of Nostalgia* (New York: Basic Books, 2001).

6 Ibid., 41.

7 J. Krakauer, *Into the Wild* (New York: Anchor Books, 1997).

8 Dermot Cole, "Krakauer's Wild Theory on McCandless Gives Short Shrift to Science," *Alaska Dispatch*, September 17, 2013, http://adn.com/commentary/article/krakauers-wild -theory-mccandless-gives-short-shrift-science/2013/09/18/; J. Krakauer, "How Chris McCandless Died: An Update," *The New Yorker*, February 11, 2015, www.newyorker.com/books/page-turner/ chris-mccandless-died-update, accessed November 21, 2016.

9 Aristotle, *Aristotle's Politics*, trans. Benjamin Jowett and ed. H.W. Carless Davis (Oxford, Clarendon Press, 1920).

THROUGH THE LENS

JULIE DECKER

n 1826, Joseph Nicéphore Niépce took what is widely regarded as being the first photograph. The exposure time for his image was eight hours. Twelve years later, Louis-Jacques-Mandé Daguerre took the first photographic image of a human being, though more by chance than by intent. Daguerre's long-range shot of a Parisian street scene just happened to capture a man having his shoes shined. Since the photograph had a ten-minute exposure time, only this man who was standing still was captured on the plate, while all other movement was blurred into invisibility.

The early technical restraint of long exposure times meant that photographers had to work mostly with static subjects, so cityscapes and landscapes because obvious subjects. Photography did not gain an instant audience as an art medium. Many people saw photography as a simple mechanical device and a tedious technical process, not as an art form. With the introduction of affordable, handheld Kodak cameras in 1888, almost anyone could be a photographer, which also prevented people from elevating the medium. Early art photographers developed a manipulated style of imagery known as pictorialism—often intentionally blurry and impressionistic, and deliberately labor intensive—as a way to elevate artistic expression above mechanical process.

In Cincinnati in 1848, Charles Fontayne and William S. Porter were capturing unprecedented levels of detail in their panoramic daguerreotypes of the town's waterfront. The photographers set up their camera on a rooftop in Newport, Kentucky, and panned across the Ohio River, capturing on eight separate daguerreotype plates a panorama of Cincinnati. Their *View of Cincinnati,* which came to be known as the Cincinnati Panorama of 1848, won top awards for its technique and artistry. The work attracted worldwide attention and survives as the oldest comprehensive photograph of an American city. Daguerreotypes, invented in 1839, were produced by the earliest practical method of photography, and they are still recognized for their superior clarity. The Fontayne and Porter photograph elevated photography and spawned an era of capturing panoramic views using something other than a paintbrush.

Many of the most noted landscape photographers have predominantly come from the United States, with its frontier myths and investment in cinema. This helped to promote the idea of the power and mystery of the American landscape. By the last decades of the nineteenth century, American artists, no longer content with the grandeur of the American West, went farther west to Alaska for a new landscape and new inspiration. The art of the American West is often seen as an out-of-touch genre, more nostalgic and historical than innovative and creative. The American West was captured by artists for consumption by the American East—people who saw the "untouched landscapes" as romantic and exotic.

Photography brought a new dimension to capturing the West and influenced the impression of Alaska held by the rest of America. Photographers have always explored wild lands for art as well as science, and the history of landscape photography is intricately tied to the exploration of the American West. Photographers like Eadweard Muybridge and Carleton Watkins went west to document iconic landscapes such as Yosemite National Park. In the later 1800s, photographers began to visit Alaska—some employed by government agencies, some as commercial photographers, and some as travelers capturing the journey. Many sold their images to trading companies. Muybridge, who traveled to Alaska in the summer of 1868, is considered the first to take photographs of American Alaska. He accompanied Major General Henry W. Halleck, then in command of the military division of the Pacific, with an assignment to photograph Alaska's military posts and harbors. Photography was a challenge—cameras were heavy and bulky and images had to be recorded on glass plates. In a rugged environment, just moving equipment was a struggle, never mind capturing the landscape.

Other professional photographers followed Muybridge. Among them were Edward de Groff and Reuben Albertstone, who took photographs at Sitka and elsewhere in Southeast Alaska during the 1880s. In 1893, Lloyd V. Winter and Edwin Percy Pond established a photography studio in Juneau and recorded events in and around Juneau, particularly the Klondike Gold Rush. They also captured the growth of the salmon and mining industries in the area, and, activities in Juneau after it became Alaska's capital city in 1906. In addition, they photographed the Tlingit people and non-Native residents of the region. The Klondike Gold Rush attracted a number of photographers to Alaska. E. A. Hegg documented life along the Chilkoot Trail and opened photography studios in Cordova and Anchorage. He was also the official photographer of the construction of the Alaska Railroad and took over 1,500 photographs of Alaska's rail projects.

Hegg later hired the photographer and painter Sydney Laurence to hand tint his photographs. Laurence is best known as a painter of Alaska, but he also made a living as a photographer. He is responsible for recording many of the earliest images of Anchorage, starting with its origins as a tent city in 1915. He also photographed snowfalls on the

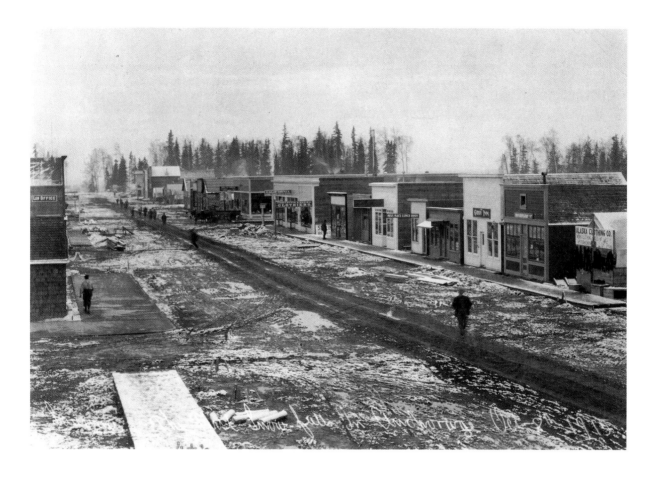

newly urban Alaska, a public auction of city lots, steamship arrivals and material yards, the Matanuska Glacier, and early Anchorage businesses and businessmen (see figure 11.1).

Though fifty years of work preceded him, Ansel Adams is widely considered the father of American landscape photography. His work transcended art and science to make him a popular culture icon. His black-and-white work focused on the landscapes of the American West. Like Watkins and Muybridge before him, Adams made many famous photographs of Yosemite National Park. Technologically innovative, Adams's photography was simple enough to maintain a direct connection to the earliest pioneers of the medium. His zone system, a technique for exposure and processing to provide the utmost control over every tone in an image, and his technical curiosity led the way for many photographers who followed. Adams came to nature before photography, and ecology became a driving factor in his life. That conservationist thread still runs through landscape photography today.

FIGURE 11.1 Sydney Laurence, while best known as a painter, was also a commercial photographer who captured several key images of early Anchorage, Alaska.

Sydney Mortimer Laurence, American, 1865–1940, *The First Snow Falls in Anchorage, Oct. 8, 1915*, 1915. Photograph, 9 × 13 cm. Collection of the Anchorage Museum.

Adams was in Alaska in 1948 on a Guggenheim Fellowship trip (one of three that he was awarded in the years 1946, 1948, and 1959). The John Simon Guggenheim Memorial Foundation (along with the post-war boom and the availability of cars) helped many photographers explore their native landscapes. Dozens of photographers, from Garry Winogrand and Robert Frank to Stephen Shore and Lee Friedlander, took off across America and documented their journeys. Unlike the timeless, painterly quality of early landscape photography, these artists explored snapshot views, such as showing the landscape through the car windshield or rearview mirror. For Adams, however, capturing the landscape took him farther west, and geological features like Denali inspired in him much more than a snapshot. Adams's image of Denali (then Mount McKinley) and Wonder Lake is now one of the best-known Western landscape photographs. To capture the image, Adams set up his "studio" at a cabin thirty miles from Denali. One evening, he positioned his equipment to photograph the mountain. As dawn began to break after 1 a.m., the top of the mountain took on a pinkish hue and, gradually, the sky became golden and the mountain received more sunlight. Adams snapped the shutter three times. Within thirty minutes, clouds had obscured the summit and they soon enveloped the entire mountain. Adams had photographed extensively in the Rocky Mountains, the Sierra Nevada, and the Southwest, but he had never encountered anything on the vast scale of Alaska. The experience moved and inspired him (see figure 11.2).

Also drawn to Denali was Bradford Washburn. The president of the Harvard Mountaineering Club, Washburn began a campaign of exploratory mountaineering that would make him one of the foremost North American alpinists of the mid-twentieth century. He was especially drawn to the Yukon and Alaska and returned multiple times to pioneer routes up and make maps of the mountain, including with his wife, Barbara, who was the first woman to summit Denali. Washburn also greatly advanced the technique of aerial photography and mountain cartography. Initially interested in gaining topographical information in order to help plan his exploratory mountaineering, he pioneered the use of large-format cameras, removing the side door from single-engine airplanes and lashing himself to the bulkhead with ropes along with a fifty-pound Fairchild F6 camera to avoid being sucked into thin air. Washburn's photographs transcended utilitarian purposes. Showing the influence of his friend Ansel Adams, Washburn's large-format monochrome prints of the mountain were beautifully composed and exposed, and full of detail, and they are now regarded as works of art (see figure 11.3).

Alaska photography eventually evolved, and resident photographers in addition to those just passing through documented the landscape. In the 1950s, a young Sam Kimura began photographing Alaska, having studied fine art photography in California

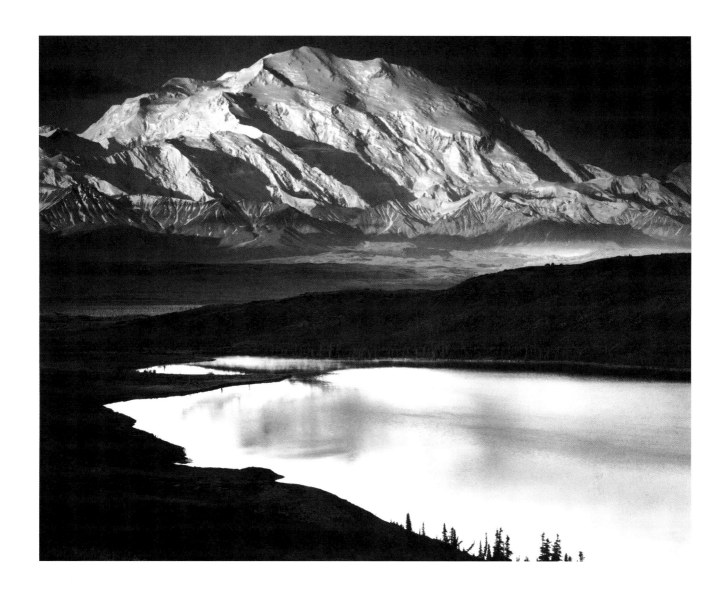

FIGURE 11.2 This iconic image of Denali captured by Ansel Adams set the standard for black-and-white nature photography and also placed Alaska's wilderness in the national consciousness.

Ansel Adams, American, 1902–1984, *Denali and Wonder Lake, Denali National Park and Preserve, Alaska, 1947*. Photograph, gelatin silver print, 102 × 124 cm. Collection Center for Creative Photography, University of Arizona.

FIGURE 11.3 Bradford Washburn was an American explorer, mountaineer, photographer, and cartographer. He also served as the director of the Boston Museum of Science from 1939 to 1980. Bradford Washburn's 1940 party, which included his new bride, Barbara Polk, was the first to climb Mount Bertha. Washburn was one of the leading American mountaineers in the 1920s through the 1950s, putting up first ascents and new routes on many major Alaskan peaks, often with Barbara, a pioneer among female mountaineers and the first woman to summit Denali. Washburn also pioneered the use of aerial photography in the analysis of mountains and in planning mountaineering expeditions. His thousands of striking black-and-white photos, mostly of Alaskan peaks and glaciers, are known for their wealth of informative detail and their artistry. They are the reference standard for route photos of Alaskan climbs.

Bradford Washburn, American, 1910–2007, *Mt. McKinley, South Face,* 1964. Silver, gelatin, paper, 57 × 67 cm. Gift of Bradford Washburn. Collection of the Anchorage Museum.

and working as a commercial photographer in New York before returning to the place where he had grown up. Kimura eventually taught at the University of Alaska and became one of the early leaders in the state to promote photography as a fine art. Many of Kimura's photographs are large black-and-white images. Many were shot with a large-format 4-by-5 camera. He worked as a commercial photographer for companies ranging from Anaconda Copper and Union Oil to Campbell's Soup, but his art photography ranged from landscape to portraits, still lifes to experimental works. He often worked outdoors with natural light, and he used Ansel Adams's zone system to create black-and-white landscapes that featured rich blacks and brilliant highlights. He also experimented with sandwiching negatives together, solarizing prints, and using dye-transfer colorization techniques (see figure 11.4).

Kimura's work was just the start of a strong tradition of photography in Alaska by resident artists. Barry McWayne grew up the son of a photographer for United Airlines and spent his early years working with his father before moving to Los Angeles. There he made his living going door to door asking to take pictures of children and then returning a few days later to sell their parents photo packages. In 1970 McWayne was offered a job as staff photographer at the University of Alaska Museum in Fairbanks. At the museum, McWayne took photographs of everything from the exhibitions to the staff. He eventually began curating the museum's photography collection and collected works from Alaska-based photographers and other well-known photographers who had photographed the state (see figure 11.5).

As a curator, McWayne had a keen eye, and he helped to establish fine art photography in museums, championing the works of Alaska photographers such as Dennis Witmer (see figure 11.6) and Charles Mason (see figure 11.7). In Anchorage, photographers like Hal Gage (see figure 11.8) were pushing the definition of landscape photography, creating series of works that featured the mud flats along the coast and the distinctly northern qualities of ice.

Artist Mark Daughhetee took studio photography beyond its first limits in Alaska, creating intricate, staged scenes, and photographers like Stephen and Lisa Gray ushered photography into the digital world. Lisa Gray was an artist well known in Anchorage for her layered black-and-white collage photography. Later, she turned to digital collage and inkjet printing after her battle with breast cancer made it impossible to handle the bulky 30-by-40-inch negatives and platinum solution her earlier work required. Both Lisa and Stephen Gray focused on real and fictional characters in their work. When he moved to digitally collaged imagery, Stephen Gray created Billy—a semi-autobiographical character who he used to narrate childhood predicaments from an adult perspective (see figure 11.9).

Photographers Clark James Mishler and James Barker (see figure 11.10) both launched successful careers as commercial photographers in Alaska, documenting the daily lives

FIGURE 11.4 Sam Kimura, American, 1928–1996, *Turnagain Arm*, 1984. Silver gelatin print, 51 × 61 cm. Gift of Joan Kimura. Collection of the Anchorage Museum.

FIGURE 11.5 Barry McWayne, American, 1943–2010, *Sheet Ice and Open Water—Nenana River at Grizzly Camp*, 2003. Carbon pigment on paper, 23 × 36 cm. Collection of the Anchorage Museum.

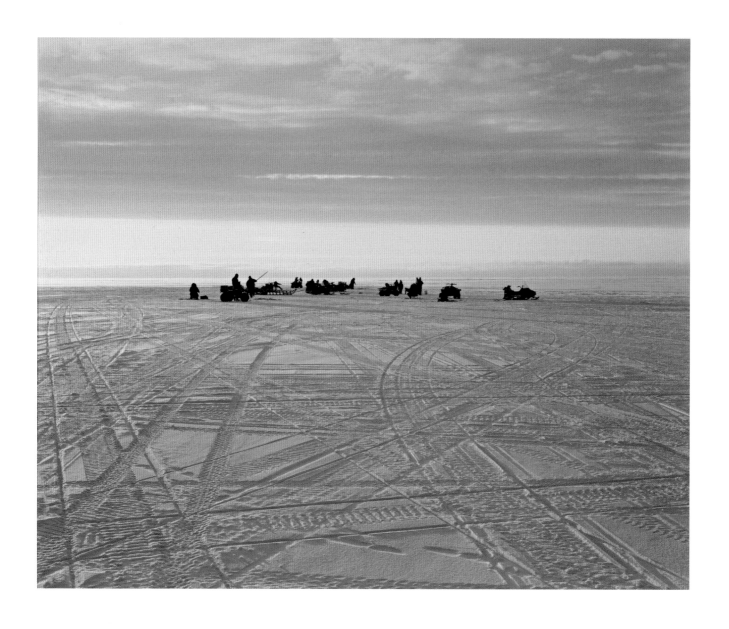

FIGURE 11.6 Dennis Witmer, American, born 1957. *Fishing for Tom Cods, November 1987, Front Street, Kotzebue*, 1987. Pigmented inkjet print, 52 × 65 cm. Collection of the Anchorage Museum.

JULIE DECKER

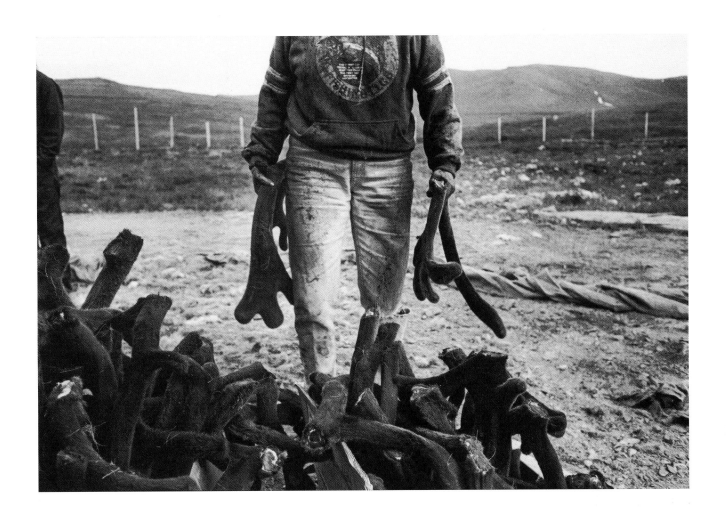

FIGURE 11.7 Charles Mason, American, born 1958, *Stacking
Velvet Antler*, 1980 (from the *Reindeer Herding in Alaska* series).
Silver gelatin print, 28 × 36 cm. Collection of the Anchorage Museum.

FIGURE 11.8 Hal Gage, American, born 1959, *Ice Patterns II, Potter Marsh,* 2004. Ink, canvas, 21 × 31 cm. Collection of the Anchorage Museum.

JULIE DECKER

of people throughout the state. Brian Adams has documented Alaska Native people and villages across the state and worked on comprehensive photographic series such as *I Am Alaskan* and *I Am Inuit* (see figure 11.11).

Many contemporary photographers offer new takes on outdoor photography, from Tim Remick, who makes large-scale portraits of climbers who have descended from Denali (see figure 11.12), to Michael Conti, who studies winter and northern culture through the lens of hockey (see figure 11.13). Contemporary Alaska Native artists working in photography, such as Erica Lord (see figure 11.14), Da-ka-xeen Mehner (see figure 11.15), and Nicholas Galanin (see figure 11.16) use the medium to comment on issues of identity, place, and the commodification of culture.

And the North still attracts photographers from around the world in search of the epic landscape, resulting in works such as Daniel Martinez's images of Alaska's oil and Cold War infrastructure (see figure 11.17), Lincoln Schatz's images of Mendenhall Glacier (see figure 11.18), Tiina Itkonen's images of the Arctic from Greenland to Kaktovik, Alaska (see figure 11.19), and Olaf Otto Becker's images of the man-made in "remote" places (see figure 11.20).

Today there is an increased interest in landscape photography, largely because of the world's rapidly changing environment. Alaska's Arctic is one place acutely affected by climate change. As part art and part document, landscape photography has a distinct ability to capture change and adaptation, even in the most remote of places. Just as the landscapes Ansel Adams photographed have become more affected by human intervention, landscape photography, too, has changed. Contemporary landscape photographers such as Edward Burtynsky and David Maisel explore scars on the landscape from human activity rather than pristine wilderness. The idea of the untouched landscape or virgin forest is now only romantic. Though many photographers worked to inspire social action by photographing polar bears and melting icebergs, what has proven compelling for the narrative of change has not been calamity, fatalism, or alienation, but the ability of photographers to find beauty even amid the scars. Landscape photography allows us to establish a personal connection to the landscapes of change and the people that reside within them.

FIGURE 11.9 Stephen Gray, American, born 1958, *Billy the Kid*, 2006. Inkjet on paper, 66 × 59 cm. Collection of the Anchorage Museum.

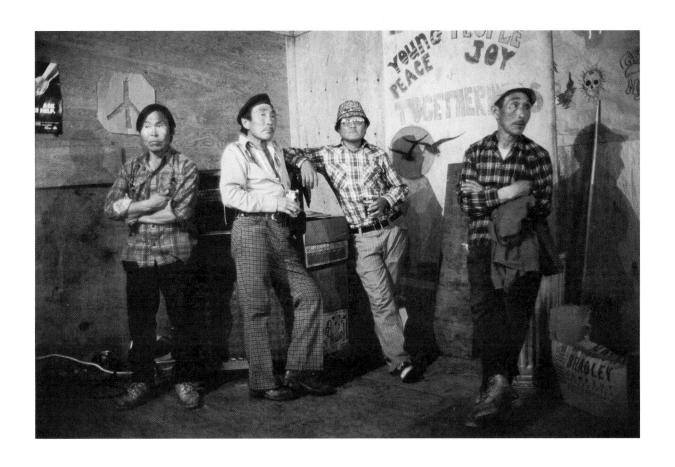

FIGURE 11.10 James H. Barker, American, born 1936, *Four Men at Chevak, Tundrafest*, 1980. Silver gelatin print, 28 × 36 cm. Collection of the Anchorage Museum.

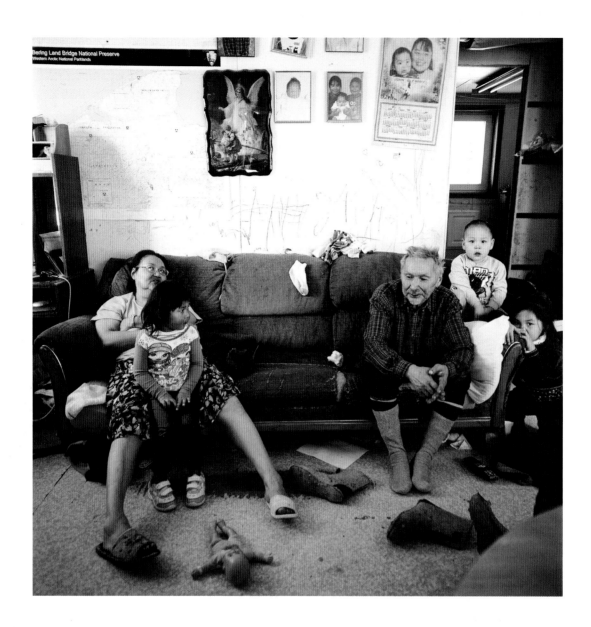

FIGURE 11.11 (above) Image of the Kiyutelluk family at their home in Shishmaref, Alaska, in March 2010. Morris Kiyutelluk wrote several recipes for the 1951 publication *Eskimo Cookbook*.

Brian Adams, Iñupiaq, born 1985, *Kiyutelluk Family*, 2010. Ink, paper, 51 × 41 cm. Collection of the Anchorage Museum.

FIGURE 11.12 (opposite) Alaskan photographer Tim Remick's goal was to capture the experience of climbing Denali with a single image. He photographed climbers moments after they stumbled into basecamp. The large-format portraits heighten the drama of the exhaustion, the adrenaline, and the emotion.

Tim Remick, American, born 1966, *#12. After 54 Years: 20,320 Feet: 14 Days*, 2010. Ink, paper, 143 × 111 × 3 cm. Collection of the Anchorage Museum.

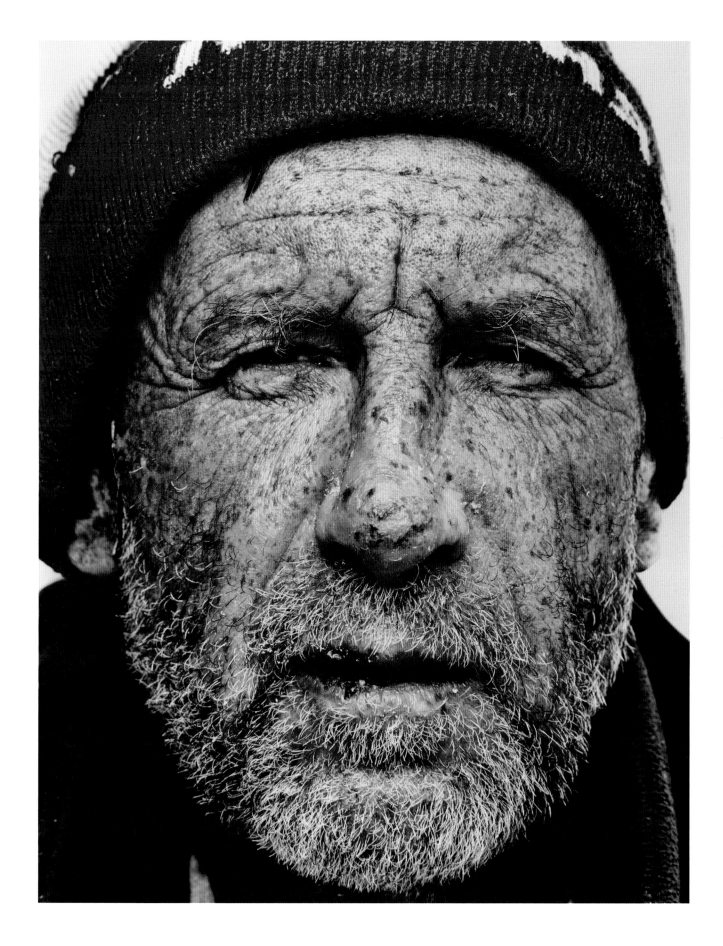

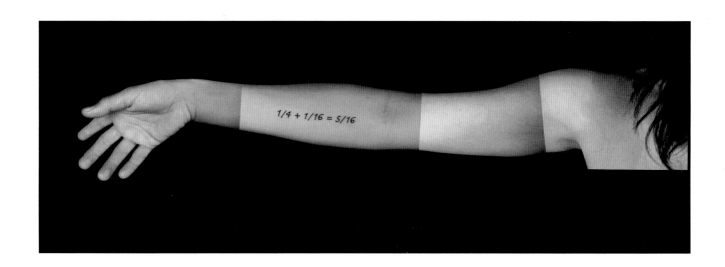

FIGURE 11.13 (opposite) Photographer and filmmaker Michael Conti's series on hockey comments on the cultural aspects of sports in the North. This work references NHL player Derek Boogaard, who died of drug and alcohol abuse at age twenty-eight. Boogaard had chronic traumatic encephalopathy, commonly known as CTE, which is closely related to Alzheimer's disease. CTE is believed to be caused by repeated blows to the head. It can be diagnosed only posthumously, but scientists say it shows itself in symptoms like memory loss, impulsiveness, mood swings, and even addiction.

Michael Conti, American, born 1971, *The Life and Death of Derek Boogaard,* 2015. Collage—paint, paper, wood, and ink, 84 × 63 cm. Collection of the Anchorage Museum.

FIGURE 11.14 (above) In this work, Erica Lord suggests that the government-regulated definition of "Indian," as determined by the blood quantum law, combined with visual reinforcement of what Indian is supposed to be like, creates a nearly unachievable level of "Indian-ness" and leaves little room for mixed-race acceptance. The blood quantum regulations instill an ever-present question about cultural authenticity.

Erica Lord, American, born 1978, *Blood Quantum (1/4 + 1/16 = 5/16),* 2007. Inkjet on paper, 39 × 105 cm. Collection of the Anchorage Museum.

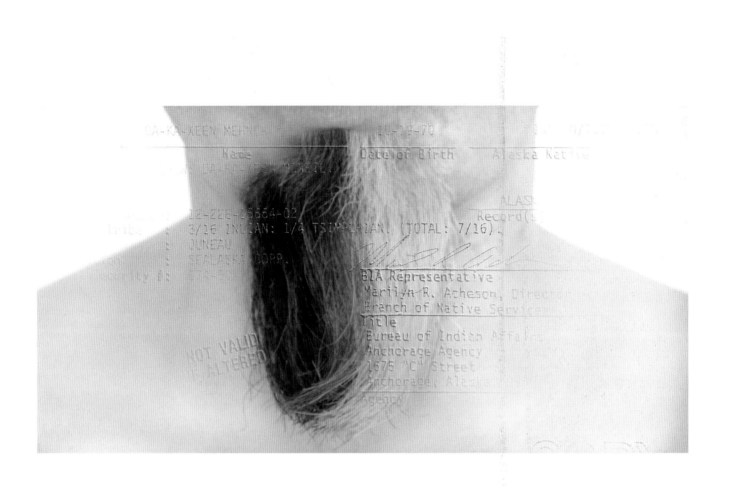

FIGURE 11.15 (above) Da-ka-xeen Mehner, Tlingit/N'ishga, born 1970, *7/16*, 2006. Ink on paper, 46 × 61 cm. Collection of the Anchorage Museum.

FIGURE 11.16 (opposite) Nicholas Galanin, Tlingit/Unangan, born 1979, *Things Are Looking Native, Native's Looking Whiter*, 2012. Ink on paper, 55 × 40 × 2 cm. Collection of the Anchorage Museum.

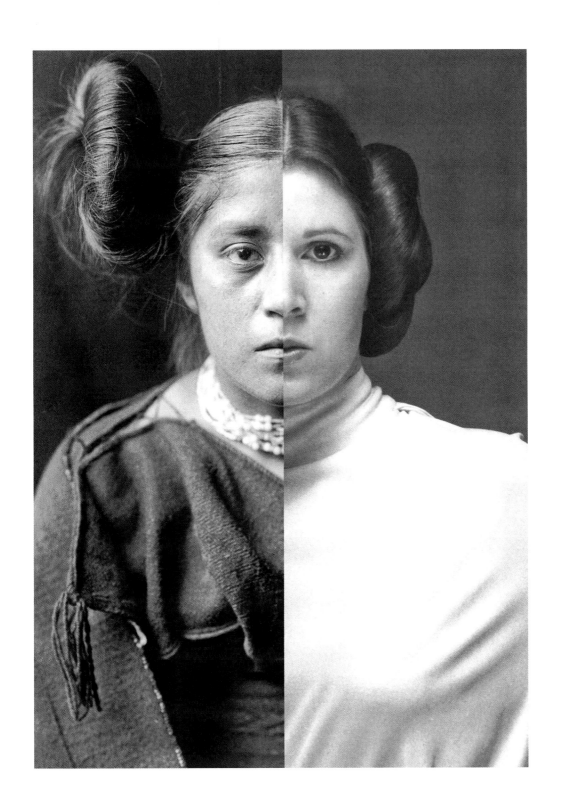

FIGURE 11.17 Daniel Martinez, American, born 1957, *I Hijacked an Oil Tanker in Valdez, Alaska,* 2010. Inkjet on paper, 41 × 54 cm. Collection of the Anchorage Museum.

FIGURE 11.18 Digital collage created from images taken during the Chicago-based artist's helicopter flight around the Mendenhall and Herbert Glaciers near Juneau, Alaska.

Lincoln Schatz, American, born 1963, *Portrait of Glaciers: Mendenhall and Herbert 3*, 2011. Ink on paper, 72 × 108 cm. Collection of the Anchorage Museum.

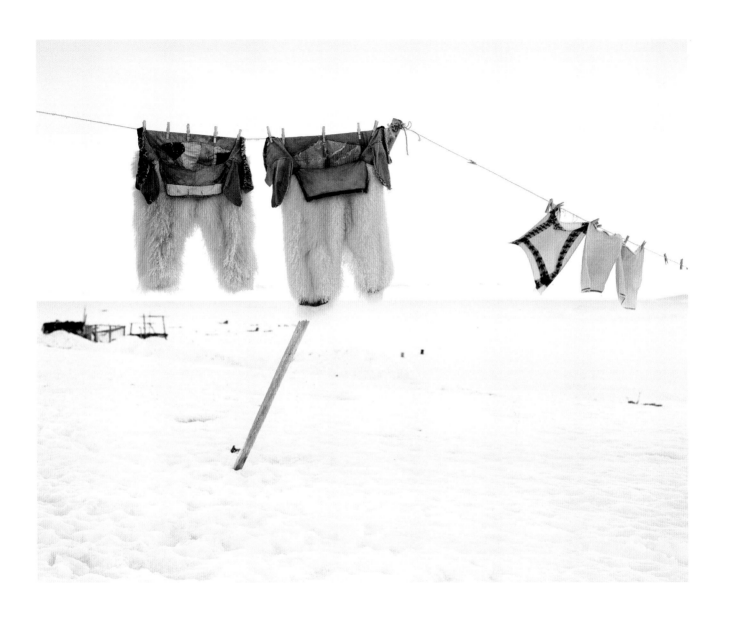

FIGURE 11.19 Tiina Itkonen, Finnish, born 1968, *Three Towels and Two Polar Bear Trousers*, 2002. Paper and ink, 80 × 95 cm. Collection of the Anchorage Museum.

FIGURE 11.20 Swiss research camp in Greenland.

Olaf Otto Becker, German, born 1959, *Swisscamp, Material Stores,* 2008. Color ink photograph, 111 × 133 cm. Gift of the artist. Collection of the Anchorage Museum.

THE
ART OF
ENVIRONMENT

JULIE DECKER

Artists of the late nineteenth and early twentieth century went west in America, portraying the romantic landscape where man was insignificant and passive in the natural environment—a mere observer, dwarfed by the grandeur of Mother Nature and her majestic beauty. Ansel Adams, Thomas Cole, Albert Bierstadt, Frederic Edwin Church, and others presented this optimistic, spiritual vision, which became central in American art. While the art at the turn of the twentieth century in Alaska depicted a similarly romantic landscape, today's artwork often questions the future of the landscape. The term *landscape* has been replaced by *environment,* implying a place imbued with conflict and change.

The latter part of the twentieth century saw new approaches to artists as advocates for the environment. Earth art, or land art—a movement started in the 1960s—drew renewed attention to the natural world and expanded the definition of sculpture art. The movement sought to reject the commercialization of art. These artists, too, went west, working in the outdoors, far away from the commercial galleries of the East Coast. By the 1970s, artists were creating mile-wide designs on and in the landscape. Christo and Jeanne-Claude brought their *Umbrellas* and *Running Fence* to the desert, and Robert Smithson added his *Spiral Jetty* to the Great Salt Lake. Other artists, ambitious with their palettes, used stomper boards to press down wheat and other crops to stamp out designs in farmland, deserts, and other remote regions, creating works to be viewed from foot as well as from above—or, in some cases, not to be viewed much at all. Smithson drew connections between his artwork and ancient Native American forms of earth art, which included constructed hills in the form of animals that could be seen from space.

Artists such as Smithson, Michael Heizer, Christo and Jeanne-Claude, and others were interested in the aesthetic value of art, but also its social value. Land artists became ecological agents, creating works that facilitated discourse and deliberation and educated the community about its relationship with its environment. Many of the projects spurred community ownership, and an emotional connection to the land they affected.

While the earlier land art was installed mostly in the deserts of the American West, by the end of the 1970s and the beginning of the 1980s, works moved into a more public sphere. Artists like Robert Morris began engaging county departments and public arts commissions to create works in public spaces such as abandoned gravel pits. Herbert Bayer used a similar approach and created his Mill Creek Canyon Earthworks in 1982, which was not just aesthetic but also functional, serving as erosion control—a reservoir during high rain periods, and a 2.5-acre park during dry seasons. In 1982, Joseph Beuys staged his "ecological action" called *7000 Oaks* as part of Documenta, the exhibition of modern and contemporary art that takes place every five years in Kassel, Germany. Just as the earthworks in the deserts of the West grew out of notions of romantic landscape painting, the growth of public art stimulated artists to pursue the urban landscape as another kind of landscape and also as a platform to engage a larger audience in a discussion of ideas and concepts about the environment.

Christo and Jeanne-Claude described themselves in interviews and on their website as "the cleanest artists in the world: all is removed, large scale works of art are temporary, the sites are restored to their original condition and most materials are recycled." The claim is oft repeated because the scale and visibility of their projects invites sustained criticism of the impact their projects may have on the environment. Being an environmentally friendly environmental artist is one of the many complications arising out of an increasingly astute artistic and scientific community, as well as a public that now speaks the language.

Some contemporary artists set out to create work that involves restoring the immediate landscape to a natural state. British sculptor Richard Long has for several decades made temporary outdoor sculptural work by rearranging natural materials found on site, such as rocks, mud, and branches—so that they have no lingering detrimental effect. Crop artist Stan Herd uses indigenous materials to create his large field works. He plots his designs and then executes them by planting, mowing, and sometimes burning or plowing the land, inspiring the term "living sculpture." Dutch sculptor Herman de Vries, the Australian sculptor John Davis, and the British sculptor Andy Goldsworthy base their work on leaving the landscape they have worked with unharmed, though sometimes altered.

The recent work of John Grade, a contemporary artist based in Seattle, not only reflects the earthscapes, but also, for a while, becomes part of them. His works combine natural products—such as clay, wood, stone, metal, and animal hides—with space-age materials to form structures designed to spend as much as a decade outdoors going back to nature. These sculptures are intended to be exposed and worn by sun and tides, and eaten by bugs and birds. One of Grade's best-known works, *Fold,* is a large wood and resin structure that is slowly being consumed by termites somewhere underground in Idaho. Later, it will be exhumed for display.

In the years before his death in 1973, Smithson planned and proposed a number of reclamation projects to mining companies in the United States. He believed that the best sites for earth art were sites that had been disrupted by industry, reckless urbanization, or nature's own devastation. Along these lines, many contemporary artists with environmental convictions blur the lines between art and activism. These artists connect with the land and force viewers to do so as well. At a time of heightened awareness of environmental degradation, many artists are voices for change—some simply depicting a changing landscape, others urging human action to effect change.

Fascinated by landscapes that have been intentionally and perhaps irrevocably altered by modern human industry, Canadian artist Edward Burtynsky creates works that not only address environmental destruction across the globe, but also paradoxically reveal the beauty of the resulting topography. His series of photographs titled *The Industrial Sublime* asks viewers to consider the tension between consumerist society's thirst for new products and ongoing sources of energy, and the need for environmental sustainability. Burtynsky, and then the viewer, find both beauty and repulsiveness in these images of consumption, manufacturing, mining, and waste disposal.

Other artists strive for optimism, celebrating nature's power of renewal, such as photographer Stephanie Lembert, whose images of pristine and lush landscapes are, in fact, depictions of reclaimed landfills around New York and Boston. The images are overlaid with text that tells the story of the transformation of these once-degraded places into healthy natural environments. In 1965, artist Alan Sonfist proposed *Time Landscape* to the City of New York, and it became a permanent installation of native trees at La Guardia Place and West Houston Street in Manhattan. The work introduced the key environmentalist idea of bringing nature back into the urban environment.

Other artists use beauty to call attention to what they see as the ugliness of man's impact on the environment. Subhanker Banerjee's photographs at first glance appear to be stunningly beautiful documentary images of the northern regions of Alaska. But here the sunsets are the result of toxins released into the air, and the footprints of the polar bear represent the footprint of both nature and man onto the northern landscape. At the artist's encouragement, the photographs have been used by environmental groups as illustrations to argue against the opening up of the Arctic National Wildlife Refuge in Alaska to oil drilling. In 2008, some of Banerjee's photographs were shown at the United Nations headquarters in New York. The artist, in this instance, is no longer a passive observer depicting a pristine wilderness. Banerjee, like the romantic artists before him, traveled to remote places unfamiliar to a mass culture, but he, unlike Bierstadt or Cole, for example, suggests that today these wildernesses are anything but untouched.

New art forms, such as renewable energy sculpture, arise out of artists interacting with technology and commenting on environmental sustainability. Representing a

response to the increasing urgency in the global climate change debates, environmental art practice is evolving into experimental technology and architecture. The response is to make an explicit intervention that has function and purpose to address ecological concerns. For example, in Vail, Colorado, on the slopes of the Rocky Mountains, Patrick Marold installed hundreds of small windmills, each with a light whose intensity matches the intensity of the wind.

Though most often associated with the study of literature, *ecocriticism* is a term that might also be applied to some of the environmentally concerned artwork being produced today. It is the study of literature and environment from an interdisciplinary point of view, where all sciences come together to analyze the environment and brainstorm possible solutions to the contemporary environmental situation. Cultural ecologist Eugene Anderson was frustrated with the broader public's indifference and complained of the widespread resistance to treating environmental catastrophe with the attention it urgently deserves. In 1995, ecocritic Lawrence Buell argued that apocalypse is the single most powerful metaphor that environmentalism has at its disposal.

Applied to the visual arts, ecocriticism likely reflects a growing sense of urgency, with the next generations possessing a heightened sense of environmental morality. Classrooms are also becoming sites of discussion for imaginative futures. Artists, like their counterparts in literature, are thinking about the impact that humans have on the environment and our complex relationships with the conditions of the earth.

Artists offer public insights that they hope will lead to greater understanding, broader perspective, and celebration of our natural world. As adept observers, artists are uniquely poised to offer personal insights and shared views of the environment—views that are complex and multifaceted, rather than the romantic presentations of earlier artists. This new environmental art is not passive or detached. It suggests activism, not observation; science, not romanticism; and new knowledge, not conventional wisdom. These artists require multiple perspectives and fields to imagine situations and outcomes that venture beyond the traditional.

Alaska, with its vast landscape, seems an obvious choice for land art, but its distance from population centers has put it away from the center of large-scale artwork. Andy Goldsworthy visited Alaska in the 1990s, drawn by the evocative relationship between material, weather, and landscape. He created lines in the landscape by freezing wood together with ice (see figure 12.1).

Perhaps the first environmental artist in Alaska arrived more than one hundred years before Goldsworthy, however. In the twenty years following the United States's acquisition of the Alaska Territory (1867), revenues from the Pribilof Island fur seal harvest paid off the $7.2 million purchase price. Henry Wood Elliott, a watercolor painter, author, and naturalist whose work focused primarily on Alaskan subjects, was an early

| JULIE DECKER

FIGURE 12.1 In Alaska, Andy Goldsworthy created works by freezing together sticks found along the shores near Anchorage.

Andy Goldsworthy, British, born 1956, *One Hundred and Fourteen Sticks*, 1995. Photograph, 85 × 148 cm. Collection of the Anchorage Museum.

artist to use his work to encourage sound environmental practices. A number of his works had an ethnographic approach, displaying Native Alaskans engaging in traditional practices; others focused on the Alaskan landscape and wildlife. Elliott produced some of the earliest images of the Pribilof fur seal harvest and wrote the first detailed account of the northern fur seal's life history. In 1886, Elliott published a book entitled *Our Arctic Province: Alaska and the Seal Islands,* which contains an in-depth exploration of Alaska's history, geography, people, and wildlife. Elliott's conservation efforts for the fur seal are his strongest legacy in Alaska. Elliott called for the need to protect the fur seals, in 1905 coauthoring a document with US Secretary of State John Hay that would eventually become the North Pacific Fur Seal Convention of 1911, the first international treaty dedicated to the conservation of wildlife. Many regard Elliott as the person who saved the northern fur seal from extinction (see figure 12.2).

To describe environmental art in Alaska is to expand its definition, as landscape in Alaska is both natural and cultural—a mix of materials, resources, people, identity, and authenticity of place.

One of the early artists to capture daily life in Alaska's villages and landscape was George Aden Ahgupuk (whose Native name was Twok). He was born in 1911 in the village of Shishmaref, on the Bering Sea coast of the Seward Peninsula. As a youth, he participated in the annual reindeer roundups and hunted walrus and seal for food. In 1930, his uncle took him to the nearest dentist, who was one hundred miles away in Nome. They traveled by dogsled. On the return trip, Ahgupuk was hunting ptarmigan when he slipped down a cliff face and fractured his leg. He and his uncle set the bone as best they could and continued homeward. Although his leg healed, the bone did not mend properly and continued to bother Ahgupuk. With no doctors or nurses nearby, Ahgupuk's leg went untreated for four years.

In 1934, a field nurse with the Bureau of Indian Affairs insisted that Ahgupuk visit the Indian Service hospital at Kotzebue. His leg injury had developed into a tubercular infection of the bone. Eventually, his leg was successfully operated on and saved, but Ahgupuk remained in the hospital for many months. To pass the time during his long recovery, he began drawing scenes of everyday life and of animals and the landscape. Paper and pencils were scarce, so he used the burnt tips of matches and drew on toilet paper. One of his nurses saw his sketches and promised to bring him paper and pencils. She asked him to draw a number of scenes to send as Christmas cards. Several others on the hospital staff also commissioned cards, and when he finally left the hospital, the young artist had earned ten dollars.

Upon returning home to Shishmaref, Ahgupuk was again faced with the scarcity of paper. He asked his mother for some sealskins and, from then onward, tanned sealskins as well as reindeer, caribou, and moose hides served as his canvases. Through trial and

FIGURE 12.2 Henry Wood Elliott was one of the first to document the devastating impact of fur seal hunting by colonists.

Henry Wood Elliott, American, 1846–1930, *The Fur Seal Millions*, 1872. Watercolor, 58 × 32 cm. Collection of the Anchorage Museum.

error, he perfected a tanning process that yielded thin, perfectly smooth and rigid skins. The process required repeatedly scraping, freezing, and bleaching a hide many times over a period of weeks or sometimes months. Throughout his career, Ahgupuk hunted most of the animals whose hides he needed for canvases.

Ahgupuk's early pen-and-ink drawings on skins were epic panoramas that included village scenes, reindeer roundups, men in kayaks hunting seals or polar bears, women ice fishing, dogsled teams, blanket tosses, and more. To finish his works, Ahgupuk often threaded strips of red alder–dyed reindeer skin along the edges to form ribbon-like borders. In 1936, American artist Rockwell Kent purchased some of Ahgupuk's drawings while on a trip to Alaska. *Time* magazine and the *New York Times* each featured articles about Ahgupuk in January 1937, and the *New York Times* included images of some drawings that Kent had collected. Kent was instrumental in Ahgupuk's induction into the American Artists Group, which later exhibited some of his work and also issued a series of Christmas cards that reproduced his drawings. Ahgupuk's drawings also served to document an earlier lifestyle that most younger Native Alaskans had only heard about.

Around 1940, Ahgupuk created one of his most notable works, titled *Radio Babies*. Created with ink and watercolor on skin, with a stitched border, the image is of a

landscape near Rainy Pass, Alaska. In a building in the foreground is Dr. Joseph Romig. Romig is on a radio, dispatching advice to an expectant mother a fair distance away in Bethel, Alaska. The baby is shown soaring over Rainy Pass on the airwaves, traveling toward the antenna in Bethel where his parents are awaiting his arrival. By shrinking the scale of the landscape in his image, Ahgupuk emphasizes the dramatic effect that new technology had in connecting remote communities across a vast state and imposing landscape (see figure 12.3).

Born in 1950, Iñupiaq artist Ken Lisbourne also captured village life in Alaska and the life of indigenous people in close relationship with the land. While many scenes depict the subsistence lifestyle, with Native hunters pursuing and harvesting seal and whale, Lisbourne also tackled difficult subjects in his work. In 2004, Lisbourne created his work *Cape Thompson!* (see figure 12.4).

As government projects and interest in Alaska's Arctic increased, conflicts increased. Native opposition to government actions at times grew into protests. In 1957, the government proposed Project Chariot, part of the Atomic Energy Commission's Plowshare Program to explore peaceful uses of nuclear energy. As part of the project, nuclear explosives were to be used to carve out a deep harbor for Northwest and Arctic Alaska. The commission planned an underwater nuclear explosion at the mouth of Ogotoruk Creek near Cape Thompson.

Physicists tried to make the case to Alaskans that such a blast could be created safely. Villagers near the site, however, opposed the project, expressing concerns about health hazards and the effect of the explosion on important natural resources. Led by Howard Rock from Point Hope, the villagers were able to prompt the government to abandon Project Chariot in 1961. For years, Ken Lisbourne had nightmares about a nuclear explosion killing everything in the area. His painting is a depiction of this nightmare.

Conflict between Native and non-Native cultures was present in Alaska prior to Project Chariot. In 1941, in Juneau, signs banning Native entry to public facilities began to be seen more and more. Elizabeth Jean Peratrovich (born Wanamaker) of the Tlingit Nation was one of the leaders of an effort to ban the "No Natives Allowed " signs. Peratrovich petitioned the territorial governor, Ernest Gruening, and became an important civil rights activist, working on behalf of equality of Alaska Natives. She was credited with advocacy that gained the passage of the territory's Anti-Discrimination Act of 1945, the first anti-discrimination law in the United States. In 2014, contemporary artist Apayo Moore created a painting portraying Elizabeth Peratrovich in the form of Rosie the Riveter from the World War II *We Can Do It!* propaganda poster. Moore's painting was developed as a form of opposition to development in Alaska around the Pebble Mine in Bristol Bay (see figure 12.5).

FIGURE 12.3 Pictured is Joseph Romig, a well-known early doctor in Alaska, dispatching advice over the radio to an expectant mother in Bethel, Alaska. The baby soars over Rainy Pass on the airwaves to an antenna in Bethel, where his mother and father anxiously await his arrival. By shrinking the scale of the landscape, Ahgupuk emphasizes the dramatic effect new technology had in connecting remote communities across an enormous state.

George Aden Ahgupuk, Iñupiaq, 1911–2001, *Radio Babies*, c. 1940.
Ink and watercolor on skin, 25 × 39 cm. Gift of the National Bank of Alaska.
Collection of the Anchorage Museum.

FIGURE 12.4 (above) When Ken Lisbourne was a young boy in the 1960s, the federal government proposed to create a major harbor near Cape Thompson on the Arctic coast of Alaska by setting off a major nuclear blast. The local Iñupiat resisted the proposal, which they felt threatened their lives and the lives of the animals on which they depended. This painting recreates Lisbourne's nightmares caused by this event.

Ken Lisbourne, Iñupiaq, born 1950, *Cape Thompson!* 2004. Watercolor, 55 × 45 × 3 cm. Collection of the Anchorage Museum.

FIGURE 12.5 (opposite) Portrayal of Elizabeth Peratrovich, a Tlingit civil rights activist in the 1940s. Peratrovich's pose references that of Rosie the Riveter in the World War II propaganda poster. She is wearing red and black clothing with Tlingit designs and has an anti–Pebble Mine pin on her shoulder. On the yellow background behind her is the Alaska state seal, altered to show Bristol Bay being destroyed by an oil rig and bulldozer.

Apayo Moore, Yup'ik, born 1984, *We Can Do It*, 2014. Acrylic on canvas, 61 × 61 cm. Collection of the Anchorage Museum.

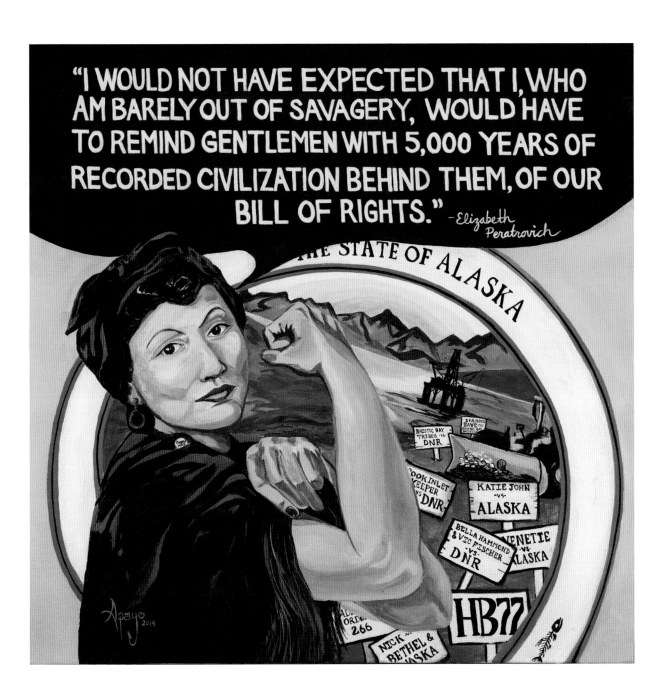

Conflicts in Alaska have often centered around the ownership, use, and development of natural resources. In 1960, federal agents arrested John Nusunginya, a representative in the state legislature at Barrow, for shooting ducks outside the hunting season established by an international migratory bird treaty. Concerned about infringement on traditional hunting and in response to Nusunginya's arrest, more than one hundred Barrow men shot ducks and presented themselves to the federal game wardens for arrest. Charges against Nusunginya were eventually dropped, but Barrow residents were warned that future violations would lead to arrest and prosecution.

The greatest conflicts, not surprisingly, come from the abundance of oil. Many early travelers to the Arctic reported oil. In 1883 the navy began to explore the Arctic coast of Alaska. A member of George M. Stoney's crew brought back a small bottle of oil from the upper Colville River vicinity in 1885. Others reported oil in the Arctic during the early twentieth century. The navy was beginning to convert from coal to oil-fired boilers and established a national program to set oil reserves aside for possible wartime use. After setting up naval petroleum reserves in California and Wyoming, in 1923, President Warren G. Harding created the 37,000-square-mile Naval Petroleum Reserve No. 4 in Northwest and Arctic Alaska. The area stretched from Icy Cape to the mouth of the Colville River. The US Geological Survey concluded that high-quality oil was present throughout. In 1944 a naval exploration party was in Naval Petroleum Reserve No. 4 to drill test wells and build facilities, and the first well was put down in 1945. Over the following ten years, two more oil fields and a large gas field were identified in the reserve. Large oil companies have developed oil fields at Prudhoe Bay on the North Slope of Alaska, now called the National Petroleum Reserve-Alaska. Oil and gas revenues continue to dominate the state's unrestricted revenue stream, accounting for 89 percent of the state's income.

The Alaska Native Claims Settlement Act of 1971 granted Alaska Natives 44,000,000 acres (180,000 square kilometers) of land in Alaska and froze development on federal lands. Toward the end of 1976, with the Trans-Alaska Pipeline System nearing completion, major conservation groups focused on protecting hundreds of millions of acres of Alaskan wilderness not affected by the pipeline, and national debate began over whether to drill in the area of the Arctic National Wildlife Reserve (ANWR).

With oil, external factors were shaping Alaska's future. Oil exploration brought change to Arctic communities. Oil development contractors hired residents from Barrow and surrounding villages. The discovery of a gas field south of Barrow provided residents with inexpensive heat and electricity, and for the first time many could afford boat motors and snow machines. Eventually, these developments caused more people to move to Barrow from outlying villages.

Not surprisingly, then, oil also dominates environmentally driven artwork from the era. While many artists inside and outside the state used their artwork to oppose development of Alaska lands, others recognized the complex codependencies Alaska resources have created for centuries. Alaska is often a place of incongruities; wealth from oil contrasted against weak infrastructure and challenging social issues. In 2010, artist Sonya Kelliher-Combs (Athabascan/Iñupiaq) created an installation at the Anchorage Museum comprising seventy-six black-and-white polymer strips resembling muktuk (the skin and blubber of a whale used as food), suspended over canning jars full of petroleum. The piece posed oil as the new subsistence commodity for Native communities. Kelliher-Combs was raised in the Northwest Alaska community of Nome. Through her mixed-media painting and sculpture, she chronicles the ongoing struggle for self-definition and identity in the Alaskan context. Her shared iconography with personal imagery combines with her use of synthetic, organic, traditional, and modern materials to move beyond such oppositions as Western versus Native culture, self versus other, and man versus nature to examine their interrelationships and inter- dependence. Kelliher-Combs also examines the relationship of her work to skin, the surface by which an individual is often mediated in culture (see figure 12.6).

Tlingit/N'ishga artist Da-ka-xeen Mehner also comments in his work on the Native as well as his own personal relationship with the Alaskan landscape. In his series of photographs *My Right-of-Way,* Mehner depicts the area along the Trans-Alaska Pipeline as a land of extremes and complexities. Mehner worked on the oil fields of Prudhoe Bay and subsistence fished on the Copper River. He also regularly picks berries along the Alaskan pipeline right-of-way near his home in Fairbanks. Beneath what looks to be a country road is a forty-eight-inch pipe that pumps 592,597 barrels of oil per day to Valdez. The right-of-way is a walking area for many, with blueberries and herds of wild musk ox and caribou. With the work, Mehner represents his experiences with how sea- sonal construction and fishing fills the pockets during the summer season, while during winter, many peck away at the savings and pull from freezers the salmon, moose, and berries that were gathered from the land (see figure 12.7). In his work *Weapons of Oil* (see figure 12.8), Mehner uses slumped glass, steel, and oil to form a Tlingit dagger, contrasting traditional with modern form and material. The landscape in Alaska is inextricably tied to oil; its presence is part of the landscape. Artists like Mehner see the beauty in the landscape, alongside the scars, wounds, and bounty.

Another primary industry in Alaska is tourism. Tourism began in Alaska with a Pacific Steamship Co. cruise to Glacier Bay in 1880. Before World War II, a trip to Alaska was expensive and inconvenient. But Alaska's natural beauty was still a draw for some. Now, around a million visitors per year travel to Alaska. Tourism, too, has an

FIGURE 12.6 The "idiot string" forms are based on tethers that hold mittens together so they cannot be separated or lost. The first of these works was made in response to suicide—an epidemic in Alaska Native communities.

Sonya Kelliher-Combs, born 1969, *Idiot Strings IV*, 2005. Walrus stomach, rawhide, wool, hair, wax, and wire. Collection of the Anchorage Museum.

FIGURE 12.7 A path runs along the Trans-Alaska Pipeline
near Fairbanks, Alaska.

Da-ka-xeen Mehner, Tlingit/N'ishga, born 1970, *My Right-of-Way, Summer,*
2009. Photograph, 61 × 27 cm. Collection of the Anchorage Museum.

FIGURE 12.8 Da-ka-xeen
Mehner, Tlingit/N'ishga, born
1970, *Weapon of Oil*, 2006.
Oil (petroleum), glass, and steel,
101 × 83 × 31 cm. Collection
of the Anchorage Museum.

impact on the landscape. It has prompted the construction of large hotels in previously undeveloped places, brought cruise ships as far north as the Arctic, created a boom-and-bust seasonal economy for many small towns, and resulted in the development of infrastructure, from roadside stops and viewfinders to paved parking lots at the base of many major geological features, whether glacier or mountain (see figure 12.9).

The government and the military constitute a large presence in Alaska. Alaska saw the Aleutian Islands become a battlefield in World War II, and, as the closest US territory to the Soviet Union, it became the focus of a major military buildup during the Cold War. Warning and aircraft control stations were constructed throughout Alaska in the 1950s to aid in air defense. In 1954, a chain of radar stations called the Distant Early Warning (DEW) Line were installed along the Arctic Ocean in Alaska and Canada to provide early warning of cross-polar attacks. Communications by high-frequency radio proved unreliable, however, so new technology, relying on tropospheric scatter of radio signals, led to the White Alice Communications System. The communications sites created communities of a sort across Arctic Alaska. When the White Alice system was replaced in 1974 by satellite communications, telephones and televisions were introduced into villages, but a strange and imposing—and obsolete—infrastructure was also left behind. Abandoned military sites from bunkers to buildings to radar facilities are fodder for artists. In 2009, Los Angeles–based artist Daniel Martinez traveled to Alaska and created a series of images of the White Alice Communication System and missile site on top of the Anvil Mountain in Nome. Four antennas and feeder towers rise from the hillside like Stonehenge, contrasting the manmade with the landscape (see figure 12.10).

Indigenous identity has always been tied closely to the landscape. Many contemporary Alaska Native artists use their work to comment on issues of natural and cultural adversity. Rebecca Lyon created her *Women of the North* series of sculptures and masks as a way to honor the women of the North for their ability to survive and adapt. The sculptures take the forms of Native dress panels, but the "clothing is constructed of nontraditional materials, such as metal." Lyon says that even though she may wear Gap jeans made from non-traditional materials, she finds she wears traditional clothing on the inside. Artist Nicholas Galanin is inspired by generations of Tlingit and Northwest Coast artists and values his indigenous culture as highly as his individuality. Through his work he comments on the politics of cultural representation. In his *Imaginary Indian* series of mask forms, he camouflaged Indian art and artifacts with traditional European ceramic designs (see figure 12.11).

Climate change has spurred dramatic art production, from artists both in Alaska and around the globe. Alaska includes lands on both sides of the Arctic Circle, which makes the United States an Arctic nation. Alaska spans a wide range of climatic and ecological

FIGURE 12.9 Barbara Kelly, American, born 1954, *Tourist Abstraction—Woman with Bag 3*, 2005. Inkjet on paper, 29 × 29 cm. Collection of the Anchorage Museum.

FIGURE 12.10 Relics of the White Alice Communications
System near Nome, Alaska.

Daniel Martinez, American, born 1957, *Nine Views of a Secret #3*, 2009.
Photograph, 67 × 86 × 5 cm. Collection of the Anchorage Museum.

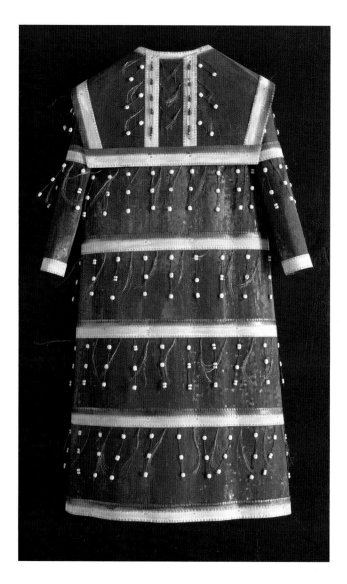

FIGURE 12.11 Rebecca Lyon, Unangan/Athabascan, born 1955, *Women of the North*, 2004. Copper, glass, shell, patina, 173 × 102 × 21 cm. Collection of the Anchorage Museum.

conditions that include rainforests, glaciers, boreal forest, tundra, peatlands, and meadows. It contains sixteen national wildlife refuges spanning tens of millions of acres and hosts 60 percent of the total area managed by the National Park Service. Over the past sixty years, the average temperature across Alaska has increased at a rate more than twice the warming seen in the rest of the United States. Warming has led to changes in ecosystems, affected many species, and created new hardships for Native Alaskans. Rising temperatures may provide a longer growing season for agricultural crops, increased tourism, and access to natural resources that are currently inaccessible due to ice cover, like offshore oil.

The *FREEZE* project in Anchorage in 2009 was a large-scale reflection on Alaska and life in the North, with artists, architects, and designers from Alaska and around the world creating outdoor installations in downtown Anchorage using distinctly northern elements like snow and ice. As an indicator of the volatile environment, while the pieces were being constructed, Anchorage temperatures were some of the lowest on record, dipping to nearly –30°F. Within days of the installations opening to the public, however, the temperatures soared to near-record warm, swinging almost 80°F and melting the works. While the artworks gained international attention, it was perhaps the climate that became the center of the narrative (see figure 12.13).

Climate change is dramatic in northern and western Alaska, affecting ways of life for many village communities. Brian Adams documented the early and dramatic effects of climate change on villages along the western coast of Alaska in his photographic series *Disappearing Villages*. Rural Alaska villages such as Shishmaref, Newtok, and Kivalina are facing relocation due to land erosion. Some of these villages have erected enormous seawalls along the barrier reefs to try to protect their and lifeways from rapid coastal land loss (see figures 12.14 and 12.15).

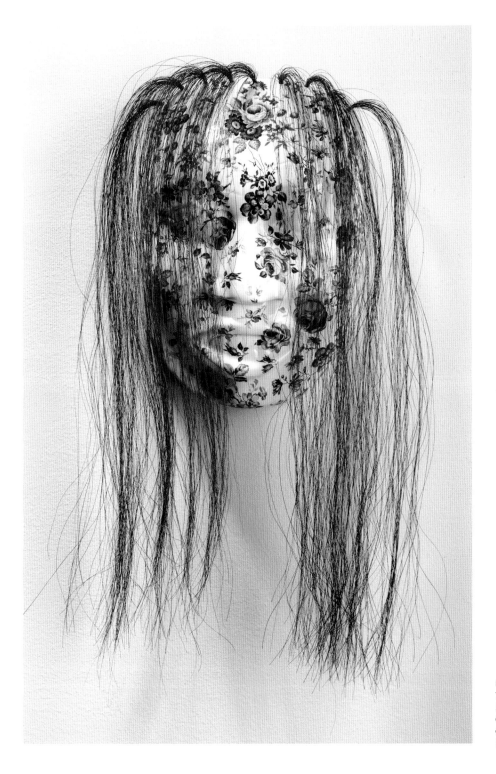

FIGURE 12.12 Nicholas Galanin, Tlingit/Unangan, born 1979, *S'igeika'awu: Ghost,* 2009. Ceramic, horsehair, 24 × 18 cm. Collection of the Anchorage Museum.

Artists reflect irony, realities, and potential futures of this landscape. While some use their work to convey alarm and to inspire action, some speak to optimism and to a shared narrative of questions more than answers. Images and artwork have moved away from simply a portrayal of the polar bear as icon, to images that reflect the complexity of both place and people. The cultures of Alaska cross boundaries and nationalities and include many voices (see figure 12.16). Artists are part of a powerful conversation about the environment across the Arctic at a time of dramatic change. As the world looks north for indicators of what southern regions may soon face, art gives the landscape visual and exportable form, allowing it to serve as beacon, message, and reflection (see figure 12.17).

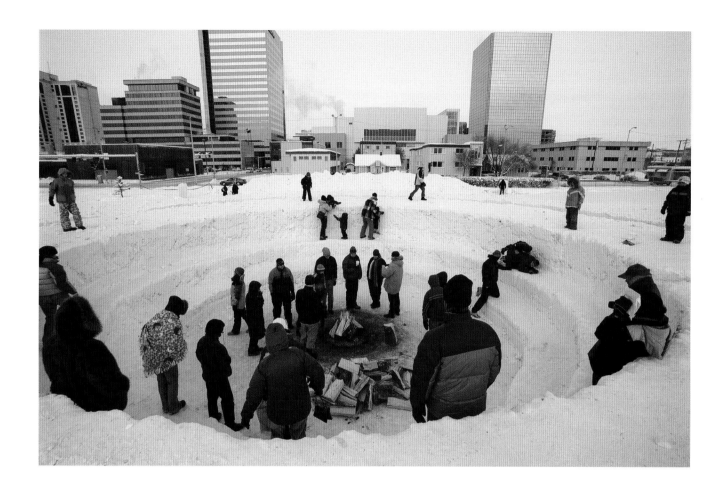

FIGURE 12.13 As part of the FREEZE project in downtown Anchorage in 2009, a project that brought artists and architects from Alaska and around the world together for a series of outdoor installations featuring snow and ice, the Molo collective created a maze from snow. Participants entered the maze by taking a piece of firewood near the entrance. At the center of the circle, the wood was collected for a communal fire

Molo collective, *Northern Sky Circle*, Anchorage, 2009. Outdoor space/installation created from a snow maze, with a community fire at the center.

FIGURE 12.14 Kivalina is a small, rural Alaskan village located at the tip of an eight-mile barrier reef between the Chukchi Sea and the Kivalina River. Due to land erosion, the village is one of many in Alaska that will eventually have to relocate. In 2006, an 1,800-foot wall was built to protect Kivalina from the Chukchi Sea. That same year, a storm with winds of forty miles per hour washed out 160 feet of the wall. Brian Adams, a native of the village, visited in 2007 to see where he had lived as an infant. By this time, the villagers had reinforced the wall with large sandbags as a temporary solution.

Brian Adams, Iñupiaq, born 1985, *Kivalina Seawall,* 2007. Inkjet on paper, 41 × 41 cm. Collection of the Anchorage Museum.

FIGURE 12.15 Brian Adams, Iñupiaq, born 1985, *Children in Newtok,
Alaska, Playing on Land Erosion,* 2008. Inkjet on paper, 51 × 41 cm.
Collection of the Anchorage Museum.

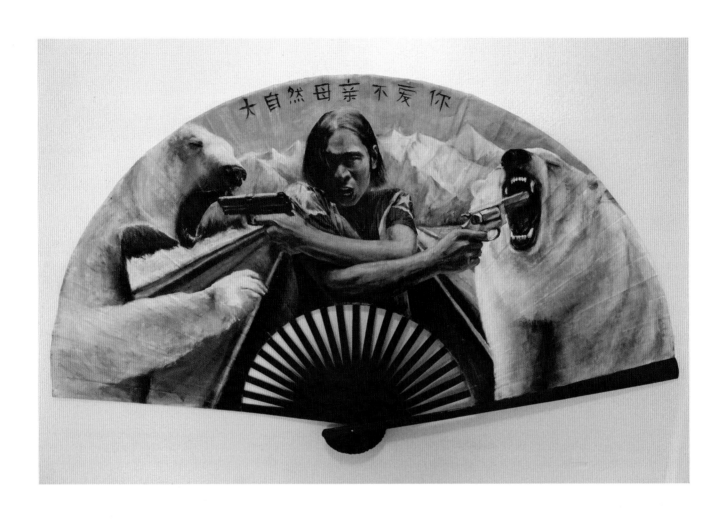

FIGURE 12.16 Thomas Chung, American, born 1988, *Mother Nature Does Not Love You,* 2016. Oil paint, acrylic paint, silk, wood, 102 × 185 × 6 cm. Collection of the Anchorage Museum.

FIGURE 12.17 Cody Swanson, American, born 1986, *Beluga Point Ferris Wheel*, 2014. Oil pastel, ink, and silver gelatin on paper, 39 × 50 cm. Collection of the Anchorage Museum.

THE NEW FRONTIER IN THE LAST FRONTIER

MARA KIMMEL and
MICHAEL BRUBAKER

The sights and sounds of the Arctic are changing. Rapidly. Noticeably. Rain now replaces snow in February instead of March. Green grass appears in April rather than May. Snow disappears from Nome before the last Iditarod finisher leaves town, and competitive cross-country skiers are confined to a single loop of manmade snow in Anchorage's internationally renowned Nordic ski park. Strange, unrecognizable bugs are showing up in far reaches of our state. The unknown has become regular (see figure 13.1).

Change is Alaska's steady state. Change is our norm—between seasons, between daylight hours, and between past and future. The difference now is the speed with which transformations in the environment, cultures, and economy are taking place. The Alaskan challenge is to make sure our people and communities have the capacity, strategy, and will to respond to the rapid changes. We rely on age-old traditions of innovation and collaboration to successfully adapt.

More than just climate is transforming. In a state that historically understands itself demographically as either indigenous or non-indigenous, diversity has replaced that dichotomy. Students in the state's largest school district speak more than a hundred languages from parts of the world as far-flung as South America, East Asia, West Africa, and Central Europe. Alaska is home to one of the fastest-growing and most diverse immigrant and refugee populations in the United States. This new mosaic overlays a state that includes the traditional territories of more than two hundred tribes (see figure 13.2).

Our economies are also transforming. Declining oil prices and reduced production mean a changing fiscal reality that forces our communities and leaders to think beyond petroleum as a staple and stable revenue source. Alaska faces the need to evolve and develop an economic future that expands and diversifies beyond its dependence on oil.

FIGURE 13.1 Calving of a glacier.

All photographs in this chapter courtesy of Getty Images.

All this affects our lexicon. We now regularly use terms like *resilience* and *sustainability*. We now know that "languages of limited diffusion" are those spoken by Alaska's newest refugees from Sudan, Somalia, Ethiopia, and Iraq. "Climigration" describes the movement of people after climate-caused transformations force a community to uproot in order to save itself. "Observing networks" of people and communities watch and report change, with elders, scientists, and policy makers all sharing information. We live in a world of "post-oil economics." Idioms are changing alongside climate.

These changes test Alaskans—what we think we are and who we want to be. Not because we are unaccustomed to change—we know it well. The Arctic has always been a place of exploration and renovation and adaptation to harsh and sudden conditions. But the rate of change is new, and Alaskans live these transformations in real time. Scientists note that the rate of climate change is occurring twice as rapidly in the North as it is in other regions of the world. Alaskans know that the changing climate creates

FIGURE 13.2 Signs pointing to cities throughout the world, from the visitor's center in Anchorage, Alaska.

a need to respond quickly and in ways that preserve our unique sense of self and identity. Change challenges Alaska and Alaskans, just as it always has, to answer with innovation and inspiration. It calls on us to tap into our core values of self-reliance, sense of place, and strength in culture (see figure 13.3).

ENVIRONMENTAL CHANGE

Alaska is a dynamic place where wind, water, and ice create landscapes that are constantly changing. Here, storms reshape coastlines, floods alter rivers, and fires blacken forests. But even in this most dynamic of places, some things never change. Some things have been the same way year after year, as reliably as the seasons, since the beginning of human memory.

This we know from indigenous knowledge, history recorded in Native languages and passed down from one generation to the next. The phenology of life is captured in seasonal names, in twenty different languages. Months are traditionally named for the time of important events—when the ice is right for fishing, when the caribou return, the best times for berries and egg gathering.

Adherence to these traditional cues have helped ensure safe and successful harvests for thousands of years. But today, in the first quarter of the twenty-first century, the timing of important events is changing. Nature is unhinging from the seasons, and language is separating from the practices of daily life.

In 2014, Alaska experienced the warmest year on record. The following year was the second warmest, and climate models project that warming will continue. What happens when the temperature rises? A climate characterized by snow can soon become dominated by rain. Hard and resilient landscapes, locked in ice since glacial times, can become soft and fragile. Communities across Alaska have already experienced significant and

permanent impacts as a result of climate change. It began decades ago, slowly, quietly perceived by people who were as familiar with the weather as with their own families. Change arrived with an unusual gust of wind or a raindrop on a winter day.

What were some of these first signals? In the north, people marveled at the unfamiliar growl of thunder on a summer afternoon, harbinger of the tundra fires to come. In the west, there was the departure of the old ice where the spring hunting camps perched on the ice edge. In the interior, the tundra, usually soft and spongy, became so dry that it crunched underfoot. In the southwest, there was the slow decline of the snow season and the gradual greening as shrubs crept higher up creek beds and mountainsides. In Southeast Alaska, people noticed graying on the tips of spruce trees and a reddening of the sea as the waters bloomed with algae. These were some of the first symptoms of systemic change in the Arctic environment. Many other changes have followed: berries blooming weeks earlier than normal; migrating salmon caught through the ice on the Yukon; strange birds for which there are no words in any Alaska Native language.

FIGURE 13.3 Melting ice near Mendenhall Glacier.

The Great Land is transforming, and Alaskans are adapting and changing with it. For rural communities and cities alike, the challenges are great, but there are also new opportunities: ships sailing north bringing tourism and trade; new emerging fisheries as salmon and other species move north; access to waters that have never been fished; a longer season for growing vegetables in a thousand backyard gardens (see figure 13.4).

Dispatches from local observers in early 2013 described conditions that were unprecedented, almost unbelievable. In January, warm weather and east winds in the Norton Sound blew whatever ice there was out to sea. Unalakleet residents, accustomed to driving across the sea ice, parked their snow-goes and put their boats back in the water. Even as far north as Barrow, conditions did not support the development of normal ice. In early June, the spring whaling season was in full swing, but several whaling parties were forced back to shore. The shore ice was breaking loose from the land and drifting out to sea (see figure 13.5).

Traditionally, the Iñupiat hunt in the spring, during the bowhead's northward migration. Camping on the sea ice, hunters scan the open water for telltale spouts and then launch their *umiats* in pursuit. But with less good ice, the spring hunting is more difficult and more dangerous. The once-stable platform of ice is now often a thin veneer, undulating with each wave. Increasingly, hunters are turning to a fall hunt to supplement their harvest. Fall hunting occurs in open seas, using oceangoing boats. The Iñupiat, ever-mindful of traditions, are not constrained by them. In the New Frontier, traditions are either adapted or lost. Barrow and other Arctic whaling communities are adapting, and finding hunting success with or without the presence of sea ice.

PROTECTING THE LAND

In Northwest Alaska, coastal villages face growing threats from the sea. Permafrost thaw, sea ice loss, storm surge, and erosion are all signs of a warming Arctic. Many coastal communities are faced with a difficult choice: either protect their land from storms or move out of harm's way. Arctic coastlines are often characterized by frozen ground, not by rock. Protecting the shore means fortifying with berms of sand or with huge granite blocks carved from the cliffs near Nome and hauled in by barge. Nome has a massive rock seawall that runs for miles along the coast. Smaller revetments can be found in Barrow, Point Hope, Wainwright, Kivalina, Kotzebue, Shaktoolik, Unalakleet, and dozens of other communities.

In Shishmaref, the rock wall has provided protection for most of the village from winter storms. Seawalls are temporary, however, and come at tremendous cost. Still unprotected and vulnerable to warming and the next storm are the airstrip, dump, subsistence camp, and gravesites. In the New Frontier, the exposed shores will need to be armored if communities like Shishmaref are to survive.

FIGURE 13.4 Cabbage growing in a backyard garden near Palmer, Alaska.

FIGURE 13.5 Polar bears feasting on the carcass of a bowhead whale near Barrow, Alaska.

Golovin is a village of about 170 people, located seventy miles east of Nome. It is one of the coastal communities threatened by erosion, coastal storms, *ivus* (ice surges), and rising seas. Located on a sandy spit extending into Golovin Bay, it is a good place for fishing, hunting seals and birds, and harvesting shellfish. The risk of flooding is growing here, and this traditional homeland cannot be sustained for much longer. Golovin has already been underwater once. In November 2011, an extratropical cyclone resulted in one of the most powerful storms on record. A storm surge of over eight feet flooded dozens of communities, including Golovin. With rising seas and decreasing sea ice to buffer the storms, the flood risk is growing each year. But Golovin has options. Behind the village, in view of the hills where residents hunt moose and pick greens and berries, there is high ground and an opportunity for a sustainable future. Community leaders are beginning, step by step, to move the village to a safer place. First there was a new community center, then a water treatment plant, and someday there will be a school up there. With each new project, progress is being made toward a more resilient and sustainable future. Building sustainable communities in the New Frontier requires an understanding of the past and a clear vision for the future.

The Iñupiat community of Kivalina is located at the southern tip of a narrow barrier island on the edge of the Chukchi Sea. As a coastal community, it is vulnerable to storm surge from the combined effects of declining sea ice, increasing waves, and erosion. Less discussed are the changes occurring inland, on the banks of the Wulik River. The Wulik River winds ninety miles from the Chukchi coast east to the Delong Mountains. For the Iñupiat residents of the area, it is the byway to subsistence resources located inland: caribou, salmon, Dolly Varden trout, whitefish, waterfowl, and berries. Most of the river is underlain by permafrost. On the banks, the frozen ground acts as a barrier, holding water and keeping the tundra soils bound together.

With warming has come widespread thawing of the shallow permafrost and an increase in the zone that thaws seasonally. Warming has caused thaw cracks as far as thirty feet from the river. Great swaths of the bank have peeled away from the frozen ground and slid into the river. One section under the cut bank revealed a thaw tunnel, eight feet in circumference, extending inland—the remains of thawed ice wedges. The thaw tunnels had created an underground conveyor, moving water and soil from deep under the bank out into the river. Like many Arctic rivers, the Wulik is becoming warmer, wider, shallower, and muddier. River navigation is a challenge, and many communities are converting from propeller to jet outboards to accommodate the growing stretches of shallow water. Climate change may soon make river navigation easier here. With less sea ice, the wind can pass over greater expanses of open water, building waves that can surge for miles up some rivers. With the right conditions, boats can and will travel farther upriver, improving navigation and access to harvest areas (see figure 13.6).

STAYING COOL IN THE ARCTIC

FIGURE 13.6 A whalebone placed along the coast in Barrow, Alaska.

In interior Alaska, summer heat can sometimes make it feel like Mexico. Temperatures as high as 100°F have been recorded in Fort Yukon, and it is getting hotter. Records from across Alaska show steady increases in average monthly temperature. This presents a new problem for Arctic engineering—designing for extreme heat and extreme cold. Structures in Alaska have traditionally been built for cold: heavily insulated, with double- or triple-pane windows and efficient heating systems. If it's hot, there is typically no system for cooling. Air conditioning is almost unheard of across Alaska, and many homes don't even have an electric fan.

Increasing summer temperatures also bring lightning and wildfire. In the summer of 2015, over five million acres in Alaska burned. It was the second biggest wildfire season on record. In some communities, like Fort Yukon, the smoke persisted for weeks. In

FIGURE 13.7 Wildfire-fighting equipment, Fairbanks, Alaska.

the absence of air conditioning, residents downwind of wildfires face difficult choices—open the windows and let in the smoke, or close the windows and bake (see figure 13.7).

In the New Frontier, buildings need to be designed not just for heating but also for cooling. In a landscape characterized by ice and permafrost, there are some obvious opportunities. The new health clinic in Fort Yukon was constructed with an actual cooling system, one of the few in Alaska. The design uses an innovative circulating system that brings cold water from the ground into the building. The result is a cool refuge from the heat and smoke outside. In other buildings and even some homes, small air conditioning units have been installed—some of the first in rural Alaska. With the promise of more hot and smoky days ahead, Alaskans are using the cold of the ground to manage the increasing warmth of the air.

MARA KIMMEL AND MICHAEL BRUBAKER

CHANGING THE HARVEST

In southern coastal Alaska, shellfish is an especially important subsistence food. Aleuts have traditionally harvested clams and mussels during the cool season in order to reduce the chance of lethal algal toxins. These toxins tend to increase in the summer months and decline in the winter, when ocean and air temperatures are colder. Driven by concerns about rising sea temperatures, residents in King Cove and Sand Point started the first subsistence shellfish-monitoring programs in Alaska. In June 2012, residents began harvesting shellfish for analysis rather than just for dinner. Since July 2015, the concentrations of harmful toxins in shellfish samples have consistently exceeded the USDA commercial harvest regulation of 80 parts per billion. This is the case both in the summer and in the winter. Thanks to local monitoring efforts, no one has become sick from shellfish, and community surveillance for these and other emerging health risks are continuing (see figure 13.8).

Shellfish safety is just one of many emerging food challenges across Alaska. Regional harvest failures related to climate change have been reported in everything from berries to ice seals, caribou to salmon. Rapid change is generally not a good thing for plants and wildlife, and the stress is being seen at all levels of the Arctic food chain. In recent years, shortages or unusual snow and ice conditions have interfered with subsistence activities. In the village of Kiana on the Kobuk River, residents reported a shorter season for drying fish. Some had to throw fish away because warm conditions had caused them to spoil. In the New Frontier Alaskans are looking for ways to increase their food security. One bright area is an extended growing season; warming conditions are allowing for the cultivation of some plants in places where that would have been impossible a decade ago. What we grow in our backyards may help to temper the uncertainty about what we can harvest off the land and sea (see figure 13.9).

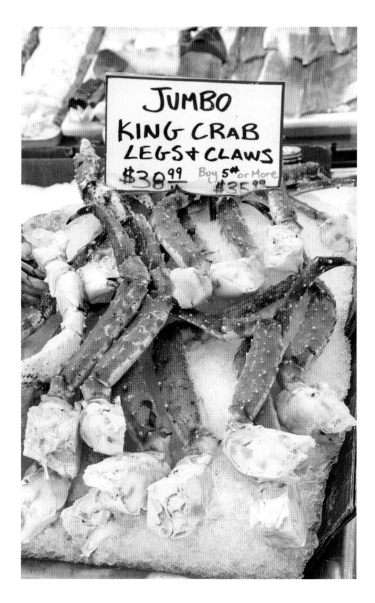

FIGURE 13.8 Alaskan king crab at a market.

FIGURE 13.9 Manmade palm trees near Barrow, Alaska.

MARA KIMMEL AND MICHAEL BRUBAKER

SOCIAL AND ECONOMIC CHANGE

Anchorage is a contemporary city steeped in indigenous origins. It is Alaska's largest village, bridging traditions, peoples, and lifestyles that date back ten thousand years and the trappings of modern urban living. Almost half the state's population—300,000 people—live in Anchorage, a city that occupies a unique intersection of space and time. Situated on the edge of wild and undeveloped spaces, Anchorage straddles the cross-roads of continents—nearly equidistant from Washington, DC, Beijing, and Berlin—and it faces a future of environmental, social, and economic challenges.

A changing climate means that Anchorage experiences more freeze-thaw events, more lightning strikes, and longer fire seasons. Climate change brings infestation of non-indigenous plants that clog the city's waterways, attack trees, and kill and disori-ent fish in local streams. The average temperatures in Anchorage in January 2015 were warmer than in New York City. The annual temperature for that same year was 2.6°F above average, making 2015 the second-warmest year on record. Drier spring seasons ele-vate wildfire danger, threatening homes and neighborhoods throughout the city. Warmer temperatures increase the chances that insect-borne diseases will spread more easily.

Anchorage's demography is changing. What was once a small Dena'ina village is now home to an increasing mix of people from foreign lands. Immigrants and refugees accelerate the city's changing identity because this population is growing at a more rapid rate than the national average, and our rate of ethnic diversification far outpaces that of other cities nationwide. In 2014, the Anchorage School District contained the twenty-five most ethnically diverse public schools in the United States. This diversity enhances the rich ethnic traditions of the city, grafting layers of language, experience, and culture onto an already intricate, vibrant mix of indigenous cultures. Diverse neighborhoods and cultures bring new skills and perspectives to the city, making it an attractive place for businesses seeking to attract and retain talented workers. Simi-larly, ethnic diversity brings linguistic capacity and critical job skills for bilingual and multilingual Alaskans, and opens doors for Anchorage to fully participate in the global economy. Attracting talent spurs economic growth and equips Anchorage to take on the challenges of tomorrow.

Tomorrow's challenges have arrived because Anchorage's economy is changing. The city's revenue base is shifting away from the petroleum industry and from reliance on federal and state dollars. Declining oil revenues and decreasing government budgets means depleted state income and fiscal dynamics beyond the municipality's control. These pressures exacerbate economic insecurity, particularly in neighborhoods where unemployment reaches over 20 percent and where 20 percent of people live in poverty. Aging infrastructures add additional stress to the city's economic outlook. The Port of Anchorage—where over 80 percent of goods come into the state—rests on rusted pilings, some dating back to before the 1964 earthquake that devastated the town.

FIGURE 13.10 Anchorage at night (from the Captain Cook Hotel).

Roads and bridges connecting Anchorage to other parts of the state suffer from deferred maintenance (see figure 13.10).

In the face of transformative changes, Anchorage is building its resilience capacity. City officials and community organizations are working to eradicate unemployment, poverty, and homelessness in order to combat chronic and systemic stresses that are foundational to our capacity to withstand the acute environmental shocks that are happening more frequently. In urban policy speak, "urban resilience" has become today's "urban renewal," and Anchorage is joining the growing number of cities worldwide framing a pathway to the future by building the capacity to respond to rapid and transformational environmental, cultural, and economic changes.

The shifts in environment, culture, and economy affect the geography of Anchorage. The city occupies the same point in space, but its orientation in the global community has fundamentally shifted. With an opening and warming Arctic, Anchorage is no longer a terminus—no longer just the end of the road. Anchorage is now a hub—a burgeoning link between distant points on the map. In the state known for its motto, "North to the Future," the future has arrived because the North is more accessible than it has ever been (see figure 13.11).

EVERYTHING OLD IS NEW AGAIN: MOVING FORWARD BY REACHING BACK

Throughout our state, Alaskans are reaching for resilience by tapping into our core character as self-reliant, deeply rooted in place, and proud of our diverse cultural traditions. These characteristics, whether Alaskans have called this area home for ten thousand years or have just arrived in the state, are part of all of us. People who live in the Arctic rely on innovation and initiative to survive and thrive in harsh and isolated conditions. Our cultures and traditions inform the ways we move into the future and understand the identity of our state, because in the Arctic, Alaska bridges the globe at the top of the world. The Last Frontier becomes the New Frontier as global horizons shift northward.

SUGGESTIONS FOR FURTHER READING

Berger, Thomas. *Village Journey: The Report of the Alaska Native Review Commission.* New York: Hill and Wang, 1985.

Einarsson, N., J. Nymand Larsen, A. Nilsson, and O. R. Young, eds. *Arctic Human Development Report.* Akureyri: Stefansson Arctic Institute, 2004.

Larsen, J. N., and G. Fondahl, eds. *Arctic Human Development Report: Regional Processes and Global Linkages.* Vol. 2. Copenhagen: Norden, 2014.

MARA KIMMEL AND MICHAEL BRUBAKER

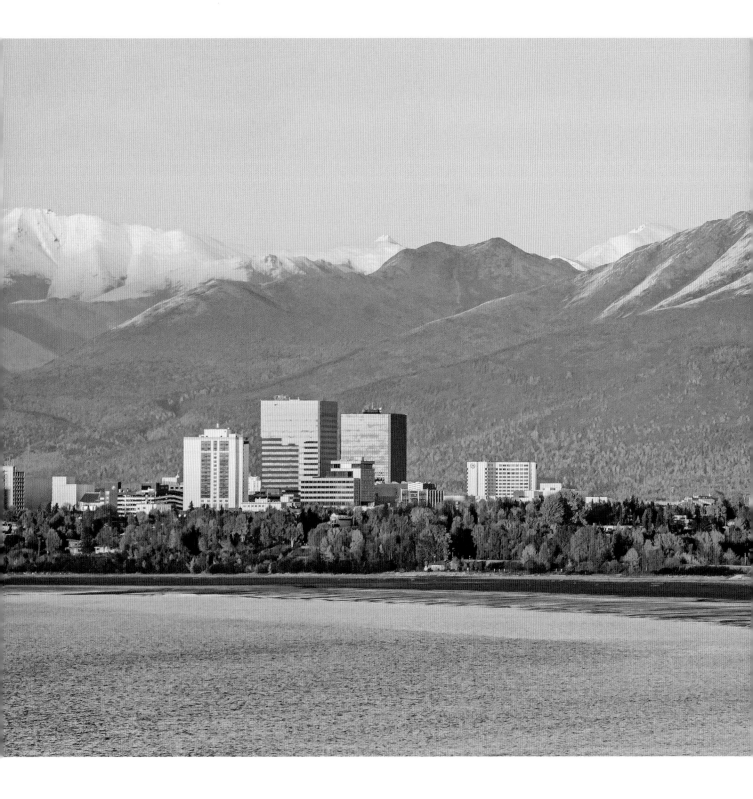

FIGURE 13.11 View of the Anchorage skyline, with the Chugach Mountains in the background.

CONTRIBUTORS

KIRSTEN J. ANDERSON

Kirsten J. Anderson is the deputy director and chief curator at the Anchorage Museum in Alaska. She has edited and contributed to various publications, including *Up Here: The North at the Center of the World.* She has an MPhil in archeology from the University of Glasgow, Scotland, and an MFA from the University of Alaska Anchorage.

ALAN BORAAS

Alan Boraas is a professor of Anthropology at the University of Alaska's Kenai Peninsula College. Boraas has investigated Dena'ina and other Alaskan cultures from the standpoint of each of the major subfields of anthropology: cultural anthropology, linguistics, archaeology, and biological anthropology. He has written for the *Alaska Dispatch News* (formerly the *Anchorage Daily News*), *Redoubt Reporter,* and *Peninsula Clarion.*

MICHAEL BRUBAKER

Michael Brubaker was born in Juneau, Alaska, and raised in Anchorage. He received his BS from Saint Lawrence University and his MA in environmental management from the University of San Francisco. For the past twenty years, he has worked in the tribal health system, helping Alaska communities understand the health implications of environmental change. This work has taken him across Alaska and around the circumpolar north. Since 2008, he has directed the Center for Climate and Health at the Alaska Native Tribal Health Consortium.

JULIE DECKER

Julie Decker is the director of the Anchorage Museum in Alaska, where she also served as chief curator. She has written extensively on the art and architecture of the North. She has edited numerous publications, including *Up Here: The North at the Center of the World*; *Alaska and the Airplane*; *Modern North: Architecture on the Frozen Edge*; *True North: Contemporary Architecture of Alaska*; *Quonset: Metal Living for a Modern Age*; and *John Hoover: Art and Life*.

DAVID HOLTHOUSE

David Holthouse is the curator of public engagement at the Anchorage Museum, as well as a journalist and playwright. His work has appeared in *Rolling Stone, The Nation, Mother Jones,* and *The Observer* (UK), numerous alternative weekly newspapers, and on the public radio program *This American Life.* His play *Stalking the Bogeyman* has been produced in New York City (Off-Broadway), London, Miami, Asheville, North Carolina, and six communities in Alaska.

PRISCILLA NAUṄAḠIAQ HENSLEY HOLTHOUSE

Priscilla Nauṅaḡiaq Hensley Holthouse (Iñupiaq) is a writer and artist based in Anchorage. Her family roots are in Kikiktagruk (Kotzebue) and Anchorage. She is a graduate of the University of Alaska Anchorage, where she earned an interdisciplinary BA in dance and anthropology. Her work has recently appeared in *First Alaskans Magazine* and *Forum,* the magazine of the Alaska Humanities Forum.

NADIA JACKINSKY-SETHI

Nadia Jackinsky-Sethi (Alutiiq) is an art historian based in Homer, Alaska, whose research focuses on Alaska Native arts and cultural revitalization. She received her MA and PhD from the University of Washington and teaches Alaska Native art history at the University of Alaska Anchorage. She is currently completing her book, *Indigenous Arts from Alaska: An Art History from the North,* a survey of Alaska's indigenous art traditions.

MARA KIMMEL

Mara Kimmel has a long career in Alaskan public policy focused on issues of rights and justice. She is a senior fellow at the Institute of the North and has been on the faculty of the University of Alaska Anchorage and Alaska Pacific University. She is the co-founder of the Alaska Institute for Justice—Alaska's only nonprofit agency providing immigration, legal, and language services and protecting human rights for all Alaskans. She has represented immigrants and refugees fleeing violence and persecution, and has worked with Alaska Native tribes to protect the rights of environmental governance. Mara has a PhD from Central European University in Budapest, Hungary, and a JD from the University of Minnesota, Twin Cities.

AARON LEGGETT

Aaron Leggett (Dena'ina) was born and raised in Anchorage and is a member of the Eklutna tribe of Dena'ina Athabascans. He currently serves as the curator of Alaska History and Culture at the Anchorage Museum in Alaska. Leggett was a co-curator of *Dena'inaq' Huch'ulyeshi: The Dena'ina Way of Living*—the first major exhibition on Dena'ina Athabascan culture—and co-editor of the exhibition's catalog. Leggett also serves as an advisor to the Alaska office of the Smithsonian Arctic Studies Center. Prior to his work at the Anchorage Museum, Leggett was the Dena'ina cultural historian for the Alaska Native Heritage Center and assistant historian for Cook Inlet Region Inc.

JOHN PEARCE

John Pearce is the chief of the Wetlands and Terrestrial Ecosystems Science Office at the US Geological Survey's Alaska Science Center in Anchorage, Alaska. He also served as a biologist for the US Fish and Wildlife Service. He has authored many articles for journals and publications.

SANDRA TALBOT

Sandra Talbot is a research wildlife geneticist and serves as the director of the Molecular Ecology Laboratory at the US Geological Survey's Alaska Science Center in Anchorage, Alaska. She is a specialist in the field of molecular genetics studies of Beringian (Alaskan) mammalian, avian, and plant species, with an emphasis on the population genetics and phylogeography of eastern Beringian species. She also served as a biologist or botanist for the US Fish and Wildlife Service and refuge wildlife biologist for the Nowitna National Wildlife Refuge in Alaska. She has also worked as a freelance scientific illustrator and has authored many articles for journals and publications. Talbot earned a BS in wildlife and range management and an MS in zoology (terrestrial ecology) from Brigham Young University, and a PhD in biology from the University of Alaska Fairbanks. She recently earned a BFA in sculpture and drawing from the University of Alaska Anchorage and is currently completing an MS in biotechnology/bioinformatics at the University of Maryland University College.

WALTER VAN HORN

Walter Van Horn is the collections assistant at the Wells Fargo Alaska Heritage Museum in Anchorage and works with the Cook Inlet Historical Society and the Anchorage Pioneer Family Project. He is the former director of collections at the Anchorage Museum in Alaska. His research has emphasized Alaska Native culture, the Works Progress Administration art project in Alaska, Eskimo drawings, and Alaska history.

Copyright © 2017 by the Anchorage Museum
Printed and bound in South Korea
Design by Laura Shaw Design
Composed in Adobe Garamond Pro, designed by Robert Slimbach,
and Avenir, designed by Adrian Frutiger

21 20 19 18 17 5 4 3 2 1

University of Washington Press
www.washington.edu/uwpress

Library of Congress Cataloging-in-Publication Data

Names: Decker, Julie, editor.
Title: North : finding place in Alaska / edited by Julie Decker.
Description: Anchorage, Alaska : Anchorage Museum ; Seattle and
 London : University of Washington, 2017. | Includes bibliographical
 references.
Identifiers: LCCN 2016047760 | ISBN 9780295741840 (pbk. : alk.
 paper)
Subjects: LCSH: Alaska. | Alaska—History. | Alaska—Exhibitions. |
 Anchorage Museum at Rasmuson Center—Exhibitions. |
 Anchorage Museum at Rasmuson Center.
Classification: LCC F904.5 .N67 2017 | DDC 979.8—dc23
LC record available at https://lccn.loc.gov/2016047760

Cover artwork: (Front) Acacia Johnson, American, born 1990,
Driving Into Night (The Last Time We Saw the Sun), 2014. Print,
87 × 72 cm. (Back) Magnus Colcord "Rusty" Heurlin, American,
1895–1986, *After Fishing*, c. 1960. Oil on board, 87 × 127 × 5 cm.
(Inside) Theodore J. Richardson, American, 1855–1914, *Muir Glacier*,
c. 1900. Watercolor, 57 × 95 cm. Collection of the Anchorage Museum.